Publisher's Acknowledgements
We would like to thank the
following authors and publishers
for their kind permission to reprint
texts: **Lynne Cooke**, New York;
Vancouver Art Gallery, Vancouver;
Zone Books, New York; and the
following for lending
reproductions: **British Film
Institute**, London; **Solomon R.
Guggenheim Museum**, New York;
Dan Graham, New York; **Rodney
Graham**, Vancouver; **Jenny
Holzer**, New York; **Kunstmuseum
Hamburg**, Hamburg; **Jeff Wall**,
Vancouver. We would also like to
thank **Angela Choon** and **David
Zwirner Gallery**, New York, and
Colin Griffiths, Stan Douglas
Studio, Vancouver, for their
assistance with this project.
Photographers: **Peter Cummings;
Zoë Dominic; Stan Douglas;
Monika Gagneau; Ellen Labenski;
Trevor Mills; Philippe Nigeat;
Fredrik Nilsen; Heike Ollertz and
Barbara Stauss; Richard-Max
Tremblay; Tom Van Eynde; Uwe
Walter; Stephen White**

Artist's Acknowledgements
Special thanks to Iwona Blazwick
and Gilda Williams for instigating
and commissioning this project,
and to Ian Farr, Stuart Smith and
Veronica Price of Phaidon Press.

All works are in private collections
unless otherwise stated.

Phaidon Press Limited
Regent's Wharf
All Saints Street
London N1 9PA

First published 1998
© Phaidon Press Limited 1998
All works of Stan Douglas are
© Stan Douglas.

ISBN 0 7148 3796 2

Printed in Hong Kong

cover, From **Pursuit, Fear,
Catastrophe: Ruskin, BC**
1993
16 mm film loop installation with
Yamaha Disklavier
14 mins., 50 secs. each rotation,
black and white, sound
Dimensions variable
Black and white Polaroid
photograph
7.5×10 cm
Lighting test still

page 4, **Marble Quarry at Hisnit
Inlet**, from **Nootka Sound**
1996
C-print photograph
46×56 cm
From the series of 30 prints,
various dimensions
Collections, Solomon R.
Guggenheim Museum, New York;
National Gallery of Canada,
Ottawa

page 6, **Stan Douglas**
1996
Filming at Nootka Sound, British
Columbia

page 30, **'I'm Not Gary'**, from
Monodramas
1991
Video for television
30 secs, colour, stereo soundtrack
Video still

page 68, **Der Sandmann**
1995
16 mm film loop installation
9 mins., 50 secs. each rotation,
black and white, sound
1970s set, DOKFILM Studios,
Potsdam, Babelsberg, Germany,
1994

page 78, From **Pursuit, Fear,
Catastrophe: Ruskin, BC**
1993
Black and white Polaroid
photograph
10×7.5 cm
Lighting test still

page 144, From **Pursuit, Fear,
Catastrophe: Ruskin, BC**
1993
Colour Polaroid photograph
10×10 cm
Continuity still

Scott Watson Diana Thater Carol J. Clover

Stan
Douglas

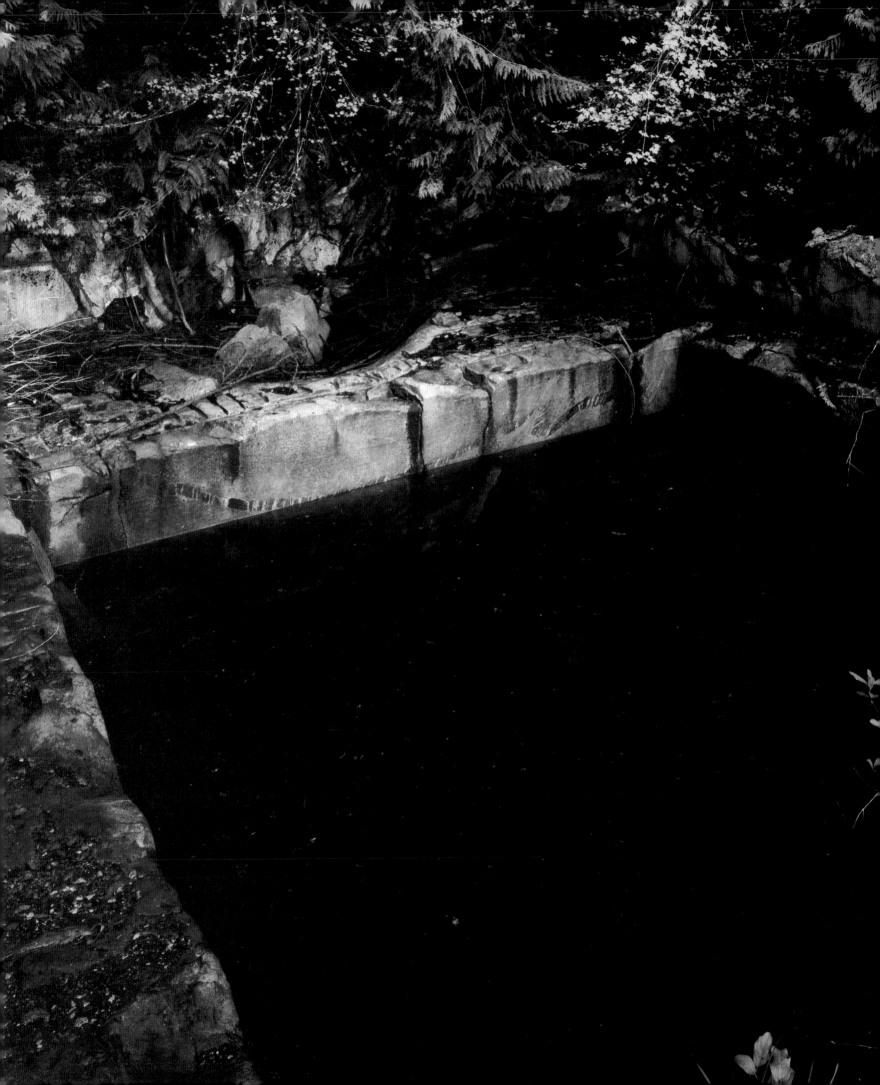

Contents

Interview Diana Thater in conversation with **Stan Douglas, page 6.** **Survey** Scott Watson

Against the Habitual, **page 30.** **Focus** Carol J. Clover Der Sandmann, **page 68.** **Artist's**

Choice Gilles Deleuze Humour, Irony and the Law, 1967, **page 80.** **Artist's Writings**

Stan Douglas Television Spots, 1987–88, **page 90.** Goodbye Pork-Pie Hat, 1988, **page 92.** Monodramas, 1991, **page 100.** Hors-

champs, 1992, **page 110.** Pursuit, Fear, Catastrophe: Ruskin, BC, 1993, **page 112.** In conversation with Lynne Cooke, 1993, **page 116.**

Evening, 1994, **page 122.** Der Sandmann, 1995, **page 124.** Der Sandmann, Script, 1995, **page 128.** Nu•tka•, 1996, **page 132.**

Project for the RIAGG, Zwolle, 1996, **page 140.** **Chronology** page 144 & Bibliography, List of

Illustrations, **page 158.**

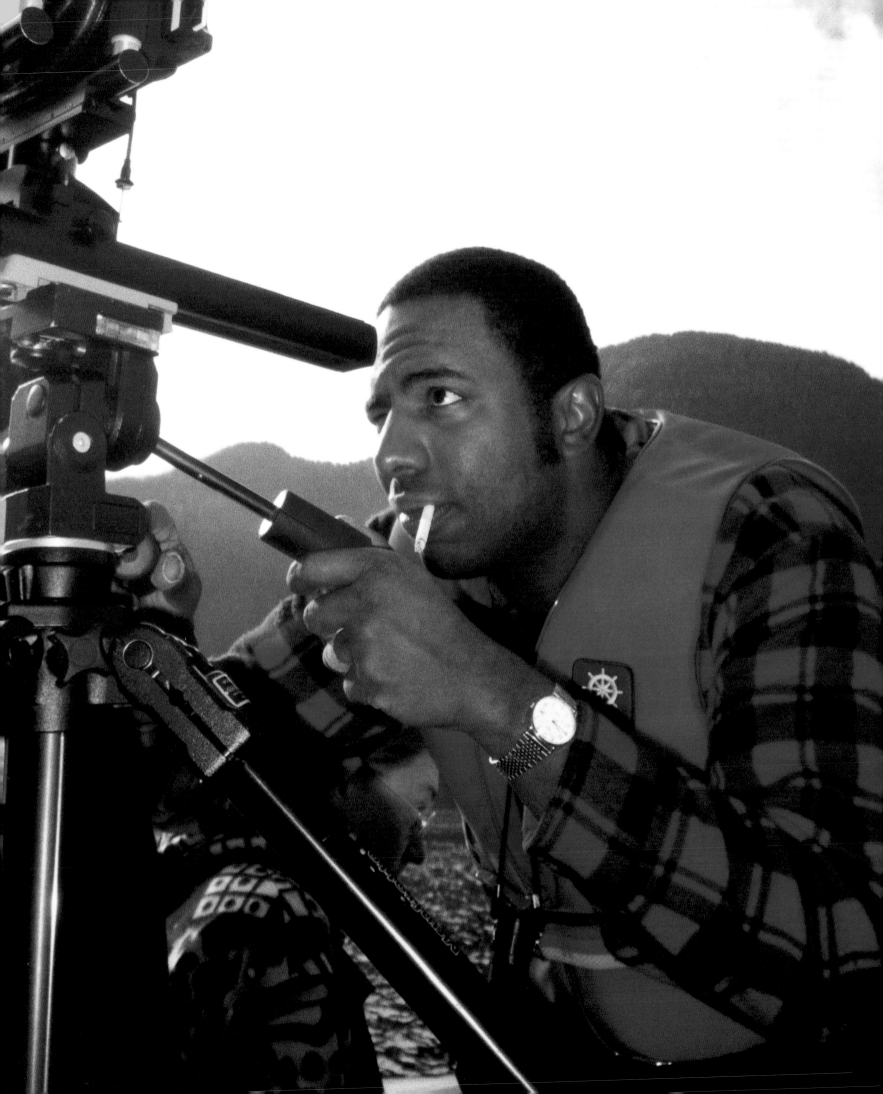

Contents

Interview
Diana Thater in conversation with **Stan Douglas, page 6.**

Survey Scott Watson
Against the Habitual, page 30 . ## Focus Carol J. Clover Der Sandmann, page 68. ## Artist's

Choice Gilles Deleuze Humour, Irony and the Law, 1967, page 80. ## Artist's Writings

Stan Douglas Television Spots, 1987–88, page 90. Goodbye Pork Pie Hat, 1988, page 92. Monodramas, 1991, page 100. Hors-

champs, 1992, page 110. Pursuit, Fear, Catastrophe: Ruskin, BC, 1993, page 112. In conversation with Lynne Cooke, 1993, page 116.

Evening, 1994, page 122. Der Sandmann, 1995, page 124. Der Sandmann, Script, 1995, page 128. Nu•tka•, 1996, page 132.

Project for the RIAGG, Zwolle, 1996, page 140. ## Chronology page 144 & Bibliography, List of

Illustrations, page 158.

Diana Thater in conversation with Stan Douglas

Diana Thater First, could we talk about your interest in Samuel Beckett?

Stan Douglas **Beckett's work represents for me the inverse of what people usually think about it. Instead of being the withering away of action to the point of stasis, I regard it as ground zero, a beginning. The manuscripts of the film *Not I* (1972), were originally written as a more or less naturalistic story. Beckett's editing process was one of reduction and distillation, the focus gradually becomes Mouth's endless task: trying to discover whether or not self-representation or autonomy are possible through a mendacious and corrupt language. This 'linguistic' problem is the starting point of all of my work – not only in the sense of spoken or written language but also in terms of different media and idioms of knowledge.**

Thater The goal then is not to effect the destruction of the subject through language, but instead to find a place for the subject to begin to reconstruct itself, in order to represent itself.

Douglas **A given language always has established tendencies or biases; in order to speak, you have to negotiate what is already embedded within it.**

Thater So Mouth speaks of herself in the third person.

Douglas **Exactly, she refuses to say 'I' because she can't use this language to represent herself.**

Thater And why the lines, 'Scream! Then listen. Scream again! Then listen again'?

Douglas **Just to confirm that she is still there. This happens a lot to Beckett's characters, where every once in a while they stop the exegesis of the play and make sure they're still alive, just in case the drama has gotten the better of them. Like in *Film* (1965), when Buster Keaton checks his pulse now and then.**

Thater Your book and exhibition *Samuel Beckett: Teleplays* (1988) is an important moment in your work. You have also discussed Beckett in relation to masochism.

Douglas **That was in a later essay on the three teleplays collectively titled *Shades* (BBC, 1977). I wrote about the relationship of subjectivity to the law, describing Beckett as a masochist who, like any good humourist, is subjected to the law even though he is well aware of how untrue it can be. The law is either something that presumes to directly (or transcendentally) represent what is good or right, or it is something that represents or promotes the best ethical position possible in an imperfect world.**

Thater So it can represent either the small possibilities or the larger ideal?

Douglas **Yes, but this ideal is impossible in the universe of Beckett. Inevitably he writes from a Eurocentric position, mourning the disintegration of the coherence of that world's values. But what he articulates is not based entirely on the internal disintegration of subjectivity. From our position, fifty years**

Caspar David Friedrich
Traveller Looking over the Sea of
Fog
c. 1818
Oil on canvas
95 × 75 cm

Anthony Page
Not I
(Samuel Beckett, 1972)
1977
Film for television
15 mins., black and white
Production still
Billie Whitelaw as Mouth
BBC/Reiner-Moritz co-production,
London

later and an ocean away, we can clearly see how many of the supposedly ontological problems of existentialism were formed in the numb landscape of Europe after the Second World War, where empires would accept decolonization only because they couldn't afford to do anything about it.

Thater You're talking about a historical point where this kind of subjectivity was totally decimated but could potentially still be reconstructed, or at least actualized as a representation of the present.

I'm also interested in the correlation in your work between your use and Beckett's use of popular forms. You pull them from many different moments of twentieth-century history through the type of language you use. One of my biggest interests in Beckett was that he used populist forms to create works that were not populist at all. For Beckett the source is primarily vaudeville; for you there are a number of forms, such as silent films or television commercials. And then there are also specific genres that you use as models, such as horror movies.

Douglas **I'm interested in horror movies because there's a bodily response, a physical response, to the image – something that never seems to be present in supposedly 'high' art.**

Thater And that's exactly what Beckett was about: the audience laughs out loud. He was interested in the fact that the audience responds openly.

The element of shock and fright – in other words, the idea of being scared as a form of entertainment (which I think film perhaps inherited from the nineteenth-century Gothic novel) – is used in your installation *Nu • tka •* (1996).

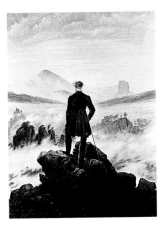

Douglas **In *Nu•tka•* the whole issue of the sublime comes up. And with the extremity of the liminal space to which it is a reaction, we also come back to the notion of the law. Are you able to assume a position transcending the natural world, or are you subject to its influence, as a part of it? The Romantics admit the latter, in as much as the terrified awe they sometimes present comes from the apprehension of the natural world's absolute indifference to human will or presence. The little figures we see from behind in Caspar David Friedrich's paintings are witnesses of sublime events but also underline the fact that the pictures represent something unrepresentable. In *Nu•tka•* the whole question of unrepresentability has been dramatized in the relationship between these two European colonists. They are in a situation they can hardly stand: they have contempt for the landscape around them, they have contempt for the people who live there, the natives, and they have contempt for each other. But that contempt, combined with their faith in the law of their respective kings, gives them their greatest comfort and sense of identity.**

Thater I want to link this back to your use of obsolete systems of representation that no longer function as they once did.

Douglas **When they become obsolete, forms of communication become an index of an understanding of the world lost to us. This is the basic hook in a piece like *Onomatopoeia* (1985–86), an onomatopoeia being a word that**

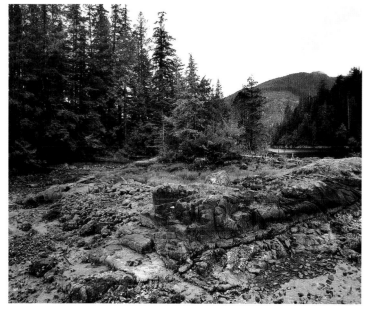
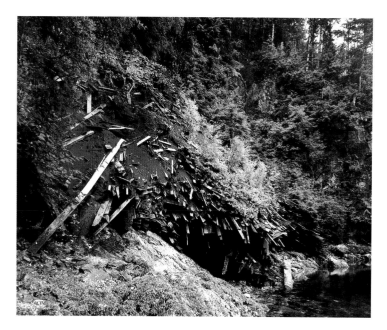
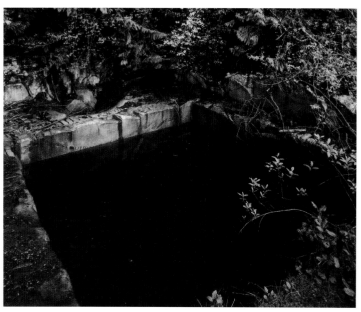
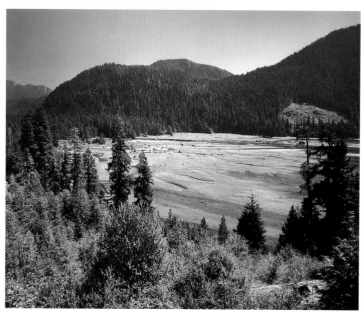

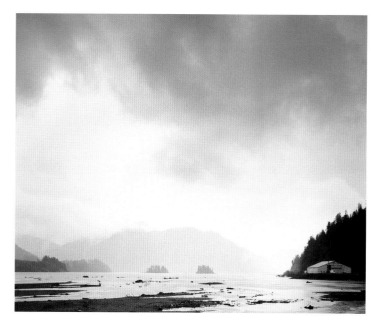

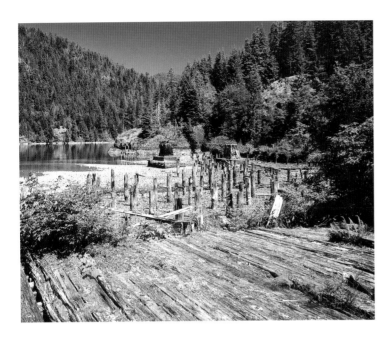

From **Nootka Sound**
1996
C-print photographs
46 × 56 cm each

left, from top, **Nootka Wood
Products Mill at McBride Bay;
E'as, Bajo Point; New Logging
Road near Head Bay**

opposite page, l. to r., from top,
**Fish Trap at Valdes Bay; Collapsed
Structure at McBride Bay; Marble
Quarry at Hisnit Inlet; Quadra
Saddle and Moocha Bay; Fish Trap
at Tsaya, Boca del Infierno Bay;
Head Bay and Tlupana Inlet**
From the series of 30 prints,
various dimensions
Collections, Solomon R.
Guggenheim Museum, New York;
National Gallery of Canada, Ottawa

makes the sound of what it represents. In the piece, a player piano plays an episode in Beethoven's *C Minor Sonata, Opus 111* that sounds like ragtime. Beethoven had probably written some kind of tarantella, and this dance is certainly not prescient of ragtime, but it sounds like ragtime to us, which means that we are unable to hear what Beethoven heard.

Thater You usually combine obsolete technology or an obsolete way of seeing the world with the particular moment in history depicted. So the technology is in the story, the actual narrative wrap, as in *Evening*, or at a distance from it, as with *Nu • tka •*.

Douglas I'm fond of Modernism in as much as I'm interested in finding forms of representation that have some structural relationship to the subject I'm addressing. *Hors-champs* (1992), for example, presents the spatialization of montage. The screen is this very thin surface through which the montage passes, and what passes through is a series of images that will or will not be censored, so whether you're watching images on the 'official' or the 'censored' side you can only witness the absence of what is being withheld from view.

Thater So *Hors-champs* is a spatialization of montage … perhaps *Evening* (1994) then is a spatialization of the television system. Would this make *Evening* the political commentary on *Hors-champs*?

Douglas I think they're equally political. *Hors-champs* is about exile, a more or less political exile, and this is also embodied in the music. In Albert Ayler's piece for his first concert in Paris in 1965 he tried to redeem the melody of *La Marseillaise*, which is the basis of a violently racialist and nationalistic lyric.

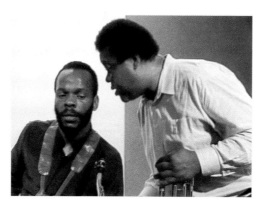
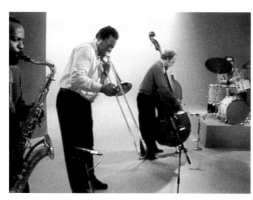
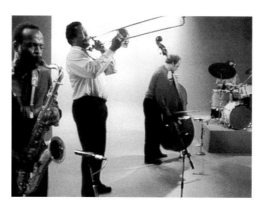

Hors-champs
1992
Video installation
13 mins., 40 secs. each rotation, black and white, sound
Dimensions variable

opposite, top, Installation, DAAD/Marstall, Berlin, 1994

opposite, bottom, Installation, Musée d'Art Contemporain de Montréal, 1996

left, Video stills
Collections, Musée National d'Art Moderne, Centre Georges Pompidou, Paris; San Francisco Museum of Modern Art

Onomatopoeia: Residua (print)
1986/93
Cibachrome print, piano roll
Print, 44.5 × 56 cm
Piano roll, l. 32 cm, ø 6 cm

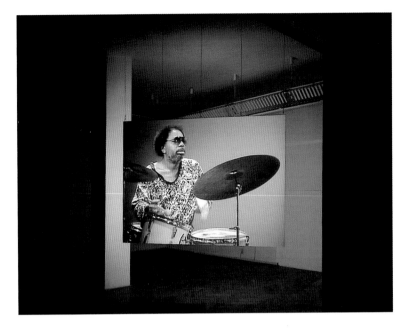

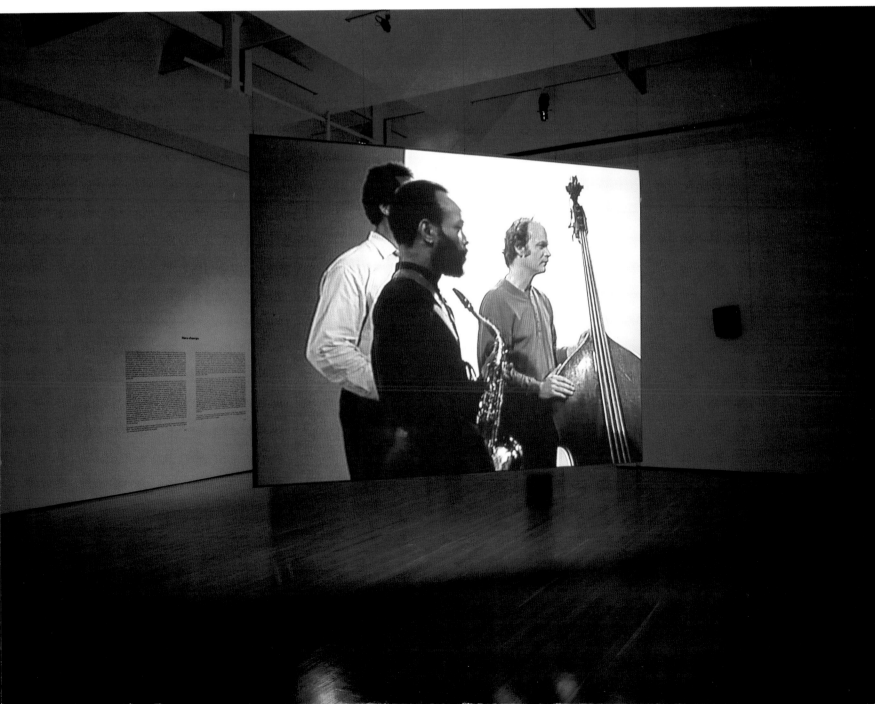

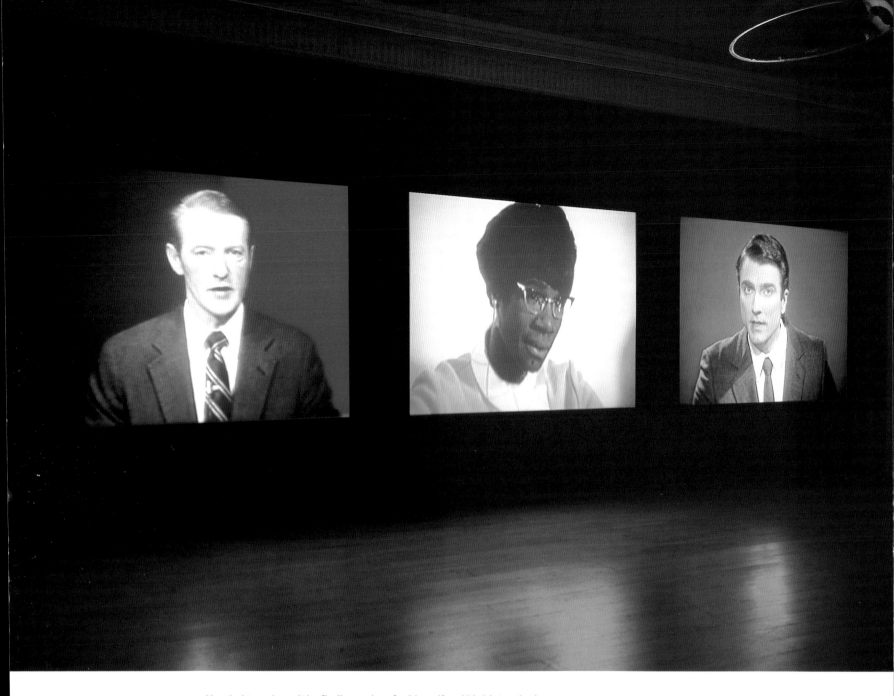

He tried to redeem it by finding a place for himself and his history in the music. He indicated its origins in military music, brought in a fanfare, then a call and response, a gospel melody and what George Lewis calls the 'country tune', even though I could never really hear it. But I guess *Evening* is much more explicit: the actual political stories are being told from the perspectives of the three fictitious television stations.

Thater With *Hors-champs* this information is contained within the music; it is coded and then translated through the viewer's experience of the actual space of the installation. In *Evening,* the elements that link and join and repeat are already part of the space you occupy as audience of the work.

Douglas **This is the way the images work on the two-sided screens; when you walk around the screen you realize that the other side always presents a collection of images that are inaccessible to you. They're '*hors-champs*', they're 'out of field'. It is a very physical thing.**

Evening
1994
Video installation
14 mins., 52 secs. each rotation,
colour, sound
Dimensions variable

opposite, Installation, Institute of
Contemporary Arts, London, 1994
Collection, Museum of
Contemporary Art, Chicago

below, Video stills

Thater What is happening on the screen begins to happen for the viewer in the room. What is the relationship between all these things that wrap around one another – the technology, the narrative, the history of the music that's being used? In *Nu • tka •* , for example, which for me is the most difficult of your installations because it's the most plain, that 'wrapping' happens in terms of the sound, in terms of the voices that wrap around each other. It begins to be like a circular musical composition; it begins to loop.

Douglas **Those two pieces – *Hors-champs* and *Evening* – are my most sculptural in a way, in as much as everything is in the room, like the three zones of sound in *Evening*, and the screen that you need to walk around in *Hors-champs*. Subsequent works have become more like pictures, like old-time screen practice.**

Thater You sculpt space with sound, which is sometimes music, sometimes read text. In the case of texts or monologues, do you attempt to give them a kind of musical form?

Douglas **Sure, absolutely. Peter Cummings and I tried to make the script for *Nu•tka•* as musical as possible, in terms of the repetitions that happen – those parts where they speak in unison, and the parts where there are words or phrases that are echoed by one or the other speaker.**

Thater And the points where they echo one another are where you're quoting from writers like Poe, Cervantes and Swift?

Douglas **There are occasional phrases from the historical characters' diaries that are heard at the same time but, yes, the six segments heard in synchronization are from these other colonial and Gothic texts.**

Thater Which points back to the Gothic. I don't think the idea of the Gothic is obvious at all in *Nu • tka •* , but it starts to become so when you quote Poe.

Douglas **Sure, there are two quotations from Poe, which describe perfectly the landscape out there, such as, 'during the whole of the dull, dark and soundless day … '**

Thater In *Nu • tka •* , the menacing elements are not present in the image so much as described by the text. We can think about that in terms of Deleuze's discussion of masochism in his essay 'Coldness and Cruelty' (1967), which is also influential on your work. He talks of the writings of Sacher-Masoch and Sade as being, of necessity, verbal, that the events taking place need to be described. Their exposition exists primarily in language. That's what seems to be happening in *Nu • tka •* ; what is menacing is not present, but is described as a projection of sorts.

Douglas **Both of the writers discussed by Deleuze are masters of speaking around whatever they're talking about. With Sade you have exhaustive lists and descriptions, and with Sacher-Masoch you have different kinds of descriptions, more loving descriptions, which have more reference to detail – the real object is never really described. The 'big' object is always something**

that is not there, it's always an absence. And absence is often the focus of my work. Even if I am resurrecting these obsolete forms of representation, I'm always indicating their inability to represent the real subject of the work. It's always something that is outside the system.

 The hugest absence in *Nu·tka·* is the natives. They were the trading partners, they were the people who were residing on the land before the Europeans got there, but they are completely out of the discussion that goes on between the two characters. Except that the Spanish Commandant is paranoid about them coming and playing tricks on him and his crew, and the Englishman fantasizes about becoming one of their mythic characters. This fantasy is actually based on a Kuakutil myth of the Puqmis. If you were shipwrecked and half-drowned, you would be lured into the woods by voices that would transform you into this pale-skinned creature with protruding eyes and an incredibly quick gait.

Thater So the natives are only present through …

Douglas **An absence.**

Thater And what the piece seeks to speak about can only be articulated through obtuse references.

Douglas **Prior to making *Nu·tka·*, I was surveying the area, finding traces of human presence in the landscape, and out of this came the *Nootka Sound* series of photographs. The typical conception of this kind of terrain is that it's untouched by culture, but anyone who has grown up in the Pacific Northwest knows that all those trees are at least second growth. You see that immediately. In addition to a hundred years of industry, there's the Spanish presence in the well, and in the midden they made as a ceremonial parade ground, or Mowachaht and Muchalaht fish traps, town sites and pictographs which might be as much as three thousand years old.**

Thater The signs of human presence become part of the exegesis in *Pursuit, Fear, Catastrophe: Ruskin, BC* (1993).

Douglas **In terms of the setting, that would be the decrepitude of the British Empire. But the story, too, is about a present absence. The narrative is framed by the three thematic sections of Schoenberg's music – pursuit, fear and catastrophe. The music is present under the sign of a lie spoken by the man in the hospital bed. As soon as he tells this lie, the music starts, and the police constable begins his investigation – pursuit. Fear and catastrophe arrive when the protagonist, Theodore, goes to confront the police about what is going on. He's told that his room-mate has died, which is probably not true. He goes on to find evidence that would discredit the constabulary, but because he's Japanese he can't do anything about it; the end.**

 All of *Pursuit, Fear, Catastrophe: Ruskin, BC* is concerned with many closed circuits: the turbine in the power plant, the officer's patrol, defining the region, and especially the alarm system in the police station, which Theodore short-circuits so that he can return undetected later, gather the evidence, close the circuit and escape.

Pursuit, Fear, Catastrophe: Ruskin, BC
1993
16 mm film loop installation with Yamaha Disklavier
14 mins., 50 secs. each rotation, black and white, sound
Film stills

l. to r., from top left, The Ruskin plant; Hiro is noticed missing at work and a colleague phones his home; Hiro's roommate Theodore answers the call; Chris Dickens convinces the constable that he had been attacked by Hiro; Constable Huntingdon descends; The constable retrieves Hiro's hat

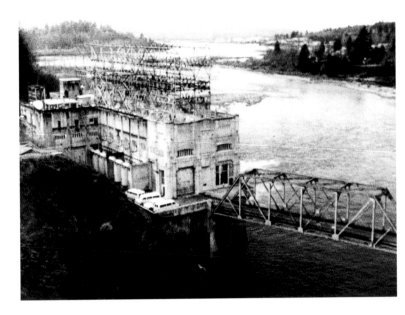
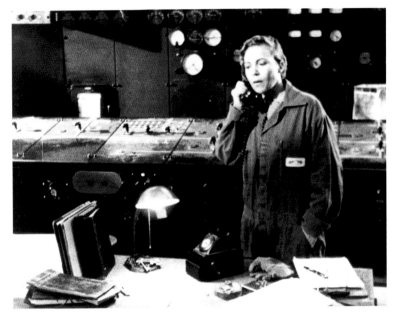
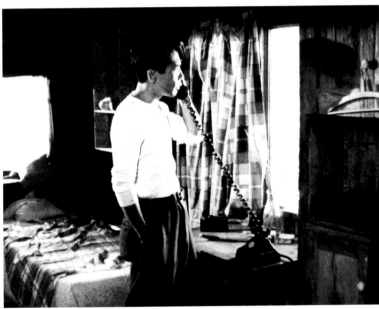

Thater All evidence of his presence is now gone?

Douglas Exactly. I was also interested in a moment in Bresson's *A Man Escaped*. There's a scene at the very end of the film where the captive does as advertised, escapes from his cell into the exercise yard, climbs over a wall, then there's another wall he scrambles over. Finally he's outside, and there's a long shot of the prison, with the concentric circles of its walls and a car circling the perimeter. A series of enclosures.

Thater In *Pursuit, Fear, Catastrophe: Ruskin, BC* you also create something very claustrophobic out of a vast geographic territory.

Douglas Yes, in its transitional moment, the catastrophe episode, there are two shots where the power plant's turbine is seen first in daylight, then at night. A big dumb machine spinning round, almost like a sublime force. Once again, here is the theme of the difference between mechanical and human time: the function of machines has always been to do exactly the same thing again and again. Mechanical time is about endless repetition, whereas human time is about transformation and change, with the processes of growth, ageing and death.

Thater Can you talk about these differing ideas in terms of music?

Douglas Musicians have invented highly developed and differentiated ways of dealing with time. In a way, every work of polyphonic music is a representation of how a group of people can inhabit time together. Is that relationship to be one of domination or one of equity?

In my work I have used repetitious structures from certain musical forms, but much of the repetition also derives from Beckett. Almost all of Beckett's plays have this kind of double structure where something happens at the beginning, and the same thing happens at the end – only differently, which I regard as a confrontation with the mechanical world. Something you cannot do with live performance, with humans, is to make them repeat themselves identically.

Robert Bresson
Un Condamné à Mort s'est Echappé
(A Man Escaped)
1956
102 mins., black and white
Film still

Thater So, repetition becomes very much about the difference between what the repeated element was at the outset, and what it has become now that time has passed.

Douglas **Yes. The difference between Albert Ayler and, for example, Stockhausen is that Stockhausen would have assumed that he could control the music and its system of difference, by determining the conceptual frames of performance and reception, whereas Ayler acknowledges that even if the music is repetitious, it is always going to be different, in each recording session or performance. Even when you're seeing the same film loop again and again your perception of it changes, because you have changed even though it has remained the same. It's like listening to recorded polyphonic music: on a second listening, you can hear things that you missed the first time around.**

Thater This seems to be made manifest by the looping devices you use which allow for the actual continuous repetition of the film itself, for example in *Der Sandmann* (1995).

Douglas **In that piece there's a very tiny permutational system that makes it appear as if you've seen a complete presentation of the space when you've only seen half of what there is to see. The second time around it has changed, even though it's the same sand, the same face, the same architecture, the same story.**

Thater The first time you see the right half of the film and the second time you see its left half?

Douglas **Yes exactly, but the two sides are in a way one side, like a Möbius strip.**

Thater Is the film an actual Möbius strip, or are they two separate loops?

Douglas **My first plan was to be a hard-ass materialist about it and use one piece of film – and I could have done that – only it's safer in long runs to use two identical films in separate loopers. But they are identical.**

Thater Earlier you talked about Modernism as part of your practice. How is it instrumental?

Douglas **It's addressed in my work always, I guess, in terms of failure. *Evening* and *Hors-champs* refer to final moments of the notion of civil society – the idea that you can get together as a group, talk on the street, and change society – before social, political and economic institutions were confirmed as the dominant forms of power. *Nu·tka·*, too, set at the beginning of the modern era (14 July 1789, in fact), addresses this in a fundamental way because the processes of negotiation and transformation that are the basis of modernity have an interesting relationship to the notion of the sublime. The sublime is fundamentally secular. If you're a mystic or if you have direct access to the real through God, no problem; but when the real recedes to that liminal space that the word 'sublime' describes, you become responsible for**

Der Sandmann
1995
16 mm film installation
9 mins., 50 secs. each rotation,
black and white, sound
Film stills

WITHDRAWN
FROM
UNIVERSITIES
MEDWAY
LIBRARY

Interview

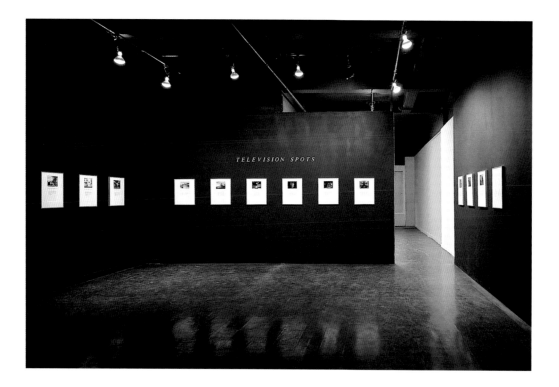

From **Television Spots**
1987–88
12 black and white photographs,
texts
23 × 18 cm each
Location photographs and
scenarios for videos
Installation, Contemporary Art
Gallery, Vancouver, 1988

the world that you've made. However, the first discovery of the modern world was that ethics are impossible without freedom – and this is what makes formalism inherently cynical.

Thater You're attempting to locate meaning without resorting to formalism or to what previously gave us access to meaning, the notions of God, or the romantic sublime, or even faith in a utopian political system.

Douglas **Sure, but it always comes back to one problem: you cannot devise an ethical world unless you are free; when you are not free whatever restricts you also restricts and determines your choices. Ethics is a form of representation that can never be tautological.**

Being tautological, or self-referential, is a limitation that I, retrospectively, found in the *Television Spots* (1987–88) and *Monodramas* (1991). The idea was simply to play two television genres, dramatic and commercial, against themselves, so that the audience wouldn't be sure if they were seeing something abiding by one or the other of the broadcasting conventions. It was an attempt to disrupt the formal means of television. So when people called the stations, upset about having their expectations confounded, I realized that the anonymity I had insisted upon – that the spots would not be identified as art – was really an act of bad faith. I couldn't tell audiences I was an artist and that what they were seeing was 'art' because as soon as that happened, they would no longer think that 'television' was speaking. A number of preconceptions would immediately come into play: primary among them the notion that art is about self-expression or formal play. Before they found out it was art, callers talked about the meaning of what they had seen, but once the spots became art they became strangely self-referential. So I figured that if I couldn't take my artistic practice to a public space, I would try and explicitly introduce meanings that were neither 'expressive' nor tautological into the museum.

Thater Can you describe how you try to reverse the usual preconceptions brought by the viewer to the museum?

Douglas **Well, the television work basically uses the alienation effect, but the museum pieces try to make their density of reference palpable. I hope that all of the work is seductive on an immediate level, but then I try to include that seduction in the network of historical connections. Imagine you're looking at a painting by Agnes Martin. I think that to understand it properly you have to imagine her historical setting, how she's responding to it, and the history of the genre she's decided to work with – it is as it is but it could have been entirely otherwise. If a tradition becomes transparent, works of art will only reinforce convention – becoming merely aesthetic, merely beautiful, and no longer meaningful.**

Thater But by taking forms out of history – and out of everyday life – and placing them in the museum, your work isn't concerned so much with what those media may reveal to us as much as what they're repressing. You've taken them out of history and you're looking back at them, so those cultural forms, instead of performing their intended function, are indicating what they *couldn't* do, or what they were trying to prevent from being seen. These subtle pieces of information become the keys to the work, and often it's very difficult for people to read. How opaque or transparent are those kinds of meanings being made in the narratives?

Douglas **I'm often asked how I can expect people to know all of the references in a work – I can't – that's why there are supplementary texts, catalogues, etc. The work is seductively simple on one level, and fairly complex on another. But it's usually being shown in a museum, not in a market place or on TV, so I hope that audiences will at least be a little bit interested in figuring it out. An artwork shouldn't necessarily have the same obligations as, say, the advertisement, which has to impress as many people as possible as quickly as possible. We shouldn't be obliged to make work that has to be understood immediately.**

Thater If we wanted to make something that could be understood immediately, then that's what we would do! We wouldn't be playing against all of these forms, in the ways that you are doing, which are complex in terms of the ways the narratives are constructed, but also in terms of the way they are cut, the kind of montage that's being used, and the way that's related to the history of cinema: what's allowed, what's forbidden, repressed. In television, what kind of information is repressed? What is repressed is what is on the other side. To see these two things simultaneously is to see what's on the screen and to see what's off-screen.

You play against forms you've extracted from television and cinema history, and your narratives are becoming increasingly complex with each new work. You seem now to be concentrating particularly on the montage, and how that has traditionally functioned in cinema.

Douglas **I guess I've become more materialist in how I approach images. In earlier works such as *Deux Devises: Breath and Mime* (1983) or *Onomatopoeia*, the images were more metaphorical in a way; metaphorical about machinery**

Diana Thater
Electric Mind
1996
Video installation
Dimensions variable

following page, **Deux Devises:**
Breath and Mime
1983
Slide installation
70 slides, 7 mins., 20 secs, black
and white, sound
Dimensions variable
Collection, Museum van
Hedendaagse Kunst, Ghent

and how the image was generated. But I've slowly been able to learn how certain kinds of images are generated – I've learned to identify the clues in photography that tell you, for example, where the camera was standing, its focal length, the film used. All these things are *in* the image. It takes time to read these clues, but they are always there. That's why I usually hide the gear in my installations – because it's already visible. Lately I've tried to place details of the generation of the image within the image itself, as much as possible.

Thater Of course many artists rely solely on metaphor as a way to create meaning – this includes the metaphorical use of the equipment, where we read something new in relation to something else which we already know – instead of choosing the harder road wherein they attempt to create meaning which is independent and not referential.

Douglas I hope to be surprised by the meanings that these works can generate, so that by putting the right materials together, they can do more or result differently from what I expected. This process is opposed to metaphorical constructions, where artists expect to control the meaning of a work by defining how it is to be read symbolically. I want to work with what an image means in a public world. So when people bring their understanding of how images work, and of how things are in the world, they can do something completely different from what I anticipated when I put them together. For a while I was obstinately *anti*-metaphor – but then I realized that language and images are always metaphorical.

Thater It can define meaning but also confines it.

Douglas Sure, as with a Joseph Beuys sculpture, where you feel you're not allowed to interpret it until you've been given the key to what these materials mean in his system. This keeps a very tight rein on the work's metaphorical possibility.

Thater Right; you can control as much as you can control, and then you have to let it go.
You spoke earlier of an ethical world which it might be possible to construct. We could locate this idea in reference to various types of utopias, for example Ruskin's concept of an ideal society, or the utopia proposed by free jazz.

Douglas For me, the Ruskinians made a sort of negative utopia, but the free jazz movement was something else. Maybe those utopias were realized just for a few hours, in a situation where the society was very, very small and briefly capable of working things out.

Thater But you move back and forth, talking about it in both positive and negative terms. For example, in *Evening* you have commercial television, which in the 1960s was part of a false communication utopia (because it is *commercial* television) set against this idea about the Black Panthers, which is actually a real and hopeful political moment in history.

Douglas Sure, and you can look at moments in these communities when the

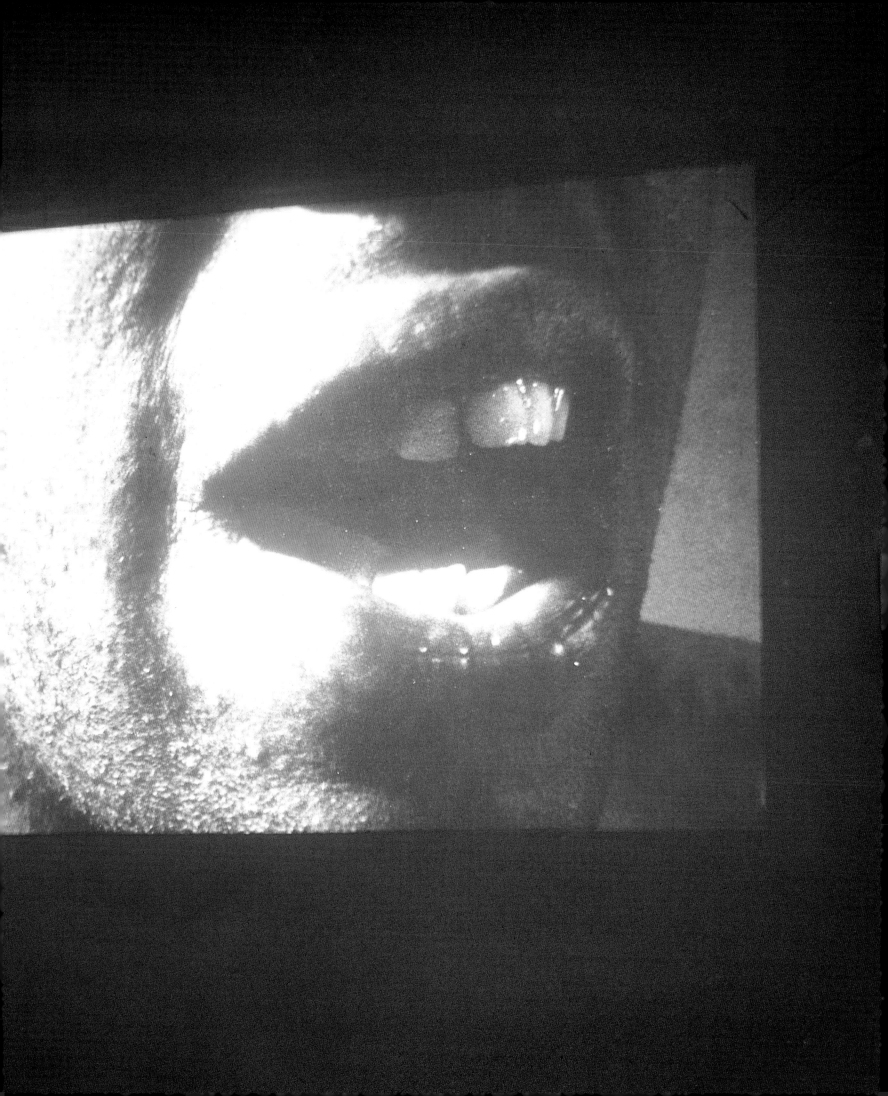

Panthers, with their breakfast programme for example, worked to make themselves autonomous, since the US government was withdrawing its support of its citizens, or that support never existed in the first place. Their utopia did take place, if only for a week or so.

Thater When you make work for a museum, as opposed to when your pieces are made for television, you talk about increasing the density and wanting to seduce the audience into reading in depth the kind of meaning the work has made possible. Yet you shoot everything with a very neutral vantage point, as the neutral camera, which is not really inviting. We are looking into that space back there, behind that camera, which would seem to be occupied by someone. How is this approach to be read?

Douglas **I guess there is the ideal viewer for each work, somebody who would recognize the idioms that I'm working with, or trying to emulate. I probably learned this economy of reference from old-school hip-hop records, when there was a much smaller repertoire of records being sampled or mixed. I used to have a lot of those records, and so when I'd hear maybe a quarter-second of James Brown, I knew it was James Brown, the song and the record it came from. Records, like photographs, always have a constellation of reference that hangs over them – a place, a period, a cultural setting – which someone familiar with the material can recognize. In a similar way, I hope my work will provoke certain associations in people familiar with the quoted cultural forms. This is very different from the kind of referencing that has developed in, say, television narrative by way of rock video where a series of narrative tropes allow the story to be told very quickly. You don't need character development, because the characters are stereotypes we've seen before, and you don't need to elaborate on a conflict because it is familiar and has been anticipated. So the velocity of story-telling increases, while the possibility of difference being represented decreases.**

Thater Is it possible to say that by stepping away from the camera, by allowing it to maintain what appears to be an objective view, these references can be presented as if independent of you, un-inflected by your presence?

Douglas **The camera is inflected by me but it presents much more than me, even though I put this thing together and I take responsibility for it. How I might express myself is not very interesting at all. I want to talk about the possibilities of meaning that these forms and situations present, rather than talking about myself.**

Thater It's a critique of a certain position, of the position of the artist in Modernism, and of being able to reduce the work of art to that artist's identity.

Douglas **Yes, and as an example, if you look at the cover of that Beckett book you've got there – there he is, wearing a wool sweater, sitting on a fire escape, looking morose; it's the cliché of a romantic poet. But for the *Teleplays* catalogue I found this picture of him wearing a suit and tie and looking like an intellectual in Paris, which is what he was!**

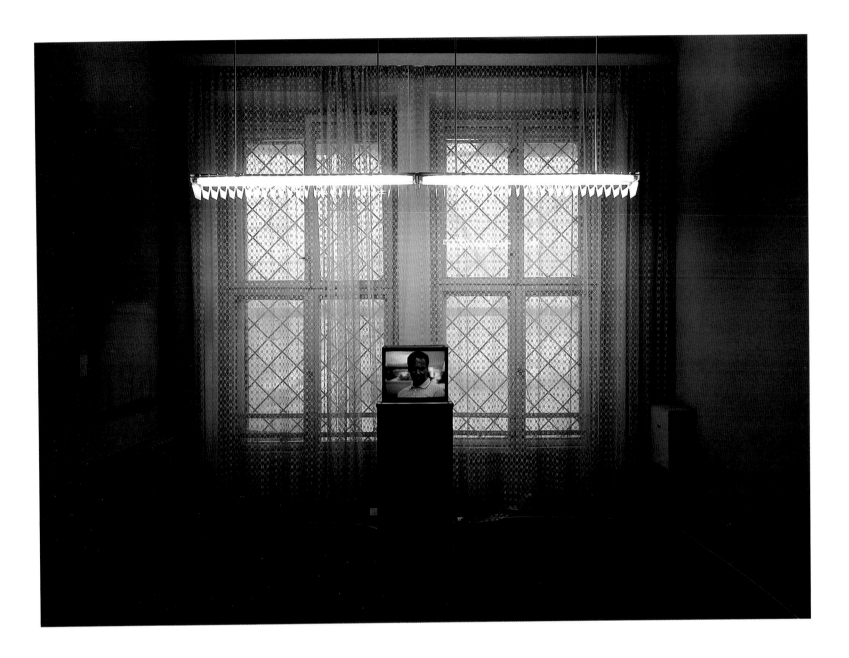

'I'm Not Gary', from **Monodramas**
1991
Video for television
30 secs, colour, stereo soundtrack
Installation, DAAD/Marstall,
Berlin, 1994

Thater Earlier we were talking about Beckett and populist forms such as silent film: what is it that interests you in silent film?

Douglas **One thing I've found particularly interesting about silent films was their extremely high narrative density – a quality that is very different from what I just described in television. There were few psychological conventions in the Hollywood sense, so the stories could be told very quickly. You could establish characters in a very brief theatrical way, without resorting to psycho-babble. I found this potential quite amazing when I shot *Pursuit, Fear, Catastrophe* ...**

Beckett certainly remembered the cinema before the psychological requirements were set in stone – and I think both silent film and vaudeville influenced the pantomime episodes in his work. Throughout the 1960s his practice became more and more rarefied, as theatre itself became more and more rarefied. But in France and England during the post-war period, theatre was both a popular and a bourgeois art form. By the 1950s he was doing work for BBC radio and work for television, before TV became the most

conventionalized and controlled public medium. At that time producers didn't quite know what to do with it. The shows broadcast on TV and radio were a lot more varied than they are now, and Beckett's media work has to be seen in that context.

Thater But again, he was placing something obscure and intellectual (high art in other words) in the context of something which was made for the masses (low art), in a reversal of the vaudeville to theatre translation that he makes in his plays. You also turned around and went in the other direction when you broadcast strange little neo-commercials on late-night local television stations in Canada. Can you talk about the *Television Spots* and *Monodramas*?

Douglas **The main difference between the *Television Spots* and *Monodramas* is that I wanted the *Television Spots* to be seen repetitiously, so that you can view the same spot again and again on the same night, and they're usually depicting a repetitious or circuitous situation. Once I got cable I realized that**

below, l. to r., from top, **Eye on You; Eye on You; Encampment; As Is**, from **Monodramas**
1991
Videos for television
30-60 secs. each, colour, stereo soundtrack
Video stills
First broadcast by BCTV, Vancouver, 1992, sponsored by UBC Fine Arts Gallery
Ten videos on laser disc
Collections, Museum van Hedendaagse Kunst, Ghent; Musée National d'Art Moderne, Centre Georges Pompidou, Paris; Solomon R. Guggenheim Museum, New York; Walker Art Center, Minneapolis

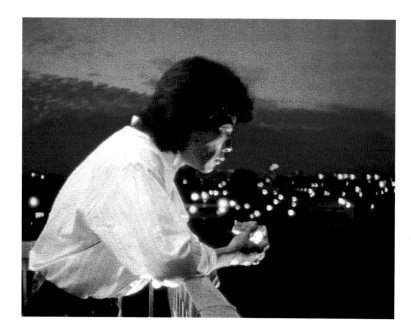

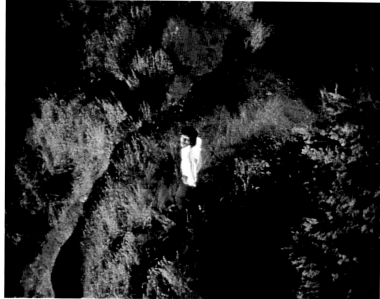

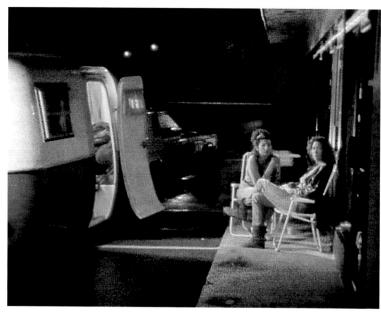

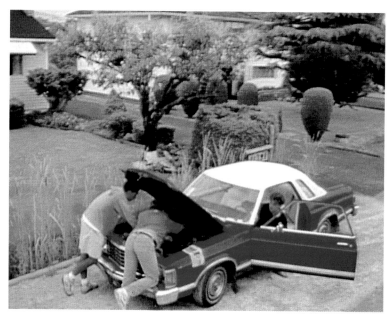

people watch TV with the remote control in their hand, and I decided to make spots that were more self-contained, so that they could be seen only once and still retain the sense of ruptured convention and interrupted habit that I was interested in establishing.

Thater So with the *Monodramas* you wanted to interrupt the course of what has become normal television viewing, and to rupture the state of mind necessary to watch television?

Douglas A word that's used all the time in marketing is 'brand'. Pepsi™ is considered a powerful brand because it is widely recognized, and has a relatively consistent meaning world-wide. Television advertisers don't expect you to run out and buy their product right away, but they hope to make it familiar to you even if you've never held it in your hands. The commodity is branded when the brand-name is impressed upon it and therefore supposedly means something – reliability, youth, privilege, whatever – and the audience is branded, too, when it makes the intended association between a thing and a 'feeling'. This is why broadcasters don't talk about how many viewers will see an ad, they talk about how many 'impressions' it will make. My spots were intended to make the wrong impression.

Thater You believe there is a thinking audience out there?

Douglas Recognizing the sophistication of audiences who have been looking at moving images with sound all their lives, and who know well enough that media is constructed, has led advertisers to devise more and more ironic and cynical advertisements – like those of Benetton. But however cynical or ironic the ad, its brand is nevertheless impressed on the mind.

Thater We've discussed the relationship that the *Television Spots* and *Monodramas* construct with the audience as one of discourse. This gets back to your idea about a rupture in the conventions of Modernism, which has taught us how to look at works of art as things that exist in their own world, separate from the social and political borders in which they were made. The rupture that you're attempting to create is a small political rupture that opens things a little, and allows this other kind of conversation back into the work of art.

Jenny Holzer
Truisms
1977–79
Posters
88 × 60 cm
Street installation, New York

Douglas As I mentioned earlier, if you have a secular understanding of the unrepresentability of the real, you take responsibility for what you're making. You can do that either cynically, through formalism, or ethically, through representation. Early influences, or the artists whose projects showed me how this worked, were Robert Venturi, Cindy Sherman and Jenny Holzer. (The *Television Spots* in particular were modelled after the first presentation of Holzer's *Truisms* on anonymous street posters.) And I was also very interested in what was happening in England in the 1970s, where there was this interface between visual artists, theory, film – the writers associated with *Screen* magazine as well as artists who also wrote, like Mary Kelly, Yve Lomax, Victor Burgin or Laura Mulvey and Peter Wollen, who politicized the terms of spectatorship.

Subject to a Film: Marnie
1989
16 mm film loop installation
6 mins. each rotation, black and
white, optical soundtrack
Dimensions variable
above, Location photographs

opposite, Installation, 'Minima
Media, Medienbiennale', II Media
Biennale, Leipzig, 1994

Thater You make works that imply different kinds of closed systems, but
because of the techniques and systems you use, to quote Deleuze, 'we may
conclude that there exists somewhere a whole which is changing, and which
is open somewhere'. But they're always open in a different place and that
allows that meaning that you were talking about to creep in through the hole.
This allows the work to engage with the world, and then to become part of a
kind of ethical and social discussion.

Douglas I appreciate the early work of Deleuze where he was looking at
certain writers' and philosophers' work, and asking: what if this body of
artistic work were a complete philosophical system? Then he untangles the
philosophical logic of this body of work, which I thought was very interesting
because it takes something that is very specific and makes it into a complete
world. That is, as you say, a closed world that is open to the world: a possible
apprehension of the real.

Thater Then we can think about your work as a history, a narrative and an
apparatus that is creating a closed system which, because of the tightness of it,
splits open and allows some moment of grace, or of freedom. You talk about
each work using a different conception of the medium, or a different genre.
But in every instance you talk about a very specific moment, where something
is desired, or some idea of utopia is forcing a desire for freedom onto its subject,
or its subject is seeking that.

Douglas I guess in terms of a general technique all the work has this idea
of suspension, like taking something that is transient, something temporal,
and suspending it in some way. With a film loop, for instance. This was my
fundamental interest in re-making the robbery sequence from *Marnie* (Alfred
Hitchcock, 1964). It is the crux of Hitchcock's film, the moment where Marnie
stops being a professional thief and becomes whatever she is later on – her
last free moment as a professional, before she comes under the influence
of the Mark Rutland character. I updated the office set and took the moment
of the crime, at the interval between working and private life – an in-between,
liminal space of a kind that I had been preoccupied with in the *Television
Spots* and *Monodramas* – and suspended it with a Möbius strip-like long
take. I'm always looking for this nexus point, the middle point of some kind
of transformation, like when the English and Spanish arrived at Nootka
Sound. I guess this accounts for the embarrassingly consistent binary
constructions in my work.

Thater Yes, there are always systems of two: in *Nu • tka •* it's the two intertwining images and voices which separate and re-connect; in *Der Sandmann* it's the two halves of the screen which merge; in *Evening* it's the two different days presented in the three images; and in *Hors-champs,* the two sides of the screen. Within each of these sets there is a historical space closing up.

Douglas **Almost all of the works, especially the ones that look at specific historical events, address moments when history could have gone one way or another. We live in the residue of such moments, and for better or worse their potential is not yet spent.**

Contents

Interview Diana Thater in conversation with Stan Douglas, page 6.

Survey **Scott Watson**

Against the Habitual, **page 30**. Focus Carol J. Clover Der Sandmann, page 88. Artist's

Choice Gilles Deleuze Humour, Irony and the Law, 1967, page 80. Artist's Writings

Stan Douglas Television Spots, 1987–88, page 98. Monodramas, 1991, page 104. Deux Devises: Breath and Mime, 1983, page 108. Perspective

Overture, 1992, page 110. Pursuit, Fear, Catastrophe: Ruskin, B.C., 1993, page 112. Hors-champs, 1992, page

118. Evening, 1994, page 122. Der Sandmann, 1995, page 124. Nu•tka•, 1996, page 128. A Luta Continua, 1993, page

Project for the RIAGG, Zwolle, 1996, page 148. Chronology page 144 & Bibliography, etc.

Illustrations, page 158.

'*And although cinema may lessen or greaten our
distance from things, as well as turn us all around
them, it abolishes the anchorage of the subject as
well as the horizon of the world in such a way that it
substitutes an implicit knowledge and secondary
intentionality for the conditions of natural
perception.*'
 – Gilles Deleuze[1]

In 1994, as a DAAD artist in residence in Berlin,
Stan Douglas wanted to do a project in the old Ufa
film studios at Babelsberg, outside Potsdam. Once
one of the world's most important centres for film
production, some of its studios were on the demo-
lition list as the Federal Republic of Germany
began to rebuild the former Democratic Republic.
Their uncertain fate was part of a vaster picture
that included the disintegration of the Soviet
Union and the collapse of Communism in Eastern
Europe. In Germany history was being rewritten.
Visiting the studios and the region around them,
Douglas discovered another transformation
underway in the local use of property. The arrival
of real estate speculation and development in
Potsdam also impinged on the small, private
gardens allotted to Potsdam apartment dwellers.
Douglas' research into the history of these
worker's garden plots, called *Schrebergärten*,
excavated other histories.

 These civic garden plots were used in the
depression and during times of war scarcity to
provide food. Their urban pastoral appearance
is therefore fraught with an undertow of toxic
national values; they figure large in the modern
history of identity in Germany. The film Douglas

ended up producing, *Der Sandmann* (1995),
evokes an experience of the uncanny in one of
these gardens.

 Der Sandmann is a kind of panoramic cinema
that depicts no specific historical event, but the
play of historical processes that both build and
destroy an imaginary *Schrebergarten*. The gardens
were named, in 1865, after the recently deceased
educationalist Moritz Schreber, who had argued
that civic garden plots would ameliorate the
deleterious effects of the Industrial Revolution.
Schreber's proscriptive mind imagined them as
places where workers could practise outdoor
calisthenics and rid their lungs of toxic factory
fumes.

 Schreber was also an advocate of strict
regimes for the body. His son, Daniel Paul, is
famous for Sigmund Freud's use of his account
of his madness as prime evidence in a theory
of paranoia. One imagines that there is some
connection between the elder Schreber's exper-
imentation with corrective devices for children's
posture and the later mental collapse of his son
who had been fitted with them as a child. In a
sense Daniel Paul was himself a product of the
Schrebergärten and Freud's account of paranoia
one of the garden's earliest harvests.

 For *Der Sandmann*, Douglas created two
gardens in the studio. The first was imagined as
a Potsdam garden in the early 1970s. After it was
filmed Douglas constructed a second garden as it
might look today under redevelopment, with the
plot razed for new construction. Each set and
surrounding studio was filmed in a continuous
360-degree sweep, thus producing two films. In

Adolph von Menzel
Hinterhaus und Hof (Tenement
back yard)
1846
Oil on canvas
43 × 61 cm

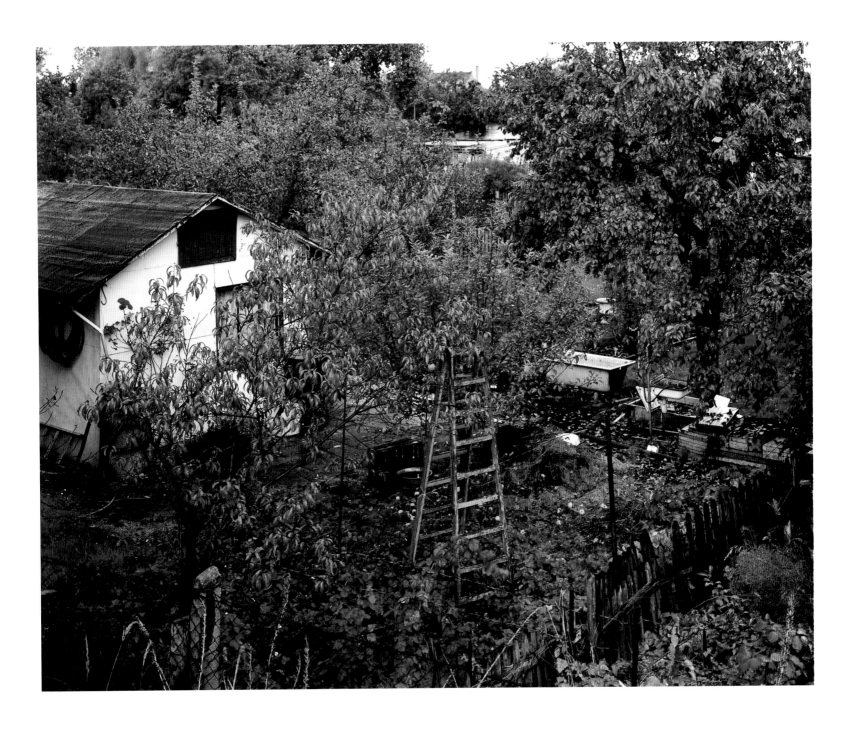

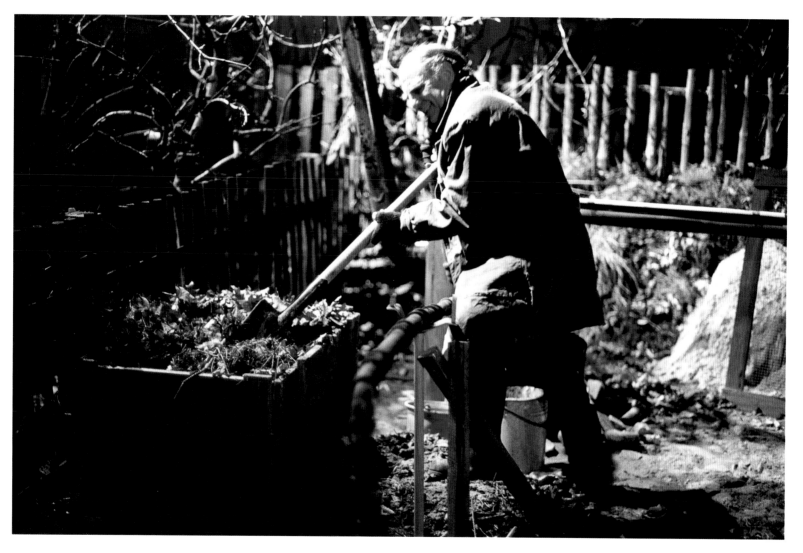

Der Sandmann
1995
16 mm film installation
9 mins., 50 secs. each rotation,
black and white, sound
Production still

the installation they are projected on the same screen, but half of each image is blocked out. As the camera pans the studio and gardens, the effect is of the new garden erasing the old and the old erasing the new in a restless, repetitive cycle. The idea of the split screen came from an early German silent film, Henrik Galeen's *The Student of Prague* (1926). In the plot, the student sells his mirror image to a warlock. When the mirror image ruins the student's life by committing a series of crimes, the student kills it and thus himself. The film calls for the student and his image to confront each other in several scenes, which were made by shooting the scenes with half the lens blocked and then reshooting with the other half of the stock. It is this technique, originally devised to present an uncanny and frightening split in identity, that Douglas reproduces in *Der Sandmann*.

For the narrative of *Der Sandmann*, Douglas grafted his own adaptation of one of the tales of E.T.A. Hoffman (1776–1822) onto the Potsdam *Schrebergärten*. The old man in the film(s) is the Sandman, a figure of childhood terror who steals the eyes of sleepless children. The story, as in Hoffman's tale, begins with an exchange of letters. In the first, Nathaniel writes to his friend, Lothar, about a mysterious old man he has seen in a *Schrebergarten*. Lothar responds, reminding

Nathaniel that this must be the old man they used to see as children, whom they believed was the Sandman. One night they had ventured into the garden of the old man, who was toiling on a fruit-less attempt to grow asparagus in winter, and had been chased away. The third letter is from Nathaniel's sister, Klara, who reminds him that it was on that very night that their father was killed.

In the film, the three letters are read by different voices but only one figure is seen: Nathaniel, portrayed as a young German black man. As he appears in one pass of the camera, Nathaniel's lips are in sync with the soundtrack. In the second pass they have shifted out of sync, as if his identity is in a state of slippage. Nathaniel's letter and the letters of the others confirm that his mental condition is precarious. As the camera circles, we see Nathaniel standing outside the set in the studio. The film does not provide a confrontation between them, but 180 degrees opposite we see the film's other figure, the obsolete Sandman.

The Sandman is working on the same task in both films, even though they depict periods almost thirty years apart. He ages slightly, but basically he is oblivious to time and the forces that will literally undermine the ground he works on. In one cycle, he disappears into the seam between the two projected images. There is a way to 'read' the confluence of references that inform this figure, this image, in allegorical terms: the Sandman is the working class. His efforts to make a better world are about to be foreclosed by the triumph of capitalism. The bourgeois narrator projects his anxiety onto the Sandman, making

him occult and threatening. Such a reading points to Douglas' modernist, utopian impulses, but it also points to the decrepitude into which these once confident working class and bourgeois identities have fallen. *Der Sandmann*, however is not an allegory stocked with symbolic figures; the montage opens out onto something else. The real operation of *Der Sandmann* is to confront a crisis about memory, time and the ability to articulate a self. Filmed on a doomed set, the old man's futile project is modernity itself.

Hoffman's Sandman story is the central literary work discussed by Freud in his essay, 'The Uncanny'. Freud takes great care to define the uncanny (*unheimlich*) as a dialectical term. He cites in full a dictionary definition of *unheim-lich* in order to show that the word contains its opposite, *heimlich*, which translates as 'secret' but has its roots in *heim*, meaning 'home'. 'Thus *heim-lich* is a word the meaning of which develops, or has the direction of, ambivalence, until it finally coincides with its opposite, *unheimlich*.' The point he wishes to establish is that the uncanny has its roots in the familiar (words like *heimat*/home), ' ... for this uncanny is in reality nothing new or alien, but something which is familiar and old-established in the mind and which has become alienated from it only through the process of repression.' The uncanny unfolds through repetition and coincidence as they invoke a sense of fatefulness, of something inescapable, of chance becoming destiny.[2] It is through Freud's text that we can see that *Der Sandmann* is a machine for the production of the uncanny. Repetition itself will generate it; but what is fateful is the displacement of the past

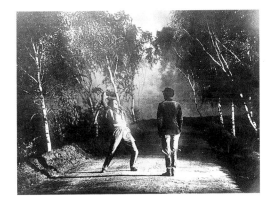

Deux Devises: Breath and Mime
1983
Slide installation
70 slides, 7 mins., 20 secs., black
and white, sound
Collection, Museum van
Hedendaagse Kunst, Ghent

by the present and the altogether more troubling displacement of the present by the past.

From the beginning of his career, Douglas has been concerned with how the imagination of history – or the repression of this imagination – determines the possibility of a self-articulating subject. He has centred increasingly complex projects on the notion of the absence of such a subject. The problem of alienation is realized through structural displacements in the works. These reveal how the history of techniques of modern representation is also the history of social relations. But far from being exercises in determinism, Douglas' works often tell the story of an accident or coincidence, perhaps fateful or uncanny, but always suggesting the possibility of freedom from what has been ordained.

Douglas' early, beautiful, simple work called *Breath* (1982) seemed to portray the impossibility of experiencing the very emotion called forth in the work – in this case, unrequited love – without also confronting the disappearance of the subject who might experience and express such a feeling. The viewer entered a room darkened for slide projections. A tape played a recording of Charles Gounod's plaintive song for tenor, *O ma belle rebelle* (*c*. 1864). The slides clicked by at a regular pace, each one the same shade of grey. An English

translation appeared in white typewriter script at the bottom of the screen, like subtitles for a foreign film.

Using fairly primitive means, *Breath* created the structure of cinema, engaging the ear with a tape, the eye with a projected image – albeit of 'nothing'. The song, not incidentally, is itself about the projection of desire and anxiety onto an absent figure. The imageless screen emphasized the aural aspect of the cinematic experience. A Hollywood film tries to integrate the sound with the action; the score offers cues for an emotional response to what the viewer is seeing. However, in *Breath* there is no action other than the intervals between the slides. The viewer is aware of the rupture between 'soundtrack' and screen, each of which deliver different versions of the same text. The voice on the tape, the 'breath' of the piece, is full of agitated passion. But on the screen, the text is emptied of all emotion. Curiously, this emptiness exaggerates and generalizes the sense of loss the song demands from the listener, and this sense of loss now attends to matters beyond the scope of the song. The installation becomes a ruin of cinema itself. In that ruin one finds the alienated human subject, whose absence is signalled by grey monochrome.

Breath no longer exists as an independent

work. It became the first half of *Deux Devises: Breath and Mime* (1983), an audio-tape/slide-projection work that Douglas first presented in a Vancouver movie house. The second half, *Mime*, juxtaposed a recording of a 1936 Robert Johnson song, *Preachin' Blues*, with a sequence of close-up slides of Douglas' own mouth miming the words. The pictures of the artist's mouth were slightly out-of-sync with the tape, creating an effect of disassociation: as if the song were a metaphorical mask that the artist was trying to inhabit. It is a displacement similar to the out-of-sync voice of Nathaniel in *Der Sandmann*.

Preachin' Blues is also a song about projecting the self into a split identity. In it, the singer imagines the 'Blues' as a malevolent personification, who is both inside and outside the singer, and who tries to have his art while avoiding complete possession. The historical context of the song is the experience of black rural America and the memory of slavery. The Gounod song is from the rarefied salons of Second Empire Paris. Juxtaposing the two songs contrasts 'high' art with 'folk' art and reminds us that race and class determine the distinction.

Renaissance *devises* told stories about how their noble owners had struggled and overcome some hardship, trial or obstacle. At the time he made *Deux Devises*, Douglas discarded all the work he had made to that date, mostly photography and slide pieces, in order consciously to begin again. *Deux Devises* was meant as a portrait of the artist at the beginning of his career, just as *Overture*, which was completed three years later, was intended as the first in a series of interrelated projects whose thematics might unfold over an indefinite period of time. By making a self-portrait in *Deux Devises*, Douglas was creating a work, in part, about his own conflicted identity. Although he is a black man, he is really 'in drag' when he tries to lip-sync the Robert Johnson song. *Mime* is about the breakdown of this mimesis. Raised in a white middle-class district of a Canadian city, race alone will not give him entry into Robert Johnson's world, where 'race' and culture so actively determine each other. Douglas can be *racialized* by racism, but he can't assume, without getting 'in drag', those experiences, in this case a blues song, that come out of the diasporic communities from which he is in a kind of exile. Similarly, the experience of racism in Canada places him in another kind of exile. As he put it, 'The doubt, that pronounal doubt, doubt of pronouns, doubt of the certainty of an *I*, is the *a priori* of my work. And it's a doubt which is understood by people who are outside of the dominant representation'.[3] This doubt is emphatic. Douglas' work is not a plea to resolve doubt with the assertion of certainty. Nor is it about staging his longing for old certainties that might offer to restore the central pronoun. Instead he assumes that this will be the necessary condition for the work and the source of its demands on the viewer's mobile attention.

It was in 1983, the year Douglas made *Deux Devises*, that he began a year-long reading of the works of Samuel Beckett. This interest in Beckett would result, five years later, in an essay and an exhibition in 1988 that gathered Beckett's eight works for film and television. Douglas' interest was

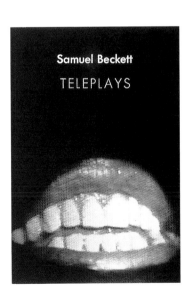

Samuel Beckett: Teleplays
1988
Catalogue of exhibition curated
by the artist
24 × 16.5 cm
Vancouver Art Gallery

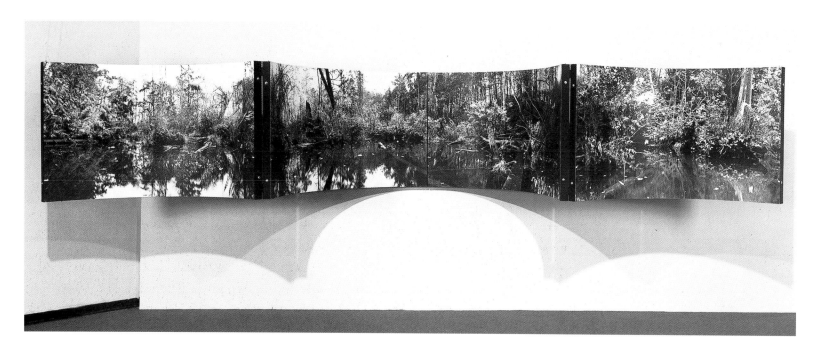

in the collapsed first-person subject of the later works, which include Beckett's teleplays. This he tackles as a question of identity politics. The sense of self as a dependable, coherent unity belongs to a certain privileged subject: male, white, European and bourgeois. Against the certainty of this subject, Douglas posits Beckett's uncertainty. His Beckett is pointedly not the hero of Adorno's *Aesthetic Theory*, but a figure in 'opposition to the heroic identities of the modernist tradition'. In the 'persistent distrust of discrete self-identity, and the potentially authoritarian subject that lies behind any such self-identification, [Beckett] has been able to delineate (or at least allowed others to imagine) the shape of an activity of meaning which, for our culture and its institutions, is still dismissed or marginalized as non-meaning.'[4]

Douglas' works of the early and mid 1980s all refer, in greater or lesser degree, to the Beckettian ontology. *Panoramic Rotunda* (1985) was a model of Beckett's unseeing eye, an eye whose vision is always tautological, unable to escape what its subject projects and negotiates as the world, always in habitual avoidance of that radical non-identity that Beckett calls the real. Mounted on a wooden armature of four quarter-circle sections, *Panoramic Rotunda* is a 360-degree photographic image of the border of a swamp. The resulting work was a model for an imagined, larger scale panorama, never intended to be realized. The model version could be used by one person standing inside the armature. It could enclose the viewer's head like a visor, blinding him or her to the immediate environment of the gallery. But *Panoramic Rotunda* is displayed opened out, hung on the wall like a specimen, so although viewers can now take in the whole image all at once, they must project themselves into its experience rather than inhabit it.

To make the image, Douglas constructed a platform in a swamp and photographed the periphery in twelve sections. The camera's view is not from the centre of the pond. At either end of each section – where the continuity of the circular view has been cut – we feel we could almost step onto the bank, while elsewhere it recedes away from us. The photograph is in sharpest focus in the vicinity of this approaching and receding rim; both the distant forest and its near reflection are out of focus.

Panoramic Rotunda
1985
Photographic installation
4 black and white silver prints, 4
wooden armatures, hinges, cables
h. 104 cm, ø 300 cm
Collection, The Morris and Helen
Belkin Art Gallery, University of
British Columbia, Vancouver

When it was a popular entertainment, the panorama had, as cinema does now, a function in the formation of collective national identity. Nineteenth-century panoramas depicted battles and other sweeping vistas, but *Panoramic Rotunda* depicts an interior zone. In the writing of history, the swamp is a metaphor for stagnation. As a personal metaphor, it is the unconscious, the birthplace of many a grade-B cinema monster. The swamp might even be analogous to the aqueous humour of the eye – in this case, an eye blind to the world. The lush vegetation and forest, reflected in the dark, limpid pool they edge, call to mind another 'panorama': Monet's waterlilies in the Orangerie, a source for Douglas' work. Just as Monet painted a private domain, the swamp depicted in *Panoramic Rotunda* was a childhood haunt for the artist – a place that triggers personal memory. The historical reference, via Monet, is to the phantasmagoria of the bourgeois interior as the site of self-construction. This place, as Walter Benjamin wrote, shattered as it achieved perfection in Art Nouveau, when botanical motives served as a last, ultimately futile stand against technical advance.[5] The delicacy and lyricism of Douglas' photograph, with its dazzling proliferation of detail, creates a world of shadows and insubstantiality. It is a place fit for 'the transfiguration of the lone soul'. But, opened and splayed on the wall, it is like the discarded carapace of a once masterful occupant.

Douglas' works often revisit a cusp where technology and representation meet, where, as he puts it, things could have gone either way. These are, of course, also the fossil-strewn

moments valued by Benjamin for the traces of a montage or dialectical image of a possible future world. As the panorama was eclipsed by technical innovation, so too whatever potential it had to modify life for the better lapsed into obsolescence. By bringing a form like the panorama back, Douglas wants to remember the history of contemporary subjectivity, to trace the path it has taken alongside the development of technologies of representation, noting the possibilities that stood before it and which were refused.

Douglas' next installation, *Onomatopoeia* (1985–86), was also a 'model' of early cinema. *Panoramic Rotunda* was a kind of elegy to bourgeois subjectivity; in *Onomatopoeia*, the factory floor confronts the upstairs parlour. The technology of cinema and that of industrial production become as one in the piece. In the installation a screen hovers over an old upright player piano. The piano plays bars from Beethoven's *C Minor Sonata, Opus 111*. Triggered by punctuations on the piano scroll, images of an empty textile factory are projected above the piano. Many are of the perforated scrolls that would have been used to 'programme' weaving into fabric patterns, echoing the looms used to make player piano scrolls. The piano is spot-lit for a performer but no-one is present; likewise, there is no-one in the factory, yet the installation is 'the scene of an accident'.

Among the many connections in *Onomatopoeia* the most important is the uncanny one between the Beethoven passage and ragtime. The resemblance is, of course, *accidental*. It is entirely dependent on the listener, who brings memory of ragtime to

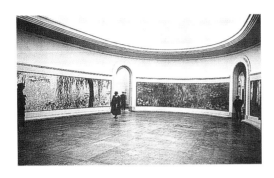

Claude Monet
The Water-lily Pond with the
Willows
1920–26
Oil on canvas
12 panels, 200 × 425 cm each
Musée National de l' Orangerie,
Paris

Jeff Wall
Restoration
1993
Transparency in lightbox
137 × 507 cm

Onomatopoeia
1985–86
Slide installation
6 mins. each rotation, black and
white, sound
154 slides, 88-note player piano,
music roll, screen
Dimensions variable

right, Slide projection stills

opposite, Installation
Collection, Vancouver Art Gallery

the exhibition, and not at all on Beethoven, who, had he stumbled on ragtime, left the possibility undeveloped.

Douglas would have known how important the Beethoven sonata was to Adorno and how, in exile with Thomas Mann in Hollywood in the 1940s, Adorno played the sonata for Mann during their discussions about music which inform the twelfth chapter of Mann's novel, *Doctor Faustus* (1947). It was through this novel that Douglas was led to the Beethoven piece. In Adorno's work, Beethoven exemplified the artist of the nineteenth century. 'Beethoven's greatness', he wrote, 'shows itself in the complete subordination of the accidentally private melodic elements to the form as a whole'.[6] Adorno theorized that the melodic element in a piece of music is emblematic of subjectivity and the bourgeois concept of individuality. The structure of the work is emblematic of the totality of the social process. The contradictions between the two are reflected, but not resolved, in the innermost tensions of Beethoven's music. The music hints at the possibility of reconciling these contradictions. But this can only be enacted in a certain space, that of a live performance, where time is temporarily suspended and daily concerns forgotten. In a concert hall, for example, normal time is replaced with the coherent development of the musical work. And it is this coherent development that augurs a utopian condition. In Adorno's famous argument, music reproduced on records or broadcast into a domestic space loses its essential character. The listener is no longer surrounded by the music and subject to its special suspension of normal time in a social situation. The

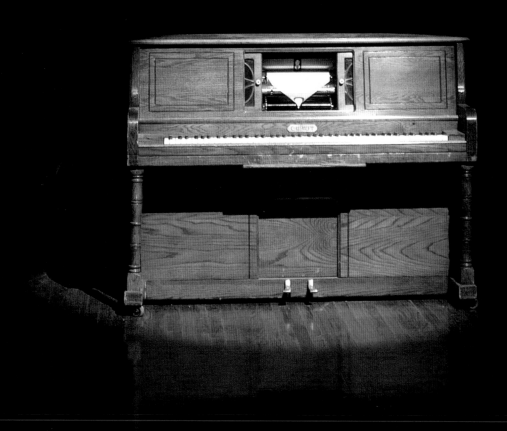

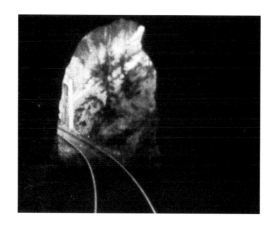

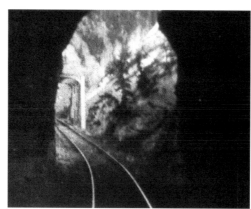

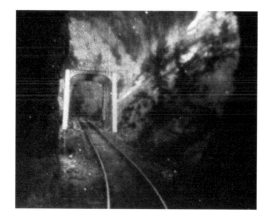

listening experience becomes fragmented, the whole fabric of the work is lost along with its utopian prospect. It is this 'atomized' situation that leads to the fetishization of music and the regression in listening: everything Adorno deplored as 'jazz'.

But the remarkable thing about the sonata for Douglas, is the *accidental* resemblance between the passage he reproduces and ragtime – a resemblance made all the more available by 'the regression in listening'. 'Jazz' is thus embodied in the nineteenth-century master's demonstration of 'great art'. The intentional resemblance displaces those 'accidentally private melodic elements' that are now no longer subordinated to any other larger 'whole'. The utopian vector is also displaced from the unfolding of a coherent development and now springs from a coincidental resemblance. The authoritative text of Beethoven becomes the generic and popular through the technology of the player piano and the mechanical reproduction of a masterwork fragment. This atomization, viewed with dismay by Adorno, might, in Douglas' work, promise the repositioning of a new listener. Although this piece is in a gallery setting, the listener is not required to suspend normal time for the ceremonial attention to a performed concert. Instead, the piece is triggered by the listener's very presence.[7]

Time in *Onomatopoeia* unfolds through various strands, not as an orderly progression through a 'text'. That the present is always working to transform the past is made obvious when we 'recognize' ragtime in Beethoven: for it is the listener, not Beethoven, who brings this to the

Overture
1986
16 mm film loop installation
7 mins. each rotation, black and
white, mono optical soundtrack
Installation, Witte de With,
Rotterdam, 1994
Collection, Art Gallery of Ontario,
Toronto

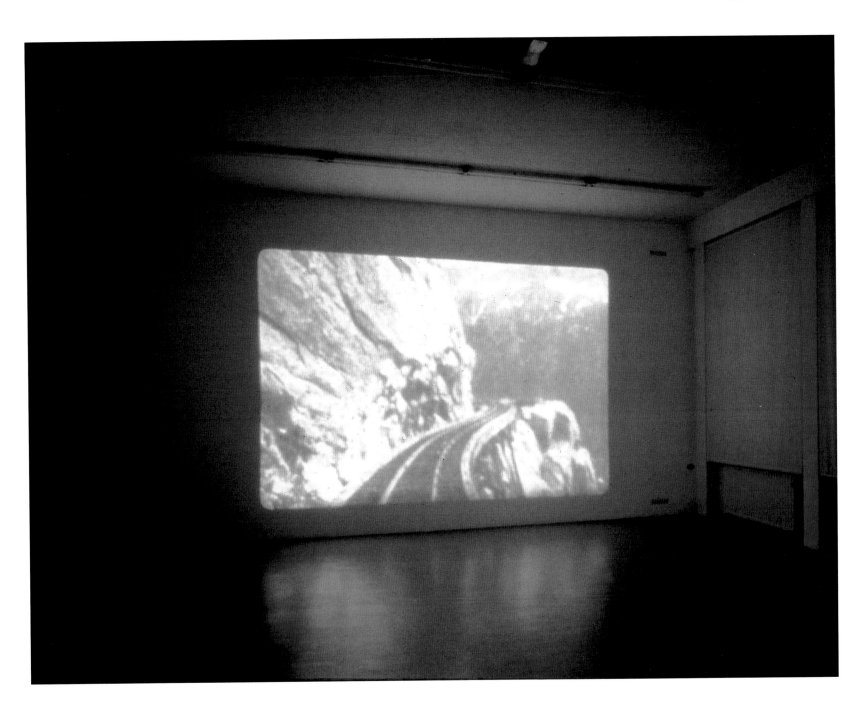

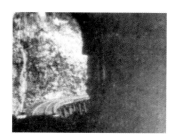 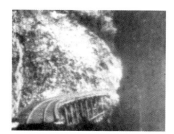 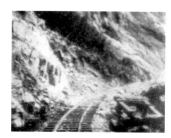

Overture
1986
Film stills

score. Perhaps we are invited to think that in Beethoven's music there lies a germ that would become variously a player piano, ragtime and a mode of industrial production. It was, after all, in Beethoven's time that mechanized textile factories first flourished. *Onomatopoeia* is about a series of analogous displacements; the machine displaces cottage labour as ragtime displaces Beethoven and the player piano becomes a performer.

The representation of time in Douglas' subsequent work, *Overture* (1986), is, as in *Onomatopoeia*, a confluence of mechanical time, which proceeds through repetition, and human time, which is known through memory. *Overture* used archival footage that Douglas appropriated and manipulated. In the 1980s the context for this kind of work was the widespread interest in the implications of montage and appropriation in art that contested its social context and politicized

the act of viewing art. In Vancouver there was, in addition, an interest in the archive of historical images. History is just a touristic commodity in a place like British Columbia, whose very name embodies a nightmarish colonial hangover.

Overture uses Edison Company films of 'train's-eye' views of Kicking Horse Canyon and White Pass, British Columbia, shot in 1899 and 1901. The camera was mounted to the front of the train, constructing a seemingly mechanical and autonomous viewpoint that veers to the edge of steep precipices and plunges through dark tunnels. The audio element is a text cribbed from passages of Proust's *Remembrance of Things Past*, which describe hypnogogic consciousness, the state of semi-awareness between sleeping and waking whereby the struggle to 'wake up' is continually frustrated. When the narrator does come to waking consciousness, he is suddenly aware of his body, an awareness that immediately calls forth thoughts of mortality. The monologue thus describes a state of disorientation. Freud associated the oneiric train journey with death; the text is about the death – and an always deferred 'rebirth' – of consciousness.

The film is constructed in three sections, and the text is divided into six passages that extend over two repetitions of the film. Thus, when the viewer first sees the same image return, it is accompanied by a different text. This induces a doubt as to whether the image really is the same. Each film section is divided by black leader, used to extend the passages in tunnels; when the screen goes 'blank', the viewer is returned to an awareness of the gallery environment. This is in

inverse symmetry to the narrative of the text, in which the view from the train must be about waking, and the tunnel passages about sleep.

Overture is, like all of Douglas' installations, a binary construction. It is often in the seam or suture between two elements that the work is most active. This is where terms can be reversed and habit broken. The search for a situation that might interrupt the habit of the viewer is also a constant in Douglas' art.

At the time he made *Overture*, Douglas was reading Beckett's study of Marcel Proust (1931). Beckett argued that there is a possible appre-hension of the real that is a direct, unmediated experience of the world and things. In this condition – and only then – we are in the present tense and in touch with the radical nature of our existence. Things seen free of habit are seen for their particular natures, independent of any general notion or cause: they are seen *essentially*. We don't experience this reality very often, if at all, because habit both binds and blinds us to our environment. 'Life is habit' Beckett wrote.[8] It is the carapace we construct to negotiate the world. It is the foundation of our sense of ourselves as subjects and keeps us from witnessing the threat of the real. Ordinary memory is only the servant of habit. 'If Habit is a second nature, it keeps us in ignorance of the first, and is free of its cruelties and enchantments'. But involuntary memory, the great wellspring of Proust's novels, has the disruptive power to restore the real. It is explosive and accidental; it cannot be triggered by an act of will. 'This accidental and fugitive salvation in the midst of life may supervene when the action of

involuntary memory is stimulated by the negligence or agony of Habit, and under no other circumstances nor necessarily then.' Fear of death conditions habit, our 'selves' and futile avoidance of the reality of non-identity.

In *Overture*, human time created by memory is opposed by mechanical time, embodied by the train, which is another version of the film – just as in *Onomatopoeia* the loom and player piano scrolls are versions of each other. Mechanical time is repetition, the engine of time in film. Underneath the time of the narrative, there is always the time that is the product of the projection machine, the camera and the sprocketed stock. In its very early years, film was closer to its material condition as a product of mechanized time. Early filmmakers shot footage of events and things, at first satisfied with the new phenomenon and the bringing to light of what Benjamin called a 'new optical unconscious of a newly visible world'. As the narrative conventions of story-telling film were invented, the full market potential of film was discovered and 'movies' were born. These conventions repressed the promise of film when it seemed as if it might both increase 'our insight into the necessities that rule our lives' and prepare us for 'an immense and unexpected field of action'.[9]

Overture was the first work in which Douglas was to spatialize time in a resolved way, achieved through the device of the loop. The early Edison films of train's-eye views of Rocky Mountain journeys were called 'Panoramic views' and were meant to stimulate tourism and investment in a newly opened frontier. The loop turns this panorama into a closed circuit. The scenario from

Alfred Hitchcock
Marnie
1964
130 mins., colour
Film still

Proust, whose book witnesses the passing of a society into obsolescence, is similarly a closed circuit. It is the obverse side of the social potential of early film, already compromised, in 1899, by use as advertising. Although he had chosen to reproduce Proust's method and the novelist's astonishment at the fact of consciousness rather than his narrative of society, Douglas means to demonstrate a relation between the film and the text. *Overture* marks the passing of narrative form from one medium, the novel, to another, film. At this juncture, a utopian possibility simultaneously opens up and shuts down.

Douglas' next film loop, *Subject to a Film: Marnie* (1989) was also about the structure of film. It did not, however, appropriate archival material: it was scripted, directed and produced by Douglas himself. The scenario *Subject to a Film* is an addendum to Alfred Hitchcock's *Marnie* (1964), a film much closer to our own moment than the Edison footage shot from a train. Like *Onomatopoeia*, *Subject to a Film: Marnie* depicts a place of work: the open-plan office of the modern corporate work space. The panorama has become the panopticon. In his 'addition' to *Marnie*, Douglas returns to, and trans-forms, the office robbery scene from the Hitchcock original. It is the end of the office day, 'Marnie' says goodbye to her co-workers but stays behind, hiding in a washroom as they leave. When they are gone she returns to her office, retrieves a key from a desk drawer, and then heads to the office safe. Then the film loops back to the beginning. The whole sequence is shot in black and white, distressed to resemble the quality of surveillance camera images. There is no soundtrack

other than the static created by dust on the stock. The only other sound is a 'klunk', produced as the splice passes through the projector. This has been placed to coincide with the moment when Marnie shuts the desk drawer.

The moment that Douglas has chosen is an intersection. It is where the work day leaves off and the return to private life begins. Like other intersections in his work, it is one crossed habitually and routinely. But the loop renders the routine both inescapable and inconclusive while Marnie's stealth reveals an unstable underside, a deviation from the everyday into a singular act of crime that will shatter routine. Anyone familiar with film theory on Hitchcock will bring this reference to Douglas' version. Hitchcock's *Marnie* is, in Kaja Silverman's writing, for example, positioned as 'emblematic of classic cinema, [in which] authorial subjectivity is constructed through an identification with mastering vision.'[10] In *Marnie*, the heroine doesn't know who she is or what motivates her; she is the unconscious, only able to come to self-realization at the end of the film through a 'talking-cure' guided by her analyst boyfriend/husband, who then becomes (like the filmmaker himself) the 'author' of Marnie. Marnie is the very embodiment of a figure who is the 'other', or the unconscious of the mastering vision of cinema.

Douglas' premise is an alternate, upside-down reading of *Marnie*. What if Marnie were not a figure of the unconscious, but a volitional being? If she were a professional thief, then her relationship with her analyst would be a lie meant only to divert him and others from the truth. In

Subject to a Film: Marnie
1989
16 mm film loop installation
6 mins. each rotation, black and
white, optical soundtrack
Dimensions variable

l. to r., from top, Marnie preparing
to leave the office; Marnie
emerges from the washroom; The
keys to her associate's desk; Re-
entering the empty office;
Opening the safe

Hitchcock's film we pursue Marnie's identity, finally 'writing' it ourselves through the power of the film's masculine directorial gaze. In *Subject to a Film ...* this identity already exists and the tracking of a surveillance camera meets it as a kind of resistance that begins to wear the film down. Marnie is the question mark the surveillance camera cannot answer.

Douglas' next film installation, produced in 1993, was *Pursuit, Fear, Catastrophe: Ruskin, BC,* an ambitious work that took the experimentation with narrative a step further. As in the earlier

installation, *Onomatapoeia,* a screen hovers over a piano and the piano plays an accompanying score. But instead of a slide sequence, Douglas produced a 14-minute, 16mm, black and white film.

The film is set circa. 1930, in the early years of the Great Depression. It is a pastiche of a silent film that might have been made around the time when the introduction of sound made silent films obsolete. The actors gesticulate emphatically and intercards give a summary of their dialogue. The plot emerged from Douglas' research into old police records. It follows the enigmatic

disappearance of a Japanese-Canadian worker at the Ruskin power plant, the subsequent investigation and the effort of the missing worker's roommate and friend to get answers from the police. In the telling details of the search for the missing person and a missing truth, we get a picture of society in British Columbia as a colonial culture riddled with racism and complacency. The film is shown continuously in a gallery installation. Its internal structure is also a loop and it ends where it began, with the protagonist slipping out of the police station in which he's seen the police record of the investigation, a record that tells him the case is closed.

Pursuit, Fear, Catastrophe: Ruskin, BC, was the first project generated by research into the history of a place. Located about an hour's drive from Vancouver, Ruskin was named after the nineteenth-century English art critic and utopian social theorist John Ruskin. It is ironic that this small, rural, hick town is named after the eminently cultured Victorian, yet the history of the town is in a sense the history of the failure of Ruskin's ideas. It was established in 1896 as a co-operative commune on a Ruskinian model. The commune depended on a lumber mill to fund its community, but the mill went bankrupt after the first year. Between the wars, and until the Japanese Internment of 1942, the area around Ruskin had attracted a large Japanese-Canadian population. In 1929, the BC Electric Company built a dam and the hydro-electric power plant that is featured in the film. The photographs Douglas took in the area around Ruskin depict the general industrialized landscape, a landscape from which things are

extracted rather than one in which things are cultivated. The series he chose to present as a portfolio focuses on the neo-Gothic hydro-electric plant and dam. They are images of dubious progress; the plant turbine a symbol of repetitive, mechanical time.

About five minutes into the film the piano begins to play a score: a transcription of Arnold Schoenberg's odd composition, *Begleitmusik zu einer Lichtspielscene* (Accompaniment to a Cinematic Scene), in three sections: *Threatening Pursuit; Fear; Catastrophe*. It was written in 1930, at the end of the silent film era, the time the hydro-electric plant was built and the time in which Douglas' film is set. The music of Schoenberg does not usually bring to mind stories of colonial society along the border between industry and the wilderness, but they are deeply intertwined by Douglas' art. The score reminds us that Schoenberg's atonal music has a rich, if degraded, legacy in countless movie soundtracks that amplify danger, menace, panic and catastrophe. As a measure of twentieth-century anxiety about technology and progress, Hollywood movies have continued to mine the example of serious experimental music. But if Schoenberg's programme was in any way utopian, Hollywood uses atonality to underscore a dystopian irrationality and mass fear, rather than hope, for the future. The silent film, as a popular art form, was over just as Schoenberg wrote his score for an imaginary film. It was an exercise, then, that he directed towards the past and the irretrievable, not towards the future.

Ruskin is a pessimistic work about the

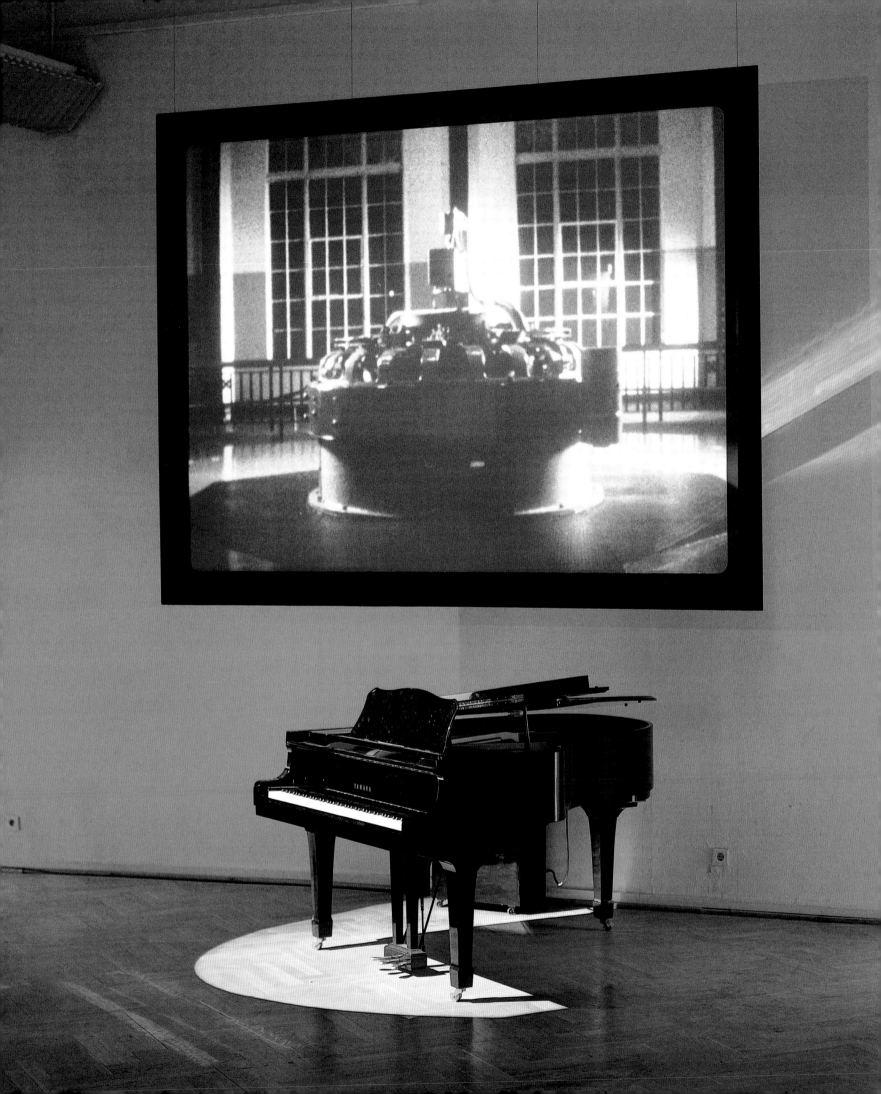

From **Television Spots**
1987–88
12 videos for television
10–37 secs., colour, mono
soundtrack
First broadcast by CBC Ottawa,
1989, sponsored by National
Gallery of Canada
Twelve videos on laser disc
Collections, Musée National
d'Art Moderne, Centre Georges
Pompidou, Paris; Winnipeg Art
Gallery, Winnipeg, Canada

right, Session I, September 1987
l. to r., from top, **Musical Vendor**
(30 secs.); **Spectated Man** (30
secs.); **Sneeze** (15 secs.); **Male
Naysayer** (10 secs.); **Female
Naysayer** (15 secs.); **Lit Lot** (15
secs.); **My Attention** (37 secs.)

opposite page, Session II,
October 1988
l. to r., from top, **Answering
Machine** (30 secs.); **No Problem**
(15 secs.); **Funny Bus** (15
secs.); **Box Office** (30 secs.);
Slap Happy (30 secs.)

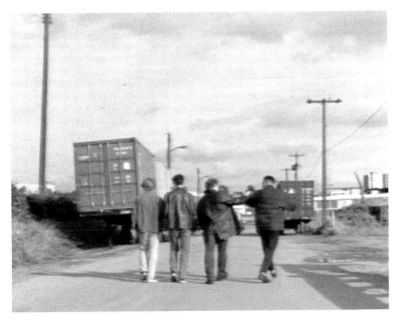

Rodney Graham
Tree with Bench, Vancouver, BC
1996
Ektacolour print mounted onto
Plexiglas
132 × 159 cm

decrepitude of Empire. Douglas was partly attracted to the site because this decrepitude challenges the 'authority' of a figure like John Ruskin, whose ugly asides about 'mongrel races' become the vehicle by which he is remembered in Douglas' film. We see how emerging corporate powers criss-crossed the landscape with dams and wires and how the frontier society was policed to keep the racial and class order from disruption. Within the very name of the small town of Ruskin is inscribed what it failed to be: a Ruskinian co-operative.

Throughout the 1980s one would have found points of correspondence in the activities of fellow Vancouver artists such as Jeff Wall, Rodney Graham, Ian Wallace, Ken Lum and Roy Arden. In the 1970s, Wall and Wallace formulated strategies to put pictures back into the autonomous art object in order to re-engage an image of society. One model for this had been Dan Graham's *Homes for America* magazine piece, which showed how the social metaphors in Minimal art made a disinterested formalist practice impossible. The Vancouver artists had a common interest in certain urban settings, mainly intersections, places of transit and dormant zones, as concrete indicators of capitalist abstractions. They all approached this subject through photography and, in varying degrees, developed practices that imitated, simulated or mastered cinematic techniques of representation. It was Jeff Wall who proposed that Vancouver was a generic city, a place where the forces of global capitalism were engaged in the radical transformation of a decaying outpost of the British Empire into the node of a new network.

Vancouver served as an example of a world transformation, yet the work of these artists often delved into very localized situations and histories.

Douglas' video installations are about moments in the history of television representation. The first video pieces he made, however, were very much a part of the Vancouver aesthetic of the 1980s, in which the urban fabric became a semiotic landscape. The juxtaposition of the new and the decrepit provided evidence of the violence and instability of urban property in a time of immense movements of capital.

At the same time that he was producing his two 'materialist' film loops, Douglas was also preparing an exhibition of the film and television work of Samuel Beckett.[11] The Beckettian notion of habit was a guide for the urban pictures he realized in *Television Spots* (1987–88) and *Monodramas* (1991). *Television Spots* is a group of twelve video works made for broadcast television. This foray into that medium was an experiment to put his art before a new public outside the precinct of the gallery. At fifteen or thirty seconds each, they are the length of a television advertisement, and when broadcast, are placed within commercial breaks. The idea was to play one spot a night in a complete cycle of twelve and then repeat it. Each spot is a terse narrative fragment; many of them depict urban situations like an underground parking lot or an industrial zone. Although they are very brief, time seems slower in them than in the ads because they depict 'real time' and are composed of only a few shots. In contrast, a television commercial contains many shots and segments, some even shorter than one second. Negation and

refusal are common themes in the spots. All the vignettes are built around a single gesture, some suggesting a difficulty in communication. For example, in *Answering Machine* (1988), the camera pans from an outside view into an interior. A woman sits smoking at a table. The phone is ringing but the woman does not answer it. The segment ends just as the caller is about to leave his message on the machine. The *Television Spots* have a dialectical humour. To decide not to answer the telephone when it rings is an everyday, private assertion of freedom and autonomy. It is a kind of disobedience.

The longest spot, *My Attention* (37 seconds), features a 'talking head' who addresses the viewer directly. He says: 'Everything seems to catch my attention. Even though I'm not particularly interested in anything.' He complains of hearing voices and his difficulty in shutting them out. He finds it hard to concentrate. The condition is schizophrenia or something like it – a mirror of the distracted state of the television viewer.

The spots appeared without preface or explanation. Interestingly, CBC, Canada's state-owned television network, refused to sell time unless the spots were 'identified'. But private stations agreed to broadcast them as the artist wished. The *Television Spots* present a crisis of meaning to the TV audience. The intention was to break the viewing habit precisely where its continuity is weakest, in the void between one ad and another. Psychic habit allows us to switch perceptual modes as television demands. We make continuity out of the sudden breaks, shifts of scene and points of view. In so doing we become

absorbed in the medium and it transforms our consciousness as it habituates us to codes, tempos and styles of visual representation. The new skills acquired in order to negotiate the 'shocks' of rapid editing are immediately pressed into the service of advertising.

In a famous formulation, television does not deliver entertainment to its viewers, it delivers audiences to advertisers. Because television so powerfully defines reality as representation, the most disruptive intervention might be to depict nothing. As Douglas himself wrote, 'the cinematic codes [of television] are methodically assembled in a manner that demonstrates how the right of authority may be upheld even by those who are dominated by its law.'[12] When the code is dis-engaged, people are perplexed.

When the *Television Spots* were first broadcast in Saskatoon, the callers wanted to know what product was being sold. As odd as the spots are and as different in terms of professional sheen, pacing and 'meaning' from standard television, viewers could still impose the code on them and even preferred to read them *in terms of* the code.

The *Monodramas* were more professionally produced, thus better disguised. Whereas the spots were ambiguous fragments, the *Monodramas* are self-contained, with their own beginning-middle-end linear narrative structure. Their style of editing mimics television melodrama while delivering discordant themes. Often, something going on outside the frame is key to the action. The 'stories' are all parables of dysfunction, inner disorientation, miscommunication and distraction or, inversely, freedom from codes of

Jeff Wall
Park Drive
1994
Transparency in lightbox
119 × 136 cm

Dan Graham
Two Home Homes, Ground Level
Plan, 1966
Wendy's Restaurant, Vancouver,
BC, 1974
1978
2 black and white photographs
top, 25 × 34 cm
bottom, 27 × 34 cm
From the series Homes for
America

From **Monodramas**
1991
30-60 secs., colour, stereo
soundtrack
First broadcast by BCTV,
Vancouver, 1992, sponsored
by UBC Fine Arts Gallery
Ten videos on laser disc
Collections, Museum van
Hedendaagse Kunst, Ghent;
Musée National d'Art Moderne,
Centre Georges Pompidou, Paris;
Solomon R. Guggenheim Museum,
New York; Walker Art Center,
Minneapolis

right, l. to r., from top, **As Is; Eye
on You; Encampment; I'm Not
Gary; Up; Disagree**

opposite page, l. to r., from top,
**Stadium; Guilty I; Guilty II;
Guilty III**

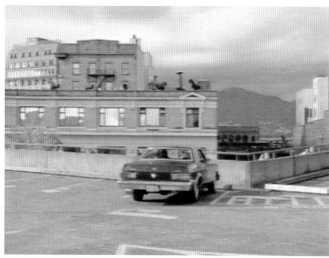

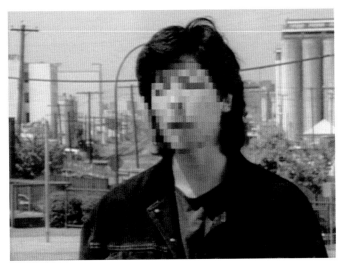
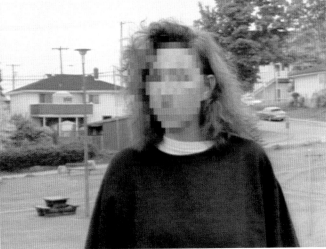
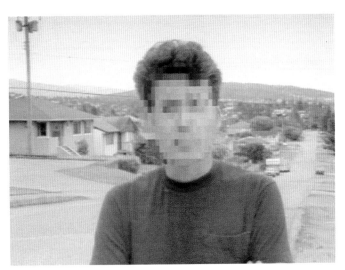

Albert Ayler
Spirits Rejoice
Judson Hall, 1965
ESP Disk CD cover

communication and recognition: a car and a bus narrowly avoid a crash at an intersection; a car cruises down a highway, another car then parks; a man sees a stranger from his balcony but when he investigates, the stranger is gone. Some carry implicit social content; in '*I'm Not Gary*', two male figures – one black, the other white – approach each other outside a suburban mall. The white man greets the black man saying, 'Hi Gary'. The black man turns and responds firmly, 'I'm not Gary'. This failure of recognition seems, on a micro-level, to represent a whole society that names minorities without hearing their voices.

Like the *Television Spots*, the *Monodramas* focus on intersections and moments occupied by habit suddenly broken. Three, *Guilty I, II* and *III*, are testimonials addressed directly to the viewer. In each version of *Guilty* the solipsistic, Beckett-like text is the same but the speaker is different. The speaker's faces have been digitized to disguise their 'identity'. This mimics the news magazine that hides the identity of the informant while extracting a confession. The text is a rambling account of free-floating guilt. The subjects are acutely self-conscious but only able to monitor their own instability and not the outside world. They are in exile, alienated from social function and context. Duplicated exactly by three different speakers, the confession of guilt becomes more a product of a regime than a spontaneous personal expression. The speakers are doubly displaced: first by their mental condition, and second by the erased but incriminating representation. The *Guilty* tapes give an articulate subject to the institutional condition that the other tapes portray. The works

for television attempted to establish a Brechtian alienation effect by dwelling on the rudiments of television editing, tempo and gesture in the context of a divided and distracted subject who mirrored the viewer. They undermined the codes of advertising and melodrama. In his later video-installations, Douglas worked with historical transformations in the medium of broadcast video as they occurred in French arts documentary (*Hors-champs,* 1992) and American newscasting (*Evening,* 1994). Both of these pieces deal with the cusp of 1968 as a revolutionary moment that history then deferred.

Hors-champs was made for Douglas' exhibition at the Centre Georges Pompidou in Paris in 1994. This was a site-specific work, involving research into the free jazz movement centred in Paris in the 1960s and the television practices that presented this music at that time. Any work referring to 1960s Paris will take the utopian almost-revolution of May, 1968 as its background. Indeed, the group improvisation and harmonic freedom of free jazz was seen by some as an artistic model of how a new post-revolution society might function.

In *Hors-champs* (which translates as 'out of field, i.e., out of camera-range) a thin screen hangs in the middle of an otherwise empty room. Scenes from what appears to be an historic tape of a jazz session are projected on both sides. The music is Albert Ayler's 1965 composition, *Spirits Rejoice*, a jazz piece that contains recognizable citations from *La Marseillaise* and the *Star Spangled Banner*. Both are anthems to the revolutionary spirit of modernity's earliest republics, France and America. The musical style combines the

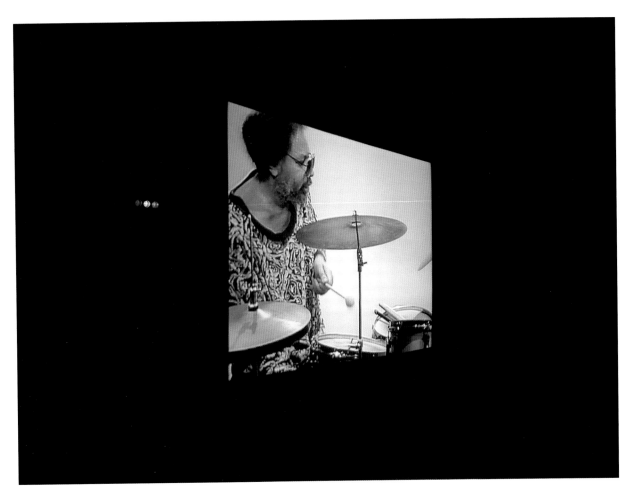

Hors-champs
1992
Video installation
13 mins., 40 secs. each rotation,
black and white, sound
Dimensions variable

top, Installation, Musée d'Art
Contemporain de Montréal, 1994

bottom, Installation, Institute of
Contemporary Arts, London, 1994
Collections, Musée National d'Art
Moderne, Centre Georges
Pompidou, Paris; San Francisco
Museum of Modern Art

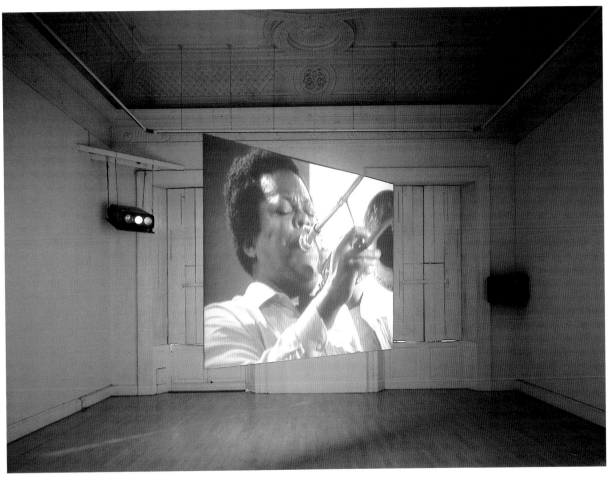

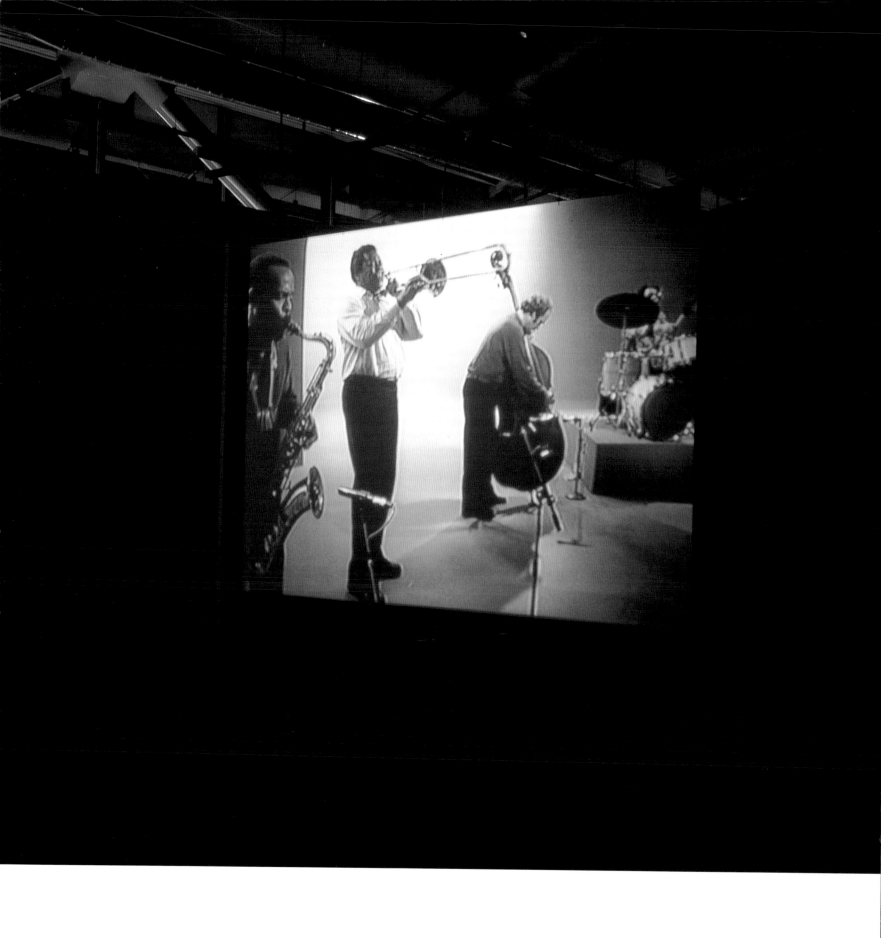

intellectual atonality of serious modern music – and thus the themes of exile, alienation and disintegration expressed by that idiom – with the free jazz rhythms developed by the African-American musicians then living in Paris. The expatriate free jazz scene flourished in Paris at a time of crisis in America itself, when black artists were still subject to discrimination.

The video projections differ on either side of the screen. On one side is Douglas' film of a session shot in 1960s style. The camera tracks each musician as the individual players take up the themes of the music and play. For the other side of the screen Douglas made a tape of what look like out-takes, the camera dwelling on players at rest. The 'official' version records the performance in a way that emphasizes the conventional unfolding or development of a piece of music. But by always choosing to focus on the performer who happens to be carrying the melodic line, this technique also fragments the composition as a whole into a series of atomized events. It is a style oriented towards individual performers, suggesting that the audience is always being offered portraits of personalities expressing themselves in solo passages, rather than centring on the relationships between performers – which is exactly what free jazz is about. The unofficial or imaginary version of the session sets out to depict these relationships by giving emphasis to pauses and intervals, players listening or playing subordinate parts.

The bifurcations always at the structural heart of Douglas' installations are pushed to an extreme in *Hors-champs*. Though both tapes share the same soundtrack and were presumably shot at the same time, what is being screened is not the recto and verso of the same situation, but two points of view: one 'official', a recreation of the style of filming such performances at the time, and the other a kind of deconstruction of that 'official' point of view. Viewers can't infer from viewing one side what is happening on the other, nor can they see both sides at once. It takes going back and forth, walking around the screen several times, to realize that the tapes are different. The screen is paper thin, like the seam in *Der Sandmann*; it is a passage between process and product, between transformation and fatefulness.

Evening, commissioned by the Renaissance Society, University of Chicago, is the result of an investigation into what Douglas considers a key moment in the development of television broadcasting. The concept of 'Happy Talk' was introduced into North American news shows in the late 1960s by a Chicago affiliate of ABC. The immediate success of this new format and style led to its universal adoption in the United States and Canada. 'Happy Talk', introduced ad-lib banter between announcers, giving them more 'personality'. At the same time, 'human interest' stories were included with the hard news and the vocal delivery was refined with new rhythms and cadences. 'Happy Talk' was introduced at a time of considerable social unrest in the United States and the new style offered a way of presenting social conflict that broke the stories of war and riots into nightly self-contained episodes. The introduction of 'Happy Talk' began the absorption of newscasting into the demands and forms of

opposite, **Hors-champs**
1992
Video installation
13 mins., 40 secs. each rotation, black and white, sound
Dimensions variable
Installation, Musée National d'Art Moderne, Centre Georges Pompidou, Paris, 1992
Collections, Musée National d'Art Moderne, Centre Georges Pompidou, Paris; San Francisco Museum of Modern Art, San Francisco

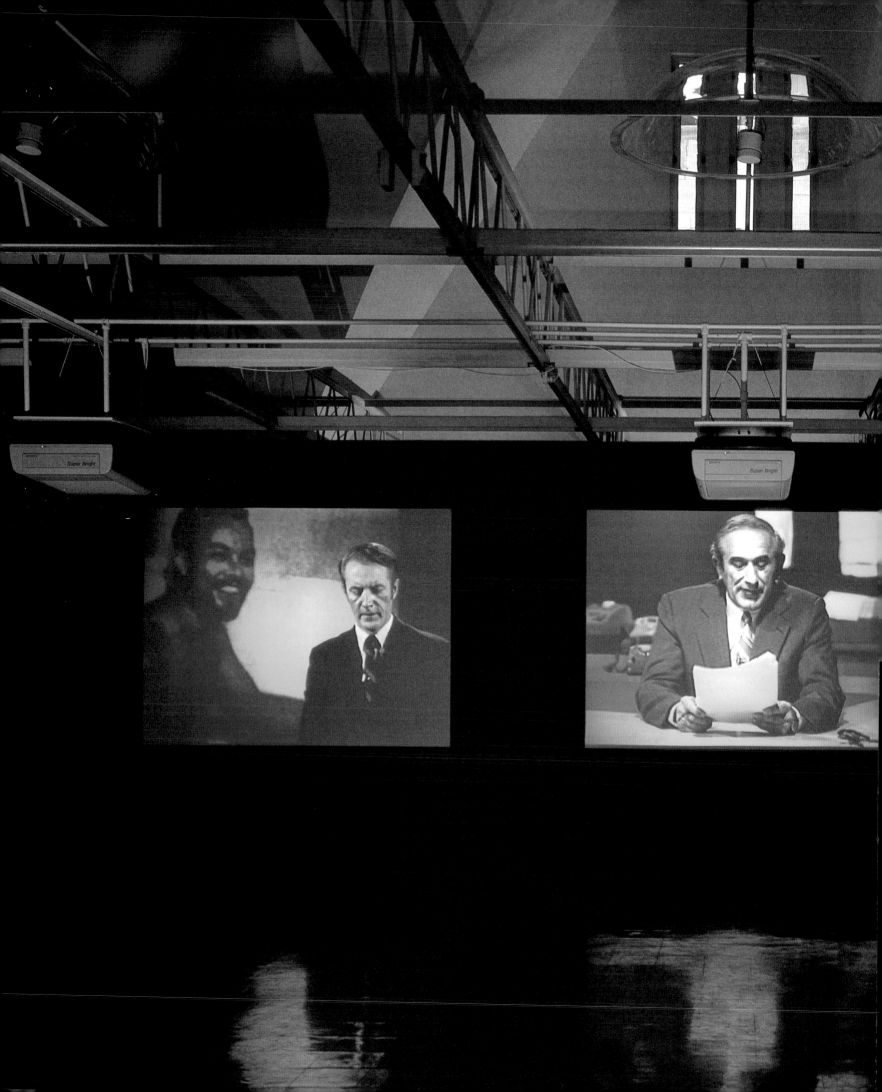

Evening
1994
Video installation
14 mins., 52 secs. each rotation,
colour, sound
Dimensions variable
Installation, The Renaissance
Society, University of Chicago,
1995
Collection, Museum of
Contemporary Art, Chicago

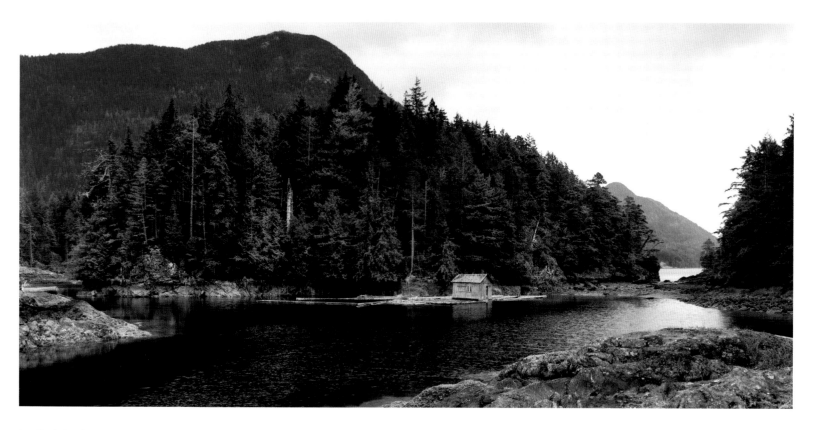

From **Nootka Sound**
1996
C-print photographs
46 × 91.5 cm
above, **Beachcomber's Float
between King and Williamson
Passages**

opposite, top, **Gold River Mill**

opposite, bottom, **Tahsis Mill**
From the series of 30 prints,
various dimensions
Collections, Solomon R.
Guggenheim Museum, New York;
National Gallery of Canada,
Ottawa

entertainment, which in turn began to influence
political campaigns as they were increasingly
waged through the medium of television. The
change of style turned away from the fiction of the
objective reporter as eyewitness and investigator
and into 'infotainment'. The breaks into casual
banter meant that the announcers stood for the
viewers themselves, who could now identify more
readily with them. Driven by marketing studies and
the demands of advertisers, newscasts were as
concerned as other television programmes to
reflect the tastes of the viewers/consumers.

In *Evening*, Douglas scripted and produced
three imaginary broadcasts that mark the
transition from the old style of presentation to the
new, using actual TV footage from 1 January,
1969. The stories are about the Black Panthers, the
Vietnam War, and the trial of the Chicago Seven.
The Chicago trial stories and those reporting
investigations into the murder of Black Panther
Deputy Chairman, Fred Hampton, are

representations that the Movement atomized into,
as Douglas put it, 'unreasoned or fragmented
"special interests"'.

Against this 'unreasoned' presentation of a
fragmented world, Douglas offers a version of
television as modernist abstraction. *Evening* is
about television and how a certain style of
representation possibly served to repress the very
social dissent it represented. The *Television Spots*
and *Monodramas* were broadcast, and the
advertisements between which they were
sandwiched, as their intended environment, were
necessary to the works. In *Evening*, conceived for
the gallery, the advertisements are gone, but their
absence is aggressively registered with stretches of
blankness in the video projections, during which
the text 'Place Ad Here' occupies the screen. In a
dialectical way, we understand that these ad
spaces not only fragment and distance further the
narratives that appear in the news, but also
represent, paradoxically, the world of consumer

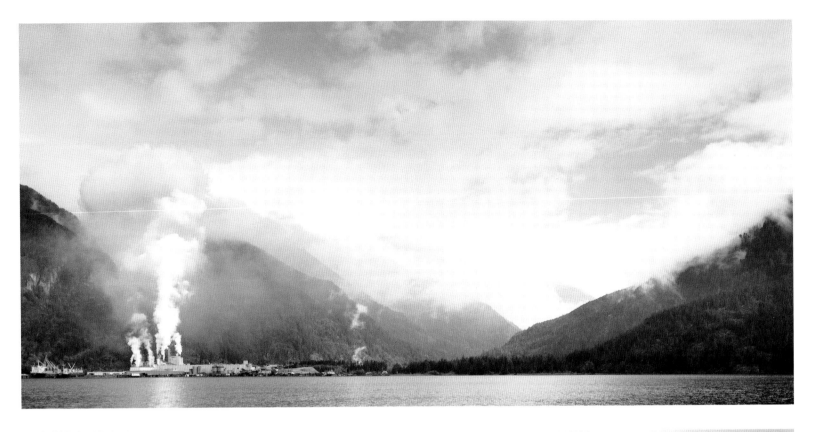

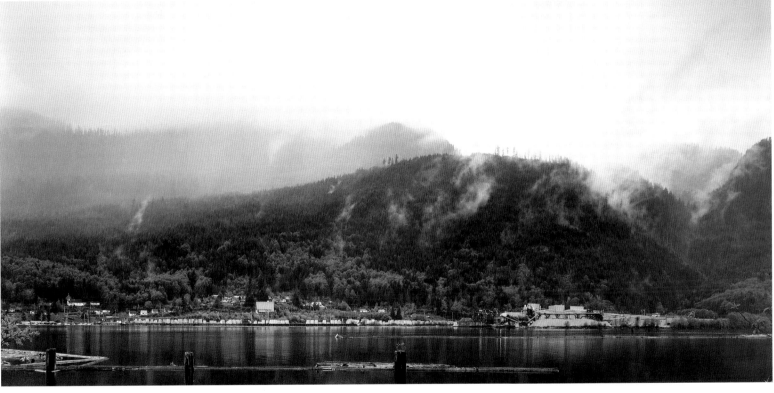

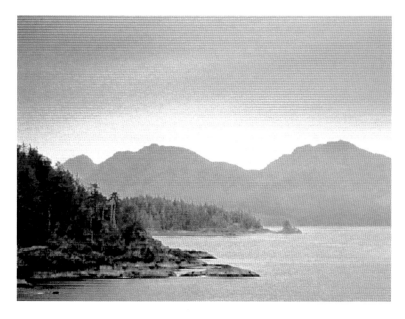

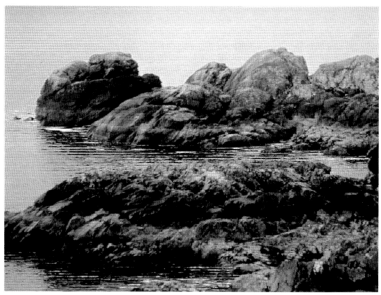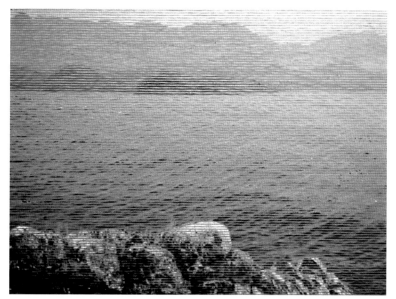

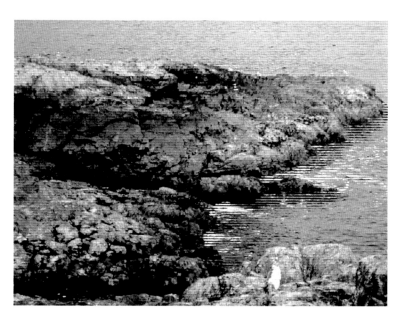

Nu • tka •
1996
Video installation
Single-channel video,
quadraphonic soundtrack
6 mins., 50 secs. each rotation
Video stills

products that the fragmentation of the news stories is trying to approximate. The strategy of presenting the blank space, in lieu of an actual advertisement, functions, as does the revelation of structure in Douglas' other works, to interrupt the absoption of the viewer.

Evening, *Hors-champs* and the earlier works for broadcast, *Monodramas* and *Television Spots* were all about television and history. Visually, Douglas' most recent work *Nu•tka•*, produced in 1977, is about the material structure of video. Its narrative centres on the primary cusp of North American history, the first contact between Europeans and First Nations People.

Douglas imagined *Nu•tka•* as a 'Canadian Gothic' and its historical background is provided in Douglas' notes. The moment is the first encounter between the Nootka people and English and Spanish explorers at the end of the eighteenth century. Nootka Sound is on the west coast of Vancouver Island and the site of recent prolonged battles over the proposed clear-cutting of the virgin rain forest. It is still a remote region of the world accessible only by air and sea. One can see evidence of this industrialized wilderness in the suite of photographs, the *Nootka Sound* series (1996) that Douglas made while researching the shoot for the video installation.

In his script for *Nu•tka•* Douglas presents two synchronous spoken narratives. One speaker is the English captain James Colnett, the other is the Spanish commander, Esteban José Martínez. Both men had ambitions to claim the region for their respective countries and, as the result of these conflicting claims, Martínez has detained Colnett

as a prisoner of war. The incarcerated Colnett loses his mental balance and enters a state of delirium. This is echoed in Martínez' ruminations, as he too, racked with doubt and thwarted ambition, begins to lose his grip. Both speakers project their anxieties upon the unfamiliar surroundings of Nootka Sound. They recount their stories simultaneously, as if more or less in the same predicament, until they cancel each other out. On six occasions Martínez and Colnett speak in unison. Each of these passages is a citation woven into the text. The first, for example, is from a classic Gothic tale, Edgar Allen Poe's *The Fall of the House of Usher* (*c*. 1840). Poe's description of the monumental gloom of the Usher estate is transposed and inserted into the 'grand narrative' of first descriptions of the new world. Other citations from Swift, Cook, Sade and Cervantes are also anchored into the Colnett/Martínez narratives. The picture is of an atmosphere of suspicion and impending calamity in a gloomy, forbidding and haunted land. The Nootka themselves are hardly referred to. In the circum-stances recounted in Douglas' scenario, the Nootka, although they are the title 'characters', have quit the scene, leaving the deteriorating Europeans to confront their failure to establish Empire.

In the video we see a double image of Nootka Sound. The pairing and folding of the image comes from two shoots, one made shortly after the other. The view, except for one short shot of the forest, is an outward prospect. The camera looks out from San Miguel Island, where, in 1798, Martínez had arrested Colnett. The view of the surveyor,

topographer or colonist, evoking the panorama, and the centrality of an observing eye, is deconstructed. Instead of a mapping of the landscape there is a disintegration and coalescence that imitates nature. The camera tilts and sweeps, showing horizon, vista, sky, sea and forest. The images penetrate each other on two sets of interweaving video raster lines. The electronic lines become a dense material screen as well as the scrim through which the landscape is seen. Periodically the movement comes to a brief halt as the images cross and become 'in sync'. But they don't synchronize exactly because they are two different shots. Douglas first tried to make the piece with a morning and afternoon shoot, but the result was illegible. When the image stops on a small rocky promontory, you can see how the activity of the sea as it meets the land has become degraded through the medium to a kind of electronic jumble.

In his text, Douglas uses the words 'uncanny apparition' to describe the moments when the two images coalesce. There is something odd about them, for the sea and sky, shot at different times of the day, are stirred by different winds and tides. This alienated landscape parodies a local 'touristic' tradition of coastal landscape motifs that suggest a kind of lordship over the terrain, with its mountain ranges, islands, rain forests and inlets. This derives from the European tradition by which property and national values are always the subtext of what is surveyed. In British Columbia, as Douglas' recounting of certain events of 1798 makes clear, an appreciation of 'nature' in art must either negotiate or suppress the social and

industrial conflicts that animate the history of this part of the world. The tourist views of wilderness scenes, promoted from the beginning of European settlement, serve as deeds of psychic ownership to counter the previous contestation of the land.[13] In *Nu•tka•*, the uncertain claim of the old world on the new is figured in an image that is running on two colliding tracks.

Here and elsewhere, Douglas explores what he calls the 'idiomatic languages' of media as if they constituted evacuated sites where the main actor has been absented. But his projects are, in addition, about the historical conditions that produce alienation. His installations are structured around a split or division that forestalls any immediate absorption into the work but instead announces something irreparable. It is as if, in his use of cinema and video, he wants to reveal the structure of an illusion that can no longer be sustained but which is nevertheless deeply embedded in the histories of these media. It is an uncanny apparition of an unmoored subject we used to call 'I'.

1 Deleuze, Gilles, 'Image-Movement and its Three Varieties: Second Commentary about Bergson', *SubStance*, 1984 , pp. 44–45

2 Freud, Sigmund, 'The "Uncanny"', in *The Standard Edition of the Complete Psychological Works of Sigmund Freud*, Volume XVII (1917–19), trans. Strachey, James, London, 1955

3 Interview with Scott Watson, 'Vancouver Artist Stan Douglas Excavates the Ruins of the Past in Search of New Utopias', *Canadian Art*, Toronto, Winter, 1994

4 Douglas, Stan, 'Goodbye Pork-Pie Hat', in *Samuel Beckett: Teleplays*, Vancouver Art Gallery, Vancouver, 1988

5 Benjamin, Walter, 'Louis-Philippe or the Interior', in *Charles Baudelaire*: *A Lyric Poet in the Era of High Capitalism*, trans. Zohn, Harry, Verso, London, 1983

6 Adorno, Theodor, 'On the Fetish Character in Music and the Regression in Listening', in *The Essential Frankfurt School Reader*, ed. Arato, Andrew and Eike Gebhardt, Continuum, New York, 1987, p. 227

7 When *Onomatopoeia* was first installed, an attendant started the piece when visitors entered the gallery. Now in a public collection, the work has been adjusted to repeat itself mechanically and plays continuously

8 Beckett, Samuel, *Proust*, Grove Press, New York, 1970

9 Benjamin, Walter, 'Artwork Essay, I', p. 499. Cited in: Buck-Morss, Susan, *The Dialectics of Seeing: Walter Benjamin and the Arcades Project*, MIT Press, Cambridge, Massachusetts, 1989, p. 268

10 Silverman, Kaja, *The Acoustic Mirror: The Female Voice in Psychoanalysis and Cinema*, Indiana University Press, Bloomington, 1988, p. 218

11 *Samuel Beckett: Teleplays*, Vancouver Art Gallery, Vancouver, 1988

12 Douglas, Stan, 'Shades of Masochism: Samuel Beckett's Teleplays', *Photofile*, Paddington, Australia, Autumn, 1990

13 Canadian critic Northrop Frye mandated that in the Canadian context 'the creative instinct has to do with the assertion of territorial rights.' 'Conclusion to a Literary History of Canada', *The Bush Garden; Essays on the Canadian Imagination*, House of Anansi Press, Toronto, 1972

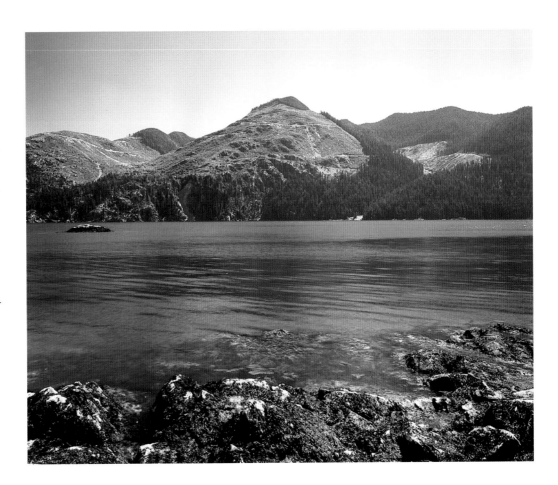

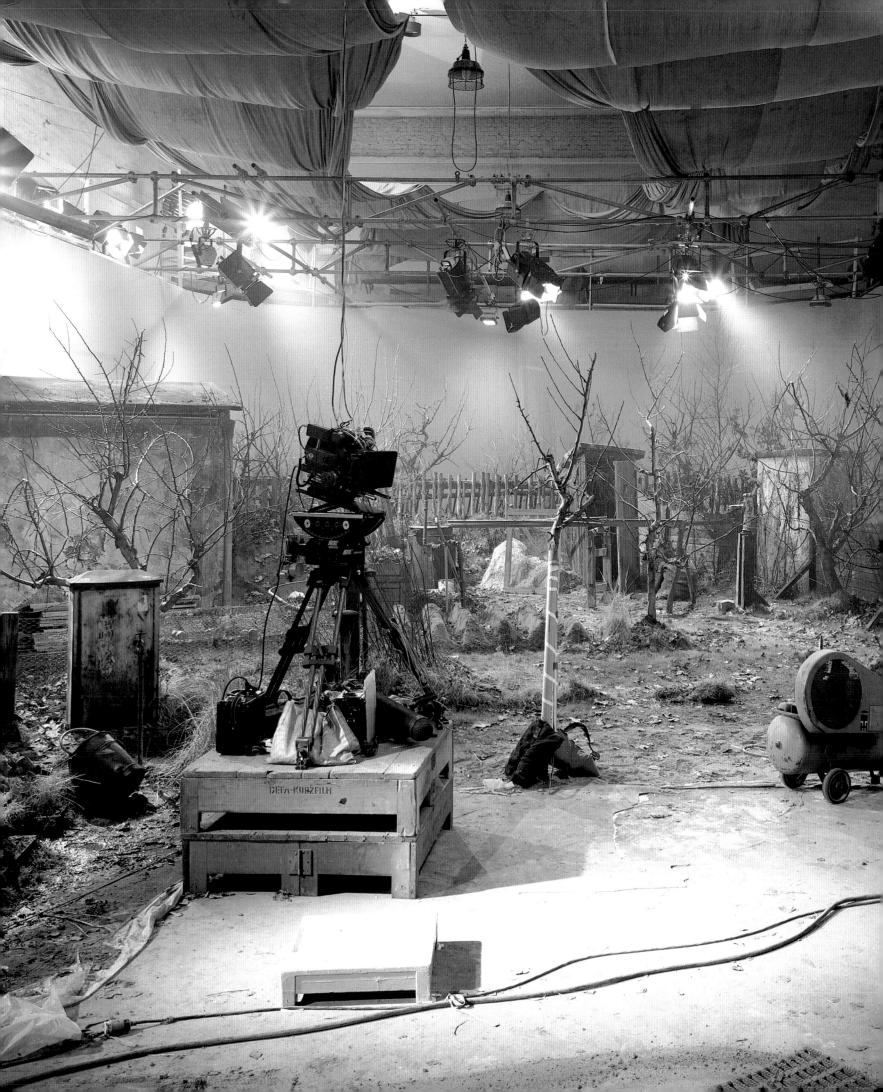

Contents

Interview Diana Thater in conversation with Stan Douglas, page 6. **Survey** Scott Watson

Against the Habitual, page 30. **Focus** Carol J. Clover Der Sandmann, **page 68.** **Artist's**

Choice Gilles Deleuze Humour, Irony and the Law, 1967, page 80. **Artist's Writings**

Stan Douglas Television Spots, 1987–88, page 88. Goodbye Pork-Pie Hat, 1988, page 92. Monodramas, 1991, page 100. Hors-

champs, 1992, page 110. Pursuit, Fear, Catastrophe: Ruskin, BC, 1993, **page 112.** In conversation with Lynne Cooke, 1993, page 116.

Evening, 1994, page 122. Der Sandmann, 1995, page 124. Der Sandmann, Script, 1995, page 128. Nu•tka•, 1996, page 132.

Project for the PIACC, Zwolle, 1996, page 140. **Chronology** page 144 & Bibliography, List of

Illustrations, page 158.

E.T.A. Hoffmann's remarkable story *Der Sandmann* owes a good part of its afterlife, at least in the English-speaking world, to Freud's 1919 essay on the uncanny (*Das Unheimliche*). For Freud, *Der Sandmann* is a rumination par excellence on the peculiar feeling of having been somewhere before, or having seen something in the past – a feeling all the spookier for seeming to be part of a design, perhaps of one's own unconscious making. And in Freud's analysis, it *is* of one's own making, for the uncanny is nothing more nor less than the psychic return of an early experience made strange by repression. To the thing or place that becomes suddenly ambiguous in our perception, split between the here-and-now and some painful past moment, our response can only be anxiety.

This is the field of Hoffmann's *Der Sandmann*, a veritable hotbed of returns, memories of memories, circles, recurrences, doubles, double takes, and anxiety in the extreme. And how visual it all is. All three of Hoffmann's letter writers (Nathanael, Klara, and Lothar), as well as the narrator, present scenarios that play explicitly to the eye, that emphasize looking and seeing. Visual images stay with us long after the niceties of plot have faded: the view, through a crack in the door, of the Sandman 'illuminated by the bright glow of the lamps', the image of Olympia's stiff-backed beauty through the telescope, the representation of

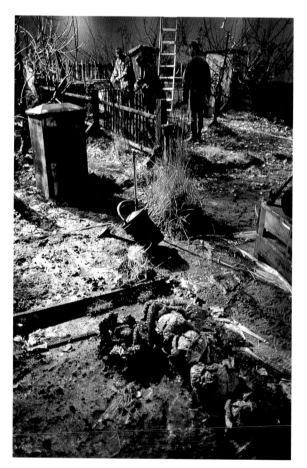

Klara as a painting or piece of architecture. To a remarkable extent, life happens through the eyes in *Der Sandmann* – as well it might in a text that has at its heart the tale of a man who, by throwing sand in their faces, causes children's eyes to pop from their heads.

What better subject for film – which after all can capture, in a way that painting can't, repetitions over time, and, in a way that literature can only suggest, visual images – than a story like *Der Sandmann*. It is one of those pieces of literature that seem already cinematic, and Stan Douglas' film of the same title appears to know just how and why that is so and to recognize that the uncanniness that so interested Freud can be powerfully produced with a

left, **Der Sandmann**
1995
Production still

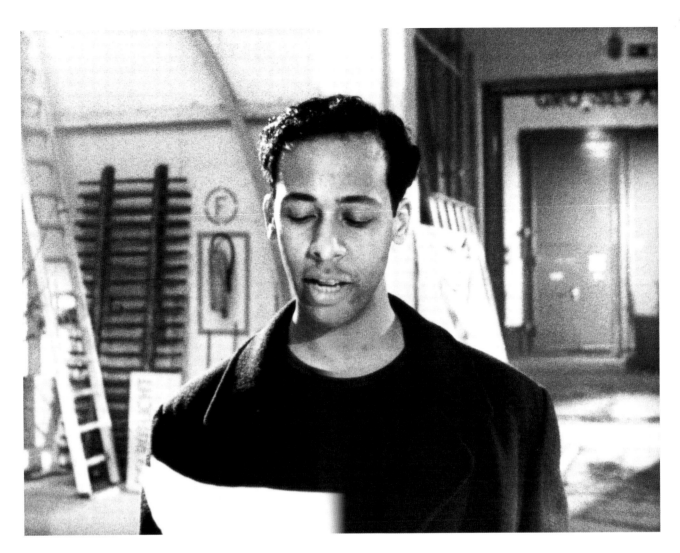

Der Sandmann
1995
16 mm film loop installation
9 mins., 50 secs. each rotation,
black and white, sound
Film still

moving picture camera.

The film as seen consists of two 360-degree rotations in a continuous pan, the second a visual and verbal repetition of the first. Both rotations move from a zero point in the interior of a garden shed (tools, ladders, equipment), out onto a garden (cabbages, tyre tracks in the mud, the detritus of gardening, a man much like the Sandman puttering in the distance), and back into the interior, in which we now clearly see film equipment as well, to the zero point. The screen is at all times split down the middle (on which more later). Each rotation features a voiceover or voice-off of three characters, whom we understand to be a reconceived Nathanael, Lothar, and Klara reading updated epitomes of the three letters of Hoffmann's story. We see the Nathanael character reading as the camera passes across him; the other two remain unseen, existing only as voices. After a brief pause at the zero point, the spoken text too begins again.

In fact, there are two gardens, an old one and a new one, and they occupy different sides of the split screen in such a way that, as Douglas himself writes, 'as the camera passes

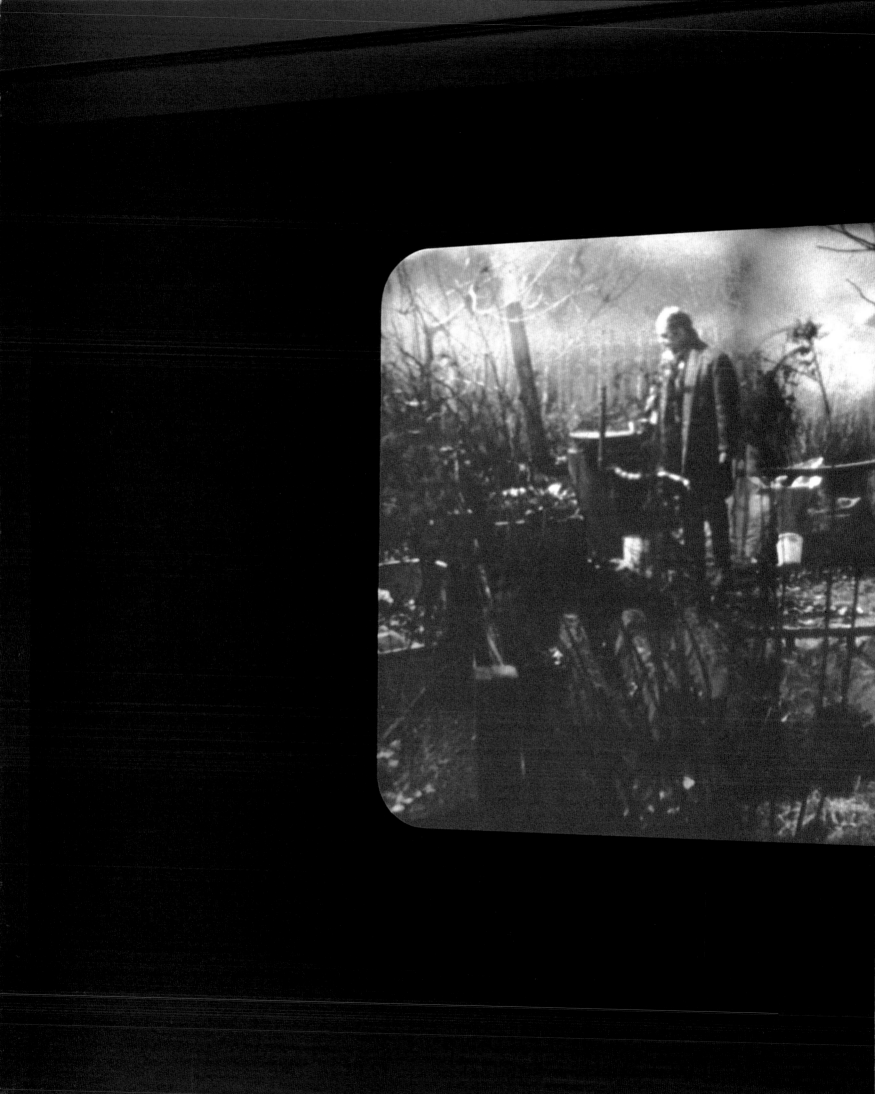

Der Sandmann
1995
16 mm film installation
9 mins., 50 secs. each rotation,
black and white, sound
Installation, Musée d'Art
Contemporain de Montréal, 1996
Collection, Solomon R.
Guggenheim Museum, New York

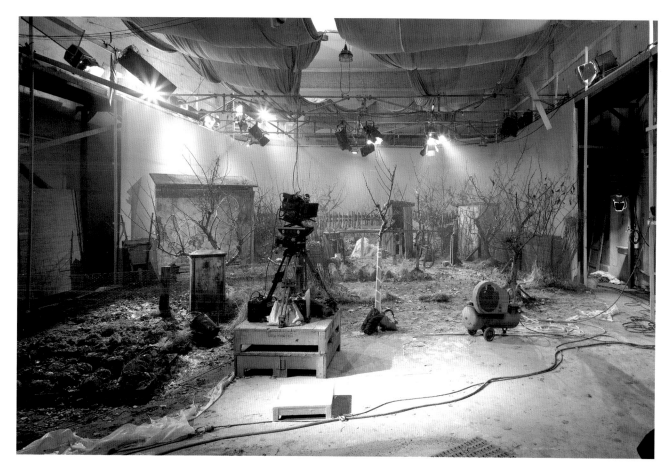

Der Sandmann
1994/97
left, 1970s set
opposite, contemporary set,
DOKFILM Studios, Potsdam,
Babelsberg, Germany, 1994

the set, the old garden is wiped away by the new one and later, the new is wiped away by the old; without resolution, endlessly.'[1] But there is only one verbal text, twice repeated. Gardens may replace one another, but the site, the earth on which we live, remains the same, and so do the fears and fantasies that structure our psychic lives. They repeat themselves in every generation, and perhaps (to judge from the non-European appearance of the man who plays Nathanael) across cultures as well.

It is not, of course, the actual repetitions and circlings-back of Hoffmann's plot that Douglas' film stages visually. It is the idea of repeating and circling back, rendered in specifically cinematic terms. The moment the second rotation begins, the whole film changes for us. It is no longer a question of what the universe we've been watching really is, but whether we can recognize the objects and remember the order the second time around (what comes next? was it like this last time? why is the synchronization of Nathanael's lips reversed?) and how those objects will 'mean' differently in the repetition. The process is made all the more urgent by the inexorability of the pan. We know too, as soon as the second rotation begins, that this is indeed a structure that could go on 'without resolution, endlessly', and we wait, as we approach the zero point, to see whether the film will go for a

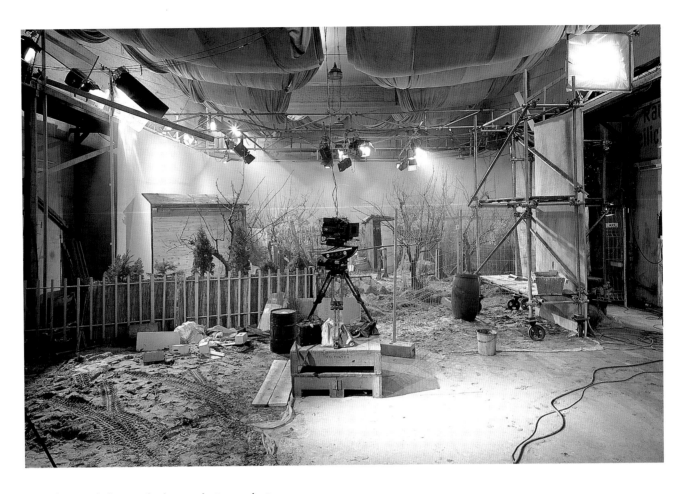

third. But it's made its point, and stops.

There is indeed something uncanny about the repetition and the sense of the unfamiliar-familiar it brings up. But the real anxiety arises in the coupling of that repetition with the vertical seam. At first glance, the images that pass before our eyes in the camera's steady rightward pan seem ordinary enough: shed walls, scaffolding, equipment, discarded objects. The first sign that things are not what they seem is a distortion in the image, the kind of barely discernible north-south ripple that makes us want to reach for the tracking dial – even though we are in an installation – until we realize that it belongs there, and that it marks a kind of split down the middle. We may or may not understand how that image was formed.[2] What is clear is that once we see the vertical seam, it's hard to see anything else. From that moment on, the objects of the visual field exist for us in relation to that seam – moving, as they pass from right to left in the slow pan, either toward or away from that divide. The question is why the seam is there, what it does. One side seems a little brighter, the other a little dimmer, but is there more?

Then the reading aloud begins, and then there appears in the frame the reader, Nathanael, himself. But his lips don't match the words. The synchronization is off: ahead?

Der Sandmann
1995
Film stills

behind? a different text? As the figure of the reader moves toward the seam we sense that we'll soon know the answer, and indeed we do. The word-sounds fall into sync with the speaking lips as the latter glide across the seam, and we understand then that the earlier lip movements were ahead of the sound, and that the left side of the frame is, for the time being, the synchronized present, while the right is the visual future.

No simple line, that seam. It marks a time fissure, running vertically through the frame. The gap is at first no more than a second in duration, but the fact that it's there at all opens the possibility that it could be wider – as it soon will be. The moment we understand the seam to have a temporal dimension, it becomes almost malign – a killer seam. Soon the objects that pass across the screen fall into it, disappearing for a moment before they re-emerge, as though they are devoured and then disgorged. And it gets more extreme as the pan moves us out into the garden phase and the divergence becomes an obviously spatial one as well. The greater the divergence, the harder we work to hold the halves in some kind of relationship. We breathe a sigh of relief when we arrive back at the zero point and the two sides fall into sync, much the way that we relaxed when the seam brought Nathanael's voice and lips into sync. With the second rotation, we begin again, and this time our efforts are literally redoubled, as we compare not only the halves of the present screen, but the patterns now with the patterns last time around.

Film theory has for decades been preoccupied with the gaps and fissures in time and space that inhere in cinema and with the spectator's relation to them. The cut that takes us from a man waking in his bedroom to the same man on the morning subway, the series of cuts that facilitate the alternation of shots between two people's faces in conversation, and so on, are deep and wide, and although our narrative and cinematic conditioning and our

deep desire for visual coherence and plenitude may allow us to 'overlook' them, we must feel them at some level. At some level, that is, we know that the people and places imaged are out of reach (perhaps even dead and gone), that time and space have been mangled, and that the whole matter before us is a manipulative concoction. But classical Hollywood cinema is literally defined by its devotion to hiding those absences as completely as possible, and delivering the fantasy as fully as it can be delivered.

Der Sandmann's seam brings the wound to the surface. If it is not the wound of classical cinema, it *is* a wound – one that never lets us forget that this is a film, that someone made it, and that it can not only be tinkered with but sliced right down the middle. Actually, the film does let us forget, for a second or two around the zero point, when the two halves match up in space and apparently time. This is the only moment in *Der Sandmann* in which we can relax and feel ourselves to be, well, at the movies. But the minute the seam appears, the fiction of plenitude and coherence falls apart. To the extent that our viewing 'work' becomes an anxious effort to put things together again, or to figure out the trick, we are struggling to create the suture we want and need and that classical cinema is designed to provide.

Freud's uncanny arises not from the mysteriously-driven repetitions themselves, but from the repression of archaic fears and desires that those repetitions stage – manifested in Hoffmann's *Der Sandmann* by, among other things, the fear of the loss, through violence, of one's eyes. Stan Douglas' *Der Sandmann* exactly captures that knot of thoughts. By putting the filmic 'cut' front and centre, the film makes us look at the kinds of losses that inhere in cinema despite its formal denials. It also, in the most literal and material way, messes with our own eyes. That seam, moving as it does across all of the structural repetitions, both the big one of the second rotation and all the small ones of the scenes and objects in between, produces the uncanny of Hoffmann and Freud as powerfully as it has been produced, and in ways that are specifically and exclusively cinematic.

1 Stan Douglas, in *Stan Douglas*, Museum Haus Lange, Museum Haus Esters, Krefeld/Oktagon Verlag, Cologne, 1997, p. 22

2 Ibid, p. 22. 'The Schrebergarten sets were shot on 16 mm film with a motion-control system that allowed the camera to make one continuous 360-degree pan of the old garden and a second pan of the contemporary site that, in terms of camera angle and motion, are identical to one another as they reveal details of the gardens and Nathanael surrounded by old-fashioned film equipment while he delivers his monologue. For exhibition, the two takes have been spliced together and duplicated so they may be presented from a pair of projectors focused on the same screen. They are out of phase with each other by one complete rotation of the studio, and only one half is that of a temporal wipe. Left and right halves meet at the centre of the screen in a vertical seam that pans with little effect over Nathanael and the studio; however, as the camera passes the set, the old garden is wiped away by the new one and, later, the new is wiped away by the old; without resolution, endlessly.'

Contents

Interview Diana Thater in conversation with Stan Douglas, page 6. Survey Scott Watson

Against the Habitual, page 30. Focus Carol J. Clover Her Sacrilized, page 66. Artist's

Choice **Gilles Deleuze** Humour, Irony and the Law, 1967, **page 80.** Artist's Writings

Stan Douglas Television Spots, 1987-88, page 88. Operative Perfektie her, 1988, page 92. Monodramas, 1991, page 100. Mise en

Champs, 1992, page 110. Pursuit, Fear, Catastrophe: Ruskin, BC, 1993, page 112. In conversation with Lynne Cooke, 1994, page 116.

Evening, 1994, page 122. Der Sandmann, 1995, page 123. Ein Stadt, zwei Städte 1996, page 128. Nu·tka·, 1996, page 132.

Project for the RADS, Seattle, 1996, page 160. Chronology page 144 & Bibliography

Illustrations, page 159.

The classical conception of the law found its perfect expression in Plato and in that form gained universal acceptance throughout the Christian world. According to this conception, the law may be viewed either in the light of its underlying principles or in the light of its consequences. From the first point of view, the law itself is not a primary but only a secondary or delegated power dependent on a supreme principle which is the Good. If men knew what the Good was, or knew how to conform to it, they would not need laws: the law is only a representative of the Good in a world that the Good has more or less forsaken. Hence, from the point of view of its consequences, obedience to the law is 'best', the best being in the image of the Good. The righteous man obeys the laws of the country of his birth or residence, and in so doing acts for the best, even though he retains his freedom of thought, freedom to think of the Good and for the sake of the Good.

This conception, which is seemingly so conventional, nevertheless conceals elements of irony and humour which made political philosophy possible, for it allows the free play of thought at the upper and lower limits of the scale of the law. The death of Socrates is an exemplary illustration of this: the laws place their fate in the hands of the condemned man, and ask that he should sanction their authority by submitting to them as a rational man. There is indeed a great deal of irony in the operation that seeks to trace the laws back to an absolute Good as the necessary principle of their foundation. Equally, there is considerable humour in the attempt to reduce the laws to a relative Best in order to persuade us that we should obey them. Thus it appears that the notion of law is not self-sufficient unless backed by force; ideally it needs to rest on a higher principle as well as on a consideration of its remote consequences. This may be why, according to the mysterious text in the *Phaedo*, the disciples present at the death of Socrates could not help laughing. Irony and humour are the essential forms through which we apprehend the law. It is in this essential relation to the law that they acquire their function and their significance. Irony is the process of thought whereby the law is made to depend on an infinitely superior Good, just as humour is the attempt to sanction the law by recourse to an infinitely more righteous Best.

The final overthrow of the classical conception of the law was certainly not the result of the discovery of the relativity and variability of laws, since these were fully recognized and understood in this conception and were indeed an integral part of it. The true cause must be sought elsewhere. In the *Critique of Practical Reason* Kant gave a rigorous formulation of a radically new conception, in which the law is no longer regarded as dependent on the Good, but on the contrary, the Good itself is made to depend on the law. This means that the law no longer has its foundation in some higher principle from which it would derive its authority, but that it is self-grounded and valid solely by virtue of its own form. For the first time we can now speak of THE LAW, regarded as an absolute, without further specification or reference to an object. Whereas the classical conception only dealt with *the laws* according to the various spheres of the Good or the various circumstances attending the Best, Kant can speak of the moral law, and of its application to what otherwise remains totally undetermined. The moral law is the representation of a pure form and is independent of content or object, spheres of activity or circumstances. The moral law is THE LAW, the form of the law, and as such it cannot be grounded in a higher principle. In this sense Kant is one of the first to break away from the classical conception of the law and to give us a truly modern conception. The Copernican revolution in Kant's *Critique of Pure Reason* consisted in viewing the objects of knowledge as revolving around the subject; but the *Critique of Practical Reason*, where the Good is conceived as revolving around the Law, is perhaps even more revolutionary. It probably reflected major changes in the world. It may have been the expression of the ultimate consequences of a return beyond Christianity to Judaic thought, or it may even have foreshadowed a return to the pre-Socratic (Oedipal) conception of the law, beyond to the world of Plato. However that may be, Kant, by establishing that THE LAW is an ultimate ground or principle, added an essential dimension to modern thought: the object of the law is by definition unknowable and elusive.[1]

But there is yet a further dimension. We are not concerned here with the architectonics of Kant's system (and the manner in which he salvages the Good in the system), but with a second discovery which is correlated with and complementary to the first. The law can no longer be grounded on the superior

From **Pursuit, Fear, Catastrophe: Ruskin, BC**
1993
16 mm film loop installation with Yamaha Disklavier
14 mins., 50 secs. each rotation, black and white, sound
Dimensions variable

Black and white polaroid photographs
10 × 7.5 cm or 7.5 × 10 cm each
Lighting test stills

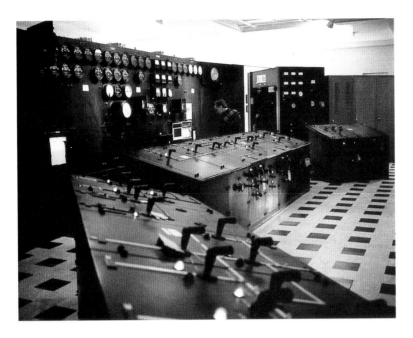

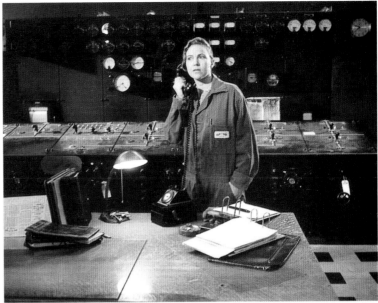

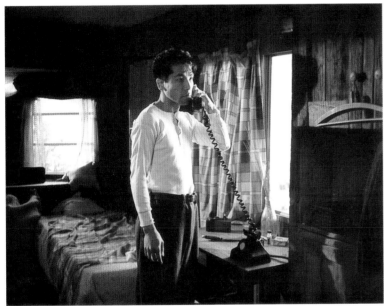

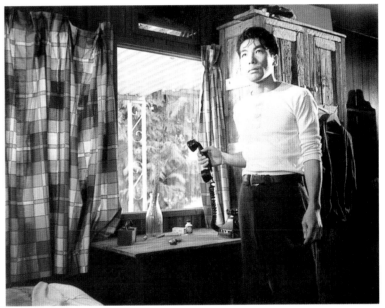

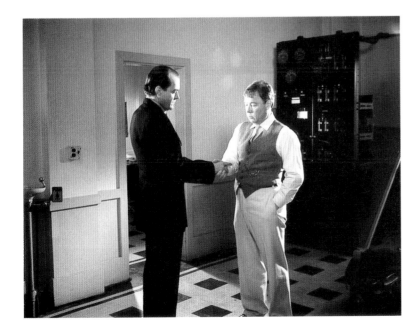

principle of the Good, but neither can it be sanctioned any more by recourse to the idea of the Best as representing the good will of the righteous. Clearly THE LAW, as defined by its pure form, without substance or object or any determination whatsoever, is such that no one knows nor can know what it is. It operates without making itself known. It defines a realm of transgression where one is already guilty, and where one oversteps the bounds without knowing what they are, as in the case of Oedipus. Even guilt and punishment do not tell us what the law is, but leave it in a state of indeterminacy equalled only by the extreme specificity of the punishment. This is the world described by Kafka. The point is not to compare Kant and Kafka, but to delineate two dimensions of the modern conception of the law.

If the law is no longer based on the Good as a pre-existing, higher principle, and it is valid by virtue of its form alone, the content remaining entirely undetermined, it becomes impossible to say that the righteous man obeys the law for the sake of the Best. In other words, the man who obeys the law does not thereby become righteous or feel righteous; on the contrary, he feels guilty and is guilty in advance, and the more strict his obedience, the greater his guilt. This is the process by which the law manifests itself in its absolute purity, and proves us guilty. The two fundamental propositions of the classical conception are overthrown together: the law as grounded in the further principle of the Good; the law as sanctioned by righteousness. Freud was the first to recognize the extraordinary paradox of the conscience. It is far from the case that obedience to the law secures a feeling of righteousness, 'for the more virtuous a man is, the more severe and distrustful' is the behaviour of his conscience toward him; Freud goes on to remark on 'the extraordinary severity of conscience in the best and most tractable people'.

Freud resolved the paradox by showing that the renunciation of instinctual gratification is not the product of conscience, but on the contrary that conscience itself is born of such renunciation. Hence it follows that the strength and severity of conscience increases in direct proportion to the strength and severity of the renunciation. Conscience is heir to the repressed instinctual drives. 'The effect of instinctual renunciation on the conscience then is that every piece of aggression whose satisfaction the subject gives up is taken over by the superego and increases the latter's aggressiveness (against the ego).' We are now in a position to unravel the second paradox concerning the fundamentally undetermined character of the law. In Lacan's words, the law is the same as repressed desire. The law cannot specify its object without self-contradiction, nor can it define itself with reference to a content without removing the repression on which it rests. The object of the law and the object of desire are one and the same, and remain equally concealed. When Freud shows that the essential nature of the object relates to the mother while that of desire and the law relates to the father, he does not thereby try to restore a determinate content to the law; he does indeed almost the opposite, he shows how the law, by virtue of its Oedipal origins, must of necessity conceal its content in order to operate as a pure form which is the result of a renunciation both of the object (the mother) and of the subject (the father).

The classical irony and humour of Plato that had for so long dominated all thinking on the subject of the law are thus turned upside down. The upper and lower limits of the law, that is to say the superior principle of the Good and the sanction of the righteous in the light of the Best are reduced to nothingness. All that remains is the indeterminate character of the law on the one hand and the specificity of the punishment on the other. Irony and humour immediately take on a different, modern aspect. They still represent a way of conceiving the law, but the law is now seen in terms of the indeterminacy of its content and of the guilt of the person who submits to it. Kafka gives to humour and irony their full modern significance in agreement with the transformed character of the law. Max Brod recalls that when Kafka gave a reading of *The Trial*, everyone present, including Kafka himself, was overcome by laughter – as mysterious a phenomenon as the laughter that greeted the death of Socrates. A spurious sense of tragedy dulls our intelligence; how many authors are distorted by placing a childishly tragic construction on what is more often the expression of an aggressively comic force! The comic is the only possible mode of conceiving the law, in a peculiar combination of irony and humour.

From **Pursuit, Fear, Catastrophe: Ruskin, BC**
1993
16 mm film loop installation with Yamaha Disklavier
14 mins., 50 secs. each rotation, black and white, sound
Dimensions variable

Black and white polaroid photograph
10 × 7.5 cm
Lighting test still

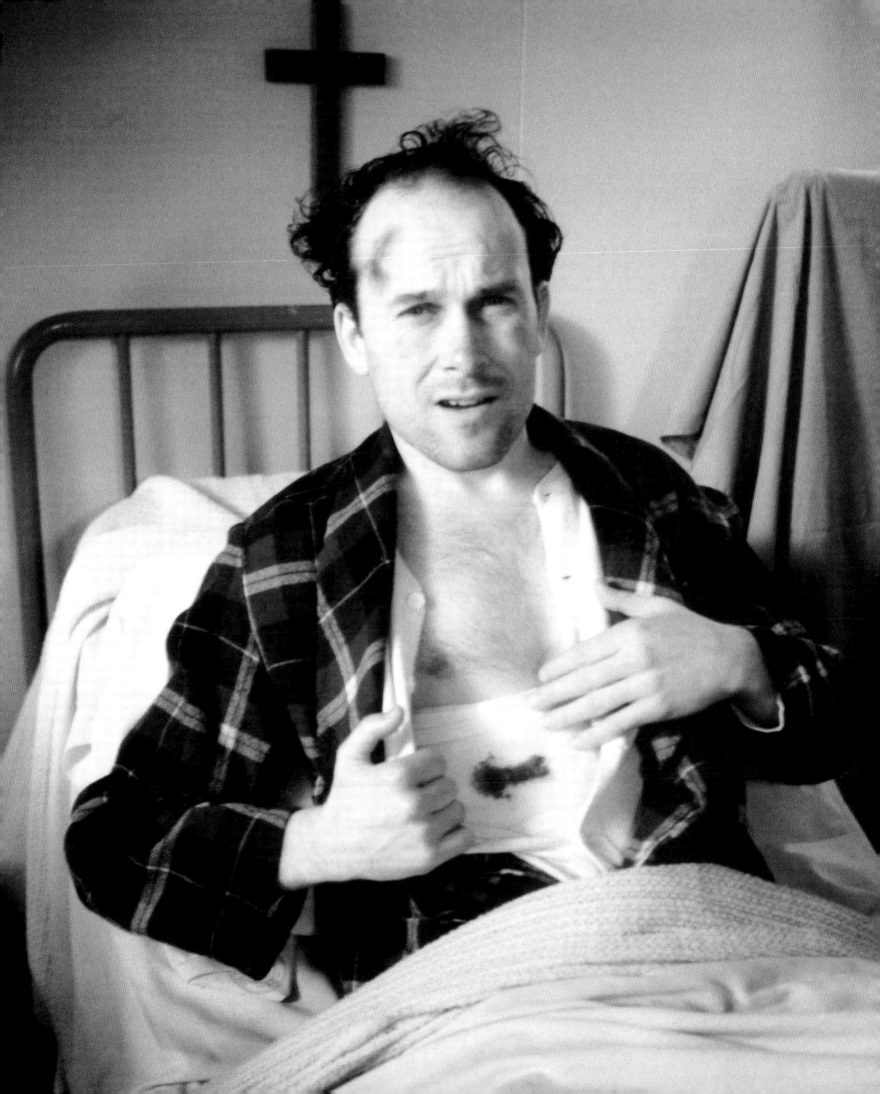

In modern thought irony and humour take on a new form: they are now directed at a subversion of the law. This leads us back to Sade and Masoch, who represent the two main attempts at subversion, at turning the law upside down. Irony is still in the process or movement which bypasses the law as a merely secondary power and aims at transcending it toward a higher principle. But what if the higher principle no longer exists, and if the Good can no longer provide a basis for the law or a justification of its power? Sade's answer is that in all its forms – natural, moral and political – the law represents the rule of secondary nature which is always geared to the demands of conservation; it is a usurpation of true sovereignty. It is irrelevant whether we see the law as the expression of the rule of the strongest or as the product of the self-protective union of the weak. Masters and slaves, the strong and the weak, all are creatures of secondary nature; the union of the weak merely favours the emergence of the tyrant; his existence depends on

it. In every case the law is a mystification; it is not a delegated but a usurped power that depends on the infamous complicity of slaves and masters. It is significant that Sade attacks the regime of laws as being the regime of the tyrannized and of the tyrants. Only the law can tyrannize: 'I have infinitely less reason to fear my neighbour's passions than the law's injustice, for my neighbour's passions are contained by mine, whereas nothing stops or contains the injustices of the law.' Tyrants are created by the law alone: they flourish by virtue of the law. As Chigi says in *Juliette*, 'Tyrants are never born in anarchy, they only flourish in the shadow of the laws and draw their authority from them.' Sade's hatred of tyranny, his demonstration that the law enables the tyrant to exist, form the essence of his thinking. The tyrant speaks the language of the law, and acknowledges no other, for he lives 'in the shadow of the laws'. The heroes of Sade are inspired with an extraordinary passion against tyranny; they speak as no tyrant ever spoke or could ever speak; theirs is the counter-language of tyranny.

We now note a new attempt to transcend the law, this time no longer in the direction of the Good as superior principle and ground of the law, but in the direction of its opposite, the Idea of Evil, the supreme principle of wickedness, which subverts the law and turns Platonism upside down. Here, the transcendence of the law implies the discovery of a primary nature which is in every way opposed to the demands and the rule of secondary nature. It follows that the idea of absolute evil embodied in primary nature cannot be equated either with tyranny – for tyranny still presupposes laws – or with a combination of whims and arbitrariness; its higher, impersonal model is rather to be found in the anarchic institutions of perpetual motion and permanent revolution. Sade often stresses the fact that the law can only by transcended toward an institutional model of anarchy. The fact that anarchy can only exist in the interval between two regimes based on laws, abolishing the old to give birth to the new, does not prevent this divine interval, this vanishing instant, from testifying to its fundamental difference from all forms of the law. 'The reign of laws is pernicious; it is inferior to that of anarchy; the best proof of this is that all governments are forced to plunge into anarchy when they wish to remake their constitutions.' The law can only be transcended by virtue of a principle that subverts it and denies its power.

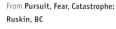

From **Pursuit, Fear, Catastrophe: Ruskin, BC**
1993
16 mm film loop installation
with Yamaha Disklavier
14 mins., 50 secs. each rotation,
black and white, sound
Dimensions variable

Black and white polaroid
photographs
10 × 7.5 cm or 7.5 × 10 cm each
Lighting test stills

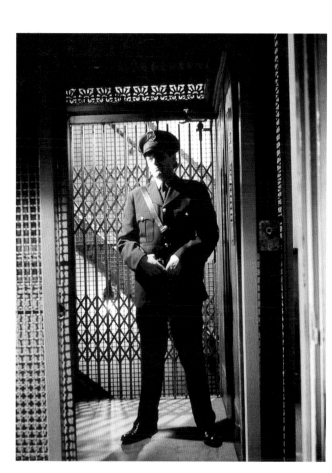

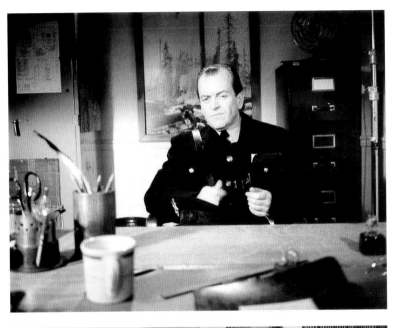

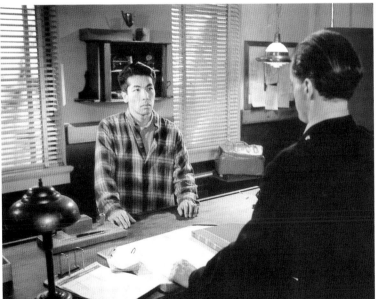

While the Sadian hero subverts the law, the masochist should not by contrast be regarded as gladly submitting to it. The element of contempt in the submission of the masochist has often been emphasized: his apparent obedience conceals a criticism and a provocation. He simply attacks the law on another flank. What we call humour – in contradistinction to the upward movement of irony toward a transcendent higher principle – is a downward movement from the law to its consequences. We all know ways of twisting the law by excess of zeal. By scrupulously applying the law we are able to demonstrate its absurdity and provoke the very disorder that it is intended to prevent or to conjure. By observing the very letter of the law, we refrain from questioning its ultimate or primary character; we then behave as if the supreme sovereignty of the law conferred upon it the enjoyment of all those pleasures that it denies us; hence, by the closest adherence to it, and by zealously embracing it, we may hope to partake of its pleasures. The law is no longer subverted by the upward movement of irony to a principle that overrides it, but by the downward movement of humour which seeks to reduce the law to its furthest consequences. A close examination of masochistic fantasies or rites reveals that while they bring into play the very strictest application of the law, the result in every case is the opposite of what might be expected (thus whipping, far from punishing or preventing an erection, provokes and ensures it). It is a demonstration of the law's absurdity. The masochist regards the law as a punitive process and therefore begins by having the punishment inflicted upon himself; once he has undergone the punishment, he feels that he is allowed or indeed commanded to experience the pleasure that the law was supposed to forbid. The essence of masochistic humour lies in this, that the very law which forbids the satisfaction of a desire under threat of subsequent punishment is converted into one which demands the punishment first and then orders that the satisfaction of the desire should necessarily follow upon the punishment. Once more, Theodor Reik gives an excellent analysis of this process: masochism is not pleasure in pain, nor even in punishment; at most, the masochist gets a preliminary pleasure from punishment or discomfort; his real pleasure is obtained subsequently, in that which is made possible by the punishment. The masochist must undergo punishment before experiencing pleasure. It would be a mistake to confuse this temporal

succession with logical causality: suffering is not the cause of pleasure itself but the necessary precondition for achieving it. 'The temporal reversal points at a reversal of the contents ... The previous "You must not do that" has been transmuted into "You have to do that!"... What else but a demonstration of absurdity is aimed at, when the punishment for forbidden pleasure brings about this very same pleasure?' The same process is reflected in the other features of masochism, such as disavowal, suspense and fantasy, which should be regarded as so many forms or aspects of humour. The masochist is insolent in his obsequiousness, rebellious in his submission; in short, he is a humourist, a logician of consequences, just as the ironic sadist is a logician of principles.

From the idea that the law should not be based on the principle of the Good but on its form alone, the sadist fashions a new method of ascending from the law to a superior principle; this principle, however, is the informal element of a primary nature which aims at the subversion of all laws. In the other modern discovery that the law increases the guilt of the person who submits to it, the masochist in his turn finds a new way of descending from the law to its consequences: he stands guilt on its head by making punishment into a condition that makes possible the forbidden pleasure. In so doing he overthrows the law as radically as the sadist, though in a different way. We have seen how these methods proceed, ideologically speaking. The Oedipal content, which always remains concealed, undergoes a dual transformation – as though the mother-father complementarity had been shattered twice and asymmetrically. In the case of sadism the father is placed above the laws; he becomes a higher principle with the mother as his essential victim. In the case of masochism the totality of the law is invested upon the mother, who expels the father from the symbolic realm.

Translated from French by Jean McNeil

From **Pursuit, Fear, Catastrophe: Ruskin, BC**
1993
16 mm film loop installation with Yamaha Disklavier
14 mins., 50 secs. each rotation, black and white, sound
Dimensions variable

Black and white polaroid photographs
10 × 7.5 cm or 7.5 × 10 cm each
Lighting test stills

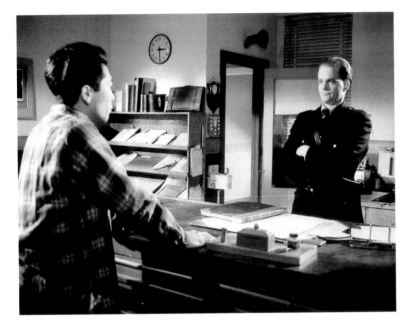

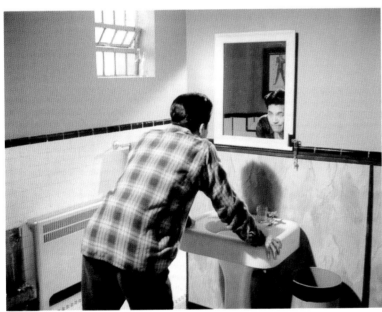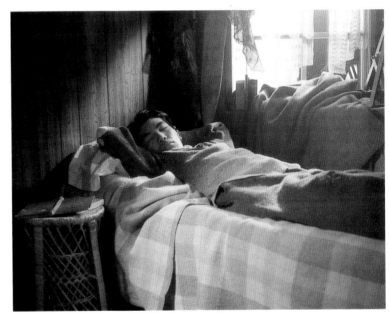

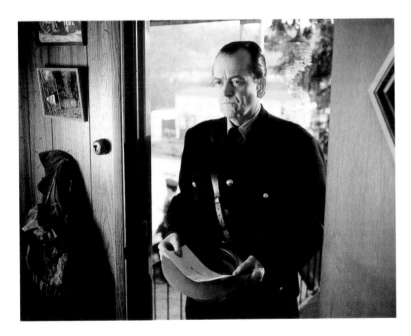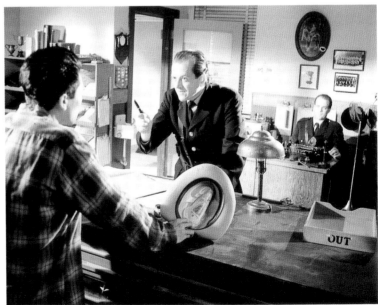

freeways, and delays of 10-minutes or more on the CTA caused by jamming doors. There was a record low of 10 degrees below zero in the city this morning -- and 15 below in the suburbs, with winds of up to 40 miles an hour. But there might be some relief tomorrow when temperatures might reach 20 degrees by the afternoon. But its not over: the mercury will likely dip below zero on the weekend as an Arctic front moves eastward.

[FILM: SUPER Kids in Snow]

Sports and some good news when we return . . .

Interview Diana Thater in conversation with Stan Douglas, page 6. Survey Scott Watson

Against the Habitual, page 30. Focus Carol J. Clover Der Sandmann, page 68. Artist's

Choice Gilles Deleuze Humour, Irony and the Law, 1967, page 80.

Artist's Writings

Stan Douglas Television Spots, 1987–88, **page 90**. Goodbye Pork-Pie Hat, 1988, **page 92**. Monodramas, 1991, **page 100**. Hors-

champs, 1992, **page 110**. Pursuit, Fear, Catastrophe: Ruskin, BC, 1993, **page 112**. In conversation with Lynne Cooke, 1993, **page 116**.

Evening, 1994, **page 122**. Der Sandmann, 1995, **page 124**. Der Sandmann, Script, 1995, **page 128**. Nu•tka•, 1996, **page 132**.

Project for the RIAGG, Zwolle, 1996, **page 140**.

Chronology page 144 & Bibliography, List &c.

Afterword, page 158.

From **Television Spots**
1988
Black and white photographs,
texts
18 × 23 cm each
From the series of 12 location
photographs and scenarios

SPECTATED MAN

A man displays himself from a street corner at a not-busy intersection. He fusses with the fading creases in his pants and the hem of his jacket: making sure that they are straight and maintaining a pose that will not interrupt their perfection. His eyes are partially cast down as they monitor the state of his attire, but on occasion they look up and around to 'confirm' that he is 'being watched.'

1. Iris out to a long shot of the man fidgeting. Crescendo of street sounds and shifting feet simultaneous with Iris.
2. After a pause, iris out to a close shot (head and shoulders) of the man as he looks about.
3. Iris in, back to the long shot.
4. Iris in to black and decrescendo of sound with iris.

SNEEZE

A woman walks alone in an underground parking lot, passing rows of vacant stalls. Suddenly she stops and sneezes. After this pause she resumes her stride and soon turns, following the path of an exit ramp which spirals downward. Apart from the sneeze, the only sound is that of footsteps in a cavernous space.

1. Iris open to a tracking shot of the woman walking. The camera follows her from behind, slightly to her right.
2. The woman pauses and the camera stops abruptly as she sneezes.
3. She turns her head, as if to better hear the echo she has caused, and then walks on.
4. Iris in to black as she approaches the exit ramp.

LIT LOT

In the close shot a pair of outdoor lighting fixtures fill the screen. The wide shot reveals an outdoor parking lot — an attendant's booth and the two lighting fixtures. A lone parking attendant sits in the booth reading a newspaper.

1. Iris out to the close shot. The lights are both on; electrical buzzing producing a chord is heard.
2. The left-hand light goes out with a crackle. Then the creaking sound of a cooling lamp housing accompanies the slow decay of red in the lamp's filament. There is now only one tone of buzzing.
3. Cut to the wide view of the parking lot: attendant with head down, reading.
4. A sudden flash from the darkened light.
5. That missing light fully on, issuing a crackle then a steady tone. One half-second later the attendant looks up — pauses — and returns to reading.
6. Iris in to black.

FUNNY BUS

A view from the back of a bus. The forward seats are occupied: two people on the right and one on the left. The laugh belongs to a middle-aged man and bears an aspect of drunken confidence.

1. Iris open to a close shot of the bus driver's interior rear-view mirror. A short burst of laughter. The driver's eyes look into the camera, then away — into the camera, then away.

2. Cut to the long shot. Appropriate engine and street sounds are audible.

3. After a long pause there is another burst of laughter. The passenger seated alone casts a timid glance toward the camera.

4. A shorter pause and then a muffled chortle. All three passengers look back simultaneously. Iris in to black.

ANSWERING MACHINE

A woman returns home to sound of her telephone ringing. She rushes to get through her two front doors, but once inside seems somewhat more relaxed. She sits down and listens to her caller.

1. Iris open to a medium shot as the woman arrives at the front door of her house. As she finds her keys, a telephone is heard to ring.

2. Cut to an interior view: another door, and beside it a window through which the woman is seen entering the first door. She unlocks and finally enters the second door.

3. The camera follows the woman as she walks into the room, puts down her bag, and sits down next to the still-ringing telephone. She lights a cigarette and waits.

4. Lights flash on the telephone's answering machine, which clicks then says, "For your convenience, our telephone is being answered automatically. Please leave the date and time of your call along with a brief message, and we'll get back to you as soon as possible." The woman inhales deeply on her cigarette. As she exhales, the caller is heard: "Ah . . . hello. Ah . . ." Iris in to black.

SLAP HAPPY

The camera follows from behind as three blue-suited men walk together in an orderly row. The pace of their feet is synchronized so that as the men on either end of the row raise their left feet, the man in the centre raises his right foot. After the slap, all left feet leave the ground simultaneously, as do all right feet in their turn. The soundtrack consists of the introductory bars of "Stand By Me" (Ben E. King version) played twice, with a three-beat gap in between.

1. Iris open with the camera moving and the three men walking. Occasional nods of consent and brief demonstrative gestures convey that they are talking. The first bars of "Stand By Me" are heard.

2. The man on the right turns and slaps the man beside him: whether this is an act of aggression or one of camaraderie is not clear. In either case, the man on the left doesn't seem to notice.

3. As the music begins again, the man who was struck pauses to compose himself, and is soon back in step with his companions.

4. Iris in to black with end of music.

Goodbye Pork-Pie Hat 1988

*'For why or? Why in another dark or in the same? And Whose voice is asking this? And
answers, His soever who devises it all. In the same dark as his creature or in another.
For company. Who asks in the end, Who asks? And in the end answers as above? And
adds long after to himself, Unless another still. Nowhere to be found. Nowhere to be
sought. The unthinkable last of all. Unnameable. Last person. I. Quick leave him.'*[1]
The work of Samuel Beckett has, for more than fifty years, set itself the task of re-
imagining a still 'unnameable last person I' by questioning all that would lend it value
as a coherent unity. Characters and voices in extreme situations of solitude seem to
await silence or death but in fact seldom come to rest and even more rarely stop
talking; persistent in their desire for something not yet said or not yet done.

Superficially, Beckett's work resembles that variety of Modernism, initiated by
Sade, which exacts from its culture extreme instances of rational form in order to
parody tacit contradictions. But unlike the Sadean libertine who in self-satisfied egoism
is content to catalogue the limits of his world, Beckett admits that the limits of his
culture are not the limits of possibility. An unfortunate consequence of the Sadean
method is that it is often only capable of replicating, in inverted form, the authority that
it had intended to criticize – maintaining as it does a theological notion of centre or
hierarchy which appropriates certainty for its blasphemy and authority for the
blasphemous subject. The difference in Beckett is that in place of this closed world
(which has been invented in order to be mastered) he imagines an uncertain one: the
residence of an even less certain subjectivity.

Given this, it seems amazing to me that anyone could be interested in 'what makes
Beckett one of the greatest dramatists, not only of our, but of any, century.'[2] Except
perhaps to ponder the meaning of this near-meaningless assertion – how its
ahistoricity, closure and affirmation of a masculine academic canon is opposed by the
practice of the person it wants to describe, an artist who, in place of mastery, has
chosen as his province 'impotence [and] ignorance.'[3] This opposition to the heroic
identities of the modernist tradition distinguishes what Beckett has actually produced
from the popular conception of his work. I am thinking of the 'absurd' one, the one that
can only remember the plays *Waiting for Godot* (1949) and *Endgame* (1956),[4] of which,
and in spite of its very particular syntax and intent, the quote below from Theodor
Adorno is typical:

*'For the norm of existential philosophy – people should be themselves because
they can no longer become anything else –* Endgame *posits the antithesis, that
precisely this self is not a self but rather the aping imitation of something non-existent.*

Hamm's mendacity exposes the lie concealed in saying 'I' and thereby exhibiting substantiality; whose opposite is the content disclosed by the 'I'. Immutability; the epitome of transience, is its ideology. What used to be the truth content of the subject – thinking – is still only preserved in its gestural shell. Both main figures act as if they were reflecting on something, but without thinking.'[5]

These comments are typical of Adorno himself and his conception of the condition of the human subject in post-war Europe: subjectivity is something that once had the *potential* to exist, for a certain class and gender in Beethoven's time, but which can only exist today in a grotesque or 'ossified' form. Varieties of totalitarianism and the machinations of what Adorno, with Max Horkheimer, called the 'culture industry' prevent the monad-like individual from recognizing this condition, exhibiting a 'humanity [that] has become an advertisement for inhumanity.'[6] This point of view finds an easy ally in *Endgame* but would, I think, find itself somewhat estranged from Beckett's subsequent plays. Both *Endgame* and *Godot* are relatively traditional plays in that they maintain the convenient separation of audience and action – taking place in a space 'spied on and relished by a hidden spectator, a theological space, that of moral failing.'[7] But after the late 1950s, Beckett's theatrical work moves closer to his prose by articulating the mendacity of 'they' as an equivalent to the 'lie concealed in saying "I"' – moving as it does from describing to *inhabiting* situations. In these theatrical settings both audience and author are asked to admit their complicity in the visibility of the spectacle, and distanced judgement or interpretative 'explanation' becomes an uneasy pretence.

While the 'last person' in the quote above from *Company* is no doubt a refusal of all but *first* persons, the phrase itself reminds me of intellectual attitudes adopted after the war by many of Beckett's contemporaries. In contrast to Beckett's persistently insufficient first persons, the philosophical existentialists and the critical theorists of the Frankfurt School often claimed for themselves a rhetorical self through which they could speak as the last instance of a subjectivity soon to be extinct. An *ideal* self. A victim of history who speaks with a tacit nostalgia for some presumed wholeness, describing, in minute detail, all that the historical moment refuses him – ignoring the way in which that history persists in himself, and ignoring as well all that has been left out of his dialectic. I don't want to argue that Beckett isn't ever prone to similar self-indulgences – only that, when most successful, he is able to recognize and write against this pathetic heroism. Often he will replicate the contrivances that produce the effect of subjective autonomy or authority and then take them to extremes in order to make

Samuel Beckett, Alan Schnieder
Film
1965
With Buster Keaton as O
25 mins., black and white
Production stills

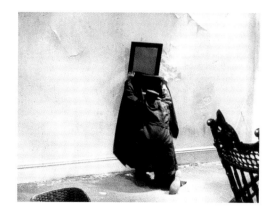 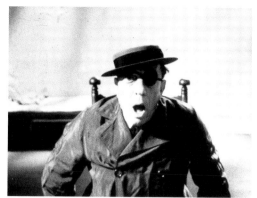

their contents apparent, or, rather, to indicate what they necessarily absent.

Since the early 1960s, Samuel Beckett has written or specifically adapted eight works for film and television. The first, a theatrical film simply titled *Film* (1963), was not only the first cinematographic project of its author but also that of its director, Alan Schnieder. As one might expect, the pair encountered a number of technical problems with their first venture into a new medium – including less than plausible continuity and a persistent strobing effect that made a great deal of footage unusable, and, because of a tight budget, caused an entire introductory sequence to be omitted from the finished work. Circumstance did, however, play against their intentions in at least one beneficial way. Because of delays in the shooting schedule, Jack MacGowran, a favourite actor of Beckett's and the one originally slated to play O (or Object, the visible protagonist), became unavailable at the last minute and Beckett suggested that the role be offered to Buster Keaton. In spite of certain reservations – 'the script was not only unclear, he admitted, it wasn't funny' – Keaton accepted the part and radically altered the character of *Film*. The piece would have worked without him, but Keaton's iconic presence amplifies the questioning of filmic perception already built into its structure.

In the script, *Film* takes as its motto Bishop Berkeley's famous dictum, *esse est percipi* – to be is to be perceived – one which could perhaps be the motto of all cinema, but is here put to peculiarly Beckettian uses:

'Esse est percipi. *All extraneous perception suppressed, animal, human, divine, self-perception remains in being. Search of non-being in flight from extraneous perception breaking down in inescapability of self-perception. No truth value attaches to above, regarded as of merely structural and dramatic convenience.*'[9]

Berkeley, on the other hand, had made a metaphysical pronouncement. He proposed that the phenomenal presence of all people, animals, and things was predicated on their mutual perceptions, and that (in order to avoid an infinite regress into an unstable universe) God was the ultimate perceiver whose omniscience permits the existence of the world, available and unavailable to mortal perception. Using the jargon of his generation, Beckett refers to a 'search of non-being' which, in *Film*, will become a 'dramatic convenience' that can play out the relation of the subject to representation – as the work exchanges Berkeley's *deus ex machina* for a more contemporary one, that is, a mechanical apparatus for divine grace.

Shortly after the film opens we catch sight of O, who instantly hurries away: trundling down avenues and alleys, across various kinds of debris in a dark overcoat and the flattened pork-pie hat that immediately identifies him as Buster Keaton. The

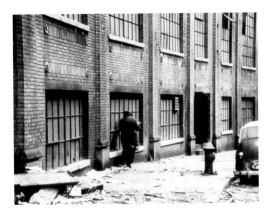
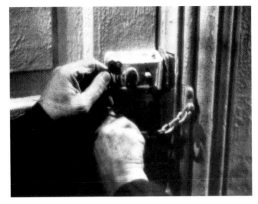

camera, named E (Eye) by the script, pursues from behind, 'at an angle not exceeding 45 degrees', the vector of O's movement or gaze (which is illustrated by hazy point-of-view shots). On a few occasions E does attempt to exceed this limit but O, by covering his face with his hands or by cowering against an available wall, is able to force E back to the 'angle of immunity'. This positioning is not, by the way, Beckett's invention. For years it has been a convention of narrative cinema used to identify the gaze of the camera with that of a fictional character – commonly taking the form of unobstructed point-of-view shots (such as O's) or those (such as E's) in which a portion of an actor's body (the back of a head, for example) is visible. But point-of-view shots cannot alone offer a credible sense of subjective vision, because 'every field traced by the camera and all the objects revealed through depth of field – even in a static shot – is echoed by another field, the fourth side, and an absence emanating from it.'[10] Typically, this absence is filled or 'sutured' when the 'absent one' of the absent field is fictionalized as *some one* – when we finally 'see', via a cut to a reverse-angle shot, the character who was previously 'seeing'. In the early portions of *Film*, however, we are not provided with a complete answer to the question, 'Who is seeing?' Curiosity with regard to the possession of O's point of view is partially relieved by E's point of view, but who is E? And why do all those who meet his gaze crumble to the ground in an 'agony of perceivedness'?

Finally, and with great relief, O makes it to his room, and soon begins to rid the area of all 'extraneous perception'. He intends to sit and examine the contents of his briefcase but is disturbed by the 'looks' of his various pets and companions: dog, cat, parrot, goldfish, and a print of 'God the Father'. Via a comic pantomime, each is in its turn set out of view and O, confident that he is alone, though still somewhat disturbed by the 'eyes' of his chair and file folder, sits and examines a collection of photographs (himself at various points in his life). He rids himself of these too, tearing them into pieces, and then slowly rocks himself to sleep. We don't see much of Keaton in Beckett's *Film* – just a terrified back and the famous flattened hat – only the final moments reveal his face, as E transgresses the 45 degrees and we are allowed the inevitable reverse angles. Sensing E's gaze O suddenly wakes and, in the concluding montage, E (Keaton) and O (Keaton) respond to their mutual perceptions: Eye dominant and his Object abject.

Film is a silent film. It announces itself as such when, in the sole aural event, a pedestrian reminds her friend to 'Sssh!' and, like the work itself, remains wilfully soundless. And as a *self-consciously* silent movie it couldn't hope for a better Object

than Buster Keaton. Keaton began his film career in the silent era, a period when the form of a commercial movie was less strictly defined than it is today. His early shorts were, for example, less interesting for the stories they told than for what they documented: Keaton's body, his acrobatic feats, incredible endurance of physical punishment, and exquisite talent for destroying things. The space of these films was little more complicated than that of a still photograph. Their editing was rudimentary, and the generally static camera was only capable of a deadpan stare at a staged event. Their focus was often an object (like a house or a boat) rather than a narrative – this, combined with a star whose typical character earned him the name 'Stone Face', meant that they would offer slight psychological identification. In contrast to the Hollywood film genres that would follow, these silent *pictures* left one with the sense of an 'outside', something unacknowledged, in excess of what the medium could represent – in excess of what the medium could, itself, perform.

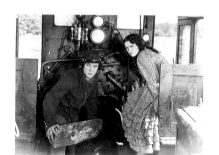

The advent of the sound film is exactly contemporary with the rise of the studio system and its formalization of how a new cinematic space would be constructed: with sound to specify an actor's persona, and that maximum angle of 45 degrees to spatially position the absent one. These innovations made it possible for a film to yield a greater impression of subjective experience, but at the same time integrated acting into the technical apparatus of film-making. A new type of actor was required. One who could, in body and voice, be fragmented (close-ups, dubbing, et cetera) and then reassembled – as if for the first time – in an editing room. Buster Keaton was, however, an old type of actor. His performance style was obstinately iconic and entirely indifferent to film-made psychology – making him useless as either star or stock character. That Keaton would (or could) not be complicit in his own instrumentalization meant that later in the sound period there would only be room for him on the margins of a film's narrative. He would be permitted only brief cameo appearances (*Limelight*, *Sunset Boulevard*, et cetera), more often than not in the tautological role of an old actor. *Film* provided Buster Keaton with his last substantial film performance in which, as Object, he attempts to deny the existence of that 'not exceeding 45 degrees'[11] and its progeny the reverse angle, the gesture which, in a way, ruined his career.

Beckett's first television play, *Eh Joe* (1965), appears, at first, to be an appendix to *Film*. It begins with an opening mime in which Joe, like O, conscientiously searches his apartment to make sure that he is alone. The cinematographic absent one has again been critically fictionalized, only in the present case as the voice of an absent woman. Joe endures the self-inflicted torture of an interior monologue out of control. He had

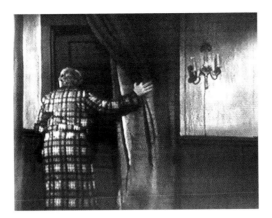

Alan Schnieder
Eh Joe
(Samuel Beckett, 1965)
1966
Black and white, film for
television broadcast
WNDT Production, Newark, New
Jersey
Production stills

Buster Keaton
The General
1926
0 mins., black and white, silent
Film still

perhaps invented it to provide himself with a sensation of power but this 'whisper in the head', the voice of an ex-lover reminding him of his history, tells him things that he does not want to hear. A phantasmic voice from the past is nothing new to Joe, he has heard others – those of his mother and father, for example – summoned to speak so that he could be rid of their memory by 'throttling' them into silence with his 'mental thuggee'.[12]

Joe's desire to evade (or obliterate) any subjectivity other than his own is illustrated by the opening mime in which he confirms his solitude by looking out of his window, his door, and even into his cupboard and under his bed. Surveillance complete, he sits down on the bed, and the camera that had been at a remove, moves in to a medium shot as the voice begins, sarcastically, 'Thought of everything?… Forgotten nothing? … You're all right now, … No one can see you now … No one can get at you now … Why don't you put out that light? … There might be a louse watching you … '[13] and then proceeds carefully to assail her auditor. On nine occasions she pauses and Joe relaxes somewhat (as if she has finally left for the day). During these intervals the camera moves slightly closer toward its object, stopping as the voice resumes. The procession of close-ups eventually leads to an *extreme* close shot of Joe's anxious face, the image that will accompany the concluding story: that of another lover, one who, unlike the speaker, failed to 'find a better' and because of Joe committed suicide.

The sequence of ever-tightening close shots – as an extreme evocation of the absent one – has the odd effect of oscillating between identification and estrangement. It is as much an analogue of Joe's psychic state as it is an index of the presence of the other – catalyzing the words heard in such a way that they are as much outside as they are inside Joe's head. Here Beckett theatricalizes the precariousness of what Nietzsche referred to as the 'grammatical custom'[14] of the coherence of a thinking subject: how much is the voice Joe's possession when she can apparently make her presence felt without his agency, and how can she be the voice of the woman she claims to be when she exhibits an intimate knowledge of a suicide that could only belong to the suicide victim herself? A psychological commonplace would have it that all this is merely an aspect of Joe's paranoid delusion; but the formal structure of the teleplay resists this reading, as it sustains its chosen cinematic conventions to the point where their typical identifications become uncertain.

Imagining for a moment that Joe is indeed the protagonist of *Eh Joe*, one witnesses the sovereignty of a primarily mental life invaded by something from without – something not anticipated by a desired autonomy. Conceived this way, the work

parodies a peculiarly masculine sensation of unity that requires a fetish object – in this case a woman's voice – that is 'capable of standing in for all those losses suffered by the male subject'.[15] Joe's objects are resurrected and then gradually murdered, silenced, along with the memory of anything that might have questioned his discrete self-identity. And, rid of his past, he is free to endure an impoverished and contentless present.

The male melancholy that I described in my opening paragraphs in a similar (and more common) way fetishizes its past, though, as a means to *self-aggrandizement* – of the melancholic as an authority, as the one who 'still remembers'. But it does so with a degree of amnesia that makes abundantly clear exactly what has been absented from its history – given that the heroic (if melancholic) identity is always gendered male, classed bourgeois, and of European descent. The suspicion with which Beckett regards closures such as this modernist nostalgia provides a content of an 'obligation to express' that paradoxically coincides with having 'nothing to express, nothing with which to express, nothing from which to express, no power to express', and 'no desire to express'.[16] His work hovers, as Julia Kristeva has said, 'on the brink of toppling over toward something else, which, nonetheless, remains impossible in Beckett'.[17] But in persistent distrust of discrete self-identity, and the potentially authoritarian subject that lies behind any such identification, he has been able to delineate (or at least allow others to imagine) the shape of an activity of meaning which, for our culture and its institutions, is still dismissed or marginalized as non-meaning.

1 Beckett, Samuel, *Company*, Grove Press, New York, 1981, p. 24

2 Fletcher, Beryl S., and John Fletcher, *A Student's Guide to the Plays of Samuel Beckett*, Faber, London, 1985, p. 20

3 'The more Joyce knew the more he could. He's tending toward omniscience and omnipotence as an artist. I'm working with impotence, ignorance … My little exploration is that whole zone of being that has always been set aside by artists as something unuseable, as something by definition incompatible with art.' Samuel Beckett, interviewed by Israel Shenker, *The New York Times*, New York, 5 May 1956, Section 11:1

4 All dates refer to the dates of a work's composition

5 Adorno, Theodor W., 'Trying to Understand Endgame',1962, trans. Michael T. Jones, in *New German Critique* 26, Spring/Summer, 1982, p.143

6 Ibid., p. 126

7 'The Italian stage is the space of this deceit, everything there taking place in a room surreptitiously thrown open, surprised, spied on and relished by a hidden spectator; a theological space, that of moral failing: on the one side, under a light of which he pretends to be unaware, the actor, that is to say, gesture and speech; on the other, in the darkness, the public, that is to say, consciousness and conscience'. Roland Barthes, 'Lesson in Writing', 1968,

trans. Stephen Heath, in *Image-Music-Text*, Hill & Wang, New York, 1977, p. 173

8 'Keaton made no effort to disguise his general bafflement. The script was not only unclear, he admitted, it wasn't

 funny'. Alan Schnieder, 'On Directing Film', in *Film*, Grove Press, New York, 1969, p. 68

9 Beckett, Samuel, 'Film', in *The Collected Shorter Plays of Samuel Beckett*, Grove Press, New York, 1984, p. 163

10 Oudart, Jean-Pierre, 'Cinema and Suture', 1969, trans. Kari Hanet, in *Screen*, Winter, 1977, pp. 35-36

11 Or rather his mother's room: 'This obviously cannot be O's room. It may be supposed it is his mother's room,

 which he has not visited for many years and is now to occupy momentarily, to look after the pets until she comes

 Out of hospital. This has no bearing on the film and need not be elucidated.' Samuel Beckett 'Film ', op. cit., p. 172

12 'That's how you were able to throttle him in the end ... Mental thuggee you called it ... One of your happiest

 fancies', Samuel Beckett, 'Eh Joe', ibid., p. 203

13 Ibid., p. 202

14 'There is thinking: therefore there must be something that thinks': this is the upshot of all Descartes'

 argumentation ... that there is thought there has to be something 'that thinks' is simply a formation of our

 grammatical custom that adds a doer to every deed ... if one reduces the proposition 'there is thinking, therefore

 there are thoughts,' one has produced a mere tautology ... But what Descartes desired was that thought should

 have, not an apparent reality but a reality in itself.' Friedrich Nietzsche, aphorism number 484, 1887, in *The Will to

 Power*, trans. Walter Kaufmann and R.J. Hollingdale, Vintage, New York, 1968, p. 268

15 'There can be little remaining doubt as to what this [fetishistic castration of women] signifies, or what it effects.

 The foot binding example foregrounds the motivating desire behind conventional fetishism, the desire to inscribe

 lack onto the material surface of the female body, and in so doing to construct a fetish capable of standing in for all

 those losses suffered by the male subject in the course of his cultural history. That fetish, as must now be perfectly

 obvious, confers plenitude and coherence only on the male subject'. Kaja Silverman, 'Lost Objects and Mistaken

 Subjects', in *The Acoustic Mirror*, Indiana University Press, Bloomington, 1988, p.2

16 Beckett, Samuel, 'Three Dialogues', December, 1949, reprinted in *Disjecta*, ed. Ruby Cohn, Grove Press, New York,

 1984, p. 139

17 'There has probably never been a keener eye directed at paternal Death in that it determines the son, our mono

 theistic civilization, and maybe even all granting of meaning: saying, writing, and doing. Carnivalesque

 excavations on the brink of toppling over toward something else, which, nonetheless, remains impossible in

 Beckett. X-ray of the most fundamental myth of the Christian world: the love of the Father's Death (a love for

 meaning beyond communication, for the incommunicable) and for the universe as waste (absurd

 communication)'. Julia Kristeva, 'The Father, Love, and Banishment,' in *Cahiers de l'Herne*, 1976, reprinted in

 Desire in Language: A Semiotic Approach to Literature and Art, ed. Leon S. Roudiez, trans. Thomas Gora, Alice

 Jardine and Leon S. Roudiez, Columbia University Press, New York, 1980, p. 155

Samuel Beckett: Teleplays, Vancouver Art Gallery, Vancouver, 1988, pp. 11-19.

Monodramas 1991

As Is, from **Monodramas:**
Location Photographs and
Scenarios
1991
Silver print photograph
25.5 × 48 cm

As Is

Three vignettes featuring three of those large automobiles peculiar to the 1970s, accompanied by a moment, from the bridge, of the disco song, 'I Want Your Love' by Chic. The cars were sold in their day as luxury vehicles, but today – having been made to look less attractive by more compact imports and domestics – they are some of the least expensive used cars one can buy. All three are of exactly the same make and vintage, but they can be distinguished by their particular colours and respective quantities of rust.

1 Music: guitar, bass, and drums only. A low-rise residential neighbourhood with more than a few Vancouver Specials lining the streets. The camera draws toward a car with its hood and both doors open. A young man sits in the driver's seat with one foot on the road, awaiting instruction. As it passes the car, the camera finds two more young men working on the car's engine – one getting his hands dirty, and the other giving unwanted advice. Dissolve to the next scene.

2 Music: a piano adds chords with each quarter note beat. Driving beside an enormous automobile on a freeway in a suburban area, the distant skyline reminds one that this is no more than twenty minutes from the city's downtown core. A long look from a short distance at one of the car's passenger windows, through which, because of glare, nothing can be seen. The car accelerates, providing an unobstructed view of itself in its entirety as it recedes into the distance. Dissolve to the next scene.

3 Music: chimes mimic the melody of the chorus, with synthetic horns punctuating the space between 'want' and 'your love'. The camera follows a car from some distance behind, as it drives slowly through a parking lot – spiralling upward to the uppermost level, which is exposed to the afternoon sky. The car finally parks and one of its doors opens. Dissolve to black and fade to silence.

4 Title: FOR LESS.

5 Title: LUXURY.

Eye on You, from **Monodramas
Location Photographs and
Scenarios**
1991
Silver print photograph
25.5 × 48 cm

Eye On You

Early evening. A visibly tired young man is found at home in his second-storey
apartment, eating warmed-up pizza, and watching the end of one of his favourite
movies, Cape Fear. Directly beside his television set, the view beyond a balcony
presents a minor highway that borders a light-industrial area. Throughout, the
protagonist is obviously bothered by something, but even he is not entirely sure what
this something might be.

1 Pizza in hand, he returns from his kitchen. The room is generally dim, but the
 darkness is punctuated by that flickering light typical of a television set. He passes
 by the TV to take in the view from his balcony. Something catches his attention.

2 He moves into a medium shot, then, as he looks down, the rhythm of his chewing
 slows.

3 A point-of-view shot presents the grassy, poorly maintained hill below, and a man
 standing perfectly still, staring at some distant object.

4 Return to shot 2; the man inside finally swallows. He then turns and rushes out
 of frame.

5 Return to shot 3; the stranger gone.

6 Return to shot 4; the man gone.

7 From a position well below where the spectator had stood, he is seen running down
 the hill, frantically looking for his stranger.

8 Return to something like shot 3; the man is seen in a familiar pose. Finally, he turns
 to look directly at the camera – with an empty mouth, he swallows once more.

9 Title: EYE ON YOU.

Encampment, from **Monodramas:**
Location Photographs and
Scenarios
1991
Silver print photograph
25.5 × 48 cm

Encampment

A warehouse district at night. Little indication that there is anything else – aside from farmland and more warehouses – for miles. Sound is generally sparse, but what few sounds there are reverberate wildly. The protagonist prepares to have an argument with someone; however, it is doubtful that he will ever get beyond this rehearsal.

1 Distance. From a height, the camera presents the protagonist from behind as he walks quickly down the centre of a corridor formed by rows of unremarkable warehouse buildings. Lowering its angle of view and tracking forward, the camera rushes to catch up with him: the sound of his footsteps becomes louder, as does that of his indecipherable rant.

2 A sudden reverse angle presents a medium shot of the man, grimacing and sputtering. Although the sound of his voice is now even louder, one still can't make out exactly what he is saying, except for fragments like ' … everything … everyone … every time … '

3 Return to shot 1. Slowing slightly, in order to pursue the man from a safe distance.

4 He is followed until he reaches an intersection between buildings, where he stops abruptly. He turns his head to partially reveal a still-open mouth and an astonished expression.

5 From the man's point of view, an old camper-trailer and its two young inhabitants are seen. One sits on the trailer's doorstep, and the other in a folding chair on the shoulder of the road – both stare at the camera.

6 Reverse shot: the man turns away and proceeds at a rapid pace, in silence.

'I'm Not Gary', from
**Monodramas: Location
Photographs and Scenarios**
1991
Silver print photograph
25.5 × 48 cm

'I'm Not Gary'

A one-block market street. It might rain. Both characters no doubt have reasonably well-paying day jobs, but the second most likely has the day off.

1 An establishing shot presents the surrounding landscape and only a few people on the street shopping, going to and from work.

2 A tracking shot follows our protagonist, as he walks under the covered sidewalk: a white man walks towards him, grinning, and otherwise doing his best to make eye contact.

3 Reverse tracking shot: the protagonist approaches, and then issues one of those involuntary twitches that often derive from conceit, but more generally occur when one is attempting to ignore the fact that a stranger is looking at oneself. The second man is now very close as he hurries to remark, 'Hi, Gary.'

4 Return to shot 2. The two men, now about three metres apart, as the protagonist looks long at the face of the second.

5 A close-up of the interlocutor, smiling and saying, as one does to an old friend, 'How you doing?'

6 The protagonist is seen in a close-up; he is not entirely sure of himself but replies anyway, 'I'm not Gary.'

Up, from **Monodramas: Location
Photographs and Scenarios**
1991
Silver print photograph
25.5 × 48 cm

Up

Three men sit together casually on a bench in an urban park. A fence and bits of sparse foliage indicate the edge of the park, and directly behind them there is a road and an office building. A discrete hand rests upon an area of grass at the bottom right of the screen.

1 An engine shuts off. A car door slams. After a moment, the wandering attentions of all three focus upon something to the left, off-screen.

2 Footsteps approach. The eyes of the three follow something as it arrives at a point near the camera.

3 A man's voice, 'Get up.' Pause. The three look up, then down.

4 'C'mon, get up.' The eyes of the men, with little or no synchronization, look to the ground then up again.

5 A soft, indeterminable sound of impact.

6 The fingers of that disembodied hand curl, then relax.

Disagree, from **Monodramas: Location Photographs and Scenarios**
1991
Silver print photograph
25.5 × 48 cm

Disagree

At a blind corner in a light-industrial area, the meeting of a well-used mid-size car and a small school bus. The camera is absolutely still; all is seen from a modest height.

1 Eventually, the car is seen clearly – as it moves toward the camera on the avenue that bisects the screen at a slight angle.

2 A signal light flashes, and the car prepares for a left-hand turn. At this moment, the school bus appears at left and begins to make a right-hand turn. The two vehicles only barely miss colliding with each other.

3 Both stop.

4 The car begins to drive away – and, a fraction of a second later, so too does the bus. Immediately both stop.

5 Pause.

6 They start and stop again in synchronization.

7 Pause.

8 Finally, the bus drives away, along the same avenue upon which the car had first appeared. The car disappears.

Artist's Writings

Stadium, from **Monodramas:**
Location Photographs and
Scenarios
1991
Silver print photograph
25.5 × 48 cm

Stadium

Twilight. An elevated view of a pedestrian walkway beside a huge domed stadium. On the right, a vacant parking area can almost be seen, and above it there is a freeway 'on' ramp. The middle of the walkway is concealed by foliage, and at left a small portion of the stadium is visible. The most prominent feature in the composition is a large electronic sign. Because it is seen from behind, it is a black and featureless rectangle resting on a post, but the constantly moving and multicoloured light cast by its front surface occasionally illuminates the ground below.

1 Faint buzzing noises correspond to the shifting and flickering light cast by the sign. Distant talk and laughter is not entirely audible beneath these sounds.

2 Long pause.

3 A small firework screeches upward, and then skitters across the paved walkway before exploding. Its point of origin is obscured by the foliage in the centre of the screen.

4 Short wait.

5 From the centre of the screen, four or five balls of light issued from a Roman candle rise progressively higher, though they never get especially far off the ground.

6 Dissolve to black.

Bad Dream, from **Monodramas:
Location Photographs and
Scenarios**
1991
Silver print photograph
25.5 × 48 cm

Bad Dream[1]

A very large playing field bordered on its four sides by: a freeway; unused land that is
apparently becoming a dump; and light-industrial and warehouse buildings. A row of
old poplar trees stand along the side opposite the freeway; the park attendant's house
is beside them, and next to it a baseball diamond. There is a residential area
immediately behind the freeway, and one can see more houses and apartment
buildings on a hill that rises in the distance beyond the stand of trees.

1 A craning pan of the freeway. After a moment, silence is broken by a middle episode
 of Arnold Schoenberg's *Accompaniment to a Cinematographic Scene*. A series of
 slow cranes and pans, of the freeway and park, begin, dissolving into one another.

2 After its final pan, the camera cranes down to find a middle-class woman sleeping
 beneath the poplars.

3 There is a musical crescendo, and the woman wakes with a start. The music is now
 gone, and the ambient sounds of traffic and light industry are heard for the first
 time. She turns away from the camera and looks to find the source of the sound
 that woke her.

4 She lies down again, and we are shown a point-of-view shot: leaves of trees.

5 Slightly nearer. The woman closes her eyes for a moment, then sits up and again
 turns away from the camera. The camera withdraws, craning upward to present the
 landscape that lies beyond the row of trees.

6 Dissolve to black.

1 Abandoned.

Wash, from **Monodramas:
Location Photographs and
Scenarios**
1991
Silver print photograph
25.5 × 48 cm

Wash[1]

Under the scrutiny of its owner, a mid 1980s luxury car is cleaned by a four-person car
wash crew. The image of their labour is accompanied by the sound of a 'jazz' drum solo.
It must be off-season for this kind of work: there is no line-up of cars, and this is
probably the business's first job in a few hours.

1 Black. The drum solo begins.
2 Dissolve to a long take of car owner's face. He is supposedly daydreaming, but
 frequently makes a point of glancing over at a nearby action. We might understand
 later that the look of satisfaction he wears has less to do with the condition of his
 car than with the treatment it is receiving.
3 The camera draws away from the man, tracking backwards: good look at him, now
 openly surveying the operation.
4 The camera presents more and more of the car wash building.
5 Finally we see a bit of the car, and a member of the wash crew.
6 The car wash crew and the car with hood and doors wide open are seen in their
 entirety: track towards them.
7 Stop. Fade to black with the drum solo's penultimate flourish.

1 Abandoned.

Guilty, from **Monodramas: Location Photographs and Scenarios**
1991
Silver print photograph
25.5 × 48 cm

Guilty

A location interview conducted at the edge of an urban or suburban park. A cluster of flesh-toned rectangles in the centre of the screen eclipses the face of the interviewee – each time he or she moves, these rectangles move also, shimmering and changing colour.

1 Dissolve from black to the speaker.[1]

'Maybe I did feel guilty, but my guilt had no actual object. It was too pervasive, too enormous for that. My guilt demanded punishment. And the punishment, fittingly enough, was to feel myself guilty. No quiet. There are always sounds coming from far away, and like the sounds, thoughts come to me as if from a great distance. Even when I'm listening to music, the words will come to me involuntarily – and even if I don't know the words to a song I will make them up.'

2 Dissolve to the same scene: a slight jerk of bad registration.

'The voices are, however, heard in my head – though I do on occasion hear them in the air or in different parts of the room. Each of them is different, and beautiful, and generally speaking with its own distinct tone or rhythm. There are many, I would say, upwards of fifteen, simultaneously admonishing with phrases like, "We shall see." Only when I am talking aloud, to myself or to other people, can I not hear them, and drown out their sounds with my own. But as soon as I stop, the well-known phrases begin again, reminding me that the monologue continues even as I speak.'

3 Title: GUILTY.

1 To be performed by at least three persons at as many different locations.

Monodramas and Loops, UBC Fine Arts Gallery, Vancouver, 1992, pp. 41-50.

Artist's Writings

Hors-champs 1992

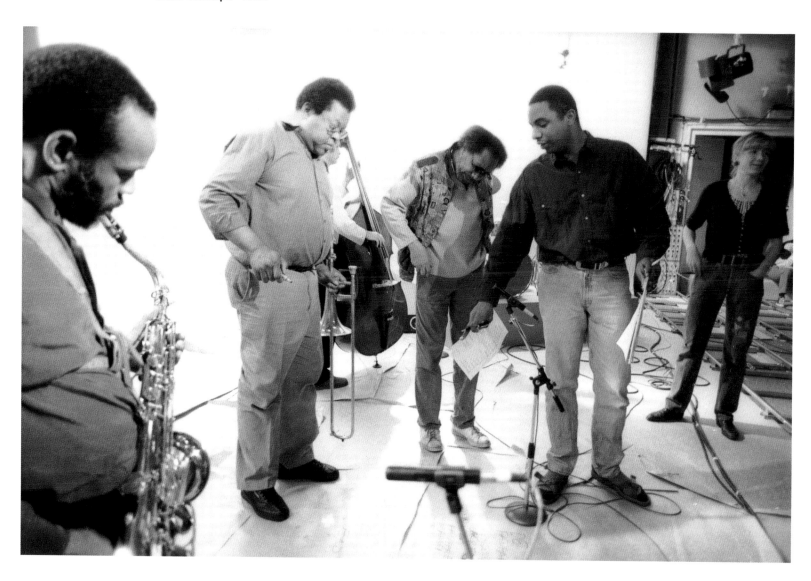

Hors-champs
1992
Production stills

Project Description

What was typically known as 'the new thing' in the United States and as 'free jazz' in
Europe was an idiom of Afro-American music characterized by simultaneous group
improvisation and relative harmonic freedom. Because of the metaphor clearly
embodied in its formal premise and (to be exact) the political commitments of many
'free' players, the music was generally associated with black nationalism in the US –
but in France, during the late 1960s and early 1970s, the music acquired other
connotations. It was, for example, so popular among the May 1968 generation that
audiences for free jazz concerts could number in the thousands, and there were even
festivals organized by the French Communist party, which regarded the music as an
ideal of social organization. By the end of the 1970s, the music's popularity had begun
to wane: perhaps because of these extrinsic associations; and though musical ideas
from the period remain important today, the legacy of free jazz is partially obscured by
the revisionism and revivalism that had been so overwhelmingly prominent throughout
the 1980s.

Hors-champs presents the performance of four American musicians who either
lived in France during the free jazz moment, or who still reside there today: George
Lewis (trombone), Douglas Ewart (saxophone), Kent Carter (bass) and Oliver Johnson
(drums). Their presence in that country may be considered continuous with the history
of black American musicians emigrating to France, which extends back at least as far as

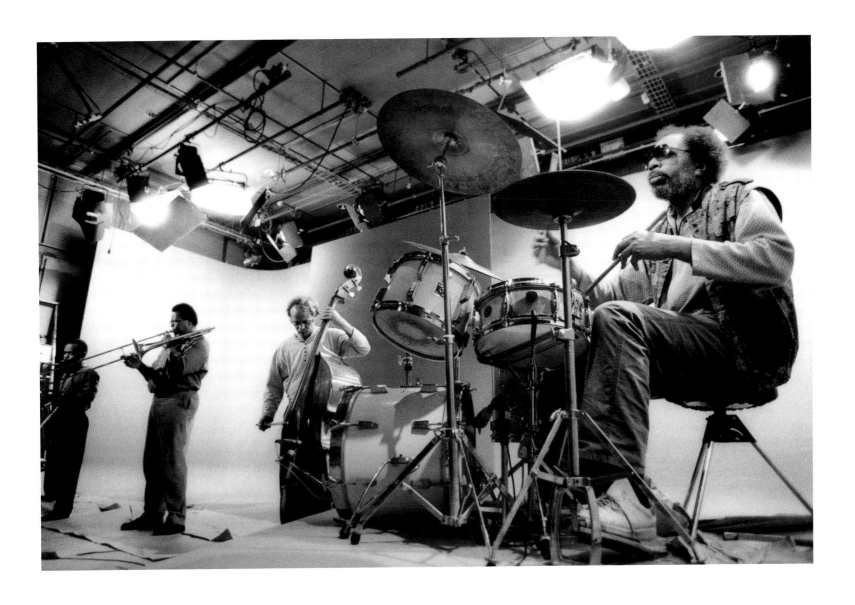

the arrival of Josephine Baker and Sydney Bechet on European soil. The music they play is based on Albert Ayler's 1965 composition, *Spirits Rejoice*, and composed of four basic musical materials: a gospel melody, an attenuated call and response, a heraldic fanfare and *La Marseillaise*. Its proximity to the fanfare underlines the origin of the latter in military music, and, like many other national anthems such as the *Star Spangled Banner* (which also makes a brief appearance), the recollection of its bloodthirsty lyric will remind one of the tacit content of myths of national identity. *Hors-champs* was shot *en direct* in the style of an ORTF musical television production from the same era as Ayler's composition – notably those of Jean-Christophe Averty. This accounts for the rough *chiaroscuro* and abstract placelessness of its *mise-en-scène*. However, while those French television productions typically used four or five cameras, we used only two: one operated by Serge Godet and the other by myself. Two video projections are simultaneously presented on recto and verso sides of a suspended wall. While one side of the screen shows a 'programme' montage of the two cameras, the other presents a simultaneous counter-narrative of everything that had been edited out.

 This project was produced at Centre Georges Pompidou by the Musée National d'Art Moderne, Paris. Rehearsals began during the week of 29 April 1992. *Hors-champs* is dedicated to the people of South Central Los Angeles.

Stan Douglas, Musée National d'Art Moderne, Centre Georges Pompidou, Paris, 1992, p. 127.

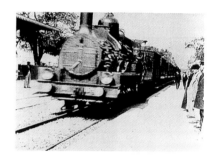

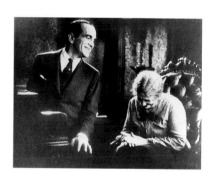

right, top, **Louis Lumière**
L'Arrivée d'un Train à la Gare de
Ciotat (Arrival of a Train at the
Station of Ciotat)
1895
55 ft., black and white, silent
Film still

right, bottom, **Alan Crossland**
The Jazz Singer
1927
89 mins., black and white
Film still

opposite, top, **Edwin S. Porter**
The Great Train Robbery
1903
10 mins., black and white
Film still

opposite, bottom, **Robert Z.
Leonard**
The Girl of the Golden West
1938
121 mins., black and white
Film still

Historical Background

Musical accompaniment has been an integral part of commercial cinema from its
earliest moments. The first commercial film presentation, Louis Lumière's *Arrival of a
Train at the Station of Ciotat* (1895), had live musical accompaniment, and since then
industrial filmmakers have found increasingly sophisticated ways of incorporating
music and sound into the cinema. Prior to the release of the first 'talkie', music, typically
performed by small orchestras in large venues and improvised by a lone pianist or
organist in smaller ones, was as important to the appeal of a motion picture as
anything presented on-screen. Musicians would perform variations on popular songs
and motifs from European art music – developing a parallel mode of address that not
only supported a film's narrative action, but could also radically transform its affect. In
some cities, the reputation of the musical accompanists would determine the
popularity of a theatre even more than its programme of films. Knowing this,
Hollywood producers soon began to streamline the production of both commercial
films and their sonic companions in a way that would absent live performance. For a
time there were a number of competing sound systems – cylinders, disks and even
player pianos and orchestrons (huge automatic instruments incorporating organs,
violins, horns and drums controlled by perforated music rolls) – but optical and
magnetic sound-on-film processes would eventually dominate.

In the late 1920s, the Vitaphone disk system was the most widespread – once it had
been purchased by Warner Brothers and used to achieve partial synchronization of dia-
logue in the immensely popular film *The Jazz Singer* of 1927. The release and immediate
popularity of the first '100 per cent all-talkie' in the following year, *Lights of New York*
(1928), confirmed the dominance of the 'audible photo-play' over the silent film with musi-
cal accompaniment. Soundtracks of the first talkies would frequently consist of nothing
but talk; however, parallel and integrated sound-on-film systems would soon permit
the reintroduction of music into the texture of cinematic production. But by this time
music had been consigned to the separate realm of special 'numbers', and more generally
to the role of providing leitmotifs to lend a film supplementary narrative support.

Two years after *The Jazz Singer* was released, the Viennese composer Arnold
Schoenberg began to write a score for an imaginary silent film, *Begleitmusik zu einer
Lichtspielscene* (Accompaniment to a Cinematographic Scene); composition began at
the beginning of the Great Depression, in 1929, and was complete by the following year.
While the *Begleitmusik* betrays many of the features of the twelve-tone style, it is
unusual in as much as it is relatively accessible and, uncharacteristically, a piece of

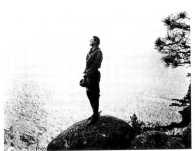

programme music. Schoenberg's twelve-tone technique had done away with the sense of rest or tonal centre that for centuries had been the supposedly natural requirement of European bourgeois music. In functional tonality, the traditional dominance of consonance in a piece of music is usually predicated upon its distinction from an 'other': melodies in 'foreign' keys and combinations of sound presumed to be dissonant. What Schoenberg had done was develop a method of composition in which all twelve tones of the tempered scale were given equal value, so that no single note would be regarded as the hierarchic centre or 'key note' in an episode of music. Schoenberg's interest in atonal materials was an extension of the expressionist inclinations of his early work. It is a disposition that is still to be found in the *Begleitmusik*'s three thematic sections – 'Threatening Pursuit; Fear; Catastrophe' – and perhaps even in the gesture of writing an instantaneously obsolete film score.

In 1933 Schoenberg was dismissed from his post at the Prussian Academy of Fine Arts in Berlin. In the same year, he embraced Judaism once more and left Germany because of the increasingly violent expressions of racism in the country. He and Gertrud Schoenberg emigrated to France and later to the United States where, in 1934, they would finally settle outside of Hollywood. Without a steady income, and unable to get his savings out of Germany, Schoenberg began to teach composition privately when he first arrived in California. Among his students were a number of film composers who, when they began to write scores for Hollywood melodramas in the late 1930s, would use techniques of atonal composition bluntly to indicate anxiety or otherwise extreme emotional states.

The district of Ruskin takes its name from the nineteenth-century art critic and utopian political theorist, John Ruskin. This modest parcel of land – the territory of Skaiet and Stalo nations where the Fraser River is fed by the Stave – was named 'Ruskin' in 1898 when the Canadian Co-operative Society opened a post office at its then-new commune. The Co-operative Society was initiated by college professor Charles Whetham in the early 1890s, and was comprised of a handful of people who wanted to establish a community that would operate in accordance with that peculiarly conservative brand of socialism espoused by the author of *Modern Painters*. In spite of the prohibition against the use of machinery in the corporate communities associated with John Ruskin's own Company of St. George, the CCS had planned to finance their experiment by operating a small, co-operatively-owned and operated lumber mill. In 1898, only two years after their utopian venture began, extraordinarily dry summer weather had reduced the flow of the Stave to the point where the Ruskinians were

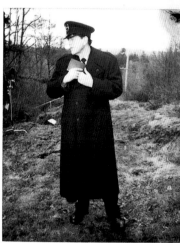

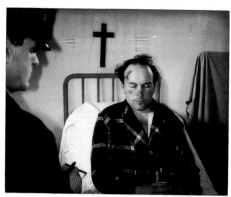

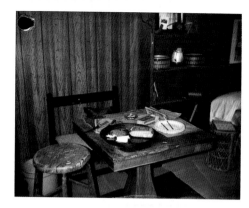

From **Pursuit, Fear, Catastrophe:**
Ruskin, BC
1993
Colour Polaroid photographs
10 × 10 cm each
Continuity stills

unable to move lumber down the river to their mill. The following year they went bankrupt and the operation was repossessed by their creditor, E.H. Heaps and Company. Over the next fourteen years, Heaps and Company's expanding operation would include the construction of shingle and box factories, two boarding houses for its (predominantly Chinese) work force, residences for management and a twenty-two room hotel on the Ruskin site. But by 1913, when they were unable completely to finance a planned foundry, they too were forced into receivership, and their assets were divided among three separate companies.

Between the two world wars, the district of Ruskin and the remainder of land north of the Fraser between Alouette Lake and the Stave River was home to a large community of Japanese-Canadian berry farmers. The majority of them had moved to this relatively remote location and into such a specialized enterprise because they had been barred, by openly discriminatory legislation, from other kinds of employ in the Lower Mainland: fishing, forestry and most professional work. By 1927, there were thirteen homes in the area, and over the next decade virtually all available farmland would be purchased by other Japanese families. They built a community centre, operated two small mills and were a major presence in the area until 1942, the year of their internment. At this time, all Japanese-Canadians, many of whom had been born in this country, were classified as 'enemy aliens' and required to register with the authorities. Once they had done so, they were sent to work camps in the Prairies and the interior of British Columbia and any major piece of land or property they owned was expropriated by the government.

Parallel to the growth and eventual dispersal of this community, another presence was being established at Ruskin – one which would readily receive government sanction. From about 1912, the Western Power Company had title to significant parcels of land along the Stave as far north as the end of Stave Lake. When Western Power was acquired by BC Electric (later BC Hydro) in 1920, the latter company realized the planned three-plant, hydro-electric power complex at Alouette lake, Stave Falls and Ruskin. The Ruskin plant was the last to be built; construction began at the beginning of the Great Depression, in 1929, and was complete by the following year. The new power station was officially opened at a ceremony attended by Lieutenant-Governor R. Randolph Bruce. After a tour of the site, the assembled crowd gathered inside the powerhouse where they would witness Bruce pass his hand over a radio device in the form of a 'magic' silver sphere – which triggered relays that opened the wicket gates which, in turn, allowed water to pass through Ruskin's massive thirty by sixty-six foot turbine for the first time. This was followed by a luncheon at which politicians and BC

Electric executives gave speeches. The Lieutenant-Governor began his address with a wild allusion to the book of Exodus ('Moses struck with his staff the Rock of Horeb, from which living waters immediately gushed') and concluded with the following lines: 'As Mr. Murrin [president of BC Electric] has so ably said, with the clouds of industrial depression hanging over us it is good to realize that his company has risen above those clouds, and has a clear vision of the sunshine and prosperity that lie beyond […] I realize that it is my office rather than myself that has been invited to perform this happy duty. It is fitting that the representative of the Crown for the time being should participate in celebrating the achievement of this new milestone along your unbroken road of progress.'

Project Description

The final form of this project will be that of an installation in which a silent, 16 mm film will be projected, accompanied by a performance from a Yamaha 'Disklavier Grand' computer-controlled player piano. This format clearly alludes to the conventional presentation of early cinema, in which a keyboard soloist, or small orchestra, would be employed to reinforce the narrative trajectory and affective character of 'silent' films. The piano will perform a new arrangement of Arnold Schoenberg's minor orchestral work, *Begleitungsmusik zu einer Lichtspielszene* ('Accompaniment to a Cinematographic Scene'), which was written for an imaginary film in 1929-30. The present film will use conventions of the silent cinema to portray a melodramatic tale derived from the daily diaries of constables working for the British Columbian Provincial Police (*c.* 1910–30); its montage will attend to the score's episodic structure and three thematic sections: Threatening Pursuit; Fear; Catastrophe.

The film is supposedly set in 1930. Certain details are appropriate to the period (the vintage of the power facility; 'ahistorical' costumes such as engineer's overalls; men wearing hats), but others are clearly contemporary (the constables drive an early 1980s Impala; mobile homes take the place of cabins). It will be shot in black and white at eighteen frames per second and will contain no cinematographic devices that could not have been achieved during the early sound period. Certain sequences (the diary entries, the journey into the woods) do suggest the presence of an absent viewer, but subjective identification with the camera is otherwise made difficult by distant, formal framing and tenuous eyeline matches – or it is highly self-conscious, as when a circular vignette announces, 'This is a point-of-view shot.' The two main characters have their own visual leitmotifs: Huntingdon his hands, and Theodore his feet.

Stan Douglas, Musée National d'Art Moderne, Centre Georges Pompidou, Paris, pp. 136-39, revised 1998.

In conversation with Lynne Cooke 1993

Lynne Cooke In the works that you have made over the past couple of years there seems to be an identifiable tendency to look for the anti-hierarchical, the nondominant, the anti-authoritative. One instance of that would be your essay in the catalogue to an exhibition of Beckett teleplays, which you curated in 1988. In it you argue that in place of a closed world like Sade's, which is invented to be mastered, Beckett 'imagines an uncertain one: the residence of even less certain subjectivity.' Another would be your proclivity for film loops, as in *Overture*, thus not only making the piece continuous, but divesting it of a climax. There's a related avoidance of narrative resolution in the film script for *Pursuit, Fear, Catastrophe: Ruskin, BC*. Do you regard this as a philosophical position or part of your aesthetic?

Stan Douglas **Both in terms of presentation and the subject matter of my work, I have been preoccupied with failed utopias and obsolete technologies. To a large degree, my concern is not to redeem these past events but to reconsider them: to understand why these utopian moments did not fulfil themselves, what larger forces kept a local moment a minor moment: and what was valuable there – what might still be useful today. In both the gallery pieces and the TV pieces I'm looking at supposedly inconsequential moments of life. Yet these are perhaps the most significant ones, because they are the ones where habit is predominant, where people aren't strictly attending to how they're behaving. So, in the narratives of the TV projects, and also in the more thematically structured gallery works, I'm trying to reconsider what has been either a habitual discarding of personal habit or a larger cultural one, in as much as cultural forces go through the same process.**

Cooke What led you to these media? How did you end up working primarily with reproductive technologies?

Douglas **Part of it is the fact that I can't draw. But it's often also the result of trying to find the appropriate medium for the subject matter of the work. I learned quite a bit about these different media trying to make the projects as different from each other as possible. A certain subject will eventually draw me to a particular medium. Since I'm interested in the cultural and the psychological effects as well as the social situation of television broadcasting, I have to work with the medium of television itself. The player piano piece, *Onomatopoeia*, is concerned with evoking certain historical moments, and certain notions of absence, which the very formal presentation both embodies and**

Ruskin Hydro-electric Power
Station
Prospectus published by BC
Electric
1930
Cover and sample page
29 × 20 cm
Artist's archival material

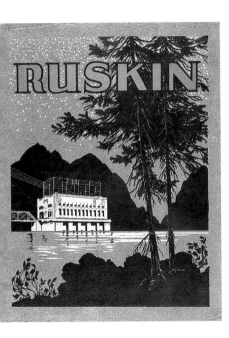

represents at the same time.

Cooke When you say you can't draw, is that a consequence of your art school training?

Douglas **I did go to art school, where I did a little bit of drafting and technical drawing. But I was just too lazy to learn how to draw.**

Cooke Does this reinforce your tendency to write?

Douglas **That has evolved with the projects. Developing them by way of notes and textual research, as well as reading a lot, gave me various models of how to write, and eventually I began doing it myself. The essay for the Beckett catalogue was the first essay I had ever written: it was out of necessity.**

Cooke How do you find your subject?

Douglas **It's always quite by accident. With the *Ruskin* works, for example, I had gone on a boating trip with some friends during which we came upon an extraordinary site: a power station built in 1930, which looks like a vampire's château set in the landscape. Next to it there is a very well-tended second-growth forest maintained by a regional hydro company, as well as a somewhat devastated runoff area. What's left of the Stave River is flanked on one side by wealthy holiday homes and on the other side by small lumber mills and a couple of trailer courts. The name 'Ruskin' made me curious about it. I learned that it was originally established as a Ruskinian utopian community, which failed after only two years of operation. Since then it has been the site of various small local communities, none of which lasted very long. Around 1900, business ventures and later, a large Japanese community formed there until the internment during World War II, when they were declared 'enemy aliens', and their land was expropriated by the government. *Pursuit, Fear, Catastrophe: Ruskin, BC* developed out of finding this location, and being fascinated by it.**

Cooke Have those who were interned fought to be recompensed? Is a political issue implicit in the work?

Douglas **About five years ago, after years of lobbying, there was a redress in Canada.**

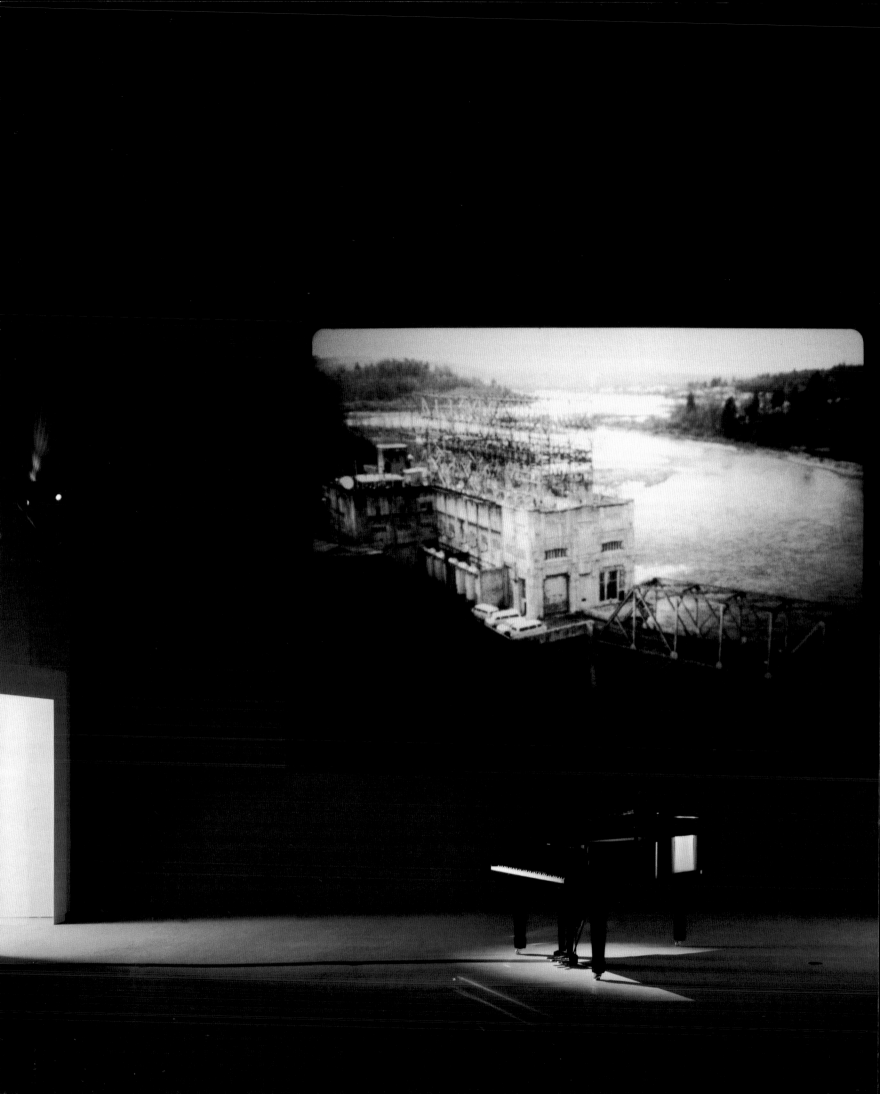

But monetary recompense for the internment, for that injustice, can only be symbolic. And it's very, very difficult to find out who was in that community, because the purpose of internment was to destroy the social fabric of the Japanese-Canadian community. It was a community of ex-guest workers – all of whom were therefore *de facto* Canadians – who were developing their own social relationships with the country. The purpose of the internment was to break up those communities and to leave them no possibility of having any solid social ground. It's only recently that people have been able to reconstruct the whole fabric – their relationships and families. Indirectly, the film-script bears upon this, in that the two policemen seem quite happy to discredit the reputation of the Japanese man, and his race as a whole.

When I did the research for this project, I went to the provincial archives and looked at the daily diaries of constables working in this area and of the others working in very isolated areas. Part of their job in the 1930s was to keep the different racial groups separate, preventing any kind of coalition that might cause a social or economic threat to the status quo. Everybody was catalogued by race. The Japanese, Chinese, 'Hindoos' – spelled with two o's – Jews, and Italians etc., were all categorized as other to the Anglo-Saxon majority. This is presented in the film in what seems a nonchalant, matter of fact manner. That was how they went about the business of containing these different racial groups.

Cooke It's automatic: routine rather than considered behaviour.

Douglas **Exactly**.

Cooke In *Pursuit, Fear, Catastrophe* ... you are dealing with the material in two different forms. There is the group of colour photographs with two text panels, which has already been exhibited, and then there's the film that you're currently making. How do the two compare? On a previous occasion you also developed the same body of material into quite different idioms, didn't you?

Douglas **Yes. Those location photographs are part of my process of going out and considering the site. In assembling them into a work for exhibition I was trying to make slightly decrepit sites around Ruskin look like nineteenth-century English landscapes: that way of cataloguing property peculiar to the landscape tradition. But then, if you look carefully at the details, you'll see abandoned cars, debris – a slightly devastated**

Pursuit, Fear, Catastrophe:
Ruskin, BC
1993
16 mm film loop installation with
Yamaha Disklavier
14 mins., 50 secs. each rotation,
black and white, sound
Dimensions variable
Installation, McDonald Stewart
Art Center, Guelph, Ontario, 1994
Collections, Vancouver Art
Gallery, Vancouver; Fondation
Cartier pour l'Art Contemporain,
Paris

landscape that otherwise appears to be pastoral.

Cooke You have examined the context through a specific medium as well as through the conventions of a particular genre. By contrast, in the film you'll represent it in completely different sets of terms – well, not completely …

Douglas **I can be a lot more diachronic in the film. I mean, I can deal with time in the film, which photographs don't lend themselves to as easily. The film has an open-ended time that folds in on itself. That's partly derived from working with the orchestral score, the Schoenberg score, which has been reduced to piano. It's like the classic post-Sophocles narrative of beginning, middle, end – pursuit, fear, catastrophe – which is typical of Western culture. Yet, by the end, the musical material has diverged so far from its origin that it's without resolution or rest. The story, too, leaves itself open. At the end there is a character who has the possibility of discrediting the policemen and the investigation – or, though he probably hasn't got the power to do that, he at least knows where his roommate has gone.**

Cooke The Schoenberg score was for an imaginary film, not for an actual film, wasn't it? And the diary entries with which the film opens are based on actual historical records, which you consulted but did not literally transcribe …

Douglas **In those two sequences of diary entries some are direct quotes – but with the names changed – of actual entries from the Ruskin area, and others were invented to make the narrative flow.**

Cooke There's an interesting relationship between the Schoenberg score, which did not accompany a real film, and this material which is quasi-documentary. In both there is a slippage, either between fact and fiction, or between the real and the imaginary, so that these oppositional categories no longer seem to pertain. The possibility of moving between them allows you to open the film itself up for investigation. Is this similar in some way to what occurs in *Subject to a Film: Marnie*, where, if I've got it right, the only sound in the film happens at the moment when the woman in the deserted office reaches with her gloved hand to unlock the safe? Is the click on the soundtrack not that of the combination lock, but a noise produced from the suture of the film's loop?

Douglas **Yes, but the suture happens just before that – when she finds the safe combination and closes the drawer. There's a similar scene in *Pursuit, Fear, Catastrophe* … a little dream sequence where suddenly the exterior is contemporary, where what you thought was a cabin throughout the entire film is revealed as a trailer court, and you see the contemporary police car coming up to Theodore's cabin. It's played across a dream sequence: he's sleeping, tossing and turning. The camera cuts from inside to outside. Then, after the digression, the film returns to 1930 again […]**

Cooke When you [refer to] 'poetic resonance', do you mean something like a space for imaginative play – a space for exploring areas of the mind that don't often come into consciousness in other arenas of experience?

Douglas **At a very blunt level I would consider poetic language to be like the harmonic relationship in a piece of music. It's not like the melody which would go horizontally and has a beginning, middle, and end, referring to past moments, or anticipating future ones. The harmonic or poetic resonance goes elsewhere, allowing an audience to have other kinds of engagement with the work. I tend to describe a work in terms of what materials are used, and of what references are there. I shy away from interpreting it because if the audience has no way of finding a language of its own to understand a project, then that project is unsuccessful. I may as well have just written on a piece of paper a statement saying, 'I mean this.'**

Cooke When you're talking about poetic resonance is there any difference between the television and the gallery works?

Douglas **No, it's the same process of poesis. Poesis also happens on that real vernacular level. Those forms – like genre movies, which are supposedly domineering and meant to over-determine one's response or relationship to them – are still received by audiences in ways that market research can't predict – although there are, of course, preferred meanings, which it does everything in its power to have accepted as being true or natural in some way. I prefer to have respect for an audience, and to allow it to participate in the construction of meaning.**

Frieze, September/October, London, 1993, pp. 41-45.

Evening 1994

Historical Background

In the late 1960s there was a major paradigm shift in US television journalism. There were, to be sure, many technical elaborations (the portable video recorder; live remote broadcasts; the transition to all-colour regional broadcasting), but equally significant changes to news stage craft were implemented, when that curious synthesis of journalism and entertainment called 'Happy Talk News' was introduced: no matter how bad the news is, present it with a happy face. This is what the format suggests on the most simple level, but it also meant the inclusion of 'human interest stories', banter between co-anchors, and new techniques of vocal delivery (narcotic rhythms and peculiar descending inflections) that were a radical departure from the bone-dry styles of recitation passed on from radio announcing. Just as television news had the technical means to present social life in the US with greater immediacy, it became more removed from that realm and increasingly obsessed with its own internal logic.

The chronically low-rated ABC-owned Chicago-area station WLS was the first to employ Happy Talk, and its huge ratings success led to the news format being imitated, almost instantaneously, across the United States. Then, as now, station managers justified their policies in terms of theorized audience approval and dollars earned but the introduction of Happy Talk may also be regarded as a hysterical response to the news of the late 1960s, and the conflicting demands of station owners, television advertisers and audiences, because Happy Talk could be used to give closure to stories about the Vietnam War and civil dissent by theatrical rather than editorial means. As one might expect, older television journalists were not all that happy about being forced to research trivialities and then give them equal time with the frequently devastating news of the day, and the 'Happy Talk' label was soon dropped and discredited, however the format itself remains the intrinsic structuring device of virtually all television news in North America.

Project Description

In *Evening* I have reconstructed through archival research of newspaper reports and television footage, two news days from 1 January 1969 and 1 January 1970 (roughly the epicentre of the adoption of Happy Talk by US broadcasters). When the work is installed, three adjacent three-metre screens simultaneously present the differing approaches to the news peculiar to three fictionalized Chicago-area network affiliate stations, 'WAMQ', ' WBMB' and 'WCSL'. The sound system is arranged so that, in certain areas, a viewer may hear the polyphony of all three stations in concert or, when

Evening
1994
Video installation
14 mins., 52 secs. each rotation,
colour, sound
Dimensions variable
Installation, The Renaissance
Society, University of Chicago,
1995
Collection, Museum of
Contemporary Art, Chicago

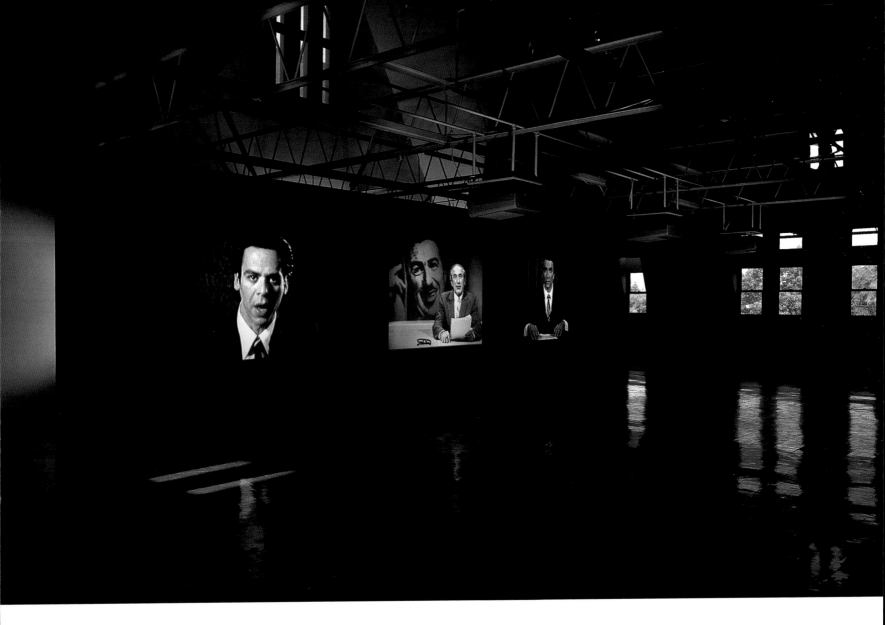

in front of a particular screen, is able to hear WAMQ undergo the transition to Happy Talk, WBMB maintain its paternal conventions, and WCSL perfect its Happy rhetoric. In addition to the United States' abiding war with Vietnam, the fulcrum stories reported are the Chicago Seven Trial and the first inquest into the assassination of Black Panther Deputy Chairman Fred Hampton. But none of these stories are reported in a way that reflects their complexity or irresolution. It should be remembered that *Evening* addresses the same medium that aided the US Civil Rights Movement in the early 1960s by making local conflicts national and later, international issues, but which, within a decade, had begun to represent precipitates of the Movement as unreasoned or fragmented 'special interests' lacking historical continuity. An analogue of this process of atomization is audible by way of the script, which I wrote to approximate a musical score. Polyphony is used to underline repetitions and differences in editorial treatment, certain stations solo when the others cut to commercial, and there are unisons of key words – such as when, at the beginning of each cycle, all of the news anchors simultaneously announce, 'Good evening.'

 Evening was produced by The Renaissance Society at the University of Chicago. It was shot on set and location in Chicago during March 1994.

Evening, The Renaissance Society, University of Chicago, 1995.

Der Sandmann 1995

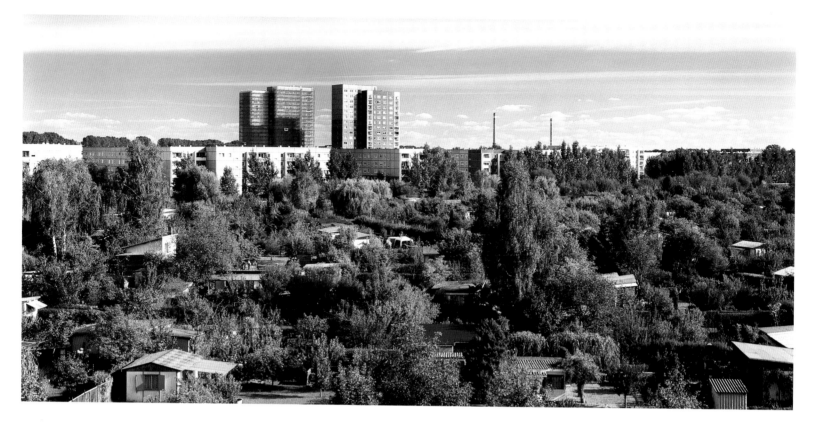

Historical Background

Early in the nineteenth century, a peculiarly urban variety of gardening was established throughout Northern Europe when rural workers drawn to cities in order to staff industrialization were allotted modest plots of land in which they could grow their own food to supplement paltry wages. Germany's first *Armengärten* (poor gardens) appeared under state decree and strict supervision in Kiel in 1805. Only those deemed 'characteristically right' were granted leases to these small parcels of land in unused, or unwanted environs of the city: simultaneously proving that they were without economic means and able to acquire the necessary tools, without stealing or state assistance. A supervisor was assigned to each garden district to determine what was to be grown, when gardening would be done, and the date of harvest – with the additional power to revoke a worker's lease if they ate their crops before submitting a percentage in taxes, or when they were found drinking, fighting or if judged to be lazy. In 1832 Leipzig adopted this model of social welfare, and a year later Berlin followed their example. By 1880 there were 2,800 *Armengärten* in Berlin alone, although statistics suggest that 4,500 would have been required in order to feed all those families in want of food.

The gardens were, of course, never a worker's property and cities always retained the right to withdraw their patronage whenever they saw fit – and the entire *Armengärten* system was shut down in 1897. In 1901, federal social security chairman Alwin Bielefeld established the short-lived *Arbeitergarten* (worker garden) programme administered by the Red Cross. But in spite of the obvious benefits offered, there was resentment among workers – both towards the programme itself, and towards the bourgeois women, the so-called *Patronin*, who served as supervisors in the Red Cross allotments. Many workers believed that the *Arbeitergärten* were a means of maintaining already strict class divisions, but war, rather than worker protest, ended the programme.

Following World War I, allotment gardens played a crucial role in feeding the general population, and their public utility was recognized by the Weimar Republic in

From **Potsdam Schrebergärten**
1994
C-print photographs
47 × 93 cm each
opposite, View of *Zu alten Zauche* with *Plattenbauten*, *Hochhäuser* and the Twin Smokestacks of Kohleheizwerke Rebrüke, Am Schlaatz

above, View of 'Im Grund', *Am Pfingstberg* and Rote Kaserne Nedlitz, Pfingstberg
From the series of 15 prints, various dimensions
Collections, Museum Boijmans Van Beuningen, Rotterdam; Solomon R. Guggenheim Museum, New York

the Allotments and Small Holdings Act of 1919. Throughout the 1920s, numerous self-regulating garden associations appeared whose 'colonies' of gardens would eventually provide necessary sources of food shelter during the depression – and one of them, *Kuhle Wampe*, in the north-west of Berlin, achieved minor celebrity when it became the setting for the Berthold Brecht-scripted film of the same name directed by Ernst Ottwald (*Cold Comfort*, 1936). Under National Socialism, the democratic origins of many of the allotment associations were obscured by imposed militaristic and ideological objectives of self-sufficiency and 'attachment to the soil'.

In the immediate post-war period, the gardens yet again helped feed a country enduring severe food shortages and later, despite their typical situation beside highways, rail lines and industrial parks, provided spaces of middle-class recreation in both zones of divided Germany. In the DDR, those who (typically) through familial legacy were members of a *Kleingartenverein* had both a weekend retreat and a supplementary source of food, the surplus of which could be sold at market. But since 1989 laws governing the gardens have been 'synchronized'. In Potsdam, at least, small quantities of produce can no longer be sold to market vendors, gardeners can no longer sleep in their *Lauben* (cottage-shacks), and plumbing and electricity are no longer permitted. And because of its proximity to Sanssouci, Frederick the Great's own garden retreat, Potsdam is these days prime real estate, and more than half of its thousands of *Schrebergärten* (Schreber gardens) are being razed for the construction of hotels, luxury housing and light industry.

Meanwhile, parallel to the growth of the more instrumental allotments of the nineteenth century, a practice of gardening with a peculiarly bourgeois character was instituted in Leipzig by an educator named Ernst Hausschildt. He proposed to the city that small gardens, composed of a modest rectangle of grass for gymnastic exercise and a little house for rest, should be provided for the physical education of young people. He established, in 1864, the first *Schreberverein* (Schreber association) named after his colleague, Moritz Schreber, who had died three years earlier, but had been promoting the idea that athletic activity in these green spaces could alleviate the

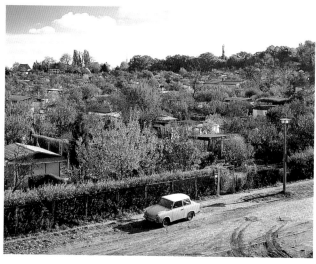

right, **Garden Designed by Lenné,** *Halbinsel Meederhorn,* Sacrow *far right,* **Two** *Lauben* **and Transmission Tower, 'Uns genügt's',** *Nuthe Strand 1,* **Babelsberg,** from **Potsdam Schrebergärten**
1994
C-print photographs
46 × 53 cm each
Collections, Museum Boijmans Van Beuningen, Rotterdam; Solomon R. Guggenheim Museum, New York

adverse psychological effects of industrialization upon children and adolescents. In 1865 the first *Schrebergärten* were planted in Leipzig – without, apparently, much success. Children soon 'lost interest' or were otherwise explained to have become resistant to visiting them, but adults retained the gardens for their own pleasure and relaxation. Another *Schreberverein* appeared in 1874; there were six in 1891 but, by 1907, when the supposed purpose of the gardens had been long forgotten, there were so many *Schrebervereine* in Leipzig that there was controversy as to which was the original organization.

Moritz Schreber himself would have remained an obscure figure if it were not for both the colloquial usage of his name – *Schrebergärten* is virtually synonymous with the official designation of twentieth-century allotments, *Kleingärten* – and the writings of his son Paul. The elder Schreber's conception of physical education was derivative of early nineteenth-century Swedish gymnastics; however, his prosthetic inventions did gain a certain infamy. The *Geradehalter* (upright-holder), for example, was a device designed to make children sit up straight at the dinner table. When a child strapped into the apparatus slouches, a counteraction is caused, which violently pulls at their neck and head. Being the experimental subject of this and similar devices quite likely contributed to the paranoia of Paul Schreber, which was articulated with obsessive thoroughness and candour in his self-published book *Denkwürdigkeiten eines Nervenkranken* (Memoirs of an Insane Man, 1903). The former lawyer explained how God attempted to transform him into a woman so he could bear God's child, how little men try to pump out his spinal marrow, how he is able to 'erase' the presence of people he passes on the street, or consume the souls of his psychoanalysts. Paul Schreber intended the *Denkwürdigkeiten* as a religious tract that would convince others of his peculiar theology, but few of his contemporaries were able to read it as his family purchased and destroyed virtually all of the edition. He did, however, find one significant early reader in Sigmund Freud, who developed his theory of paranoia from a reading of this confessional.

Project Description
Der Sandmann is a continuous film loop for two 16 mm projectors.

It takes as its setting a fictional *Schrebergärtenkolonie* somewhere at the edge of the city of Potsdam. In a 1920s-vintage Ufa studio at Potsdam-Babelsberg, two variations of this locale were constructed: the gardens as they might have appeared twenty years ago, composed of characteristic materials and foliage, and the same

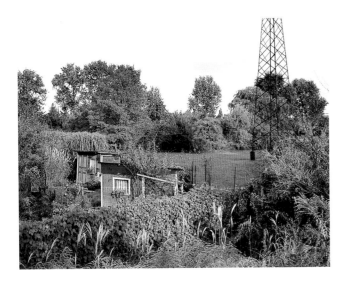

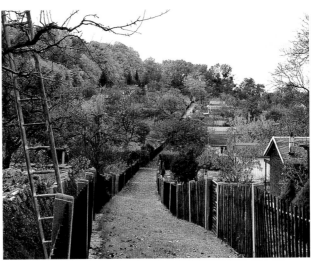

far left, Trabant beside 'Im Grund', *Am Pfingstberg*, **Pfingstberg**
left, **Path through 'Berg auf',** *Am Pfingstberg*, **Pfingstberg,** from **Potsdam Schrebergärten**
1994
C-print photographs
46 × 53 cm each
Collections, Museum Boijmans Van Beuningen, Rotterdam; Solomon R. Guggenheim Museum, New York

gardens today, with currently fashionable *Lauben* architecture and half of the area razed by a construction site. The latter set was built upon the former, as in a palimpsest, but one abiding feature is the old man – the Sandman – toiling away at some mysterious contraption that, after two decades, is still not quite working.

Three narrators read texts based on the exchange of letters that opens E.T.A Hoffman's tale, *Der Sandmann* (1817) – whose layers of misrecognition and narrative tropes were described by Freud as exemplary of estrangement and repression in his 1919 essay *Das Unheimliche* (The Uncanny). The first narrator, Nathanael, has returned to Potsdam after a long absence, and is disturbed by the sight of a peculiar character obsessively sifting sand in a *Schrebergarten*. He writes to his childhood friend Lothar for clues. Lothar responds, amazed that Nathanael could have forgotten that this was the old man the pair believed to be that malevolent Sandman who steals the eyes of sleepless children. One night, the young friends venture into his garden, intending to reclaim the stolen organs, only to be promptly discovered and cursed by the old man whose piles of sand and strange machines were merely the tools of a luckless inventor who thought he had discovered a new method of growing asparagus in winter. Nathanael's sister, Klara, having read her brother's letter to Lothar, writes also – to console her sibling, and to remind him that the night of his escapade with Lothar was the same night that their father was killed in a bar fight. This coincidence, which he has conspicuously forgotten, must have been why the young Nathanael could not stop crying that it was his own fault, that, 'It was the *Sandman*!'

The *Schrebergärten* sets were shot on 16 mm film with a motion-control system that allowed the camera to make one continuous 360° pan of the old garden and a second of the contemporary site that, in terms of camera angle and motion, are identical to one another as they reveal details of the gardens, and Nathanael surrounded by old-fashioned film equipment while he delivers his monologue. For exhibition, the two takes have been spliced together and duplicated so they may be presented from a pair of projectors focused on the same screen. They are out of phase with each other by one complete rotation of the studio, and only one half of each projector's image is seen on left and right of the screen. The effect created is that of a temporal wipe. Left and right halves meet at the centre of the screen in a vertical seam that pans with little effect over Nathanael and the studio; however, as the camera passes the set, the old garden is wiped away by the new one and, later, the new is wiped away by the old; without resolution, endlessly.

Stan Douglas, Museum Haus Lange, Museum Haus Esters, Krefeld/Oktagon Verlag, Cologne, 1997.

Artist's Writings

Der Sandmann, Script 1994/97

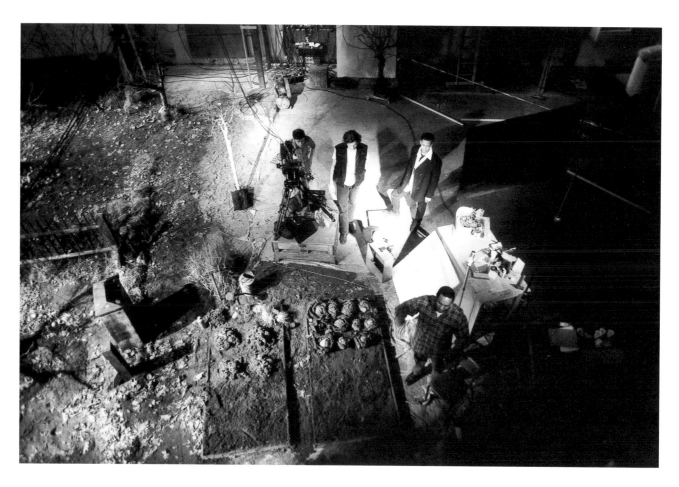

Nathanael

Dear Lothar,

It's been ages since I've written: You've got to be wondering what happened to me! And Klara, I'm sure, will think I'm up to no good. After months of travelling, I thought I should take a break – and that there would be no better place than the scene of our shared childhood. But maybe not. Something's wrong here. Whenever I stray too far from the tourist sites – I'm lost. I can't exactly say what it is but, places that once simply looked old now seem sinister. And even this attempt to describe my disorientation sounds pathetic as soon as I see it on the page in front of me.

I should get right to the point and tell you what happened. Although the mere thought of it makes me laugh – and if you were here to see my 'nemesis', you'd think I was joking! Anyway, a few days ago, on October 30th, I was walking beside the large *Kolonie* a few streets from where we used to live, when I was seized by an overwhelming sense of dread. Its cause? This is the strange part. It was nothing more evil than an old man working in his *Schrebergärten*. To be sure, he was a weird-looking old man, but it was the whole scene that got to me, it was as if I had seen it all before. He was improbably dressed in old-fashioned evening clothes draped in a long black smock, shiny from age, as he shifted and organized piles of sand, while brewing some strange-smelling concoction in a cauldron. I stood there for I don't know how long – staring – until he sent me on my way with a threatening look presumably perfected over years of practice …

What is it, Lothar, about this character that I find so disturbing? That's the thing I just can't figure out. But I do know that my fear, and my apprehension, has an origin somewhere in our childhood in Potsdam. This is why I am writing you: What is this strange old creature to me?

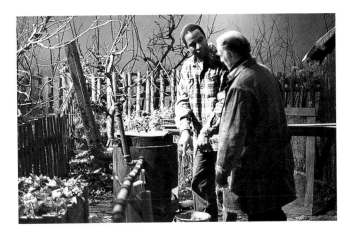

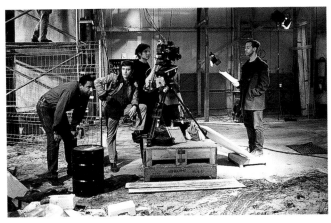

Lothar

Dear Nathanael,

What is he to you? How could you forget the 'Sandman'? Nothing and no-one scared us as much as Herr Coppelius! I remember him vividly: an ochre-yellow face with bushy eyebrows suspended over a pair of green eyes. His crooked mouth and blue lips were always in motion as he worked in his garden – muttering his secret axioms and private jokes.

Don't you remember? We were obsessed by him because of the cruel tale my brother once told me. I asked my brother what kind of man the Sandman was. He looked at me sideways then scoffed, 'Oh Lothar, don't you know that yet? He comes to children when they won't go to bed and throws handfuls of sand into their eyes till they bleed and pop out of their heads! Then … he throws the eyes into a huge sack and takes them to the dark side of the moon … where he feeds them to his own children … who sit in a nest … and have crooked beaks like owls!' I confided in you, but we were afraid to ask anyone else about this creature. We knew Coppelius was the Sandman.

Finally, we conspired to invade his garden and liberate the eyes we thought he kept hidden in his burlap sacks. We snuck out after bedtime one night and stole into the garden. Seconds after entering, you nudged me, 'Hey, look! That bush over there looks like it's coming towards us!' It was. And it was also coughing, and scraping, and talking to itself as it came: the dreaded Sandman had returned. Noticing our footprints in his pristine bed of sand he began ranting and raving even more than usual. We cautiously looked out from the shadows where we were hiding to find the Sandman filling our view. Baring his teeth, he bleated, 'Little beasts!' Then ran us out of his yard hurling stones at us and curses at our families.

And this you have forgotten?

Robert Wiene
The Cabinet of Dr Caligari
1919
90 mins., black and white, silent
Film still

Klara

Dear Nathanael,

Although it's true you haven't written for a long time, it seems I'm still on your mind – why else would you have addressed Lothar's letter to me? I must confess I realized your mistake as soon as I saw 'Dear Lothar' – and I should have resealed the envelope then and there – but I read it anyway …

I delivered your letter to Lothar in person, and you will be annoyed to hear that we talked about you all night! Our conversation brought back things that I hadn't thought about for years. Like, when we were young, there wasn't much that really frightened you, only two of the most unlikely things: this Sandman of yours and the sound of a water heater igniting. In a playful mood uncle Siggy once told us that the tiny blue flame beneath every gas water heater was the apparition of a demon trapped inside; and that that 'whoosh' of the heater igniting was the sound of the demon trying to escape. I understood your wince when you heard that sound – but I had no idea who your Sandman was until Lothar explained him to me. Even when you refused to watch those marionettes on TV, I thought you were just too 'grown-up' for that childishness – but later in the evening when mother used to say, 'Okay, off to bed! The Sandman's coming: I can already hear him!', you heard another's footsteps.

Lothar has already written to tell you that your frightful spectre is nothing more evil than the mildly nuts old gardener Coppelius – who thought he'd discovered a method of growing *spargel* out of season, without a greenhouse, by layering sandy Brandenburg soil with boiled loam and heating it all with his lunatic plumbing. Maybe the fear he inspired in you two came from his suspicion of people in general, and his disdain for children in particular. I am surprised that you kept all of this so private for so long. I'm alarmed, too, that you could have forgotten its connection to the saddest moment of our childhood: you really don't remember do you? The same night you snuck out with Lothar, mother was called from home. She came back very late. We were asleep. She woke us up to tell us father had been killed. Now I understand why you cried so desperately: '*It's my fault! It's my fault!* It was the *Sandman!* The *Sandman!*

Stan Douglas, Museum Haus Lange, Museum Haus Esters, Krefeld/Oktagon Verlag, Cologne, 1997.

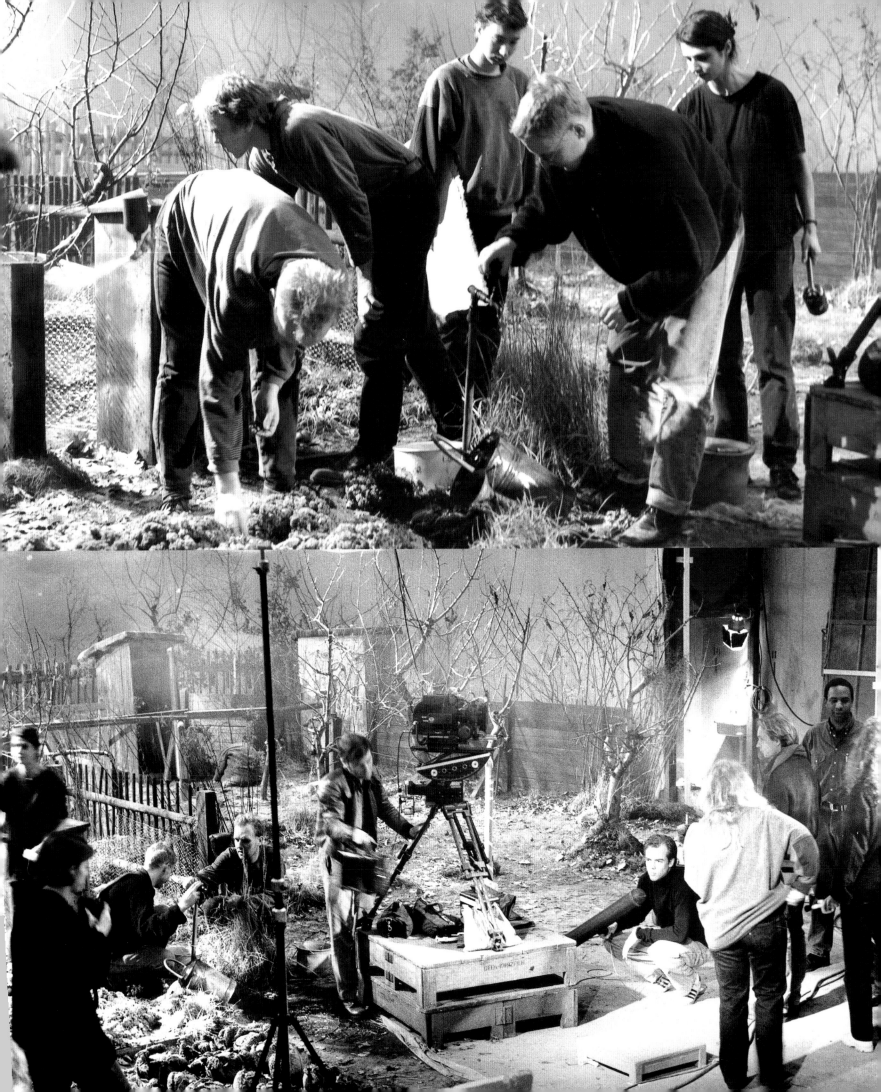

Historical Background

The Gothic romance was typically characterized by a return of the repressed: some past transgression haunts, then destroys the culpable person, family or social order. It is no surprise that these narratives flourished during the era of high imperialism – when remote and exotic areas of the world were being drawn into the European orbit and providing, if not the mise-en-scène, then at least the sublimated object of Gothic anxiety. What would contact and mingling with radically foreign cultures bring? Gothic tales answer: a decrepit clan wallows in decadence awaiting its final annihilation (*Fall of the House of Usher*); a monster appears, threatening to infect the whole of the social and natural order (*Frankenstein*); the bourgeois individual himself might become infected, and begin to display mortally morbid symptoms (*Dracula*). *Nu·tka·* is a Canadian Gothic.

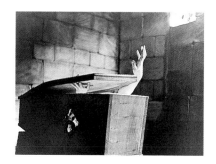

The project is set in one of the most sublime moments of the romantic period – that of first contact between natives and Europeans on the West Coast of Vancouver Island at Nootka Sound. The Spanish explorer Juan Pérez was the there first, in 1774, but it wasn't until four years later that James Cook, thanks to an abiding misunderstanding, gave the area its name. When asked by the Captain the name of his home and of his people, Chief Maquinna replied to the Englishman's unfamiliar sign language and words, 'Nu·tka·!' – meaning 'go' or 'turn-around' – suggesting that the visitor anchored at Resolution Cove could find safe harbour nearby at Yuquot or, perhaps, that he should go back to where he came from.[1]

For a few years, the 'Nootkans' (Nuu-chah-nulth) and Europeans were great trading partners – once the latter discovered what kind of prices sea otter pelts could fetch in China, and the former found that by re-routing existing trade patterns novel items such as ironwork and guns could be acquired. Ships owned by US and English companies became frequent visitors to Maquinna's summer village of Yuquot at the northern entrance to the Sound but, when rumour that the Russians had begun to move south from the Aleutian Islands reached New Spain, the Spanish would be compelled to return. On 17 February 1789, Estéban José Martínez was dispatched from San Blas with two hastily outfitted ships and instructions to establish a colony at Nootka Sound, and the ultimate goal of claiming the entire northwest coast of North America for the Spanish Crown – thus preventing England or Russia from doing the same.

As Martínez's *Princessa* approached Yuquot on May 4 its captain found, to his dismay, three vessels already anchored in the vicinity of the bay Cook named 'Friendly Cove': US trading vessels the *Columbia* and the *Lady Washington* and a ship with a

Ivan Barnett

The Fall of the House of Usher

1950

70 mins., black and white

Film still

Tod Browning

Dracula

1931

84 mins., black and white

Film still

James Whale

Frankenstein

1931

71 mins., black and white

Film still

Scottish Captain and English crew, although flying Portuguese colours, the *Ifigenia Nubiana*. Martínez spent the next few days reacquainting himself with Maquinna (whom he had met during Pérez' 1774 voyage) and introducing himself to his cagey harboured colleagues; but once the *Princessa*'s Companion vessel, the *San Carlos*, arrived on the twelfth, Martínez felt confident enough to react to a disturbing passage he had read in the *Ifigenia*'s papers: licence to attack and capture Spanish vessels. As the *Ifigenia*'s Portuguese flag was being replaced by that of Spain, the Mowachaht people of Yuquot became aware of the growing, and potentially violent, tensions between their European guests and moved the village a few miles up the outside coast.

Since he did not yet have the means to incarcerate prisoners, Martínez instructed his prize to sail to Macao under its own recognizance and to pay the ship's value to the Spanish crown – an order was disobeyed as soon as the *Ifigenia* was out of sight. Instead of heading south, it sailed immediately north, continued trading furs as before, then crossed the Pacific for China. When the ship arrived in Canton, its employer, John Mears, was informed of the *Ifigenia*'s adventure; and because he believed he had already claimed the Sound for England when he built a packet there the previous autumn, began a process of petition that would later bring Spain and England to the brink of war.

On 24 June, Martínez conducted the formal possession ceremony – an address to the land, the moving of stones and cutting of trees – but only a week later, on 2 July, his claim would be challenged by the arrival of another of Mears' vessels, the *Argonaut* captained by James Colnett. Negotiation began with civility but soon devolved into a violent argument over authority and status with Martínez, the highest ranking

Friendly Cove, British Columbia

c. 1925

Black and white photograph

Artist's archival material

Friendly Cove, Nootka Sound and Nootka Island

c. 1820

Map

Artist's archival material

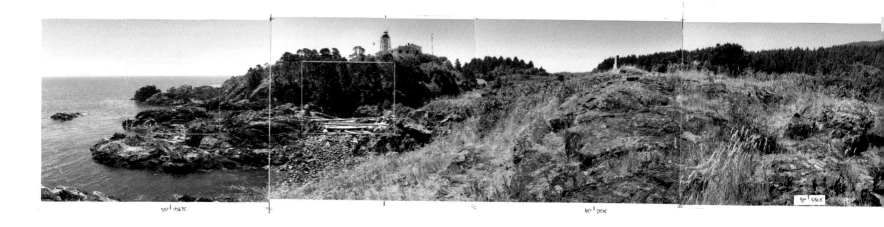

Nu • tka •
1996
C-print, crayon, ink
25.5 × 230 cm
Pre-production photographic
sketch

representative of his Catholic majesty on the northwest coast, refusing the challenge of a man he regarded as an employee of a trading company. When Colnett declared that the Sound was British territory, and that he had come to build fortifications, Martínez informed him that he had no alternative but to detain him as a prisoner of war.

Around 9 July, the English Captain entered into a paranoid delirium. He was agonized by his failure to complete his enterprise and, under the conviction that he was about to be hung, twice tried to commit suicide by drowning. Chief Callicum of Clayoquot Sound, who knew the English as reasonable trading partners, did not enjoy seeing his economic options limited. He decided to let Martínez know what he thought of him and, egged on by Colnett, began a tirade against the Commandant, calling him a thief and a liar. Irritated that the Chief could not be assuaged by the promise of gifts, Martínez fired a 'warning shot', but one of the *Princessa's* crew, assuming that the Commander had missed his mark, took aim and shot Callicum dead. Disgusted by this assassination, Maquinna lead his people further away from Yuquot and vowed never again to have commerce with Martínez and the Spanish garrison. On 12 July, when the refitted Argonaut and its prisoner-crew were ready for transport, its companion vessel, the *Princess Royal* came into sight. After some subterfuge, it too was arrested and on 14 July 1789, as Parisian crowds were challenging the very foundation of aristocracy by putting the Enlightenment's principle of democracy into action, the two English ships embarked for the Department of San Blas, a possession of the Spanish crown.

Even though he had received orders to abandon the fort at Yuquot, Martínez had by late summer devised a grandiose scheme in which San Miguel would be the first of four presidios and sixteen missions – a huge monopoly trading company that would dominate commerce all along the west coast of North America. The Commandant had hoped that the incoming Viceroy would rescind his predecessor's orders. But as the October rains began to set in, Martínez, who was still shunned by the natives and had not yet received support from San Blas, decided to abandon his settlement and head south. When he arrived in New Spain, Martínez was informed of explicit imperial instructions to maintain the outpost at Nootka – but since news of Callicum's assassination had reached, and scandalized, the Spanish public, it was clear that he would not return.

On 3 April 1790, Francisco Eliza arrived with three ships that would re-establish the Spanish presence at Nootka. After much negotiation, and assurances that Martínez was

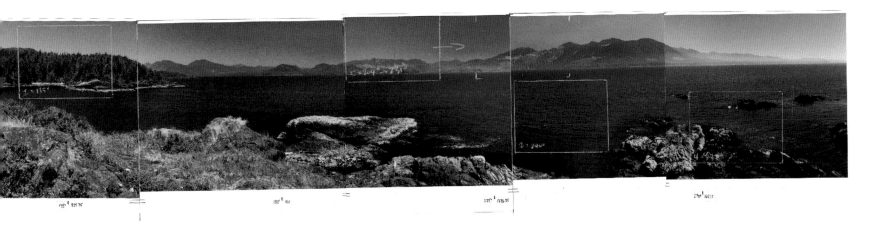

no longer in charge, Eliza was able to develop an amicable trading relationship with Maquinna and other Nuu-chah-nulth leaders. But an ocean away, John Mears had journeyed to London where he presented an embellished narrative of his stay at Yuquot and the capture of his (recently released) trading vessels to the Houses of Parliament. Mears' tale precipitated the so-called, 'Nootka Controversy', which lead the Spanish and English empires to threaten each other with military reprisal over the next four years. However, by 1795, in consideration of the remoteness of Nootka Sound and the growing US presence in the area, both powers signed the third Nootka Convention agreeing that neither would occupy the northwest coast. In March, English representative Thomas Pearce and his Spanish correspondent, José Manuel de Álava, witnessed each other ceremonially raising and lowering his nation's flag – and the Spanish presence came to an end.

With the absence of Europeans on the west coast of Vancouver Island, trade there was dominated by the ships from the US, but after 1803 that too came to an abrupt halt once news spread about the massacre of the *Boston* at the hands of Maquinna's warriors. The chief of the Mowachaht Confederacy had endured many insults from Europeans, but when the US ship's captain, John Salter, swore at and insulted Maquinna to his face (expecting that he couldn't speak English), this was the final blow that lead to an attack killing all but two of the ship's crew. One of these, John R. Jewitt, eventually escaped to publish a captivity narrative recounting the twenty-eight months this blacksmith endured as Maquinna's slave.

Jewitt proposes that the massacre of his colleagues was retribution for fourteen years of European transgression – lies, theft, murder – but a recent oral history suggests that an additional injury was the cause of the wrath of a chief noted for his diplomacy. While the Spanish were still at Yuquot, they began regularly raping Nuu-chah-nulth women and torturing, with red-hot iron rods, those who resisted. It was for this (as well as a way to reassert the autonomy of his people) that Maquinna wanted revenge and awaited a pretext. The same speaker also has an alternative account of why San Miguel was abandoned: the Spanish found tiny sailing vessels occupied by living, homuncular sailors at the bottom of the well they used for drinking water. They immediately filled the well with stones and quit Yuquot.

Project Description

Nu·tka· is a video installation in which two distinct images are interlaced on the same screen – weaving one image track, visible on the 'even' raster lines of a video projection with another, presented on 'odd' raster lines. These video tracks are played from disc, continually looping, with a quadraphonic soundtrack: two disembodied voices that drift around the exhibition space as they recount distinct narratives, which, like the images, are woven into one another, sometimes speaking simultaneously and sometimes in exact synchronization. The work is set in the late nineteenth century at Nootka Sound, with conflicting tales told by the Commandant of Yuquot's first Spanish occupation, José Estéban Martínez, and by his captor, the English Captain James Colnett – each of whom believed he had the right to claim land already occupied by a peculiarly 'absent' third party, Chief Maquinna and the people of the Mowachaht Confederacy. In monologues derived from historical documents and their personal journals, the delirious Englishman alternates between recollection of his capture and the fantasy of escape, while the Spanish commander betrays signs of paranoia as he becomes increasingly uncertain of his ability to dominate the region.

The two image tracks were shot on 35 mm film in two continuous takes from a vantage point on San Miguel Island, the original Spanish defensive site at Yuquot. The interlaced images are mostly in continual motion, panning and tilting, presenting various features of Nootka Sound – but they briefly come to rest, and into exact registration, on six occasions. At these moments, the uncanny apparition of a landscape subject to conflicting winds and opposing tides is seen. Concurrently, one hears Colnett and Martínez describing their respective delusions in exact synchronization with exactly the same words (excerpts from the Gothic and colonial literatures of Edgar Allan Poe, Cervantes, Jonathan Swift, Captain James Cook and the Marquis de Sade). As the narrators go their separate ways – recounting their contempt for one another and inability to endure the situation in which they find themselves – the interlaced image pulls apart also. Outside of the six synchronous moments the narratives, like images, are blurred, doubled, and, at a limit of legibility, sublime.

1 What Maquinna actually said to Cook is uncertain because 'Nu·tka·' is not a complete word; however,

 Mowachat words beginning with these two syllables tend to refer to circular motion.

Stan Douglas, Museum Haus Lange, Museum Haus Esters, Krefeld/Oktagon Verlag, Cologne, 1997.

opposite, **Nu • tka •**
1996
Video installation
Single-channel video,
quadraphonic soundtrack
6 mins., 50 secs. each rotation
Dimensions variable
Installation, Solomon R.
Guggenheim Museum, New York
Collection, Solomon R.
Guggenheim Museum, New York

overleaf, **Abandoned Wharf at Nootka Cannery, overlooking Nootka Channel**, from **Nootka Sound**
1996
C-print photograph
46 × 91.5 cm
From the series of 30 prints,
various dimensions
Collections, Solomon R.
Guggenheim Museum, New York;
National Gallery of Canada,
Ottawa

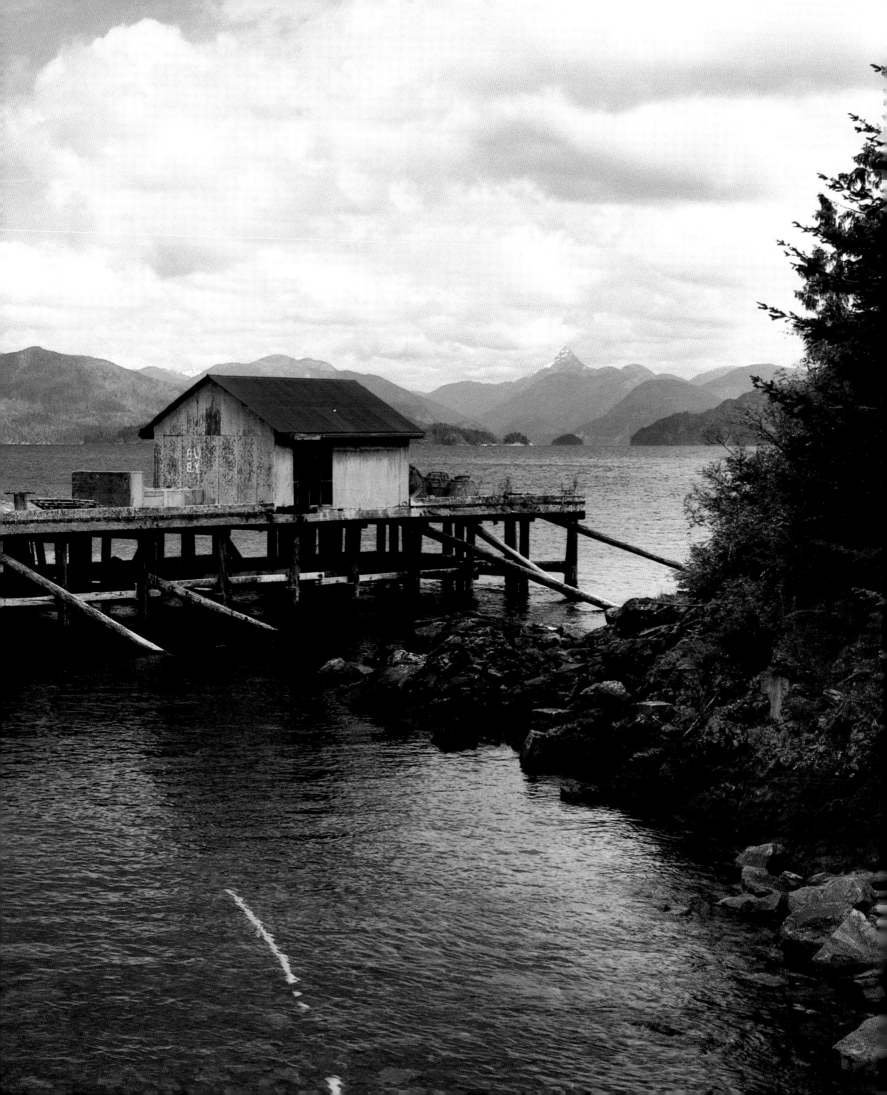

Project for the RIAGG, Zwolle 1996

In spite of any claims that they can describe universal conditions of the human subject, psychoanalytical concepts and techniques are necessarily historical and culturally specific. The success of Behaviourism in mid-century Europe likely had more to do with the grim prospect of post-war reconstruction than many of its adherents would like to admit, just as Freud may not have catalogued the basic narratives of human socialization, although he certainly did create an extremely detailed portrait of his clientele, the Viennese bourgeoisie of the late nineteenth century. Holland has a peculiar psychoanalytic tradition which, based upon the fragmentation of its society, was not preoccupied with basic structures, but instead with the complex and contingent relationship between a citizen and their societal pillar. A social portrait as detailed as Freud's was in fact developed by the Dutch therapist Querrido in the early post-war period when he proposed a method of social psychology directly out of the example of Dutch society. His key work, *Introduction to Integral Medicine*, made the reasonable, but until then unfortunately rare, propositions: that it may not only be a patient's interior experiences but also their exterior relationships that are the cause of crisis; and that the 'equilibrium' which he regarded as the goal of therapy could only be achieved in consideration of these two domains.

The argument of *Introduction to Integral Medicine* evolved out of a series of interviews with psychiatric patients in the months following their release from hospital. The first cases examine how respondents were recovering from more or less somatic illnesses, but the studies that conclude the book narrate recoveries which had been inhibited by extrinsic factors: economic problems as well as conflicts within familial, religious and social relations. Elaborating on Querrido's conception, one could suggest that psychotherapy is an attempt to discern that liminal space, or border, which demarcates inside and outside – self and other – and how this border may be shared by both parties. Likewise, this project for the RIAGG, Zwolle, takes as axiomatic the proposition that a city, much like a human subject, might be best understood from its periphery. Once the manner in which a city or person distinguishes itself from its surroundings is discovered, in that zone where it is no longer self-identical, one can begin to understand how the community or individual tacitly conceives of itself. The project will both represent and have intrinsic to its structure these dynamics of identity and difference, of individual and community. The RIAGG (Regional Institute for Community Mental Health Care) is situated on the banks of the Zwarte Water – a river that, a few hundred metres east, flows around what remains of Zwolle's seventeenth-century walls and in the opposite direction is traversed by a highway that connects the

Project for the RIAGG, Zwolle
1996
C-print
28 × 35.5 cm
Location photograph

Project for the RIAGG, Zwolle
1996
C-print
35.5 × 28 cm
Model for the project, Münster,
Germany

Netherlands from north to south. The Centre is literally at the city's margin – just as its crucial function is the negotiation of another liminal space: the permeable membrane that is an individual's coincidence with their community.

A pair of projection screens, 4.2 metres wide by 5.6 metres tall, will be mounted on top of the RIAGG's elevator shaft, integrated with the existing architecture, and positioned back-to-back: with one screen facing the highway, and the other inflected toward Zwolle's market square. From dusk until dawn, pedestrians in the city centre will be presented with images of people engaged in conversation in peculiar locations at Zwolle's expanding periphery, while motorists on the highway will see conversants in the old town's narrow intersections and *cul de sacs*. All of the conversations will be dramatic condensations of a selection of the 1,630 interviews conducted in preparation for *Introduction to Integral Medicine*, however the interviewer will be absent. These discursive fragments – questioning, affirming, explaining, listening, etc. – will be performed in a studio by a company of actors, shot individually in medium and close shots, then composited into their settings, at Zwolle's centre or margin, and mastered on video disc.

The montage on both screens will be generated in real time by computer-controlled disc players programmed in accordance with the so-called 'Kuleshov Effect' – the fact that each time the same set of cinematic materials is recombined in a different order, its affective character changes. Thus, the three hundred or so video segments to be presented on each screen can be combined in such a way that the sequence of montage will only repeat itself after a period of twenty-five hours. And these indeterminate dramas, projected onto screens marking a point both inside and outside the city of Zwolle, will be timed so that it would likely take six months before a person travelling on the highway or visiting the city centre at the same time every day saw the same conversation – that continuous process of negotiation which is an individual's relationship to their community.

Skulptur Projekte in Münster, Verlag Gerd Hatje, 1997, pp. 127-28.

Contents

Interview Diana Thater in conversation with Stan Douglas, page 6. Survey Scott Watson

Against the Habitual, page 30. Focus Carol J. Clover Der Sandmann, page 68. Artist's

Choice Gilles Deleuze Humour, Irony and the Law, 1967, page 80. Artist's Writings

Stan Douglas Television Spots, 1987–88, page 90. Goodbye Pork-Pie Hat, 1988, page 92. Monodramas, 1991, page 100. Hors-

champs, 1992, page 110. Pursuit, Fear, Catastrophe: Ruskin, BC, 1993, page 112. In conversation with Lynne Cooke, 1993, page 116.

Evening, 1994, page 122. Der Sandmann, 1995, page 124. Der Sandmann, Script, 1995, page 128. Nu•tka•, 1996, page 132.

Project for the RIAGG, Zwolle, 1996, page 140. Chronology page 144 & Bibliography, List of

Illustrations, page 158.

Selected exhibitions and projects
1979-87

1979–82
Studies (Interdisciplinary Department), **Emily Carr College of Art**, Vancouver, British Columbia

1982
'Helen Pitt Graduate Award',
Robson Square Media Centre, Vancouver

1983-84
Works as a disc jockey at Faces night club, Vancouver

1983
'Slideworks',
Ridge Theatre, Vancouver (solo)

'PST: Pacific Standard Time',
organized by YYZ Gallery, Toronto, **The Funnel Experimental Film Theatre**, Toronto; **Western Front**, Vancouver (group)

'Vancouver: Art and Artists 1931–1983',
Vancouver Art Gallery, Vancouver (group)
Cat. *Vancouver: Art and Artists 1931–1983*, Vancouver
Art Gallery, Vancouver, texts Jo-Anne Birnie Danzker,
Lorna Farrell-Ward, Scott Watson et al.

1985
'Panoramic Rotunda',
Or Gallery, Vancouver (solo)

1986
'Onomatopoeia',
Western Front, Vancouver (solo)

'Mechanics of Memory',
Surrey Art Gallery, Surrey, Canada (group)
Cat. *Mechanics of Memory*, Surrey Art Gallery, Surrey,
Canada, text Jane Young

'Songs of Experience',
National Gallery of Canada, Ottawa (group)
Cat. *Songs of Experience*, National Gallery of Canada,
Ottawa, texts Jessica Bradley, Diana Nemiroff

'Broken Muse',
Vancouver Art Gallery, Vancouver (group)
Cat. *Broken Muse*, Vancouver Art Gallery, texts Helga
Pakasaar, Keith Wallace

'Camera Works',
Or Gallery, Vancouver (group)

1987-90
Board member of the **Or Gallery**, an artist-run centre,
Vancouver

1987
'Stan Douglas: Perspective '87',
Art Gallery of Ontario, Toronto (solo)
Broadcast, **CHCH**, Hamilton, Ontario
Cat. *Stan Douglas: Perspective '87*, Art Gallery of
Ontario, Toronto, text Barbara Fischer

Selected articles and interviews
1979-87

1982
Barb, Daniel, 'Stan Douglas', *Vanguard*, Vancouver,
September

1983

1985
Watson, Scott, 'The Afterlife of Interiority: Panoramic
Rotunda', *C Magazine*, Toronto, Summer

1986
Culley, Peter, 'Dream as Dialectic: Two Works by Stan
Douglas', *Vanguard*, Vancouver, September/October,
1987

Laing, Carol, 'Songs of Experience', *Parachute*,
Montreal, September/November
Wood, William, 'Skinjobs', *C Magazine*, Toronto,
Summer
Tourangeau, Jean, 'Sins of Experience', *Vanguard*, Vol
15, No 6, Vancouver, Winter, 1987

Young, Jane, 'Broken Muse', *C Magazine*, Toronto,
Summer, 1987

Lawlor, Michael, 'Camera Works', *Parachute*, Montreal,
June/August, 1987

1987
Day, Peter, 'Perspective '87: Stan Douglas', *Canadian
Art*, Vol 4, No 3, Toronto, Fall/September
Gale, Peggy, 'Stan Douglas: Perspective '87', *Canadian
Art*, Spring, 1988

Selected exhibitions and projects
1988-89

1988-92
'Samuel Beckett: Teleplays'
Vancouver Art Gallery, Vancouver (curator), toured to
Power Plant, Toronto; **Walter Phillips Gallery**, Banff;
National Gallery of Canada, Ottawa; **Winnipeg Art
Gallery**, Manitoba; **Museum of Contemporary Art**, Los
Angeles ; **EXIT Art**, New York; **Alberta College of Art**,
Calgary, Alberta; **Australian Centre for Photography**,
Sydney; **Dalhousie University Art Gallery**, Halifax,
Nova Scotia; **London Regional Art Gallery**, London,
Ontario; **Art Gallery of Algoma**, Sault Ste. Marie,
Ontario; **Dunlop Art Gallery**, Regina, Saskatchewan;
Owens Art Gallery, Sackville, New Brunswick; **Prairie
Gallery**, Grande Prairie, Alberta; **Edmonton Art
Gallery,** Alberta; **Centro per l'Arte Contemporanea
Luigi Pecci**, Prato, Italy; **Galerie Nationale du Jeu de
Paume**, Paris; **Musée Cantini**, Lyon; **Teatro Franco
Parenti**, Milan
Book, *Samuel Beckett: Teleplays*, Vancouver Art Gallery,
Vancouver, ed. Stan Douglas, texts Samuel Beckett,
Linda Ben-Zvi, Clark Coolidge, Stan Douglas, Willard
Holmes

1988
'Television Spots (First Six)',
Artspeak Gallery, Vancouver (solo)

'Television Spots (First Six)/Overture',
Optica - Un Centre d' Art Contemporain, Montreal
(solo)

'Behind the Sign: Collaboration Between Writers and
Visual Artists',
Artspeak Gallery, Vancouver (group)
Cat. *Behind the Sign: Collaboration Between Writers
and Visual Artists*, Artspeak Gallery, Vancouver, texts
Cate Rimmer, Stan Douglas, Deanna Ferguson, Scott
Watson, Miriam Nichols, et al.

Book *Link Fantasy*, with Deanna Ferguson, Artspeak
Gallery, Vancouver

'Made in Camera',
organised by VAVD Editions, **Galleri Sten Eriksson and
Lido**, Stockholm (group)
Cat. *Made in Camera*, VAVD Editions, Stockholm, texts
David Robins, Barbara Fischer, et al.

'Television Spots/Subject to a Film: Marnie (studies)',
Contemporary Art Gallery, Vancouver (solo)
Cat. *Stan Douglas. Television Spots*, Contemporary Art
Gallery, Vancouver, text Miriam Nichols

LINK FANTASY

*Stan Douglas
Deanna Ferguson*

1989
'Subject to a Film: Marnie/Television Spots',
YYZ Gallery, Toronto (solo)

Residency at the **Banff Centre for the Arts**,
Banff, Canada

Selected articles and interviews
1988-89

1988-92
Zazlove, Arne, 'Samuel Beckett's Teleplays', *C
Magazine*, Toronto, Autumn, 1989

1988

Culley, Peter, 'Window Dressing', *Vanguard*, Vancouver,
April/May
Harris, Mark, 'Stan Douglas', *C Magazine*, Toronto,
Spring, 1989
Henry, Karen, 'Television Spots', *Parachute*, Montreal,
July/August, 1989

Watson, Scott, 'Zweimal Canada Dry – Sechs Künstler
aus Vancouver', *Wolkenkratzer Art Journal*, Berlin,
March/April

1989
Hoolbloom, Mike, 'Stan Douglas Talks at YYZ',
Independent Eye: Leading the Theatre, Vol 10, No 2,
Toronto, Winter

Stan Douglas

Television Spots

Selected exhibitions and projects
1989-90

'The Vancouver Exchange',
Cold City Gallery, Toronto, (group)

'Biennial Exhibition of Contemporary Canadian Art',
Musée des Beaux Arts du Canada, Ottawa, (group)
Broadcast, **CBOT**, Ottowa
Cat. *Biennial Exhibition of Contemporary Canadian Art*,
Musée des Beaux Arts du Canada, Ottawa, text Diana
Nemiroff

Lecture, *Shades of Masochism: Samuel Beckett's
Teleplays*, **National Gallery of Canada**, Ottawa

'Photo Kunst',
Staatsgalerie, Stuttgart, Germany (group)
Cat. *Photo Kunst*, Staatsgalerie, Stuttgart, Germany,
text Jean-François Chevrier

1990
'Passage de l'image (video program)',
Musée national d'art moderne, Centre Georges
Pompidou, Paris, toured to **Fundació La Caixa de
Pensions**, Barcelona (group)
Cat. *Passage de l'image (video program)*, Musée
national d'art moderne, Centre Georges Pompidou,
Paris, texts Christine van Assche, Raymond Bellour,
Catherine David

'Re-enactment, Between Self and Other',
The Power Plant, Toronto (group)
Cat. *Re-enactment, Between Self and Other*, The Power
Plant, Toronto, text Barbara Fischer

'Issues in Contemporary Video',
Mendel Art Gallery, Saskatoon, Canada (group)
Broadcast, **STV**, Saskatoon, Canada

'The Eighth Biennale of Sydney: The Readymade
Boomerang: Certain Relations in 20th Century Art',
Art Gallery of New South Wales, Sydney (group)
Cat. *The Eighth Biennale of Sydney: The Readymade
Boomerang: Certain Relations in 20th Century Art*, Art
Gallery of New South Wales, Sydney, texts René Block,
et al.

Lecture, *Shades of Masochism (revised version)*,
Australian Centre for Photography, Sydney

'Aperto '90',
XLIV Venice Biennale(group)
Cat. *Aperto '90, Biennale di Venezia*, Venice, texts
Bernard Blistene, Stuart Morgan, Linda Shearer, et al.

Lecture series, *Vancouver Anthology*, on recent history
of art in British Colombia, Western Front, sponsored by
the Or Gallery, Vancouver (organiser)

Lecture, *Public Art in a Nutshell*, Politics of the Image,
Dia Center for the Arts, New York

'Privé/Public: Art et Discours Social',
Winnipeg Art Gallery, Canada, toured to **Galerie d'art
Essai** and **Galerie du Cloître**, Rennes, France (group)
Broadcast, **TV Rennes**, Rennes, France
Cat. *Private/Public. Privé/Public*, Winnipeg Art Gallery,

Selected articles and interviews
1989-90

Danzker, Jo-Anne Birnie, 'The Beauty of the Weapons',
Canadian Art, Toronto, Autumn

1990

Gagnon, Monika, 'Re-enactment; Between Self and
Other', *C Magazine*, Toronto, Summer

Issues in Contemporary Video

This is the first in a Mendel Art Gallery series of exhibitions and special events which will address issues in the production and interpretation of contemporary video art. This exhibition speaks particularly to the role of narrative in contemporary video production. Subsequent exhibitions will focus on formal techniques and thematic groupings. With these four videotapes, viewers are invited to consider the fundamental differences between the conventions of narrative in commercial television and film, and those used by video artists.

Selected exhibitions and projects
1990-92

Winnipeg, Canada, text Shirley J. R. Madill

'Trois installations cinématographiques',
Ambassade du Canada, Services culturels, Paris (solo)

1991
'The Projected Image',
San Francisco Museum of Modern Art, San Francisco
(group)
Cat. *The Projected Image*, San Francisco Museum of
Modern Art, San Francisco, text Robert R. Riley

'Regina Work Project: Working Truth/Powerful Fiction',
Mackenzie Art Gallery, Regina, Canada (group)
Cat. *'Working Truth/Powerful Fiction*, as part of the
Regina Work Project, Mackenzie Art Gallery, Regina,
Canada, texts Jessica Bradley, Cindy Richmond

Book, *Vancouver Anthology: the Institutional Politics of
Art*, (A project of the Or Gallery), Talonbooks,
Vancouver (designer and editor)

'Monodramas, vidéos de Stan Douglas',
Galerie Nationale du Jeu de Paume, Paris (solo)

'Trois Installations cinématographiques',
Canadian Embassy, Paris (solo)

'Schwarze Kunst: Konzept zur Politik und Identität',
Neue Gesellschaft für bildende Kunst, Berlin (group)
Cat. *Schwarze Kunst*, Realismus Studio der NBK, Berlin,
texts Frank Wagner, Hilton Als, Yasmin Ramirez

'Northern Lights: An Exhibition of Canadian Video Art',
Canadian Embassy, Tokyo, toured to **Nagoya City Art
Museum**, Japan; **Hakkaido Museum of Modern Art**,
Sapporo, Japan (group)
Cat. *Northern Lights*, Canadian Embassy, Tokyo, text
Peggy Gale

1992
'Monodramas and Loops',
UBC Fine Arts Gallery, Vancouver(solo)
Cat. *Monodramas and Loops*, UBC Fine Arts Gallery,
Vancouver, texts Scott Watson, John Fiske

'Documenta IX',
Kassel, Germany (group)
Cat. *Documenta IX*, Kassel, Germany, texts Jan Hoet, et
al.

'The Creation ... of the African-Canadian Odyssey',
The Power Plant, Toronto (group)
Cat. *The Creation ... of the African-Canadian Odyssey*,
The Power Plant, Toronto, text Nkiru Nzegwu

Talk, *Television Talk*, **Video In**, Vancouver; **Art
Metropole**, Toronto

'Monodramas',
Art Metropole, Toronto (solo)
Broadcast, **CKVR-TV**, Toronto

Selected articles and interviews
1990-92

1991
Reveaux, Tony, 'Fleeting Phantoms: the Projected
Image at SFMOMA', *Art Week*, New York, March
Joselit, David, 'Projected Identities', *Art in America*,
New York, November, 1992

Verjee, Zainub, 'Vancouver Anthology', *Front*,
Vancouver, November/December
Fetherling, Douglas, 'Vancouver Anthology', *Canadian
Art*, Vol 9, No 3, Toronto, Autumn, 1992
O'Brian, John, 'Vancouver Anthology', *Parachute*, No
66, Montreal, April/June, 1992

1992

Rhodes, Richard, 'Documenta IX', *Canadian Art*, Vol 9,
No 3,Toronto, Autumn
Royoux, Jean-Christophe, 'Documenta IX: the Call of
the Phrase', *Galeries*, No 50, Paris, August/September

Nzegwu, Nkiru, 'The Creation of the African-Canadian
Odyssey', *The International Review of African American
Art*, Vol 10, No 1, Toronto, Spring

Taylor, Kate, 'Out of the gallery and into the world of
television', *The Globe and Mail*, Toronto, November

Bosseur, Jean-Yves, *Le sonore et le visuel: Intersections
musique/arts plastiques aujourd'hui*, Dis Voir, Paris

Selected exhibitions and projects
1993-94

1993
'Working Drawings',
Artspeak Gallery, Vancouver (group)

'Hors-champs',
David Zwirner, New York.(solo)

'Hors-champs',
Transmission Gallery, Glasgow (solo)

'Hors-champs',
World Wide Video Centre, The Hague, The Netherlands
(solo)

'Canada – une nouvelle génération',
Musée des Beaux Arts, and **FRAC Franche-Comté**,
Dole, France (group)
Cat. *Canada – une nouvelle génération*, FRAC des Pays
de la Loire, Dole, France, texts Anne Dary, Jean-
Francois Taddei, Marc Mayer, Catherine Bédard

'Monodramas',
Galerie Christian Nagel, Cologne (solo)

Project, 'Police Daily Record', *frieze*, No 12, London,
September

'Behind the Signs',
Artspeak Gallery, Vancouver (group)
Cat. *Behind the Signs*, Artspeak Gallery, Vancouver
texts Cate Rimmer, Scott Watson, Miriam Nichols

'Tele-Aesthetics',
Procter Art Center, Bard College, Annandale-on-
Hudson, New York (group)
Cat. *Tele-Aesthetics*, Procter Art Center, Bard College,
Annandale-on-Hudson, New York, text Sandra Antelo-
Suarez, Bill Jones

'Out of Place',
Vancouver Art Gallery, Vancouver (group)
Cat. *Out of Place*, Vancouver Art Gallery, Vancouver,
texts Gary Dufour, Peter Culley, et al.

'Gent te Gast, de keuze van Jan Hoet uit de collectie
van het Museum van Hedendaagse Kunst in Gent',
De Beyerd, Breda, The Netherlands (group)

'Self Winding',
Sphere Max, Tokyo (group)

1994
'Stan Douglas',
Centre Georges Pompidou, Paris, toured to **Museo
Nacional Centro de Arte Reina Sofia**, Madrid;
Kunsthalle, Zurich, **Witte de With**, Rotterdam;
Deutscher Akademischer Austauschdienst, Berlin
(solo)
Cat. *Stan Douglas*, Centre Georges Pompidou, Paris,
France, texts Christine van Assche, Jean-Christophe
Royoux, Peter Culley

Selected articles and interviews
1993-94

1993

Büchler, Pavel, 'Digging it', *Creative Camera*, No 324,
London, October/November

Stals, José Lebrero, 'Stan Douglas: Christian Nagel',
Flash Art, Milan, no 173, November/December

Cooke, Lynne, 'Broadcast Views. Stan Douglas
interviewed by Lynne Cooke', *frieze*, London,
September/October
Luca, Elisabetta, 'Stan Douglas', *Juliet Art Magazine*,
No 64, Trieste, October/November

1994
Fargier, Jean-Paul, 'Charmants Fantomes', *Le Monde*,
Paris, 13 January, under 'Arts et Spectacles'
Lebert, Muriel, 'Stan Douglas. La Situation du
Spectateur dans l'Oeuvre', *Artefactum*, No 52,
Antwerp, Summer
Pieters, Din, 'Fascinerende tv-en filmbeelden in Witte
de With', *NRC Handelsblad*, Rotterdam, October
Pontzen, Rutger, 'Plotloze films uit Terminal', *Vrij
Nederland*, Amsterdam, September

Selected exhibitions and projects

1994

Cat. *Stan Douglas*, Museo Nacional Centro de Arte
Reina Sofia, Madrid, Spain, text Christine van Assche

'Hors-champs/Matrix 123',
Wadsworth Atheneum, Hartford, Connecticut (solo)

'Stan Douglas',
Macdonald Stewart Art Centre and **Art Gallery of York
University**, Guelph and Toronto (solo)
Cat. *Stan Douglas*, Macdonald Stewart Art Centre and
Art Gallery of York University, Guelph and Toronto

'Beeld/Beeld (Image/Image)',
Museum van Hedendaagse Kunst, Ghent, Belgium
(group)

'Stain',
Galerie Nicolai Wallner, Copenhagen (group)
Cat. *Stan Douglas, Douglas Gordon, Joachim Koester*,
Galerie Nicolai Wallner, Copenhagen, text Simon
Sheikh

Artist's residency, **Deutscher Akademischer
Austauschdienst**, Berlin

'Neither Here Nor There',
Los Angeles Contemporary Exhibitions, Los Angeles
(group)

'Summer Group Show',
David Zwirner, New York

'2,198,062',
Theoretical Events, Naples (Group)

'Hors-champs',
Contemporary Art Museum, Houston (solo)

'Stan Douglas',
Institute of Contemporary Arts, London (solo)

'Notational Photographs',
Metro Pictures and **Petzel/Borgmann Gallery**, New
York (group)

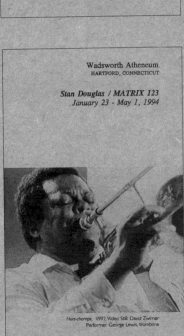

Wadsworth Atheneum.
HARTFORD, CONNECTICUT

Stan Douglas / MATRIX 123
January 23 - May 1, 1994

Hors-champs, 1992 Video Still: David Zwirner
Performer: George Lewis, trombone

This MATRIX exhibition is supported
by funds from Aetna Life & Casualty
and the LEF Foundation.

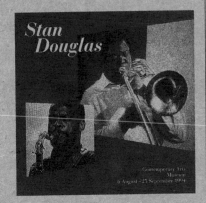

Stan Douglas

Contemporary Arts
Museum
6 August - 25 September 1994

Selected articles and interviews

1994

Roos, Robert, 'Anders omgaan met film en video',
Trouw, Amsterdam, September
Sarrazin, Stephen, 'Le Cadet de la föret: Spoorzoeken
in het werk van Stan Douglas', *Metropolis*, Utrecht,
August
Schwartz, Ineke, 'Beeldende kunst blijft te vaak op
afstand', *De Volkskrant*, Amsterdam, September
Vergne, Philippe, 'Stan Douglas: Musee national d'Art
Moderne, Centre Georges Pompidou', *Parachute*, no 74,
Montreal, April–June
Vogel, Sabine V., 'Lesen auf der Rückseite der Bilde',
Frankfurter Allgemeine Zeitung, No 222, Frankfurt,
September
Welling, Dolf, 'Overrijk aanbod van tentoonstellingen',
Rotterdams Dagblad, Rotterdam, September
Vogel, Sabine B., 'Review: Kunsthalle Zurich',
Artforum, New York, January
Vogel, Sabine B., 'Fehlgeschlagene Utopien: Interview
mit dem Videokünstler Stan Douglas', *Zitty*, Berlin,
March , 1995
Berg, Ronald, 'Das Monodrama im Monitor',
Tagesspiegel, Berlin, 15 February

McNally, Owen, 'Freedom Rings', *The Hartford Courant*,
Hartford, Connecticut, 21 January

Rudolfs, Harry, 'Douglas Loops and Splits in Guelph
and Downsview', *Excalibur*, York University, North York,
Ontario, March

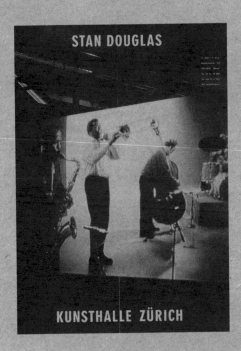

STAN DOUGLAS

KUNSTHALLE ZÜRICH

Stan Douglas

Art Gallery of York University
February 23 to March 27, 1994
Macdonald-Stewart Art Centre

ICΛ

Cork, Richard, 'Unhappy case of nostalgia', *The Times*,
London, September
Elwes, Catherine, 'Stan Douglas at the ICA', *Art
Monthly*, No 180, London, October
Lewis, Ben, 'Stan Douglas', *What's On*, London,
September

'Les Absences de la Photographie',
Institut Goethe, Montreal (group)
Cat. *Les Absences de la photographie*, Cinema libre,
Montreal, text Nicole Gingras

'Minima Media, Medienbiennale', 2nd Media Biennale
of Leipsig (group)
cat.*Minima Media, Medienbiennale*, text Dieter Daniels,
Inke Arnes, et al.

'In the Field: Landscape in Recent Photography',
Margo Leavin Gallery, Los Angeles (group)

Canadian Artist's Network: Black Artists in Action,
Toronto (group)

'Currents 24: Pursuit, Fear, Catastrophe: Ruskin BC',
Milwaukee Art Museum, Milwaukee (solo)
cat. *Currents 24: Pursuit, Fear, Catastrophe: Ruskin BC*,
Milwaukee Art Museum, Milwaukee, texts Dean Sobel
and Stan Douglas

1995
Public Information: Desire, Disaster, Document
San Francisco Museum of Modern Art, California
(group)
Cat. *Public Information: Desire, Disaster, Document*,
San Francisco Museum of Modern Art, California, texts
Gary Garrels, Jim Lewis, Abigail Solomon-Godeau,
Sandra S. Phillips, Robert R. Riley, John S. Weber

'Spirits on the Crossing',
Setagaya Museum of Art, Tokyo, toured to **National
Museum of Modern Art**, Kyoto; **Hakkaido Museum of
Modern Art**, Sapporo (group)
Cat. *Spirits on the Crossing*, Setagaya Museum of Art,
Tokyo, texts Diana Nemiroff, Shinji Kohmoto, Yuko
Hasegawa

'Le Monde Après la Photographie',
Musée d'Art Moderne, Villeneuve d'Ascq,
Communauté Urbaine de Lille, France (group)
Cat. *Le Monde Après la Photographie*, Musée d'Art
Moderne, Villeneuve d'Ascq, France, text Regis Durand

'1995 Whitney Biennial',
The Whitney Museum of American Art, New York
(group)
Cat. *1995 Whitney Biennial*, The Whitney Museum of
American Art, New York, texts Klaus Kertess, John
Ashbery, Gerald M. Edelman, John G. Hanhardt, and
Lynne Tillman

'Subject to a Film: Marnie, Overture and Recent
Photographs',
David Zwirner, New York (solo)

Royoux, Jean-Christophe, 'Resonance: Stan Douglas &
Olivier Cadiot', *Galeries Magazine*, No 58, Paris, April
Stals, José Lebrero, 'Global Art', *Flash Art*, Milan, No
177, Summer
Watson, Scott, 'Making History', *Canadian Art*, Vol 11,
No 4, Toronto, Winter

1995

Greaves, McLean, 'Canadian artists crash Whitney's
showcase', *The Globe and Mail*, Toronto, 1 April

Eccles, Tom, 'Stan Douglas at David Zwirner', *Art in
America*, New York, October
'Goings on About Town', *The New Yorker*, 24 April
Hagen, Charles, 'Art in Review', *The New York Times*, 21
April
Schjeldahl, Peter, 'In Love Again', *The Village Voice*,
New York, 11 April

Selected exhibitions and projects
1995

'Trust',
Tramway, Glasgow, Scotland (group)

'A Notion of Conflict: A Selection of Contemporary
Canadian Art',
Stedelijk Museum, Amsterdam(group)
Cat. *A Notion of Conflict: A Selection of Contemporary
Canadian Art*, Stedelijk Museum, Amsterdam, texts
Rudi Fuchs, Dorine Mignot

'Evening and Hors-Champs',
**The Renaissance Society at the University of
Chicago**,(solo)

'Displaced Histories',
Canadian Museum of Contemporary Photography,
Ottawa, Ontario (group)

'Stan Douglas: Pursuit, Fear, Catastrophe: Ruskin BC',
Walter Phillips Gallery, Banff, Canada (solo)

'Video Spaces',
The Museum of Modern Art, New York (group)
Cat. *Video Spaces: Eight Installations*, The Museum of
Modern Art, New York, text Barbara London

'Stan Douglas, Monodramas',
Neueraachenerkunstverein, Aachen, Germany (solo)

'Das Ende der Avant Garde – Kunst als Dienstleistung',
**Sammlung Schürmann, Kunsthalle der Hypo-
Kunlturstiftung**, Munich (group)

'L'Effet cinema',
Musée d'Art Contemporain de Montréal, Montreal
(group)
Cat. *L'Effet Cinema*, Musée d'art contemporain de
Montréal, Montreal

'1995 Carnegie International',
The Carnegie Museum of Art, Pittsburgh (group)
Cat. *1995 Carnegie International*, The Carnegie Museum
of Art, Pittsburgh, text Richard Armstrong

'Instants Photographiques: Oeuvres choisies de la
Collection',
Couvent des Cordeliers, Paris

'3e Biennale de Lyon',
Palais de Congress, Lyon (group)
Cat. *3e Biennale de Lyon*, Musée d'Art Contemporain,
Lyon, France, texts Dan Cameron, Barbara London,
Gladys Fabre, et al.

Selected articles and interviews
1995

Artner, Alan, 'Witnessing a television time warp', *The
Chicago Tribune*, 14 May

Hagen, Charles, 'Back in Fashion, Video Installations',
The New York Times, 11 July
Heartney, Eleanor, 'Video in Situ', *Art in America*, New
York, October
Turner, Patricia C., 'Video exhibit enters the third
dimension', *The Star Ledger*, Newark, New Jersey, 5
July

Volk, Gregory, 'Stan Douglas', *ARTnews*, New
York, October
Casebere, James, 'Möbius Strip', interview with Stan
Douglas, *Blind Spot*, New York, No 6
Curtis, Sarah, 'Stan Douglas', *World Art*, New York,
February
Gale, Peggy, 'Stan Douglas. Evening and Others',
Parachute, No 79, Montreal, July – September
Vogel, Sabine B., 'Die Sprachen der Medien', *Artis*,
Utrecht, February/March

Selected exhibitions and projects
1996

1996
'Stan Douglas',
Musée d'Art Contemporain de Montréal, Montreal
(solo)
Cat. *Stan Douglas*, Musée d'Art Contemporain de
Montréal, text Gilles Godmer

'Defining the Nineties: Consensus-making in New York,
Miami, and Los Angeles',
Museum of Contemporary Art, Miami (group)
Cat. *Defining the Nineties: Consensus-making in New
York, Miami, and Los Angeles*, Museum of Contemporary
Art, Miami, texts Bonnie Clearwater, Michael Duncan,
Allan Schwartzman

'Hall of Mirrors: Art and Film Since 1945',
Museum of Contemporary Art, Los Angeles, toured to
The Wexner Center for the Arts, Columbus, Ohio;
Palazzo delle Esposizioni, Rome; **Museum of
Contemporary Art**, Chicago (group)
Cat. *Art and Film Since 1945: Hall of Mirrors*, Museum of
Contemporary Art and The Monacelli Press, Los
Angeles and New York, texts Jerry Brougher, Jonathan
Crary, Russell Ferguson, Bruce Jenkins, Kate Linker,
Molly Nesbit, Robert Rosen

'NowHere',
Louisiana Museum of Modern Art, Humblebæk,
Denmark (group)
cat. *NowHere*, Louisiana Museum of Modern Art,
Humblebæk, Denmark, texts Anneli Lars Gramby,
Iwona Blazwick, et al.

'Shifting Spaces: Reading the Shadows',
Procter Art Center, Bard College, Annandale-on-
Hudson, New York (group)

'Overture'
Museum of Image and Sound, São Paulo, Brazil (solo)

'Rough Bush',
Or Gallery, Vancouver (group)
Cat. *Rough Bush*, Or Gallery, Vancouver, text Reid Shier

'Nach Wiemar',
Kunstammlung zu Weimar, Germany
Cat. *Nach Wiemar*, Kunstammlung zu Weimar, Germany,
texts Klaus Biesenbach, Nicolaus Schausen, Hans
Ulrich Obrist, et al.

'Jurassic Technologies. Revenant: 10th Biennale of
Sydney',
Art Space, Sydney, Australia (group)
Cat. *Jurassic Technologies. Revenant: 10th Biennale of
Sydney*, Art Gallery of New South Wales, Sydney, texts
Lynne Cooke, Jonathan Crary, Elisabeth Sussman, et
al.

'Real Fictions: Four Canadian Artists',
Museum of Contemporary Art, Sydney (group)
Cat. *Real Fictions: Four Canadian Artists*, Museum of
Contemporary Art, Sydney, texts Peggy Gale, Dot Tuer,
et al.

'Art in the age of Post-colonialism and Global
Migration',
Steirischer herbst 96, Graz, Austria (group)

Selected articles and interviews
1996

1996

hall of mirrors
ART AND FILM SINCE 1945

Selected exhibitions and projects
1996-97

Cat. *Inklusion Exklusion. Kunst im Zeitalter von Postkolonialismus und globaler Migration*, Steirischer Herbst 96, Graz, Austria, texts Peter Weibel, Edward W. Saïd, et al.

'Stan Douglas Photographs',
Zeno X Gallery, Antwerp, Belgium (solo)

'Stan Douglas',
Museum Haus Lange and **Museum Haus Esters**, Krefeld, Germany (solo)
Cat. *Stan Douglas. Potsdamer Schrebergarten. Der Sandmann*, Museum Haus Lange and Museum Haus Esters, Krefeld, Germany, texts Stan Douglas, Julian Heynen

'1996 Hugo Boss Prize',
Guggenheim Museum, SoHo, New York (group)
Cat. *The Hugo Boss Prize: 1996*, Guggenheim Museum, SoHo, New York, texts Lisa Dennison, Nancy Spector, Jon Ippolito

'Stan Douglas. Two Early Works',
David Zwirner, New York (solo)

'Unfrieden: Sabotage von Wirkichkieten',
Kunstverein and **Kunsthaus**, Hamburg (group)

'The Culture of Nature',
Kanloops Art Gallery, Kanloops, Canada (group)

1997
'Between Lantern and Laser: Video Projects',
Henry Art Gallery, Seattle, Washington

'Time Frames',
Friedman Gallery, Albright College Arts Center, Reading, Pennsylvania (group)

'Public Service and Other Announcements',
Philadelphia Museum of Art, Philadelphia (group)

'Stan Douglas',
Galerie Daniel Buchholz, Cologne (solo)

'The 5th International Biennale in Nagoya-Artec '97',
Nagoya, Japan (group)

'Photographs by Stan Douglas',
Centre genevois de gravure contemporaine, Geneva (solo)

Selected articles and interviews
1996-97

Blomberg, Katja, 'Im Schrebergarten', *Frankfurter Allgemeine Zeitung*, Frankfurt, 20 December, 1997
Smolik, Noemi, 'Stan Douglas', *Kunstforum*, Cologne, February/March, 1997

Saltz, Jerry, 'Eyes on the Prize', *Time Out*, New York, 28 November
Johnson, Ken, 'Eyes on the Prize', *Art in America*, New York, April, 1997

Smith, Roberta, 'Past and Present, Dancing Toward Progress', *The New York Times*, 27 December
Camhi, Leslie, 'No Tech', *The Village Voice*, New York, 14 January, 1997
Jones, Ronald, 'Stan Douglas', *frieze*, London, March/April, 1997
Schwendener, Martha, 'Stan Douglas', *Time Out*, New York, 2-9 January, 1997
Turner, Grady T., 'Stan Douglas at David Zwirner', *Art in America*, New York, June, 1997

Carels, Edwin, 'The cinema off screen...', *Archis*, Utrecht, October
Gale, Peggy, 'Stan Douglas/Moving Targets', *Paletten*, No 224, Issue 57, Gothenborg
Williams, Linda, 'Weightless Realms', *Photofile*, No 40, Paddington, Australia, August

1997

Selected exhibitions and projects
1997-98

'Evening',
Museum of Contemporary Art, Chicago (solo)

'Documenta X',
Kassel, Germany (group)
Cat. *Documenta X*, Edition Cantz, Kassel, Germany, text
Catherine David

'Skulptur Projekte in Münster',
Münster, Germany (group)
Cat. *Sculpture Projects in Münster 1997*, Verlag Gerd
Hatje, Münster, Germany, ed. Klaus Bussmann, Kasper
König, Florian Matzner, text Daniel Buren

'Longing and Memory',
Los Angeles County Museum of Art, Los Angeles,
(group)
Cat. *Longing and Memory*, Los Angeles County Museum
of Art, Los Angeles, text Lynn Zelevansky

'4e Biennale de Lyon',
Lyon, France (group)
Cat. *4e Biennale de Lyon*, Réunion des Musées
Nationaux, Lyon, France, texts Harald Szeeman,
Raymond Barre, et al.

'Trade Routes: History and Geography',
1997 Johannesburg Biennale, **Institute of
Contemporary Art**, Johannesburg (group)

''97 Kwangju Biennale',
Kwangju, South Korea (group)
Cat. *Unmapping the Earth*, Kwangju Biennale Press,
Kwangju, South Korea, texts Paul Virilio, John
Rajchman, Harald Szeeman, et al.

'Browser: Artropolis '97',
Roundhouse, Vancouver
Cat. *Browser: Artropolis '97*, Roundhouse, Vancouver,
texts, Kitty Scott, Andrew Renton

'Stan Douglas: Overture y Monodramas',
Fundacion Museo Alejandro Otero, Caracas,
Venezuela (solo)
Cat. *Stan Douglas: Overture y Monodramas*, Fundacion
Museo Alejandro Otero, Caracas, Venezuela, texts Tahía
Rivero, Jesús Fuenmayor and Julieta González

1998
'Voice Over: Sound and Vision in Current Art',
organised by National Touring Exhibitions, London,
toured to **Arnofini**, Bristol, **Hatton Gallery**,
Newcastle-upon-Tyne; **John Hansard Gallery**,
Southampton; **Cornerhouse Gallery**, Manchester;
Castle Museum, Nottingham; **Royal Botanic Garden**,
Edinburgh (group)
cat. *Voice Over: Sound and Vision in Current Art*,
National Touring Exhibitions, Hayward Gallery,
London, text Michael Archer

Selected articles and interviews
1997-98

La Belle, Charles, 'Longing and Memory', *art/text*, No
59, Sydney, November/January

Schumacher, Rainald, 'Stop the Train: Stan Douglas,
Beat Streuli, Bruce Nauman and Gary Hill', *Flash Art*,
Milan, May/June
Tuer, Dot, 'Mining the Media Archive', *Fuse Magazine*,
Vol 20, No 5, Toronto, November
Cameron, Dan, ' Glocal Warming', *Artforum*, Vol 36, No
4, New York, December

1998

Selected exhibitions and projects
1998-99

'Sharon Lockhardt/Stan Douglas/Hiroshi Sugimoto',
Museum Boijmans Van Beuningen, Rotterdam
(group)

'Wounds: Between democracy and redemption in
contemporary art',
Moderna Museet, Stockholm (group)
Cat. *Wounds: Between democracy and redemption in
contemporary art*, Moderna Museet, Stockholm, text
Pier Luigi Tazzi

Coutts Contemporary Art Foundation Award, Monte
Carlo

'Crossings',
Kunsthalle, Vienna (group)

'Altered States',
Begane Grond, Utrecht (group)

'Public/Private Landscapes',
Unionbrauerei/Dortmunder U, Dortmund, Germany
(group)

'Ghost Story',
Kunstlerhaus Wien, Vienna (group)

'Win, Place or Show',
Kunstverein, Salzburg, Austria (solo)

'Stretch',
Tensta Konstalle, Stockholm (group)

1999
Stan Douglas: Retrospective,
Vancouver Art Gallery, Vancouver (solo)

'Nu • tka • ',
Centro Cultural Recoleta, Buenos Aries (solo)

'Detroit Projects',
Art Gallery of Windsor, Windsor (solo)

Selected articles and interviews
1998-99

Horrigan, Bill, 'Taxing Memories', *art/text*, No. 60,
Sydney, February/April

1999

Bibliography

Artner, Alan, 'Witnessing a television time warp', *The Chicago Tribune*, 14 May 1995

Barb, Daniel, 'Stan Douglas', *Vanguard*, Vancouver, September 1982

Berg, Ronald, 'Das Monodrama im Monitor', *Tagesspiegel*, Berlin, 15 February 1994

Blomberg, Katja, 'Im Schrebergarten', *Frankfurter Allgemeine Zeitung*, Frankfurt, 20 December 1997

Bosseur, Jean-Yves, *Le sonore et le visuel: Intersections musique/arts plastiques aujourd'hui*, Dis Voir, Paris 1992

Büchler, Pavel, 'Digging it', *Creative Camera*, No 324, London, October/November 1993

Cameron, Dan, ' Glocal Warming', *Artforum*, Vol 36, No 4, New York, December 1997

Camhi, Leslie, 'No Tech', *The Village Voice*, New York, 14 January 1997

Carels, Edwin, 'The cinema off screen...', *Archis*, Utrecht, October 1996

Casebere, James, 'Möbius Strip', interview with Stan Douglas, *Blind Spot*, No 6, New York, 1995

Cooke, Lynne, 'Broadcast Views. Stan Douglas interviewed by Lynne Cooke', *frieze*, London, September/October 1993

Cork, Richard, 'Unhappy case of nostalgia', *The Times*, London, September 1994

Culley, Peter, 'Dream as Dialectic: Two Works by Stan Douglas', *Vanguard*, Vancouver, September/October 1987

Culley, Peter, 'Window Dressing', *Vanguard*, Vancouver, April–May 1988

Culley, Peter, *Stan Douglas*, Centre Georges Pompidou, Paris, 1994

Curtis, Sarah, 'Stan Douglas', *World Art*, New York, February 1995

Danzker, Joe-Anne Birnie, 'The Beauty of the Weapons', *Canadian Art*, Toronto, Autumn 1989

Day, Peter, 'Perspective '87: Stan Douglas', *Canadian Art*, Vol 4, No 3, Toronto, Fall/September 1987

Douglas, Stan, *'Link Fantasy'* (with Deanna Ferguson), Artspeak Gallery, Vancouver 1988

Douglas, Stan, 'Goodbye Pork-Pie Hat', *Samuel Beckett: Teleplays*, Vanguard, Vancouver, November 1988

Douglas, Stan, 'Shades of Masochism: Samuel Beckett's Teleplays', *Photofile*, Paddington, Australia, Fall 1990

Douglas, Stan, 'Joanne Tod and the Final Girl', *Joanne Tod*, Saskatoon: The Power Plant/Mendel Art Gallery, 1991; *Parachute*, No 65, Montreal, January/March 1991

Douglas, Stan, 'Introduction', *Vancouver Anthology. The Institutional Politics of Art*, Talonbooks, Vancouver (designer and editor)

Douglas, Stan, 'Accompaniment to a Cinematographic Scene: Ruskin, BC', *WestCoast Line*, Vol 26, No 2, Simon Fraser University, Burnaby, Canada, Fall 1992

Douglas, Stan, 'Police Daily Record', *frieze*, No 12, London, September 1993

Douglas, Stan, 'Pursuit, Fear, Catastrophe: Ruskin, BC (1993)', *Jahresring 41: Jahrbuch fur moderne Kunst*, Munich, 1994

Douglas, Stan, *Television Talk*, Little Cockroach Press, No 1, Art Metropole, Toronto, April 1996

Douglas, Stan, 'Television Talk', *Art Recollection. Artists' Interviews and Statements in the Nineties*, Danielo Montanari & Exit & Zona Archives Edition, New York 1997

Eccles, Tom, 'Stan Douglas at David Zwirner', *Art in America*, New York, October 1995

Elwes, Catherine, 'Stan Douglas at the ICA', *Art Monthly*, No 180, London, October 1994

Fargier, Jean-Paul, 'Charmants Fantomes', *Le Monde*, Paris, 13 January 1994

Fetherling, Douglas, 'Vancouver Anthology', *Canadian Art*, Vol 9, No 3, Toronto, Autumn 1992

Fischer, Barbara, *Stan Douglas: Perspective '87*, Art Gallery of Ontario, Toronto, 1987

Fiske, John, *Monodramas and Loops*, UBC Fine Arts Gallery, Vancouver, 1992

Gagnon, Monika, 'Re-enactment: Between Self and Other', *C Magazine*, Toronto, Summer 1990

Gale, Peggy, 'Stan Douglas. Evening and Others', *Parachute*, No 79, Montreal, July–September 1995

Gale, Peggy, 'Stan Douglas/Moving Targets', *Paletten*, No 224, Issue 57, Gothenberg, 1996

Gale, Peggy, 'Stan Douglas: Perspective '87', *Canadian Art*, Spring 1988

Godmer, Gilles, *Stan Douglas*, Musée d'Art Contemporain de Montréal, 1996

Greaves, McLean, 'Canadian artists crash Whitney's showcase', The Globe and Mail, *Toronto*, 1 April 1995

Harris, Mark, 'Stan Douglas', *C Magazine*, Toronto, Spring 1989

Heartney, Eleanor, 'Video in Situ', *Art in America*, New York, October 1995

Henry, Karen, 'Television Spots', *Parachute*, Montreal, July-August, 1989

Hoolbloom, Mike, 'Stan Douglas Talks at YYZ', *Independent Eye: Leading the Theatre*, Vol 10, No 2, Toronto, Winter 1989

Horrigan, Bill, 'Taxing Memories', *art/text*, No 60, Sydney, February/April 1998

Jones, Ronald, 'Stan Douglas', *frieze*, London, March/April 1997

Joselit, David, 'Projected Identities', *Art in America*, New York, November 1992

La Belle, Charles, 'Longing and Memory', *art/text*, No 59, Sydney, November/January 1997

Laing, Carol, 'Songs of Experience', *Parachute*, Montreal, September/November 1986

Lawlor, Michael, 'Camera Works', *Parachute*, Montreal, June/August 1987

Lebert, Muriel, 'Stan Douglas. La Situation du Spectateur dans l'Oeuvre', *Artefactum*, No 52, Antwerp, Summer 1994

Lewis, Ben, 'Stan Douglas', *What's On*, London, September 1994

Luca, Elisabetta, 'Stan Douglas', *Juliet Art Magazine*, No 64, Trieste, Italy, October/November 1993

McNally, Owen, 'Freedom Rings', *The Hartford Courant*, Hartford, Connecticut, 21 January 1994

Nzegwu, Nikiu, 'The Creation of the African-Canadian Odyssey', *The International Review of African American*, Vol 10, No 1, Toronto, Spring 1992

O'Brian, John, 'Vancouver Anthology', *Parachute*, No 66, Montreal, April/June 1992

Pieters, Din, 'Fascinerende tv-en filmbeelden in Witte de With', *NRC Handelsblad*, Rotterdam, October 1994

Pontzen, Rutger, 'Plotloze films uit Terminal', *Vrij Nederland*, Amsterdam, September 1994

Reveaux, Tony, 'Fleeting Phantoms: the Projected Image at SFMOMA', *ArtWeek*, New York, March 1991

Rhodes, Richard, 'Documenta IX', *Canadian Art*, Vol 9, No 3, Toronto, Autumn 1992

Roos, Robert, 'Anders omgaan met film en video', *Trouw*, Amsterdam, September 1994

Royoux, Jean-Christophe, 'Documenta IX: the Call of the Phrase', *Galeries*, No 50, Paris, August/September 1992

Royoux, Jean-Christophe, *Stan Douglas*, Centre Georges Pompidou, Paris, 1994

Royoux, Jean-Christophe, 'Resonance: Stan Douglas & Olivier Cadiot', *Galeries*, No 58, Paris, April 1994

Rudolfs, Harry, 'Douglas Loops and Splits in Guelph and Downsview', *Excalibur*, Canada, March 1994

Sarrazin, Stephen, 'Le Cadet de la föret: Spoorzoeken in het werk van Stan Douglas', *Metropolis*, Utrecht, August 1994

Schjeldahl, Peter, 'In Love Again', *The Village Voice*, New York, 11 April 1995

Schumacher, Rainald, 'Stop the Train: Stan Douglas, Beat Streuli, Bruce Nauman and Gary Hill', *Flash Art*, Milan, May/June 1997

Schwartz, Ineke, 'Beeldende kunst blijft te vaak op afstand', *De Volkskrant*, Amsterdam, September 1994

Schwendener, Martha, 'Stan Douglas', *Time Out/New York*, 2-9 January 1997

Smith, Roberta, 'Past and Present, Dancing Toward Progress', *The New York Times*, 27 December 1996

Smolik, Noemi, 'Stan Douglas', *Kunstforum*, Cologne, February/March 1997

Sobel, Dean, *Currents 24: Pursuit, Fear, Catastrophe: Ruskin BC*, Milwaukee Art Museum, Milwaukee

Stals, José Lebrero, 'Global Art', *Flash Art*, Milan, No 177, Summer 1994

Stals, José Lebrero, 'Stan Douglas: Christian Nagel', *Flash Art*, Milan, no 173, November/December 1993

Taylor, Kate, 'Out of the gallery and into the world of television', *The Globe and Mail*, Toronto, November 1992

Tourangeau, Jean, 'Sins of Experience', *Vanguard*, Vol 15, No 6, Vancouver, Winter 1987

Tuer, Dot, 'Mining the Media Archive', *Fuse Magazine*, Vol 20, No 5, Toronto, November 1997

Turner, Grady T., 'Stan Douglas at David Zwirner', *Art in America*, New York, June 1997

Turner, Patricia C., 'Video exhibit enters the third dimension', *The Star Ledger*, Newark, New Jersey, 5 July 1995

van Assche, Christine (ed.), *Video et apres. La collection video du Musée national d'art moderne*, Centre Georges Pompidou, France, 1991

van Assche, Christine, *Stan Douglas*, Centre Georges Pompidou, Paris, 1994

Vergne, Philippe, 'Stan Douglas: Musée national d'art moderne, Centre Georges Pompidou', *Parachute*, No 74, Montreal, April/June 1994

Verjee, Zainub, 'Vancouver Anthology', *Front*, Vancouver, November/December 1991

Vogel, Sabine B., 'Die Sprachen der Medien', *Artis*, Utrecht, February/March 1995

Vogel, Sabine B., 'Fehlgeschlagene Utopien: Interview mit dem Videokünstler Stan Douglas', *Zitty*, Berlin, March 1995

Vogel, Sabine B., 'Review: Kunsthalle Zurich', *Artforum*, New York, January 1994

Vogel, Sabine V., 'Lesen auf der Rückseite der Bilde', *Frankfurter Allgemeine Zeitung*, No 222, Frankfurt, September 1994

Volk, Gregory, 'Stan Douglas', *ARTnews*, New York, October 1995

Watson, Scott, 'Making History', *Canadian Art*, Vol 11, No 4, Toronto, Winter 1994

Watson, Scott, 'The Afterlife of Interiority: Panoramic Rotunda', *C Magazine*, Toronto, Summer 1985

Watson, Scott, 'Zweimal Canada Dry – Sechs Künstler aus Vancouver', *Wolkenkratzer Art Journal*, Berlin, March/April 1988

Watson, Scott, *Monodramas and Loops*, UBC Fine Arts Gallery, Vancouver, 1992

Welling, Dolf, 'Overrijk aanbod van tentoonstellingen', *Rotterdams Dagblad*, Rotterdam, September 1994

Williams, Linda, 'Weightless Realms', *Photofile*, No 40, Paddington, Australia, August 1996

Wood, William, 'Skinjobs', *C Magazine*, Toronto, Summer 1986

Young, Jane, 'Broken Muse', *C Magazine*, Toronto, Summer 1987

Zazlove, Arne, 'Samuel Beckett's Teleplays', *C Magazine*, Toronto, Autumn 1989

Production Credits

Overture, 1986
Cast
Voice, Gerlad Creede
Crew
Editing Assistance, Linda Andrews
Film Source, Library of Congress
Thanks to: Cineworks Filmmakers
Collective; Alpha Cine Service
Produced by Stan Douglas

Television Spots, 1987–88
Session I, September 1987
Musical Vendor
Ice Cream Vendor, Dean Schultz
Spectated Man
Suited Man, Gerald Creede
Sneeze
Sneezing Woman, Jan Coyle
Male Naysayer
Lifeguard, Scott Marshall
Female Naysayer
Interviewee, Erin O'Brien
Lit Lot
Parking Lot Attendant, Stan
Douglas
My Attention
Confessor, Frank Totino
Crew
Cinematographer, Kevin Hall
Camera Assistant, Greg Middleton
Gaffer, Dave Goyer
Best Boy, Steve McGrath
Stylist, Lori Hinton
Sound Recordists, Steve McGrath,
Susan Lord
Thanks to: The Canada Council;
Dickee Dee; 1017 McLean; Donna
Chisholm
Produced by Stan Douglas

Session II, October 1988
Answering Machine
Smoker, Mina Totino
No Problem
She, Donna Scott
He, William Wood
Funny Bus
Laughter, Susi Milne
Passengers, Bill Jefferies, Cate
Rimmer, Reid Shier
Box Office
Attendant, Delia Douglas
Slap Happy
Four Fellows, Kevin Davies, Jeff
Derksen, Peter Cummings, Phil
McCrum
Crew
Cinematographer, Greg Middleton
Camera Assistant, Dave Taylor
Driver, Judy Radul
Grip, James Bugara
Sound Recording, Iain Macanulty
Thanks to: The Canada Council;
The Western Front; Don Gill;
Donna Chisholm
Produced by Stan Douglas

Subject to a Film: Marnie, 1989
Cast
Marnie Edgar, Tasmin Kelsey
Susan Claybourne, Nancy Shaw
Office Workers, Allyson Clay, Jim
Chohanik, Peter Cummings,
Christine Davis, David MacWilliam,
John Newton, Anne Ramsden,
Cate Rimmer, Henry Tsang, Neil
Wedman, William Wood
Crew
Cinematographer, Greg Middleton
Camera Assistant, Dave Taylor
Gaffers, Esther Scannel, Mark
Scannel
Stylist, Anya Ellis
Production Assistants, Susan Lord,
Mina Totino
Thanks to: The Canada Council; BC
Hydro
Produced by Stan Douglas

Monodramas, 1991
Cast
As Is
Suburban Mechanics, Stewart
Douglas, Dave Glass, Austin Rich
Mezzourban Driver, Helga
Pakasaar
Urban Driver, Judy Radul
Eye on You
Chewing Viewer, Hiro Kanagawa
Encampment
Complainer, David Eichorn
Travellers, Zena Daruwalla,
Jennifer Griffin
'I'm Not Gary'
Friend of Gary, Billy Mitchell
Not Gary, William S. Taylor
Up
Bench Sitters, John Anderson,
Rodney Graham, Neil Wedman
Hand, Lionel Huppee
Disagree
Breaking Driver, Phil McCrum
Guilty I, II & III
The Culpable, Jennifer Griffin,
Hiro Kanagara, Billy Mitchell
Crew
Writer, Director, Editor, Stan
Douglas
Cinematographer, Dan Nowak
Camera Assistants, Greg
Middleton, Mark Zagar
Production Manager, Helga
Pakasaar
Gaffer, Shawn Milstead
Best Boy, Paul Bougie
Key Grip, Lionel Huppee
Grips, Vincent Phillips, Terry
Weaver
Sound Recordist, Dwight Rhodes
Audio Engineer, Rob Kosinuk
Production Assistants, Phil
McCrum, Judy Radul
Thanks to: The Video In
Produced by Stan Douglas

Hors-champs, 1992
Musicians
Tenor trombone, George Lewis
Tenor saxophone, Douglas Ewart
Percussion, Oliver Johnson
Double bass, Kent Carter
Crew
Writer, Director, Editor, Stan
Douglas
Producer (for MNAM), Christine
Van Assche
Assistant Director, Corinne Castel
Production Assistant, Myriam
Bezdjian
Lighting Videographer, Serge
Godet
Camera Operator, Stan Douglas
Rehearsal Camera, Jacques Nibert
Camera Assistants, Patricia Godal,
Jean Paul Vallorani
Gaffer, Frédéric Lemaire
Best Boy, Vivien Lemaignan
Grips, François Creton, Aymeric de
Valon
VTR Operator, Didier Coudray
On-line Editor, Christian Bahier
Audio Engineer, Nicolas Joly
Assistant Audio Engineer,
Stéphanie Combot
Construction Co-ordinator, Gérhard
Rasch
On-Set Photography, Valérie Lagier
Make-up, Solange Beauvineau
Lighting Doubles, Frédéric Buram,
Frédéric Guépin, Serge Kalagan,
Daniel Nga-Nlen, Hubert Rivet,
Daniel Rota, Christophe Yapo Atse
Technical services, Service
audiovisuel, CGP
Thanks to: Pascal Anquetil;
Banlieus Bleues; The Canada
Council; Philippe Carles; Bobby
Few; Steve Lacy; New Morning;
Steve Potts; Alan Silva; Sylvian
Torkian; Vidéotheque de Paris
Produced by Musée National d'Art
Moderne, Centre Georges
Pompidou, and Documenta X

Pursuit, Fear, Catastrophe:
Ruskin, BC, 1993
Cast
Constable Huntingdon, Don
Thompson
Theodore, Hiro Kanagawa
Christopher Dickens, Hrothgar
Matthews
Constable Moore, Doug Dickman
Plant Boss, Jim Smith
Worker, Florentia Conway
Hiro Sato, Byron Lawson
Huntingdon's Hand, Dave
Moulding
Crew
Writer, Director, Editor, Stan
Douglas
Cinematographer, Danny Nowak,
CSC

Piano Reduction and Disklavier
Arrangement, Michael Century
Art Director, Garth Fleming
Pre-production Manager, Terry
Ewasiuk
Production Manager, Jan Durban
Unit Manager, Ida Maria Pan
Script Supervisor, Monika Kin
Gagnon
Camera Assistant, Robert Simpson
Clapper/Loader, Marcus James
Gaffer, Brian Savage
Best Boy, Kevin Shortt
Lamp Operator, Paul Bouche
Key Grip, Timo Juonolainen
Grip, Jonathan MacLeod
Assistant Art Directors, Wendy
Harke, Fred Lawrence
Set Decorator, Ingrid Haring
Set Dressers, Libby Alliston,
Andrew Bewer, Denise Dicknell,
Yale Kussin, Brian Morozoff
Costume Designer, Tracey Pincott
Make-Up & Wardrobe, Carey
Williams
Prop Master, Scott Bourgeois
Props, Daniel Guimond
Stills, Anji Smith, Kelly Wood
Craft Services, Lisa Bowmar
Story Boards, Reid Shier
Video-Film Conforming, Lori Olsen
Negative Cutting, Burt Bush
Lab, Alpha Cine
Installation Technician, Peter
Courtemanche
Thanks to: Alexander Studios;
Alpha Cine I. E. Artspeak Society;
BC Cultural Services Branch Media
Arts Program; BC Hydro Ruskin
Plant; The Canada Council Arts
Award Service; Cannel Films;
CCEC Credit Union; Maureen
Douglas; National Film Board
of Canada; Triple Creek Estates;
Vancouver Art Gallery; Norm van
Koughnett
Produced by Stan Douglas

Evening, 1994
Cast
Anchors:
Dennis Cameron, WCSL 1969/WAMQ
1970, Tom Cramer
James Mooney, WCSL 1969
(reporter)/1970, Greg Eldridge
Finton O'Neil, WBMW 1969/70,
Ron Engler
Bill Loudon, WAMQ 1969/70, Tim
Gamble
Ed Hughes, WAMQ 1970, Tom
Herbstritt
James Deverell, WCSL 1969/70,
Rick Plastina
Reporters:
Jackie Hale, WAMQ 1969/70,
Patricia Andrew
Keith McAllister, WCSL 1970,
Harvey Fries

Keith Stacey, WAMQ 1969/WBMB
1970, David Lewis Fitsch
Barry Williams, WMBM 1969/70,
Ali LeRoi
Patrick Keenan, WBMB 1969,
Michael Weber
Crew
Writer, Director, Editor, Stan
Douglas
Producer, Susanne Ghez
Production Co-ordinator, Fenell
Doremus
Cinematographer, Scott Stearns
Gaffer, Doug Polen
Sound Recordist, Tom Yore
Script Supervisor, Melissa Sterne
Art Director, Lissa Claffey
Set Decorator, Rebecca Howard
Wardrobe, Meg Everest
Make-up, Kim Epperly
Set Designer, Matt Sullivan
Production Assistants, Eric Ettl,
Jim Fetterly, Lou Frierson, Eric
Salus, Eric Sanders
Pre-production and Research,
Randy Alexander, Neil Laird,
Joseph Scanlan
Media Composer Tutor, Ken Cathro
On-Line Editor, Rene Beland
Pro-Tools Editor, Marty Taylor
Production Assistance,
Kartemquin Films, Chicago
Disc Mastering, Digital Audio Disc
Corporation, Terre Haute
Thanks to: Douglas G. Baird; John
D. Callaway; Claire Cass; The
Chicago Historical Society;
Chicago Park District; University
of Chicago Court Theatre;
Bernardine Dohrn; Jeff Haas; Al
Hall; Kartemquin Films; Kerry
Kemmer; Flynt Taylor; Larry
Viskochal; WGN-TV
Produced by The Renaissance
Society at the University of
Chicago and made possible by the
generous support of: The Bohen
Foundation; Canada Council
Media Arts Program; Lannan
Foundation; Peter Norton Family
Foundation. Additional
programme support was made
possible by: The City Art Program
of the Chicago Department of
Cultural Affairs; Digital Audio Disc
Corporation; The Illinois Arts
Council; The John D. and
Catherine T. MacArthur
Foundation; Refco. Inc; Regents
Park by the Clinton Company; The
Sara Lee Foundation; Sony
Electronics Inc; The Andy Warhol
Foundation for the Visual Arts

Der Sandmann, 1995
Cast
Nathanael, Frank Odjidja
Lothar, Thomas Marquard

Klara, Adelheit Kleineidam
Herr Coppelius, Rudolf W. Marnitz
Crew
Writer, Director, Editor, Stan
Douglas
Production Manager, Volker Ullrich
Art Director, Susanne Hopf
Assistant Director, Caroline
Veyssiere
Location Manager, Dirk Göbel
Research Assistant, Barbara Stauss
Camera and Research Assistant,
Heike Ollertz
Cinematographer, Martin Kukula
Camera Assistant, Gerd Breiter
Sound Recordist, Peter Carstens
Boom Handler, Jan Bunge
Motion Control Hardware, Gordon
Monahan
Motion Control Software, Stock
Gaffers, Klaus Krämer, Jakob
Kneiper
Grip, Marcus Noack
Construction Co-ordinator, Axel
Nocker
Set Construction and Dressing,
Ralph Brandt, Raimund Kirchner,
Frank Müller, Björn Nowak
Production Assistants, Anthea
Boyle, Rutiger Matzert, Reiner
Schümann
Costumes, Tanja Schmidt
Make-up, Tatjana Krauskopf
Casting, Manfred Bernt
Translation, Sandra Collins
Catering, Gina Guzy
Driver, Sascha Schwill
Production Stills, Heike Ollertz,
Barbara Stauss
Editing and Sound Cut, Berget
Bernt
Optical Effects, Morton McAdams
(Futur Effects)
Prototype Projector
Synchronization, Gordon Monahan
Final Projector Synchronization,
Jean Darbesson
Studio, DokFilm GmbH,
Babelsberg-Potsdam
Camera and Editing Facilities,
Deutsche Film and
Fernsehakademie, Berlin
Thanks to: Reinhard Hauff; Nikolai
Horness; Klaus Kertess; Friedrich
Meschede; Gesila Seitz
Produced by the 1996 Whitney
Biennial Exhibition and the DAAD
Berliner Kunstlerprogramm

Nu•tka•, 1996
Cast
James Colnett, Roger Crossley
José Estéban Martínez, Guillermo
Verdecchia
Crew
Director and Editor, Stan Douglas
Research and Monologues, Peter
Cummings, Stan Douglas

Cinematographer, Kim Derko
Camera Assistant, Robert Simpson
Motion Control, Peter
Courtemanche
Machinist, Jim Page
Quadraphonic Audio Mix, Jennifer
Lewis
Charter and Guide, Ray Williams
Water Taxi, Max Savey
Motion Picture Equipment,
Clairmont Camera, Vancouver
Film Transfer and Colouring,
Rainmaker, Vancouver
On-Line Edit and Effects, Post-
Haste, Vancouver
Thanks to: The Canada Council,
Ray Williams, Darryl Williams
Ed and Pat Kidder, Nootka Light,
Yuquot Cabins, Mowachat Band
Council, Mina Totino, Steve
Mooney, Yvonne Marshall, BC
Archives & Record Service
Produced by Stan Douglas and
David Zwirner

Public Collections

Museum of Contemporary Art,
Chicago
Museum van Hedendaagse
Kunst, Ghent
Walker Art Center, Minneapolis
The Museum of Modern Art, New
York
Solomon R. Guggenheim
Museum, New York
National Gallery of Canada,
Ottawa
Fondation Cartier pour l'Art
Contemporain, Paris
Musée national d'art moderne,
Centre Georges Pompidou, Paris
Museum Boijmans Van
Beuningen, Rotterdam
San Francisco Museum of Modern
Art, San Francisco
Art Gallery of Ontario, Toronto
Vancouver Art Gallery, Vancouver
UBC Fine Arts Gallery, Vancouver
Winnipeg Art Gallery, Winnipeg,
Canada

Comparative Images

page 56, **Albert Ayler**
Spirits Rejoice

page 132, **Ivan Barnett**
The Fall of the House of Usher

page 117, **BC Electric**
Prospectus

pages 94, 95, **Samuel Beckett,
Alan Schnieder**
Film

page 18, **Robert Bresson**
Un Condamné à Mort s'est
Echappé (A Man Escaped)

page 132, **Tod Browning**
Dracula

page 112, **Alan Crossland**
The Jazz Singer

page 9, **Caspar David Friedrich**
Traveller Looking over the Sea of
Fog
Kunstmuseum, Hamburg

page 133, **Friendly Cove, British
Columbia**

page 133, **Friendly Cove, Nootka
Sound and Nootka Island**

page 35, **Henrik Galeen**
The Student of Prague

page 53, **Dan Graham**
Homes for America

page 52, **Rodney Graham**
Tree with Bench, Vancouver, BC

page 46, **Alfred Hitchcock**
Marnie

page 27, **Jenny Holzer**
Truisms

page 96, **Buster Keaton**
The General

page 113, **Robert Z. Leonard**
The Girl of the Golden West

page 112, **Louis Lumière**
L'Arrivée d'un Train á la Gare de
Ciotat

page 39, **Claude Monet**
The Water-lily Pond with the
Willows
Musée National de l'Orangerie,
Paris

page 8, **Anthony Page**
Not I

page 113, **Edwin S. Porter**
The Great Train Robbery

page 21, **Diana Thater**
Electric Mind

page 32, **Adolph von Menzel**
Hinterhaus und Hof (Tenement
back yard)

page 97, **Alan Schnieder**
Eh Joe (Samuel Beckett)

page 53, **Jeff Wall**
Park Drive

page 39, **Jeff Wall**
Restoration

page 132, **James Whale**
Frankenstein

page 130, **Robert Wiene**
The Cabinet of Dr Caligari

List of Illustrated Works

pages 22-23, 36, **Deux Devises:
Breath and Mime**, 1983
pages 14, 15, 59, 60-61, 123,
Evening, 1994
pages 12-13, 57, 58,110, 111,
Hors-champs, 1992
*pages 25, 26, 54-55, 58, 100-
109*, **Monodramas**, 1991
pages 10-11, 62, 63, 67, 138-139,
Nootka Sound series, 1996
pages 64, 134-135, 137,
Nu • tka • , 1996
pages 40, 41, **Onomatopoeia**,
1985–86
page 12, **Onomatopoeia:
Residua**, 1986/93
pages 42, 43, 44, **Overture**, 1986
page 38, **Panoramic Rotunda**,
1985
pages 33, 124-129, **Potsdamer
Schrebergärten** series, 1994
pages 140-141, 142, **Project for
the RIAGG, Zwolle**, 1996
*pages 17, 49, 81, 83, 84-85, 87,
114, 118-119*, **Pursuit, Fear,
Catastrophe: Ruskin, BC**, 1993
page 37, **Samuel Beckett:
Teleplays** catalogue, 1988
*pages 18, 34, 70, 71, 72-73, 74,
75, 76, 78-79, 128, 129, 130,
131*, **Der Sandmann**, 1995
pages 28, 29, 47, **Subject to a
Film: Marnie**, 1989
pages 20, 50-51, 92, 93,
Television Spots, 1987–88

Wycliffe was still trapped in a limbo between past and present. Instant memories recalled in scenes and phrases that surfaced for a moment and were gone. Francine in the chancel of the village church, wearing a blue gown and caught in the spotlight, singing a lullaby – the Virgin in a nativity play. Francine at Mynhager, leafing through an album of old photographs, pondering over them – intent, lost.

Francine, at the top of the stairs, a gun in her hand, standing over a body which lay in a pool of blood: the body of Gerald Bateman MP, her natural father.

W.J. Burley lived near Newquay in Cornwall, and was a schoolmaster until he retired to concentrate on his writing. His many Wycliffe books include, most recently, *Wycliffe and the Guild of Nine*. He died in 2002.

By W.J. Burley

A Taste of Power
Three Toed Pussy
Death in Willow Pattern
Wycliffe and How To Kill a Cat
Wycliffe and the Guilt Edged Alibi
Wycliffe and Death in a Salubrious Place
Wycliffe and Death in Stanley Street
Wycliffe and the Pea Green Boat
Wycliffe and the Schoolgirls
The Schoolmaster
Wycliffe and the Scapegoat
The Sixth Day
Charles and Elizabeth
Wycliffe in Paul's Court
The House of Care
Wycliffe's Wild Goose Chase
Wycliffe and the Beales
Wycliffe and the Four Jacks
Wycliffe and the Quiet Virgin
Wycliffe and the Winsor Blue
Wycliffe and the Tangled Web
Wycliffe and the Cycle of Death
Wycliffe and the Dead Flautist
Wycliffe and the Last Rites
Wycliffe and the Dunes Mystery
Wycliffe and the Guild of Nine
Wycliffe and the House of Fear
Wycliffe and the Redhead

Wycliffe
AND THE
GUILD OF NINE

W.J.Burley

An Orion paperback

First published in Great Britain in 2000
by Victor Gollancz Ltd
This paperback edition published in 2001
by Orion Books Ltd,
Orion House, 5 Upper St Martin's Lane,
London WC2H 9EA

Printed and bound in Great Britain by
Clays Ltd, St Ives plc

The Orion Publishing Group's policy is to use papers that
are natural, renewable and recyclable products and
made from wood grown in sustainable forests. The logging
and manufacturing processes are expected to conform to
the environmental regulations of the country of origin.

www.orionbooks.co.uk

Some of the characters in this book made their first appearance in *Wycliffe and the Quiet Virgin*. Here the story, which is complete in itself, tells of what happened to them ten years later.

Chapter One

A day in April

Archer's Guild of Nine was a craft colony on the site of a disused mine on the seaward slope of the moor, west of St Ives. The old buildings, adapted for workshops and living accommodation, were scattered on either side of a disciplined watercourse which, in living memory, had been streamed for tin. The site overlooked the village of Mulfra, and beyond that, under a vast canopy of sky, the sea.

On this particular morning that sky was a pale watery blue with dusky, ragged clouds driven before a stiff onshore breeze. The sun shone fitfully, according to whimsical changes in the pattern of those scurrying clouds.

'Nothing doing in wood-carving this morning?'

'Paul is ready to varnish his frieze and he's having a clean-up. You can hardly breathe for dust.' Francine was perched on one of the benches, legs dangling.

Alice Field assembled the exquisite little elements of a miniature four-poster bed, and as she attended to jointing and alignment her conversation was sporadic.

In addition to a couple of already assembled four-posters, her bench was littered with little groups of chairs, tables, presses and chests; all to a scale of one-twelfth. No metrication nonsense in this workshop.

'So, how does it feel, living over the job?'

Francine considered. 'All right, I suppose. It saves me the trip in and out every day. Don't you find that a bit of a bind?'

Alice put down her bed, examining it with a critical eye. 'Not really. I like to get away from this place. In any case, Tom wouldn't stand for living on the site even though it would save us money.'

With total objectivity, Francine wondered what it might be like to be 'us'.

Two women talking while one of them worked.

Francine, in her middle twenties, slim, pale of skin, with red-gold hair, had a face which, at that other time, might have launched those thousand ships. Her expression was pensive, withdrawn, giving nothing away.

Alice, perhaps a year or two older, was plump, fair and outgoing.

'Who's buying this lot?' Francine had slipped off her perch and was examining two Lilliputian houses under construction on another bench.

' "This lot", as you call it, is part of an order from the States for five fully furnished houses.' A touch of pride.

Alice picked up the prepared elements of another four-poster and set to work on the assembly. 'Our Lina knows how to drum up business; I'll say that for her. Must be her Dutch blood.'

The window of the workshop looked out on a stretch of moorland, a shallow depression with scattered buildings which had once been part of the mine complex. Close at hand was a large sign at the entrance to the site. There was a logo, depicting Sagittarius firing his arrow, and an inscription:

The Archer Guild of Nine.
Craft Workshops.
Visitors by appointment.

Francine was still examining the little houses. 'I can imagine kids making short work of these.'

'They're not for kids; they're for adults.'

Francine was incredulous. 'You mean grown-up people spend good money on dolls' houses? . . . They must be kinky!'

Alice was piqued. 'It's nostalgia for childhood, Fran. But I doubt if you ever had one.' She paused to make a tiny adjustment to the jointing. 'I can imagine your first thought when you entered this

2

world and opened your little eyes. "Is all this on the National Health or are we paying for it?" '

Alice laughed at her own joke. Francine smiled. 'Very funny!'

Alice said, 'Getting back to basics and being nosey, was it Paul's idea that you should move into the flat over the workshop?'

'I don't know what you mean.'

'Oh, come off it, Fran! You can't pretend that the two of you living with his mother and the rest didn't cramp your style.'

'The move wasn't Paul's idea; it had nothing to do with him.'

'How old is Paul?'

'He's twenty-seven, a year older than I am. Why?'

'Isn't it about time the two of you made up your minds? It's no business of mine but playing the field doesn't endear you to the women. I suppose you know there's talk about you and Emile?'

'Emile!' Francine was roused. 'But that's nonsense! He's painting my portrait and he's nearly old enough to be my father.'

'And what difference has that ever made? I only hope he's painting you with your clothes on. Anyway, you need to remember that he's Lina's private perk and it doesn't do to upset Lina.'

'I had no idea. I thought he was supposed to be gay.'

'That's more than likely, but it doesn't stop him being Lina's property. There's a lot you don't know, or pretend you don't, about this place, Fran.'

Francine was silent for a while and when she spoke again she sounded unusually diffident. 'Do you have sex with Tom?'

Alice turned to her in astonishment. 'I've been married to the man for six years – what do you think we do?'

'And before you were married?'

'When we had the chance.'

'Your choice or his?'

Alice grinned. 'Let's say mutual attraction. But what's this leading up to?'

'I'll have to have it out with Paul. Now I've got the flat he'll be getting ideas, and I've no intention of going down that road.'

'You mean marriage?'

'Good God, no! I mean sex.'

3

Alice put down her little bed, still incomplete, and gave Francine her undivided attention. 'Are you saying that you've never had it off with Paul?'

'Nor with anybody else. It repels me.'

Alice was shaken. 'My God! *Virgo intacta* at twenty-six! What is this? Are you after some sort of record? . . . Paul isn't exactly my idea of a ball of fire but I can't help feeling sorry for the poor man.' She went on, 'It puzzles me what you see in men if you feel like that.'

'I don't know. It's a game I suppose. They're so damned smug . . . You feel you want to . . . I don't know— '

'To take them down a peg? Is that it? So you lead 'em up the garden and then it's "Back in your box, Bonzo" . . . If it's a game it's a dangerous one, Fran.'

'It's not like that.'

'Anyway, while we're on the subject of your sex life, or lack of it, are you still seeing much of Bob Lander?'

'He comes to the carving shop now and then for a gossip and I look in at the pottery.'

Alice resumed work on her bed. 'If you ask me, there's a thing between him and Emile. By the way, how do you get on with his keeper?'

'Oh, Derek's all right; I quite like him. Of course, he's extremely intelligent and Bob treats him like he was some sort of guru. It's a funny set-up but I like going there now and then, when I get bored.'

Alice said, 'Lina doesn't like to see anybody too friendly with Bob or Derek.'

'Any idea why?'

'Maybe she doesn't trust them. I don't know. It could be a policy of divide and rule. Anyway, Derek is a top-class potter and in a position to make his own arrangements, whatever Lina thinks.' Alice looked across at Francine. 'But where does all this leave Paul?'

Francine said, 'Paul is different. He's been around a long time and I'm used to him.' A frown. 'In a funny sort of way, I need him.'

'And that's all that matters. No wonder he goes about looking

4

like a wet week. Is this sex thing something that happened to you while you were away?'

'When they locked me up, you mean. No, I don't think so, though the kind of sex that was on offer there didn't appeal to me either.'

Francine added after a break, 'You don't understand what it's like to be me, Alice.'

'Does that mean you'd rather be somebody else?'

Francine looked puzzled. 'Somebody else? I've never even thought about it. I'm quite content as I am.'

Alice was having trouble with the alignment of one of the joints and there was silence for a while, broken at last by a sudden sharp shower which drenched the windows and blotted out the moor.

When it was over Alice said, 'You spend a lot of time with Paul apart from working together – what do you do?'

'In the evenings we mostly play chess. He's good, and he's teaching me. I like it, and last week I beat him twice.' She broke off. 'Funny! You'd think he'd have been upset, but he seemed pleased.'

Alice sighed. 'Chess! . . . I don't know what to make of you, Fran. I only hope you know what you're doing.'

Another longish pause then Alice, hesitant, asked, 'Is it true what they're saying, that you've come into money?'

'Yes. From an aunt I scarcely knew. I suppose it's all around the site?'

'There's talk. What will you do?'

Francine smiled. 'I'm thinking of buying in here if I can get the right sort of deal from Lina.'

A few days later

In Emile Collis's studio Francine, wearing a floral dress, posed in an armchair. Sitting askew, an open book in her lap, she was apparently absorbed in what she read.

Half-length portrait of a young woman reading.

The painting carried its catalogue entry (if it ever got that far)

5

like a label. As a portrait painter Collis was almost a century too late.

In a grubby paint-stained overall he worked at his easel. He was fortyish, lean and bony, with a mass of tiny black curls which contrasted oddly with his pale features.

'You've moved your head, Fran . . . Turn just a little more to the light and keep your eyes on the book.'

'I'm getting stiff, Emile.'

Collis dropped his brush into the pot. 'Yes, all right. We'll take a break.' He stood back from his easel. 'I can't get your profile. Damn it! I've drawn you often enough, I ought to be able to do this with my eyes shut, but just because this is bloody paint . . . '

Collis lived and worked in a long low building on the rising ground behind the Archers' house and his studio was sandwiched between his flat and the frame workshop. It was square and bare with three or four easels, a painter's trolley on castors, a stool or two and cupboards around the walls. The light was controlled by blinds.

On two of the easels there were blocked-in canvases of beach scenes and propped on the edge of each was a photograph from which the picture could be developed. 'Beach and coastal scenes with figures' were Collis's staple contribution to the Guild.

Francine massaged her thighs.

'Feel like a coffee?'

'If you like.'

While Collis went to make the coffee Francine wandered into the framing shop. Collis framed all the Guild's pictures, arguing that a frame can make or break a picture.

The shop was equipped with a state-of-the-art mitring machine and a bench with a variety of clamps for gluing, while mouldings of all sorts and sizes were stacked in racks against a wall.

'Oh, you're in here. Coffee's ready.'

'Do you frame the pictures Lina buys in Amsterdam?'

Emile looked mildly put out. 'So you know about them.'

'Doesn't everybody?'

A small shrug. 'Possibly. I suppose they must do if you say so, but Lina likes to think not.'

6

'Why?'

'Perhaps she feels the Guild members wouldn't like her having a side-line.'

'Archer has his St Ives gallery.'

'Yes.'

'*Do* you frame the pictures she buys?'

Collis hesitated, then, 'No. She takes them to a little shop near the Oude Kerk in Amsterdam.'

'So they arrive framed?'

'Yes, but why the interest, Fran?'

'I just like to know.'

'Well, now you do, so come and have your coffee.'

She followed him back through the studio into his flat and the little kitchen–living room which was not unlike her own.

'Biscuit?'

Francine had not finished. 'You lived in Amsterdam for a time, didn't you?'

'Yes, but that wasn't where I met Lina and Archer.' Collis sat back in his chair. 'Look, Fran, let's get this straight. I think I know what it's all about. You've come into money and you're thinking of investing in the Guild.'

'Did Lina tell you that?'

'Yes.'

'You must be in her confidence.'

'I wouldn't say that, but I do want to say something to you. Think very carefully about what you're doing.'

'I always do.'

'Good! Now let's get back to painting.'

'Just one more question. You are gay, aren't you, Emile?'

He turned on her. 'What the hell is that to do with you?'

'I'd just like to know.'

'Yes, and one of these days you'll know too much. Have you been talking to Blond Bob?'

'Not about you.'

'Good! I'd like you to keep it that way. Now, are you going back to the pose or not?'

An hour later Collis put down his brush. 'It's no good! That's it for today, Fran.'

Francine got up from the chair and threw down the book. 'Do I put you off?'

'You're no help.'

'Marsden never complained when he painted me.'

'Perhaps you didn't talk so much.'

'Can I look?'

'No.'

'Do you want me tomorrow afternoon?'

'I don't know.'

'Suit yourself.'

After Francine had gone Collis covered his palette and was attending to his brushes when he had another visitor.

'Lina!'

Lina Archer was a well-built, muscular, vigorous woman in her late forties. She wore her assisted-blonde hair in a page-boy cut, her eyes were blue and cold. Lina Archer: a firm figure appropriate to her Dutch ancestry.

'You look flustered, Emile.'

Collis said nothing and Lina went on, 'I saw Francine leaving. Has she been getting at you?' Her English was perfect and colloquial; only her slightly gutteral delivery gave any clue to her origins.

'Just questions.'

'What sort of questions?' Lina was peremptory.

'Oh, about the pictures. Do they arrive framed, or do I frame them.'

'What did you tell her?'

Collis was silent and Lina demanded, 'I'm asking you what you told Francine.'

Collis's manner was that of a schoolboy caught out. 'I told her that you take them to a shop in the Oude Kerk.'

Lina's expression hardened. 'That was foolish.'

Collis said nothing and Lina went on, 'I want that girl with us, Emile. She could be very useful and not only through her money. She's the right sort, but she needs careful handling.'

Collis was sullen. 'I think she could be dangerous.'

'And so you hand her information which she would be better without at this stage.' A brief pause, then, 'Anyway, there's probably no harm done. I can manage that young woman.'

The Friday before Whitsun

The wood-carvers' workshop occupied the ground floor of a little two-storied building on the far side of the stream. Francine's flat, above the workshop, was reached by an outside stair at the back.

At half-past eight in the evening Francine was in her living room, awaiting the arrival of a visitor. She was restless, though she refused to admit that the prospect of the visit troubled her. She told herself more than once that she was fully briefed, that she held the cards and could make her own terms.

All the same, she had put on the floral dress which she wore for the painting, the only dress she had. And she was looking around her little room with a critical eye. Absurdly perhaps, she had even bought a bottle of sherry.

At shortly after half-past eight she saw Lina making her way over the bridge. Lina in trousers and woolly jumper, looking masculine. Francine thought, I've got it wrong. She waited while the woman walked round to the back of the house, climbed the stairs and knocked. Only then did she get up to let her in.

'Francine!' The tone, the manner – Lina always got it right. Now it said, I've come to talk to you and that is a concession in itself.

Despite the differences in age and experience, they were well matched.

In the living room Lina looked about her. 'You haven't changed anything much. Archer and I lived in this little flat for a few months while they were getting the house ready.' Then, with a disarming smile, 'I can see that you are not house proud.'

'Does that count for or against me?'

Lina was taken aback. 'I'm sorry! I assure you— '

9

'No need to apologise. You've come here, presumably, to make your assessment, as I shall make mine. I simply want to keep an eye on the score.'

Lina recovered sufficiently to smile. 'I can see that I shall have to watch my step.'

They sat on either side of a small table by the window and Lina got down to business. 'I understand that your legacy amounts to around fifty thousand pounds.'

'That is the amount I'm considering as an investment in the Guild.'

'Certainly that would allow us to expand. I have in mind metal-working of some kind – not the small-scale stuff – jewellery and such like. That wasn't a success when we tried it earlier. But there is a growing demand for high-quality ornamental ironwork. Of course, whatever we do we shall have to recruit one, or possibly two really good craftsmen.'

'Would that be difficult?'

'I'm not sure. What will be difficult is persuading Archer to accept the changes. I mean, the Guild will need to be reconstructed on different lines; lines that will conflict with the astrological model he had in mind from the start.' She smiled. 'But don't worry about that; I think I can handle it.'

Francine remembered her sherry. 'Would you care for a glass of sherry?'

'What? Oh, yes, that might be pleasant.'

The bottle and glasses were produced. 'Ah, fino!' Lina approved.

Francine poured the sherry. 'I'm sorry I've no jenever. Isn't that what you call it?' Francine being mischievous.

'I do not drink gin!' Lina said, with emphasis. She raised her glass. 'To the Guild and its future!'

The toast drunk, Lina got back to business. 'I assume that you fully understand the present Guild set-up.'

'I'm not sure that I do.'

Raised eyebrows. 'But surely! You've been a Guild member for a long time and recently, from what I hear, you have made it your

business to sound out other members – filling in matters of detail, I suppose.' Lina added with her thin-lipped smile, 'To the annoyance of some of them, I believe. But let me run over the facts, if only to remind you. Members of the Guild rent their premises and equipment from us— '

Francine interrupted. ' "Us" being the management – you and Archer.'

A moment of hesitation. 'If you wish to put it like that.'

'But that is how it is, and if I invest in the Guild I shall want to join the management on terms according to my investment.'

Lina sipped her sherry and replaced her glass on the table. 'I see that you have it all worked out. But going back to our present organisation, as I was about to say, we obtain the orders on terms agreed by the members— '

Again Francine interrupted. 'I understand that, but there is a condition which says that members are not allowed to do business except through the Guild.'

A broad gesture. 'But surely that is a reasonable, indeed an inevitable condition in the circumstances.'

'Perhaps, but you and Archer, though members, are not apparently bound by it.'

A pause, and a cold stare. 'I suppose you are referring to Archer's gallery in St Ives. But that is a quite separate undertaking pre-dating the formation of the Guild, and Archer— '

Francine cut her short. 'But there is also the matter of your dealings in imported pictures from Amsterdam, and with the little shop near the Oude Kerk. Are these also quite separate under-takings?'

Francine's shots seemed to find a target. Lina paused with her sherry glass halfway to her lips. She was flushed. 'You have been listening to gossip, Francine! I cannot believe that you could see these arrangements as contrary— '

Having effectively rocked the boat Francine felt she could afford to offer some reassurance. 'There is no need to get heated, Lina. I'm not out to make difficulties. Far from it. But if I am to join you and Archer in the management of the Guild I shall want all aspects of

the business taken into account. I shall want to know exactly what is going on.'

Lina was disturbed, her manner less confident. 'You realise that I shall want to discuss all aspects of this with Archer. I have no doubt that we shall be able to work out some sort of agreement but my main problem will still be to overcome his objections to changing the structure of the Guild to which he attaches so much importance.'

She stood up. 'I hope that we shall talk again.'

Francine said, 'I've just one more question.'

'Indeed?'

'What exactly is the position of Blond Bob?'

Lina seemed surprised by this. 'Bob Lander is at present Derek Scawn's assistant in the pottery. There is, as you know, a vacancy in the Guild and Derek would like to see Bob filling that place. Why do you ask?'

Francine was casual. 'No special reason. I just had the impression from talking to him that there was more to it than that.'

'Yes. Well, Bob tries very hard to make himself interesting.'

Lina waited for some response and when none came she seemed put out. 'At least we've broken the ice and, as I said, I shall talk to Archer. I hope that in the meantime— '

'In the meantime I have nothing to say to anyone.'

Lina nodded. 'That is good. We shall talk again.' And she left, significantly less assured than on her arrival.

After she had gone Francine sprawled on the tatty armchair, looking at the two glasses and the sherry bottle on a table by the window. She got up, poured herself half a glass and drank it off. She was unused to alcohol and it went to her head. She felt elevated.

She had started something.

Usually she thought little about her future, and when she did her thoughts were vague, but Lina's visit had changed everything. Now there was the prospect of getting involved with the Guild on terms that would give her real authority. Coping with Lina would be a challenge but she looked forward to that.

A totally new way of life. And she was intrigued to think where it

might lead. But no sex, and certainly no marriage. Smiling to herself, she recalled the nativity play all those years ago, when a newspaper had dubbed her 'The Quiet Virgin'. She decided to settle for that.

Restless, she wondered about going for a walk but dusk was closing over the moor and she finally decided on bed.

She got up from her chair and went through to the little bedroom at the back of the house. Twin beds: one made up, the other tumbled as she had left it that morning. Her black-faced doll lay neglected on the pillow. She undressed, got into bed and pulled the clothes over them both.

Wrapped in a shawl, Blackie had been a stand-in for baby Jesus in the nativity play. Later, when she was arrested, she had been allowed to keep him with her. Later still, at the cost of a litany of dirty jokes, she had held on to him through three years in the Young Offenders.

Now, in the near darkness, lying on her back and staring up at the ceiling she told herself that she and Lina had much in common. *Lina's my sort; too much so perhaps.* She even wondered if there would be room for the two of them.

And a little later she was thinking; *Lina's got Archer and I've got Paul . . .*

She turned on her side and cuddled down with the doll in her arms. 'Never mind, Blackie! You'll always be here.'

And then, 'Poor Archer . . . Poor Paul!'

That same evening

Archer was sitting at his table by the window, surrounded by his books and his manuscript records. Star charts were Blu-tacked to the walls and there was a single bed tucked away, as far as that was possible, behind the door.

With his greying silky hair and beard, meticulously trimmed, he looked like some Victorian icon, a Tennyson, or a Darwin after a visit to the barber.

From his window he had a view of the moor stretching away to the cliffs and the sea. The sky was darkening, and though there was

13

still the remnant of an orange flush away to the west, he could already see the flashing signal from Godrevy light.

With no wind, the silence was total.

Depressed, resentful and unable to settle to his work, he listened for his wife's return. She had not even told him where she was going; but he knew.

At last he heard the sound of her key in the front door and minutes later, her footsteps on the stairs.

'So there you are!'

Where else had she expected to find him?

She came into the room looking flushed. Archer braced himself. Although she owed him an apology for going behind his back he knew he would soon be under attack.

'I've been talking to Francine.'

'I know.'

Lina switched on the light and sat herself on the end of the bed. 'Someone had to talk to her.'

Archer gathered together the bones of his argument. 'That girl is trouble, Lina. She's a Scorpio and she should never have been admitted to the Guild. I was against it from the start.'

Pleased with this firm opening, he fondled his beard and went on, 'Of course, there's nothing we can do about that now, but we can— '

Lina cut in. 'We would have lost Paul if we hadn't admitted her. They work well together and, in any case, she is more than paying her own way.'

Archer shuffled the papers in front of him. 'All I'm saying is that we mustn't allow her to get any further. If she puts the money from her wretched legacy into the Guild she will be a partner with us.' He shifted his chair so that he faced his wife. 'And you know what Scorpios are: once they move into any situation they are never content until they dominate it.'

Lina smiled. 'But you must know by now, Archer, that I am not easily dominated.'

Archer gestured irritably. 'No, but that doesn't reassure me. My idea when I started the Guild was that it should be an opportunity

for fruitful co-operation between nine like-minded crafts people. Not a battlefield . . . That girl would destroy everything that I value in the Guild.' A brief pause before, greatly daring, he added, 'And sometimes I think that is what you want.'

Lina was mild. 'No, that is unfair. I don't want to destroy anything, but in business there is no standing still. You either grow or you go under, and in order to grow we need capital.'

'So you tell me, but I have never heard any convincing reason why a steady turn-over cannot be maintained.' Archer turned back to his table. 'We shall never agree on this, Lina . . . Never!'

There was a lull. Archer went through the pretence of resuming work while Lina sat and waited, knowing there was more to come.

It was longer in coming than she had expected and she was on the point of leaving when Archer turned to face her once more.

'There's another thing that worries me about that girl. It seems that she is upsetting the others by going around asking questions.'

Lina was guarded. 'I suppose it's natural that she should want to know exactly what she would be putting her money into, and what the attitudes of the others would be.'

Archer was dismissive. 'There's more to it than that, as I think you must know. Emile is certainly not himself and hasn't been since he's been seeing so much of that girl.'

'He's painting her portrait. Has he said anything to you?'

'Not directly.' Archer made a vague gesture. 'There's something going on and the girl is stirring it up. It's not only Emile . . . There's Lander . . . I can't put it into words but there's a general sort of unease— ' He broke off. 'You're quite sure you don't know what it's all about?'

'If you want my honest opinion, I think you're imagining it.'

Once more Archer turned back to his table. 'In that case there's no more to be said.'

Lina stood up. 'Well, nothing has been agreed with Francine. It was just a preliminary talk, and I am very tired. The girl is not as discreet as she might be and no doubt there will be problems. All I am saying is that her money would make a great deal of difference

to our prospects and the possibility of an arrangement is worth considering.'

Archer was about to reply but Lina was gone and her 'Good-night' came from across the passage.

Chapter Two

The Wycliffes had finished their meal and cleared away. Helen was reading a novel, Wycliffe turned the pages of the *Western Morning News*.

The room looked out on a garden bounded by trees through which they could glimpse the waters of the estuary. It was growing dusky but neither of them had got up to switch on the lights.

A photograph and a minor headline caught Wycliffe's attention. 'There's a piece here about Paul Bateman. He's made a name for himself as a wood-carver and he's done a frieze for one of the National Trust houses.'

Helen said, 'Remind me.'

'That Christmas, ten years ago. You were staying with David in Kenya, when Jack was born— '

'And you spent Christmas with the Bishops at that weird house with a funny name on the cliff near Zennor. That girl shot her father. Wasn't he an MP or something?'

'Mynhager, that was the house. Yes, Gerald Bateman. Paul was his son and the girl who shot him was his natural daughter.'

Helen said, 'What happened to the girl? I remember that she had a French name and that you were very impressed by her.'

'Francine Lemarque. She was sixteen and they sent her to a Young Offenders. I felt badly about it but I did nothing . . . Bateman was a bastard and deserved what he got. I often wonder what happened to Francine. She was a strange girl. A few nights

17

before the shooting she gave a little gem of a performance as the Virgin in the church nativity play.* I intended to keep in touch.'

Helen said, 'Cheer up! It's Saturday. We've got the Whit weekend in front of us and it could even be fine.'

'And on Tuesday I've got to face the new chief. Just our luck to be among the first forces in the country to be saddled with a woman CC.'

'Does it worry you?'

'No. As King Louis said of a new Pope, "If he doesn't suit I shall take a course with him." '

'Sounds virile. What would you do?'

'Apply for my pension.'

'Let's go to bed.'

That same evening

Once more Francine was looking out of her window, expecting a visitor. She saw Paul crossing the stream. Tall and slim and dark and tentative. Paul always looked where he was going and thought about what he would say.

Francine told herself, 'He's nice. Like a tabby cat who purrs when he's stroked. If only he would bite . . . '

She waited. Paul looked up, saw her and waved. She heard him on the stairs. She had told him not to knock and a moment later he was in the room, standing, questioning.

Francine did nothing to help him and finally he said, 'What shall we do?'

'I don't mind.'

Another interval. 'What about a game?' He was looking at the chessboard.

'If you like.'

They sat at the little table by the window; the chessboard was set up and Paul said, 'White to open.'

Francine, preoccupied, made her move without interest: 'Pawn to K4.'

* Wycliffe and the Quiet Virgin

18

They used the old notation because that was how Paul had been taught.

He responded. 'Pawn to K4.'

Francine hesitated, then, 'Knight to KB3.'

From Paul, after consideration. 'Pawn to Q3.'

Several moves later Paul said, 'You don't want to go on with this, do you?'

'No. We need to talk.'

'About us?'

'Yes.'

'Is there anything new to say?'

'There is. I've made up my mind about one thing. We can never live together as a couple, Paul. I'm sorry.'

'You mean that you will never have sex with me.'

'Yes, that is what I mean.'

'Because we have the same father?'

Francine hesitated, then decided to cheat. 'Yes.'

Paul sighed and was silent for a long time, then, 'Well, if that's how it must be I can live with it. One day you may change your mind and as long as we carry on working and sharing as we do, I shan't complain. I want to be with you, Fran; that's what matters.'

It was Francine's turn to be silent and now, deeply worried, Paul asked, 'Is there someone else? Is what they're saying true?'

'There is no one else.'

'Then we carry on as now.'

'We carry on working together.'

'And outside of work?'

'No, Paul. I don't think so.'

'But— '

'Listen. We are two quite different people. We happen to have been thrown together for a few years when we were young and impressionable, but in the things that matter we have nothing in common. I killed a man, Paul – your father and mine— '

'I have never blamed you for that. I have never held it against you. That man destroyed the only family you knew.'

19

Francine played with her queen, rolling the little piece between finger and thumb. 'You've been good to me, Paul; and understanding, beyond anything I could expect. I owe you everything.' She paused. 'But I'm not the sort to pay my debts. We are different; we want different things. You want stability – security – I want to live life near the edge, and I want to start before I'm too old to handle it.'

Paul sat for a little while in silence, then with many hesitations he said, 'You've been going around asking a lot of questions about the running of the Guild and now you are getting involved with Lina . . . Do you think that is the way to get the best out of your life here?'

It was the first time Paul had even come near to criticising her and it was an odd experience. She said, 'I am not getting involved as you say. I intend to find out what is going on first, then I shall decide what I want to do about it.'

There was another long silence then, in a choking voice, Paul said, 'I can't talk any more now, but I'm not going to give up.' In a vigorous movement he got to his feet, catching a corner of the chessboard so that several pieces rolled off on the floor, and he was gone.

Francine remained seated for a while. The low sun was shining in at the window and she realised that she was uncomfortably warm and sticky. The exchange with Paul was inevitable but it had been disturbing. She went into the kitchen, saw the bottle of sherry on the shelf, and drank straight from it. She decided to have a bath.

In the bedroom she undressed, put on her dressing-gown and went into the little bathroom where there was scarcely space to move around. She turned on the taps to provide the blend of hot and cold that she preferred and waited. For the first time, she realised she was sleepy. The sherry?

She sat on the bath stool and felt increasingly drowsy. The bath was filling and she watched through a haze of uncertainty. She had a headache. The bath seemed to be over-filling.

She couldn't face it. She reached for the taps and turned them

off, then staggered back to the bedroom, supporting herself briefly against the doorpost. She reached the bed, pulled back the clothes, and fell into bed. Blackie rolled over the edge on to the floor.

Whit-Sunday morning

Mulfra Cove lay open to its vast horizon: the sun shone fitfully out of a broken sky and cloud shadows darkened the face of the sea. Out there one had only to follow the great circle and it was next stop Newfoundland.

Closer to hand were the tumbled boulders and weed-strewn sands of the cove. There was no wind, but a slow swell broke along the shore with a curious ripping sound like the tearing of linen.

The cove was bounded by two promontories and halfway down the nearer one Mynhager, home of the Bishop family, clung to its ledge, almost as rugged and ragged as the cliff itself. Mynhager translates with an Arthurian flavour into 'edge perilous'; a mad place to build anything, but the house had been there for more than a century.

It was breakfast time for the remnants of the Bishop family – the two sisters, Caroline and Virginia. Paul was not with them.

Both women were in their late forties. For years now they had taken their meals in the kitchen, where tall cupboards, a giant stoneware sink and a massive central table bedded uncomfortably with a chest freezer, a microwave and a fan-assisted oven.

Virginia had in front of her a bowl of milky bran-flakes without sugar. She ate absent-mindedly, her attention on yesterday's *Telegraph*, folded beside her plate.

Caroline ate her toast, spread with butter and marmalade. Caroline had always been plump, now she was becoming fat. She was thinking of Paul, and how she had never quite got used to being a mother, but she worried about him . . .

Virginia finished her bran-flakes and lit a cigarette. Caroline started to clear the table and Virginia spread her newspaper over the available space.

Caroline said, 'Paul didn't come home last night. That's two nights running.'

'So he stayed at the craft centre. He's done it before.'

'I'm afraid that now Francine's got the flat there he'll move in with her.'

Virginia turned the pages of her newspaper. 'I suppose he might. They call it sex.'

Caroline stopped on her way to the sink with a handful of cutlery. 'It's easy to see you haven't got a child of your own, Vee.'

'No, that's one blessing I've escaped. Thanks be! But if Paul is sleeping with Francine there's not much you can do about it. He's twenty-seven, for God's sake.'

'I'm still his mother.'

'But that's not what's worrying you, is it? Your problem is who his father was.'

Caroline pouted. 'You can be very hurtful when you want to be, Vee.'

'Yes. Well, if you remember, we agreed all those years ago that to survive we had to face reality, but we're still not very good at it.'

Virginia had started on the crossword. Caroline dropped the cutlery into the washing-up bowl with a clatter.

The door bell clanged, sounding like a signal to lower the drawbridge.

Caroline said, 'There's someone at the door,' and went to answer it.

Virginia was aware of a mild commotion before Caroline returned, flustered. 'It's the police; there's two of them. I've taken them into the drawing room. It's about Francine— '

'What about Francine?'

'She's dead . . . They think she's been murdered.'

That same Whit-Sunday morning in the Wycliffes' garden

A late spring morning in the garden of the Watch House and Wycliffe felt that momentarily he was as near to perfect contentment as he was ever likely to get. His book had slipped from his fingers on to the grass, his eyes were almost, though not

completely, closed and he was seeing the world through a vaguely distorting fluid opalescence. Helen, busy with her weeding, seemed insubstantial, and her actions improbable. At the slightest movement of his lids even the estuary changed its configuration: trees became taller and more slender, or shrank and spread their branches. He was in control.

In his enjoyment of the moment, in the very background of his mind he was aware of only one tiny flaw. It was Sunday – and Whit Sunday at that. His progenitors on both sides had been dyed-in-the-wool Methodists. Of course he had given up trying to emulate the Red Queen in believing six impossible things before breakfast, and he sometimes wondered if there could be a religion without magic, and without fear. But being dyed-in-the-wool still meant something and so, in a mildly disturbing fashion, did Whit Sunday.

Then he opened his eyes wide and in an instant he was back in the real world, a much more complex and disturbing world where there were decisions to be made; one in particular.

Bertram Oldroyd, his chief, had finally retired and his successor had been appointed. A woman. To say that the appointment had surprised everybody was an understatement. Even Oldroyd, obviously the first to hear, resorted to the vernacular and admitted to being gobsmacked. But whatever they thought or said, the new chief was a woman: Jane Elizabeth Sawle LLB, formerly deputy chief of Severn Valley.

Wycliffe, along with his colleagues, had already met her in a socialising get-to-know-you session, with drinks and party morsels. A pleasant enough woman, late forties, dignified but not starchy. Word had it that the Home Office had her in their sights for the Inspectorate and that this was a stepping stone.

The question was Stay? Or Go? And for once Helen had been no help. 'Just ask yourself if you can do without it.' The very question he could not answer.

Then his mobile put an end to both enjoyment and introspection. Even Macavity, the Wycliffe cat, opened a disapproving eye.

'Wycliffe!' Fiercely.

As it happened, the duty officer in CID was DS Lucy Lane.

'We have a suspected homicide in the St Ives area, sir. This morning a young woman was found dead in her flat above one of the craft workshops belonging to an outfit that calls itself the Guild of Nine. The police surgeon has diagnosed carbon-monoxide poisoning, resulting from a blockage in the vent from a gas water-heater. And DI Prisk is satisfied that the blockage was deliberately contrived.'

'Where exactly is this Guild place?'

'On the moor, close to the village of Mulfra, a few miles along the coast road from St Ives.'

St Ives, Mulfra, a craft workshop . . . It was uncanny . . . Paul Bateman, Francine Lemarque . . . No, it was too absurd!

He didn't ask the name of the dead girl. In any case, it was quite likely that Lucy would not have known it.

But the names alone were enough to open a Pandora's box of memories. He listened to what more Lucy had to tell him, then he called DI Kersey.

'I'm afraid the weekend's over, Doug. I'll give you what details I've got, then I want you to notify SOCO and follow me down with a small team. It's Lucy's Sunday on so I'll get her to pick me up.'

For several years Lucy Lane had worked with him on all his major cases and she had consistently refused promotion. It happened that their temperaments, even their prejudices, dove-tailed, so that they functioned naturally as a team. At one time there had been gossip, but it had long since talked itself out.

Helen suspended her weeding and came towards him, sweeping her hair back with a bare arm because her hands were earthy. Now there were traces of grey in that hair but the gesture was exactly as he remembered it from the days when they were a newly married couple and he was a beat copper in the Midlands.

'Something cropped up?'

'A suspected homicide near St Ives.' He did not mention Mulfra. 'Lucy is coming to fetch me.'

Matter-of-fact. Just another case; a crisis in the lives of total strangers.

24

While waiting for Lucy he telephoned Dr Franks, the patholo-gist, and was lucky to find him at home. Franks was almost certainly bored for his manner was breezy and forthcoming. 'Well, Charles, what have you got for me?'

And, as usual, this breeziness provoked a sour response from Wycliffe. 'A homicide, apparently. What were you expecting?'

Helen had packed his bag and he added something to read in bed. He changed into a workaday suit. Lucy came to pick him up, and it was still short of midday when they arrived in that cradle of Cornishness called Penwith. The name translates as 'the end of the end', which may seem needlessly repetitive, but being there for a while brings enlightenment to the perceptive.

They drove to St Ives and out by the coast road which follows the margin of the granite moor where it meets the slaty rocks of the coastal plain.

A sharp shower, then the sun shone again. Wycliffe recalled vividly that earlier time when he was driving alone to spend Christmas with the Bishops at Mynhager.

They arrived in the former mining village of Mulfra, with its stark little church, its chapel, its 'Men's Institute', its pub and its cottages, all strung out along the road, sprawling only a little towards the sea on the one hand and into the moor on the other.

Wycliffe knew the village well. Ten years ago he had even stayed for a few nights at the Tributers', a pub which had survived the collapse of mining by catering for those odd enough to want to live there, and for visitors wishing to see something of the real Cornwall.

Lucy said, 'Here we are!' A uniformed constable was stationed at the entrance to a track leading up into the moor.

'It's about a quarter of a mile, sir, and the track is quite passable. DI Prisk is in charge and he's there with the police surgeon.'

Two or three cottages with little other sign of life, but all around, buried for the most part, the artefacts of people who had lived and worked on this land through six or seven thousand years; with some of their bones – not many, for bones succumb to the acid soil and, in any case, cremation was fashionable for much of the time.

The track divided, a fact not mentioned by the guardian copper,

but a woman from one of the cottages was hanging out her washing with a wary eye on the sky. She removed a peg from between her teeth. 'You keep right. What's happening? Is it some idiot who's fallen down a shaft?'

They were climbing gently on a winding track bordered by clumps of gorse in full bloom, golden and blatant.

In fact, the track soon divided again with a made-up road off to their right and a large well-painted sign: 'The Archer Guild of Nine' with a logo in the form of a stylised bow and arrow.

Lucy said, 'How subtle can you get?'

The path they were leaving was marked by an improvised fingerpost: 'To Nirvana'.

'They must have some odd ones around here.' Lucy again. Wycliffe had scarcely spoken a word throughout the trip.

They followed the made-up road into a shallow valley with scattered buildings. A water course divided the site, and the centre of interest was on the other side. Several vehicles were parked near the smallest of three buildings, of which they could see only the gable end. Lucy said, 'The bridge doesn't look much, but I suppose if they got over, we can.'

They did, and Lucy parked in line. A waiting uniformed man said, 'Around the back, sir.'

The building was two-storied and the steps led up to a little wooden balcony which ran around the corner of the house.

They had been spotted and DI Prisk appeared on the balcony. 'Up here, sir.'

Prisk was new to the job and for some reason Wycliffe found difficulty in taking him seriously. Perhaps it was a remark made by a member of the promotions board which dogged the poor man: 'He may be a good copper but he looks like a bloody rabbit.'

It was too true: the prominent incisors, the pinched cheeks and large pointed ears combined to make the image indelible.

At the top of the steps a door with glass panes stood open to a short passage. 'The room on the right, sir.'

It was a bedroom and Wycliffe took in the scene from the

doorway. Twin beds; and the body of the girl was sprawled on one of them, only partly covered by a dressing-gown.

Wycliffe looked down at her and muttered to himself, 'I knew it!'

The other bed was made up and undisturbed. By the window a portable electric fire burned, creating an intolerable stuffiness.

The police surgeon came up the passage to join him. 'In the circumstances I thought I'd better wait.'

Prisk said, 'Dr Forbes . . . Superintendent Wycliffe.'

Forbes was new and young, and sure of himself. Nobody's push-over. If you stay in a job long enough everybody else is new or young, or both.

'Not much I can say. She died of anoxia resulting from carbon-monoxide poisoning. You can see the characteristic patchy, reddish flush.'

Prisk added, 'And, as you'll see directly, the flue was deliberately blocked.'

Wycliffe was forcing himself to really look at the body on the bed. He saw the pale skin with the tell-tale patches, he saw the face in profile, partly obscured by the red-gold hair. It was one of the strangest and most disturbing moments in his experience.

So far he had not spoken a word to the others since entering the bedroom, nor had he acknowledged what he had been told.

Now he said in a colourless voice, 'This is Francine Lemarque.'

Prisk was at his side. 'You knew her, sir?' Prisk was clearly puzzled, first by his silence, now by his manner.

'Yes, I knew her. But what's she doing here?'

It was a silly question but Prisk did his best. 'It seems she worked for the Guild of Nine in the wood-carving shop downstairs. She'd been with them for a couple of years but she moved into this flat only a few weeks ago.'

Wood-carving . . .

Wycliffe was struggling to match this present with the remembered past.

So Paul and Francine had remained together. Rather, they had come together again after Francine had served her sentence . . . And now . . . ?

He continued to look at the body as though mesmerised. The face, seen in profile, was untouched except for that flush, but the eyes were staring.

Deeply moved, he controlled himself and set about the routine questions.

'Who found her?'

'The chap she worked with called Bateman – Paul Bateman. He's downstairs in the workshop and he seems devastated.'

Wycliffe saw in his mind's eye the lean, shy youth who had followed Francine around like a loyal but unwanted dog.

'Does he live on the site?'

'No, he lives with his people in the house down by the cove.'

'Mynhager.'

Prisk looked at him oddly. 'Yes. I understand the girl lived there too until a few weeks ago, when she moved into this flat.'

Wycliffe struggled to keep his mind on the present. He turned to the doctor. 'Anything to say on time of death?'

Forbes pondered. 'Last night. My guess is that she's been dead between twelve and sixteen hours, but Franks may have other ideas. That electric fire has retarded rigor but accelerated putre-faction.'

Wycliffe snapped, 'Yes, turn the damn thing off!'

Prisk was getting restless. 'I think you should see the cause of all this, sir.'

On the other side of the passage there was a tiny bathroom and the bath was two-thirds full of water.

Prisk pointed to a gas water-heater on the wall. 'There's a gas tank that supplies the buildings on this side of the stream and that heater is the culprit. The vent has been deliberately blocked. You can see it from the balcony.'

Wycliffe followed him outside and around the corner of the balcony. Prisk pointed to a standard square louvred vent, secured to the wall next to the little window of the bathroom and within easy reach. What looked like a bath towel had been wound around the vent and pressed in tightly, effectively blocking the louvres on all sides.

Prisk said, 'Ingenious, don't you think?'

Ingenious. Wycliffe saw it differently. As the manifestation of a cold festering hatred which he had never experienced and would never understand.

Back in the flat Forbes was ready to bow out. 'Well, if that's all, I'll be off. The rest is up to Franks. This was supposed to be my free Sunday. I'll let you have my report.'

Fox, the long, lanky Scene-of-Crime officer, turned up with, among other things, his assistant. Fox's unfortunate assistant was treated like a beast of burden.

With his camera Fox made a preliminary survey, clicking and picking his way around like a discriminating stork.

Wycliffe was still trapped in a limbo between past and present. Instant memories recalled in scenes and phrases that surfaced for a moment and were gone. Francine in the chancel of the village church, wearing a blue gown and caught in the spotlight, singing a lullaby – the Virgin in a nativity play. Francine at Mynhager, leafing through an album of old photographs, pondering over them – intent, lost.

Francine, at the top of the stairs, a gun in her hand, standing over a body which lay in a pool of blood: the body of Gerald Bateman MP, her natural father.

Now Fox was saying, 'You'd think she was too old for this sort of thing.' He had picked up a black-faced doll from the floor and dropped it on the bed.

Wycliffe recalled DI Kersey's words after Francine's arrest. 'She insisted on taking her black doll with her.'

Lucy Lane had disappeared. It was part of their routine. She would take a general look around, mingle and gossip where occasion arose, and come back with some lively titbits.

Wycliffe turned to Prisk. 'Let's get out of here.'

They went to stand on the little balcony. 'Have you contacted the relatives?'

'Yes. As soon as we had an ID my sergeant and a WPC went to Mynhager, where she lived before she came here. I asked Paul Bateman to break the news, to go with them, but he wouldn't. It

seems they're not exactly relatives but they're all she's got around here, at any rate.'

Wycliffe, reflective, said, 'Yes, the Bishop family. She wasn't related to them in the ordinary sense, but they had good reason to take her in.'

Prisk looked at him. 'You really do know this young woman, sir. Anyway, according to my chap their reaction was odd; not indifferent exactly, but cautious.'

Wycliffe could believe that. 'Presumably they asked about Paul?'

'Yes, and our man explained the situation.'

'Right! Now, what about the set-up here, this craft colony or whatever it is?'

'I can't tell you much, sir. It was started before my time by a chap called Archer, who still runs it. He leased the old mine buildings and spent a packet on renovation and conversion. God knows how he got it through Planning.'

'Know anything about him?'

'I met him once in connection with a break-in at his gallery in St Ives. Seems a decent bloke. Arty type from way back. He's got a wife, but I've never met her. They say she's a foreigner – Dutch, I believe.'

'Any gossip about the place?'

Prisk pouted. 'Not much. The locals don't like the set-up on their doorstep but there's nothing you could pin down.'

Lucy joined them and Wycliffe asked, 'What's your impression?'

SOCO and Forensic would go over the flat with the proverbial fine-tooth comb. (Odd analogy – this device for combing out head lice). Anyway, their reports would run to pages of typescript, but it was from Lucy that he would learn how the place had been lived in.

'She wasn't house proud. The loo and the kitchen sink could do with some of that magic stuff that kills all known germs. And the vacuum cleaner could do with an outing. There's a locked desk in the kitchen–living room. It's a toy lock but I suppose we'd better leave that to Fox.. A radio but no TV. A fair number of books, mostly paperbacks by female authors. Austen to Woolf,

Mansfield and Murdoch. She must have had something in that head of hers.

'One other thing. It looks as though she had company last evening. On a table by the window there's a chessboard, apparently set up for play but it seems there might have been a quarrel; the pieces have been upset and there are some on the floor.'

They were interrupted by Franks, ready to add his special blend of wisdom, whimsy and wit in a recipe that was guaranteed to raise Wycliffe's hackles.

At the bottom of the steps he was already complaining. 'Well, Charles, it's a holiday weekend so I suppose you had to find something to keep yourself occupied.'

He climbed the steps, followed by his secretary. The pathologist's secretaries came and went. To date they had all been young and nubile; this one was matronly, a pleasant-looking woman in her forties. Perhaps at last his tastes were maturing to match his age.

'This is Viv. I don't think you've met her.'

A moment or two later he was bending over the body on the bed. 'Oh dear! What a waste! . . . Well, let's see what we can make of her.'

Viv stood by him, making selective notes from a flood of words. 'Anoxia as a result of CO poisoning . . . Otherwise, a healthy young woman . . . A virgin, incidentally. You'd have thought she'd have done something about that. She couldn't have been short of offers . . . Now, how did she get like this? Accident? Or some foul deed?' He turned to Wycliffe. 'Is that still a question?'

Wycliffe controlled himself. 'Apparently not.' He showed Franks the bathroom, the heater and the outside vent with its draped towel. 'Does that make sense?'

'As murder – yes. She would have undressed, put on her dressing-gown, gone into the bathroom and fussed about as women do, while she ran her bath.'

'Wouldn't she have noticed the fumes from the heater?'

'Probably not. The haemoglobin of our red cells, Charles, has a greater affinity for carbon monoxide than for oxygen and will pick it up from very low concentrations in the air we breathe.'

'Blocking the oxygen uptake.' Wycliffe disliked being spoon-fed, especially by Franks.

'Exactly, Charles! You're learning. The girl would feel a bit dizzy, she might have developed a sudden headache. Enough anyway to make her give up the idea of a bath. Obviously she turned off the water and went back to the bedroom.' Franks spread his hands. 'But too late. It's the classic pattern.'

'We've no way of knowing when the vent was blocked.'

'Your problem, Charles.'

'How long has she been dead?' Wycliffe pointed to the electric fire. 'Remember, that thing was on when our people got here and for some time afterwards.'

'I thought there was something. So all I've really got to go on is my crystal ball. What do you expect me to say? All right, let's make it latish yesterday evening and it's unlikely that I shall be able to improve on that.'

'Anything else?'

'Not until I've had her on the table. Now, if you'll get her to the mortuary SAP I might still get tomorrow off. I'll be in touch.'

He turned to his secretary. 'Right, Viv. We're away.'

Wycliffe walked with Franks to his car. The secretary went ahead and Franks watched her with an expression which could only be described as rueful. 'How's Helen?'

'Fine.'

'You're lucky, Charles. You got all this over early.'

'I'm no good at cryptic crosswords but is that a way of telling me that you're thinking of marriage?'

'What else is there at my age?'

'She seems a nice woman and she needs to be if she's going to put up with you.'

Franks said nothing for a while, then, 'She doesn't talk much, which is something . . . By the way, I'd like you and Helen to come to the wedding. Register Office of course. No flowers by request.'

'We'd like to come. When is it?'

Franks looked at him in astonishment. 'God! Don't rush me, Charles. I haven't asked her yet.'

As he was getting into his car, he turned. 'You look miserable, Charles. Just remember that every silver lining has a dirty great cloud behind it. So cheer up.'

A moment later the Porsche departed in a gravel-scattering screech of tyres. For years Franks had got away with driving like a lunatic and sleeping with his secretaries; for so long Wycliffe had come to the conclusion that there must be a department up there with the sole responsibility of looking after the Frankses of this world.

Kersey arrived. 'I've got Shaw, Dixon and Thorn with me but Potter and Curnow are on call if and when we need them. You said a small team.'

Wycliffe disliked having people around until the organisation was there to use them. A brief consultation with Prisk and it was agreed to set up an Incident Room in the Penzance nick where communications were good.

'Leave that to Prisk and Shaw. We shall need a caravan on the site. Get that organised and we'll have a briefing in the morning and get down to a routine. I want to clear my own mind before I start confusing other people's.'

The mortuary men arrived and carried the body away on a stretcher, enveloped in a plastic shroud. They had problems with the stairs but eventually they reached the waiting van and what remained of Francine Lemarque was driven away to the mortuary; there to suffer indignities that would do her no good at all but might help to discover who had killed her and so make everybody feel a bit better and a little safer.

At least there were no sightseers. In fact, the residents were being singularly discreet. And no media interest so far. A lot can happen on a Sunday, especially during a holiday weekend, before their instincts are aroused.

The body gone, it was possible to take a look at the bedroom. Lucy pointed to a framed drawing hanging above the bed head. It was in pencil, a head and shoulders of Francine, and it was the work of a natural.

It was inscribed, 'With love, Emile.'

Lucy said, 'I wonder who he is.'

'At any rate he can draw. Interesting.'

Wycliffe was striving to clear his mind, to be objective and professional. 'We believe that Francine died in the late evening or early in the night. Of course the vent must have been obstructed at some time before then, but it's visible from several places on the site. The obstruction itself wouldn't be noticed but anyone putting it there in daylight would be taking a risk.'

'So the inference is that the vent was blocked the night before.'

'They wouldn't know when she would take a bath.'

'But would that matter?' Anyway, let's go down and talk to the boy.'

He still thought of the twenty-seven-year-old Paul Bateman as 'the boy'.

Wycliffe was going through a very strange experience; it was like opening a book he had never read only to find that he had an intimate knowledge of some of the characters.

In the workshop downstairs Paul was seated on a work-bench by the window, legs dangling, surrounded by the tools of his craft. A young WPC sat on the only chair, prim and band-box neat.

She shook her head and murmured, 'Nothing, sir. Not a word.'

When she had gone Wycliffe said, 'You remember me, Paul?'

'Yes.'

On one of the benches there were several carved female figures in a similar stage of completion, and standing against one wall was the section of that frieze which he had seen in the newspaper photograph: an intricate design of fruit and flowers.

Wycliffe said, 'Perhaps we should move to somewhere we can talk.'

'I'm all right here.'

'I understand your distress, Paul, but we have to find out who did this to Francine.'

'Yes.'

'When did you last see her – alive?'

'Yesterday evening.' Paul had never been much given to speech;

34

a born craftsman, he expressed himself through the work of his hands and he was inept with words.

'You were playing chess?'

'Yes, we had started to play but Fran wanted to talk.'

'What about? Anything in particular?'

He hesitated. 'I don't know exactly. She wanted to change things, not to be together so much.'

'She wanted to stop working with you?'

Paul looked vaguely around the carving shop. 'No, I don't think it was that.' A pause, then, 'She didn't want anything beyond that.' His voice broke and there were tears in his eyes.

'You quarrelled?'

'No, I was upset and I just left.' He turned away to hide his tears. 'I went home.'

'What time was this?'

'I don't know. It wasn't dark.'

'You stayed at home?'

'No, I went back later; I couldn't settle. It was quite dark then; there was no light in the flat and I thought that Fran must have gone to bed . . . I couldn't bring myself to disturb her . . . I wish to God I had.'

'So what did you do?'

'I spent the night here – I do that sometimes. There's a sort of bed at the end there.' He pointed down the workshop.

'I noticed a spare bed in the bedroom upstairs; did you never spend the night there?'

'Never.'

'So last night you were here in the workshop.'

A nod. 'If I'd gone up to her when I arrived back here I might have . . . ' His voice choked on the words.

Wycliffe said, 'No, I don't think so.' After a brief pause he added, 'And when you went upstairs, early this morning, you found her.'

'Yes.' The word was barely audible.

Wycliffe tried again. 'Why did she move out of Mynhager to come here?'

35

Paul shook his head. 'It was her idea and it seemed the thing to do. I mean, we were working together here and I thought that we would end up by living together, but that was not what Fran wanted.'

'But you worked well together?'

'Oh, yes.' He pointed vaguely at the figures grouped together on the floor. 'All those figures are Fran's work, and they're good. I'm no use at working in the round.' He stopped speaking. It was clear that he wanted to say more but he had difficulty in making up his mind. In the end it came. In a low voice he said, 'I can't help wondering if all that has happened was because of the money.'

'What money?'

'Fran was left quite a lot of money by a relative. I don't know any details.'

'Didn't she speak to you about it?'

'No. I only got to hear of it from gossip on the site. They were saying that Fran wanted to buy herself into some sort of partnership with the Archers.'

'You didn't ask her about it?'

'No. If she wanted to discuss it with me she would have told me. So far as I was concerned it made no difference, but it was after she knew about the money that . . . Well, it was then that things changed.'

Wycliffe decided on a different line; the money angle could wait. 'Did you ever have the impression that Francine wanted to avoid a closer relationship because you were her half-brother?'

Perched on the edge of the bench Paul was staring down at his feet. He spoke quietly. 'She said that, but I knew it wasn't true. It was just an excuse. She didn't want me.' The words were spoken with bleak resignation.

A pause, then he looked up. 'But what does it matter now?'

Wycliffe decided that he must begin to act like a policeman. He said, 'I want you to go with one of my officers to Penzance Police Station where you will be asked to make a statement for the record.'

'Am I under arrest?'

Wycliffe took pity. 'No, Paul, and you are not accused of anything. This is routine, which follows inevitably from the fact that you were close to Francine and that you were here last night. You understand?'

'Yes.'

Wycliffe walked down the length of the workshop to an area at the back where wood was stored in racks. In a corner there was a camp bed with a mattress, a pillow of sorts and two or three blankets.

Outside, Lucy, who had sat through the whole interview but had not spoken a word, said, 'Do you want me to warn them of his arrival? They'll need to be briefed.'

'No. Kersey will be going to Penzance and Paul can travel with him. I would like him to conduct the interview and I'll have a word. Put him in the picture.'

Chapter Three

Whit-Sunday continued

Lucy pointed across the stream to a substantial two-storied house with a lichen-covered slate roof. 'That's where the Archers live, and the Guild office is there.'

The sun was shining, and the moor was a pattern of greens with splashes of yellow gorse, dotted with grey boulders and crag-like outcrops of granite.

They found the office at the side of the house. It was well-equipped and business-like but unattended. There was a bell on the desk which Lucy pressed, and in due time a wispy little woman, grey-haired and sixtyish, came through from the house. She wore an apron, and she was wiping her hands on a towel.

She looked at Wycliffe. 'Oh, I remember you. You're the policeman. I thought they might send you.'

Wycliffe was puzzled, then recognition dawned. Yet another figure from the past – Evadne Penrose; he remembered her name. Not bad after ten years. But she seemed to have shrivelled, as though sun-dried: her face was a network of wrinkles.

Pleased with himself, he said, 'You're Mrs Penrose. You were a friend of the Lemarques and you lived in Wesley Terrace.'

The little woman was unimpressed. 'Yes, I'm Evadne Penrose and I was a friend of Jane Lemarque but I couldn't say the same of her husband or, for that matter, of her daughter, though I wouldn't have had this happen to anybody. Yes, I still live in Wesley Terrace but I come here to help out.'

Wycliffe tried to stay clever. 'I remember that you were interested in astrology.'

'I'm not only interested, as you put it, I *believe* that our destiny is influenced by the celestial sphere, and during the last ten years I've been making a serious study of the subject. That's why I'm here. Archer and I have a lot in common – including the fact that we are both Sagittarians.' She added, 'But you didn't come here to talk to me.'

It took Wycliffe a moment to recover. 'I want to talk to everybody who has anything to tell me about Francine and her relationships.'

Pouted lips. 'Yes, well, Francine was a Scorpio.' She broke off. 'Anyway, I'll get them to talk to you.' And she was gone.

A moment or two later a large and distinguished-looking man came through from the house, already talking. 'My name is Archer – Francis Bacon Archer. This is a terrible thing. I can't begin to take it in. I mean, that the poor girl should be murdered is bad enough, but here, of all places!'

Wycliffe introduced himself and Lucy Lane.

'Do sit down, both of you.' A gracious manner.

He was impressive, and there was something familiar about him. Wycliffe wondered whether he was yet another haunting from the past, then he remembered. He had been reading a biography of Eric Gill, and here was a photofit of the man on the cover: the father of the twentieth-century craft colony.

The image came complete, with the beautifully sculptured silky hair, the beard and the moustache. Even the spectacles were right – narrow lenses with pale rims. No doubt there was a round, broad-brimmed, black hat somewhere handy, even if there was no stone-carver's smock in a closet.

Archer's choice of a role model said much about the man himself, but he had adopted astrology as his religion, instead of Gill's aberrant, if colourful, Roman Catholicism. Wycliffe wondered if he shared Gill's sexual proclivities. No doubt that would emerge.

And the expansive manner was there. 'We shall miss her greatly,

both as a person and as a craftswoman. She and Paul Batemen were a well-matched pair: Francine's best work was done in the round, while Paul is a real master of relief.'

They sat down. Was it by chance that Archer's desk was placed so that the soft light from the window did justice to his profile?

Already mildly prejudiced, Wycliffe got down to business. 'I understand that Francine Lemarque had been a Guild member for some years and that for several weeks she occupied the flat above the wood-carvers' workshop where, last night, she was murdered.'

A pause, to let the brutal word sink in. Then, 'We need you to tell us what you can about her way of life and her relationships – anything which might shed light on her death.'

Archer stroked his beard. 'I am in a very difficult position, Mr Wycliffe. Francine came to us after serving a sentence in a Young Offenders' institution, and it was only because of her association with Paul Bateman, and the fact that she had taken a course in wood-carving while in custody, that, after a trial period, we felt able to offer her a place here.'

Archer sat back in his chair. 'She spent some months in my gallery in St Ives as a sort of probation. I— '

Wycliffe cut him short. 'I know her earlier history very well, Mr Archer. And I know that she was not directly related to the Bishop family at Mynhager. If any of this turns out to be relevant we already have material to work on. You can best help by telling us about her life here, particularly during recent months.'

Archer readjusted his ego. 'I'll try.'

Wycliffe went on, 'I've already spoken to Paul and he has gone to Penzance Police Station to make a statement as a witness to the circumstances.'

Archer clasped his hands on the desk top. 'We are very worried about Paul, Mr Wycliffe. Since Francine came to live with us on the site he has changed. I know nothing of the details but it has been obvious to anyone that things had not gone the way he had hoped and expected.'

'How did Francine fit in with the other members of your Guild?'

Archer shifted in his chair. 'I don't know whether you have any knowledge of astrology, Mr Wycliffe, but I have made some study of the subject. Francine was a Scorpio, born early in the month of November, and I have to say that she was in every way true to her birth sign. Scorpios are secretive and intense, with tremendous will-power. They are inclined to be ruthless and they can be dangerous enemies.'

'You are saying, then, that she did not fit in; perhaps that her presence here was disruptive?'

This was too direct for Archer and he side-stepped. 'We are craftsmen, Mr Wycliffe, and each of us is absorbed in the very individual work we have on hand, but I have to admit that we do not always achieve that sense of community and mutual trust for which I have hoped and worked.'

Wycliffe was losing patience. 'Whatever that may mean, Mr Archer, DS Lane will be spending some time here, with others, inquiring into Francine's relationships, and you and your members will, as a matter of routine, be required to account for those relationships as far as possible.'

Lucy Lane came in on cue. 'To start we shall need a list of the people who work here and the names of any regular visitors.'

Archer seemed about to protest. 'I assure you, Mr Wycliffe— '

It was at that moment Wycliffe became aware of a tallish blonde woman, standing in the doorway which led from the house. Archer must have seen her at the same moment and he became flustered. 'Oh, Lina, my dear! . . . Do join us . . . Superintendent Wycliffe and Sergeant Lane are here about poor Francine.'

Then, to Wycliffe, 'This is my wife and partner in our enterprise. She is a painter, but she now concerns herself more with the business side.'

Lina came into the room, closing the door behind her, and took the chair Archer placed for her. She wore a turtle-neck jumper with expensively tailored trousers. Well-packaged elegance.

Wycliffe had the impression that she had been waiting, ready prepared to make her entrance. Younger than Archer? Perhaps, but not much; there were tell-tale lines around her mouth and eyes.

As she sat down she took charge. 'It is obvious that Mr Wycliffe wants to know more of the nature of our Guild, of our work and of our relationships. In the circumstances that seems perfectly reasonable and we must help in any way we can.'

Knowing her background, Wycliffe was impressed by her remarkable command of English.

Archer said, 'My wife is Dutch; we met when she was working in the conservation department of the Rijksmuseum in Amsterdam.' From his manner it was evident that Archer still had pride in his Trojan horse.

Lina leaned forward in her chair, resting her hands lightly on the table top. 'Anything we can do to assist your inquiries we shall do gladly.'

Wycliffe said, 'Perhaps you will tell us something of the nature of your Guild and how it works.'

'Of course. Our conditions require that there shall be nine of us engaged in art and craft work which we market as a group. We find it convenient and pleasant to work and, in some cases, to live together as a community. Apart from Archer and myself, Paul and Francine, whom you already know about, we have a very distinguished potter in Derek Scawn. He lives on the site with his assistant, Robert Lander, who, I believe, is some sort of relative but he is not a member of the Guild.'

She broke off with a glance at Lucy, who was taking notes. 'Am I going too quickly for you?'

Lucy was reassuring and Lina continued. 'And there are three more – Emile Collis, our resident painter; Alice Field, who looks after miniature crafts and Arthur Gew, our typographer and engraver.'

A satisfied smile. 'And there, I think, you have us.'

Lucy Lane said, 'So, at the moment, you seem to be one member short.'

Lina shifted in her chair. 'You are quick, Miss Lane. Yes, we do have a vacancy at present. Some months ago the young woman who ran our jewellery department left us. The department was not a success and there is some discussion about how she should be

replaced. Derek Scawn has nominated his assistant, Robert Lander, for the vacancy but at the moment it remains open.'

Lina, satisfied that she had dealt successfully with a minor hiccup could not resist embroidering. She went on. 'Of course, in any group such as ours there are bound to be currents and cross-currents, but in a terrible situation like this they are easily exaggerated.

'Anyway, to complete our story, I should add that, as a quite separate business, Archer has his own gallery in St Ives where he sells paintings and craft work.'

She sat back, pleased with herself. 'I'm quite sure that Archer will have no objection to you meeting and talking to any or all of us if it will help. In fact, you had better have one of our brochures. At least it will identify the people I have mentioned.' She reached into a drawer. 'And here are some copies of our site plan which will help you to find them.'

A polished performance which left no doubt about who was running the show, and Wycliffe found himself mildly bewildered, with a fistful of glossy art work.

He gathered the reins and his wits. 'Thank you. That was very clear. Now, perhaps, we can concentrate on Francine and her relationships with the others. For example, Mr Archer mentioned that in recent weeks there appears to have been some tension between Francine and Paul Bateman.'

A pursing of lips. Lina said, 'There is, I believe, a simple explanation for that. Francine was spending too much time with Emile Collis, our painter.'

'You think there was something between them?'

A dismissive gesture. 'I think Francine was merely being provocative.'

'Another point: I understand that Francine had come into money and that there was some question of her investing in the Guild. Could this have been a source of friction?'

Lina was ready. 'I wondered when we would come to that. And I have to say that indirectly it could have given rise to tension. Francine told me that she had inherited a substantial sum from an

aunt and that she would be interested in a possible investment in the Guild.'

'You were willing to consider such a proposal?'

Lina glanced at her husband. 'To consider it – yes. But there were difficulties in that it would have entailed substantial changes in the nature and organisation of the Guild.'

'Were these possible changes resented by the others?'

Lina looked mildly uncomfortable. 'I suppose you could say that there was resentment in some quarters.'

'Presumably you had discussions with her?'

'I went to see her one evening with a view to finding out exactly what her position was, and to explain ours. Of course, there was no question of reaching any decisions at that stage. We simply had a discussion that was entirely amicable.'

'When was this?'

'I talked to Francine on Friday evening.'

'You visited her in her flat?'

'Yes.'

'At what time did you leave?'

'I can't say exactly. It was dusk.' A sharp look. 'Is this important?'

Wycliffe did not answer directly. 'We believe that Francine died in the late evening or early in the night on Saturday, the day following your visit, but the obstruction could have been put in place at any time before that. It would become effective only when she used the bath heater. The vent is visible from several places on the site and though the obstruction itself might not be noticed, anyone putting it there in daylight would be conspicuous.'

'So someone may have put whatever it was there during darkness on Friday night. Are you suggesting— ?'

'Certainly not. I am simply inquiring into the possibility that someone may have been seen on the balcony or in the vicinity. Every possibility, however unlikely, has to be followed up.'

'All I can say is that I saw no one.' Lina was flustered.

Wycliffe decided that it was a good point at which to break off.

He stood up. 'Well, thank you for your help. DS Lane will be here with others to talk to the rest of the Guild members and it will be necessary later to take formal statements in some cases. Being Sunday, I suppose there will be few people on the site?'

Lina was dismissive. 'We don't work to fixed hours or days, Mr Wycliffe. It depends on what commissions we have. And, of course, some of us live here anyway. As a matter of fact, I think we prefer having our free time when the shops are open, so it is quite possible that we may have a full house today.' Lina evidently took pride in her mastery of colloquial English.

Wycliffe had had as much as he could take in one session, but on the point of leaving, he said, 'I see you have Evadne Penrose working for you.'

Archer looked surprised. 'You know her? . . . Of course, she was a friend of Jane Lemarque and you would have met her then.'

Lina cut in. 'I hardly think Evadne would agree that she works for us – rather that she helps us out. You may not know that she is a firm believer in astrology. And, like Archer, she is a Sagittarian, so what more could we ask?'

They were seen off by Archer, and outside Wycliffe said, 'So there we are! The best butter, nicely wrapped. Now it's over to you, Lucy. I'm not asking you to do a hut-to-hut. Just pick out one or two you think might be interesting and go fishing. Obviously we shall have to interview them all formally when we've more to go on.'

'May I ask, sir, what you intend to do?'

'I'm hoping to renew an acquaintance of ten years ago; a chap called Marsden, a painter. If he's still around and on form he'll know a good deal of what goes on here. Whether he'll tell me about it is another matter, but there's no harm in trying.'

'And where does this oracle live?'

'I'll show you. I want you to drive me there before you start here. By the way, what's the time?'

'If you look at the clock on the dash you'll see that it says three forty-five.' Lucy was nobody's nanny.

'What about trying for a snack at the Tributers'?'

'One of your better ideas, sir, if you think they'll bother with us at this time of the day.'

'I've got friends around here, Lucy. At least I hope I have.'

The Tributers' was empty except for a plump woman behind the bar polishing glasses. She looked up, hesitated, then, 'Mr Wycliffe! My dear life! It must be ten year if it's a day!'

Phyllis Tregigo at sixty, still looking as plump and rosy-cheeked as ever on a diet which figured eggs, bacon, pasties and cream high on the menu.

'Good to see you again, Phyllis. This is Detective Sergeant Lane.'

'Pleased to meet you, my dear. And there was me thinking he'd brought his wife to see me like he promised all they years back.' She turned to Wycliffe, 'Ah, well! I suppose you're mixed up with this business on the moor. I thought you must've got too high up for that sort of thing but I'm some glad you're here.'

'We wondered if you could manage a sandwich or two and a cup of coffee?'

Later, leaving The Tributers' after a salad with home-cured ham, Lucy said, 'I must add Phyllis Tregigo to my list of your fans.'

They turned off the coast road down a narrow lane by the pub. A little blue and white sign read, 'To Mulfra Headland and Cove'. Two or three cottages and the lane became a dirt track with a low granite wall against rising ground to the right, and the steep sides of a barren valley to the left. Down there the same stream which flowed through the craft site made its tortuous way to the sea.

Across the valley a single cottage stood in isolation. The Lemarques had lived there: Francine, with her mother and the man she believed to be her father. More memories. It was ten years ago but nothing seemed to have changed. As if to drive home the point it started to rain. Then it was Christmas; now it was spring.

They came to Marsden's cottage: the lean-to studio was still there and its glass roof still had its quota of gull droppings, essential, according to Marsden, for filtering the light.

Lucy pulled up by the cottage. 'You'd better check that he's in before I leave you.'

'He's in all right; can't you hear?' Music was blasting out of the cottage and Wycliffe recognised a Verdi chorus, though with Marsden it might equally have been Gregorian chant or the Spice Girls. A man of catholic tastes.

'Come back in about an hour, Lucy. I've got my mobile if you want to get in touch before then.'

Lucy found a place to reverse and drove off.

Wycliffe banged on the door and eventually the music died, the door opened and there was Marsden filling the gap. 'My God, it's the Law!' Marsden would have made a good drinking partner for Sir Toby Belch, up to all his tricks. He hadn't changed much: his face was a little fatter, his colour a trifle higher and his dark curls had given way to a grey fuzz.

'Do come in! How long is it? Must be seven or eight years.'

'It's more like ten.'

The room hadn't changed much either. It was spartan, with coir matting on the stone floor, a cupboard, a kitchen table and chairs, and a couple of Windsors by an open grate where damp logs smouldered.

Add a state-of-the-art music centre, a storage cabinet for records and CDs. What was both new and surprising was a telephone.

A cat sprawled, paws extended, by the hearth.

'Is that still Percy?'

'Of course it's Percy. We wear well in this neck of the woods, don't we, boy?' And he nudged the cat gently with the toe of his slipper. 'Can you do with a beer? Tributers' home brew. Remember?'

Once settled, Wycliffe said, 'Francine Lemarque – I suppose you've heard?'

'Nobody tells me anything. What about Fran?'

'She was found dead in her bed this morning.' Wycliffe described the circumstances.

Marsden was silent for a while, then he said, 'Poor little Fran! That kid never had any luck . . . You've got the bastard who did it?'

'No.' Wycliffe told what he knew.

'You're not saying you think it was the boy? Paul couldn't kill a louse. And he was daft about her. You must remember how he danced to her tune when they were schoolkids. And when your lot got her put away he never missed a visit. Nothing's changed.'

'Did she ever come to see you?'

'Now and then, when she was feeling browned-off.'

'When was she last here?'

Marsden frowned. 'About a week ago.'

'What did you talk about?'

'Anything or nothing.'

'But you must have known that she'd left Mynhager and was living in a flat above their workshop in the Archer set-up. The fact is, I'd like to know more about this Guild of Nine.'

Marsden paused with the tankard to his lips. 'I'm getting the message. You've heard on the grapevine that Marsden sometimes puts in an appearance there, so if there's any dirt he'll know about it even if he isn't up to his neck in it.'

He looked at Wycliffe. 'Is that how it goes?'

'Not quite, but it will do.'

Marsden took time to consider and finally he said, 'Our Lina is the brains behind that outfit.'

'Lina being Archer's wife?'

'The boy is quick. Anyway, I don't know of anything crooked going on there. She runs a good business. They've sold some of my stuff and got fair prices. True, they take a nice whack for the kitty but I'm not whingeing on that account.'

'So a thriving business, well run and above board. I'm glad to hear it.'

Marsden spoke into his beer. 'Like hell you are. You smell a rat or you wouldn't be here.'

Wycliffe said nothing and after a while Marsden went on, 'Lina is away quite a bit.'

'So?'

'For one thing she makes regular visits back home; I'd say five or six times a year. You know she's Dutch?'

48

Wycliffe said, 'I'm told that Archer met her when she worked in the Rijksmuseum in Amsterdam.'

Marsden made a dismissive gesture. 'Archer is a stuffed dummy, but Lina manages for both of 'em. Anyway, on these visits back home she attends picture auctions.'

'Does she buy much?'

'There must be one or two auctioneers in the business who are not sorry to see her among the punters. She's known.'

'What does she buy?'

Marsden jibbed at these direct questions. 'How should I know? I only pick up a bit here and there from old mates when they're this way, or if they phone, needing a spot of local colour quick.'

In the ensuing silence Percy drew himself together, standing on all fours, arching his back and stretching. Then he mewed plaintively at Marsden.

Marsden said, 'Percy wants to go out. Bladder's getting weaker, like mine.'

When Marsden returned he sat for a while, supping his beer and staring into the fire. Wycliffe knew better than to try to hurry him.

And in the end it came. 'There's something odd about the way she spreads her money. I mean, she doesn't stick to a period or a group or a style. The subject doesn't seem to matter much either. As long as it's by a name, with a reasonable provenance and within her price range, that's all she seems to care about.'

'And what is her range?'

'Anything from five to ten grand. She never gets carried away and tops that. Don't ask me what ten grand is in guilders or euros but it's real money anywhere, though she's not playing against the big boys.'

'You've been keeping an eye on her.'

Marsden shifted heavily in his chair. 'I admit that along with one or two mates who travel, we've got interested. We're intrigued because we can't see what she's up to.'

'Do you know what happens to the pictures?'

'She sells them on, of course. She's not setting up a bloody

gallery. With the few I've been able to trace, she's made a bit. But on balance, after allowing for expenses and commission, it's doubtful if she does more than break even. The game doesn't seem worth the candle. It's odd. That's all.'

'A hobby?'

Marsden sighed and scratched his forehead. 'Perhaps. I suppose Shylock could have had a hobby, but I wouldn't bet on it.'

Wycliffe thought it time to try a fresh move. 'Do you know Emile Collis?'

'Lina's poodle. Is she trying to involve him?'

'I did get that impression. Why? Is Francine really supposed to have had designs on this man?'

Marsden shrugged. 'If Fran showed any interest in Collis it wasn't for what he had to offer in bed. Even with Lina you can bet that it would be a matter of property rather than petting.'

'How does he rank as a painter?'

'He's a first-rate draughtsman and a good technician – knows his colours and how to handle them, but he's short on imagination. Anyway, he's known for the sort of thing he does, and he sells.'

'I suppose most of the Guild output is marketed through Archer's gallery in St Ives?'

Marsden laughed. 'Then you suppose wrong. No way! Most of it is sold in London – Lina again. The paintings go to Oldberg in Mason's Yard, or to the Raphael in Grafton Street. For the craft work she gets specific commissions from the London stores and from abroad; mainly from the States.'

'So where does Archer come in?'

Marsden grinned. 'He paints pretty little pictures which he peddles in his gallery along with Guild stuff which isn't quite up to the London market. Generally, he's no more than a sort of animated extension of their logo. A good front.'

A pause before he added, 'Sometimes I feel sorry for the poor bugger.'

Wycliffe tried again. 'When Fran came here did she ever mention Lina's Amsterdam pictures?'

Marsden frowned. 'Yes, she did, and it surprised me that she

knew about them. She was interested and tried to pump me as you have, but there was nothing I could tell her more than I've told you.'

'Did she tell you that she'd come into money?'

'No. Had she?'

'From the Bristol aunt who came down when she was in trouble before.'

Marsden sighed. 'Poor Fran. Just her luck. Now I suppose some other bugger will get the fun of it.'

Wycliffe stood up. He had what he came for: the recovery of times past along with a useful background to the Archer enterprise, but something remained and he approached the subject, unsure of Marsden's response.

As though on a sudden thought, he asked, 'What happened to your portrait of Francine?'

'It's still where you saw it. I'm not parting with that. Not now, anyway. Want to take another look?'

Wycliffe followed him into the lean-to studio. The picture had acquired a new position, against one of the walls, and Marsden had gone to the expense of gallery-type lighting. The picture was covered with a drape which he removed.

And there it was again, a study in blues and greys and greens and purples, with a flush of pink in the flesh tones. A sixteen-year-old girl in a flowered wrap with one breast exposed. She was watching herself in a mirror.

Wycliffe remembered Marsden's words: 'She's catching a glimpse of the promised land and not sure that she's going to like it . . . She's on the threshold . . . Another week, another month, she'll have crossed over. And nobody will ever see that look again . . . But I've captured it on canvas . . . Like a butterfly pinned in a box . . . '

It was true, and Wycliffe felt humbled. It distressed him to think that a couple of hours ago he had seen what had happened to this young girl after she had crossed that threshold.

Marsden was still looking at his painting and suddenly, unexpectedly, he chuckled. 'After sitting for me for two or three

hours with breaks, looking like that, she would slip off the throne, pull up her dress to cover herself and say, "That's eight quid you owe me." '

He sighed. 'There'll never be another Francine.' And he added, 'At the right time I intended to give her that picture. Occasionally, on one of her visits, she would come in here, switch on the lights and stand in front of it, but she never made any comment – not a word.'

Wycliffe felt guilty. 'I must admit that I lost sight of her after the trial.'

'You couldn't have exerted yourself; she was easy enough to find. Bloody coppers! You're all the same underneath. She was paroled after three years. She should never have been sentenced.'

'She killed a man.'

'She stepped on a cockroach.'

It was strange. Ever since he had arrived on the moor that morning Wycliffe had had the feeling that he was taking up where he'd left off; picking up the threads. And it was not pleasant.

The truth was that he had tried hard to forget. There had never been a case in which he had become so personally, even emotionally, entangled, and now he was faced with a tragic sequel.

Marsden saw him off. 'Copper or no, there are worse about, so if you're going to be around for a day or two, you know where I live.'

Wycliffe stood outside the cottage, wondering about his next move. No sign of Lucy yet. He turned to Marsden. 'If my sergeant comes knocking on the door tell her I've gone on to Mynhager.'

'You'll see changes there.'

'Do you still see anything of Caroline?'

Marsden grinned. 'Now and then. Like when Easter Monday falls on a Tuesday. Then we celebrate for old time's sake. What's it got to do with you, anyway?'

It had stopped raining and there was a watery sun. He walked on a couple of hundred yards around the next bend, and there was the sea and the cove and the cliffs, and that crazy house.

It was there that he had spent that Christmas. It was there

that the Bishop family had lived and still lived. And it was there that Francine Lemarque had shot her father, Gerald Bateman MP, a rising politician, a minister-in-waiting and a murderer twice over.

Wycliffe told himself, I've got to face it sometime, so it might as well be now.

'Alice Field, Craftwork in Miniature'. According to the plan this mysterious activity was carried on in a little building close to the entrance and Lucy decided to start there. Through the window she could see a young blonde woman bending over a low bench doing something to the roof of a dolls' house.

Her reception was friendly. 'Are you from the police? . . . I'm trying to work but it's impossible to settle down to anything. I mean . . . It's scarcely believable.'

'Detective Sergeant Lane – Lucy.' It was not difficult to see that informality was the recipe for the day.

'I'm Alice – Alice Field. You've probably been briefed by our Lina.'

Lucy looked about her and marvelled at the variety and perfection of the little models.

Alice said, 'Yes, it's an odd way to earn a living.'

'Not as odd as mine sometimes.'

'So, about poor Fran— '

'You knew her, of course.'

'Find yourself a stool.' Then, 'Yes, I knew her. In a way she was a friend and it's hard to realise that she's gone. She came here whenever she was bored with her own work or at cross-purposes with Paul . . . God knows how he'll cope without her . . . Yes, I suppose I knew her as well as most.'

'Then you can help us. We are trying to piece together what we can about her and her relationships here and outside. I understand that there had been strains between her and Paul since she came to live in the flat.'

'You've been listening to our Lina but I suppose there's something in what she says.'

'In particular she hinted that it might have something to do with Francine's relationship with the painter, Emile Collis.'

After a longish pause Alice said, 'I know that she and Emile were spending time together. Emile was doing a series of sketches in preparation for a portrait which I think he had begun to paint. He sees himself as a frustrated portrait painter, and with a model like Fran what more could he have wanted? Fran told me about it herself.'

She summed up. 'I think it's very unlikely that there was sex involved.'

'Lina made it pretty clear that she thought Francine was leading him up the garden and making him miserable. Would you say that she was a tease with men?'

Alice considered. 'Don't forget I work here. But I will say this, I'm sure that for some weeks Emile has been a very worried man but I doubt if his worries have had much to do with Francine.'

'Have you any idea what is worrying him?'

'Not a clue. I know him as somebody who's always around and that's about all. He has very little to say for himself but he seems well in with the Archers.'

'Lina mentioned another man – apparently he works in the pottery— '

Alice grinned. 'Bob Lander – Blond Bob, as they call him. Somehow I don't think Fran would have got far with him. He seems a nice enough sort of bloke but my guess is that women don't interest him – not as such, anyway.' She broke off, 'Talk of the devil— '

Through the window Lucy had a glimpse of a sturdy, muscular young man, on the short side, with almost yellow hair. He wore a leather jacket and he was leaving the site on foot.

Alice said, 'My guess is that he and Emile could have something going for them, but don't quote me.' A brief pause, then, 'By the way, could you do with a coffee?'

'I thought you'd never ask.'

A few minutes later, when they were drinking their mugs of instant, Lucy asked, 'Do you live on the site?'

'Good Lord, no! I've got a house and a husband in St Ives. There are three of us who don't live here, although sometimes we might as well.'

'It would help if you could tell me something of the set-up, and perhaps where Francine fitted in – or didn't. This Guild of Nine – what exactly is it?'

Alice smiled. 'I expect you've already had Lina's version.'

'I would like yours. I understand that there are supposed to be nine of you.'

'Yes. Archer has a thing about numbers and there has to be nine of us, the mystical trinity of trinities and all that stuff. Added to that, there's his name, and the fact that he was born under the sign of Sagittarius, the Archer, in the ninth house of the Zodiac. There you have it all as I understand it, including our logo.'

She smiled. 'Archer is quite likeable in many ways but he plays at life like a child. He wanted to start a craft colony resurrecting Eric Gill's at Pigotts, but this isn't the thirties and he's certainly no Eric Gill.' She laughed. 'Neither as a craftsman nor as a womaniser.

'Anyway Lina let him go ahead, but she turned his dream colony into a small-scale factory that makes a respectable profit.'

All grist to the mill.

A moment later Alice said, 'Going back to Francine and being honest, she made something of a reputation for being a bit of a tease with men. All go to a certain point then, "You're in the wrong shop, Buster!" ' A moment of hesitation. 'I don't think it was like that. Not so long ago she talked to me about her attitude to sex.'

'And?'

'I sometimes had the impression that sex scared her. She might even have felt guilty because of it. Of course she put up a show along the lines of not being at the beck and call of any man. The emancipated woman and all that, but I sometimes wondered how deep it really went.'

Alice brushed back her hair from her eyes. 'One thing's for sure, Paul suffered, poor man. He doted on her and got precious little in return.'

Lucy finished her coffee. 'You've been a great help. You wouldn't

believe how difficult it is, breaking into other people's lives, and that's what much of this job amounts to.'

Alice nodded. 'I think I'll stick to making toys for well-heeled types who want to relive their childhood.'

Chapter Four

Whit-Sunday evening continued

The bells of Mulfra church were ringing, the light was golden and there was a great stillness. Once more Wycliffe found himself standing in the stone-walled courtyard in front of the Gothic door studded with nails. Nothing had changed. Even their old Rover was still parked on the cobbles. It looked like a hearse and was well on the way to being a museum piece, yet Wycliffe still felt he had gone back all of those ten years to that Christmas visit.

He tugged at the wrought-iron chain and heard the bell clang. At last the door opened and there, as on that first visit, was Caroline, looking a little older, a little fatter, her mouth a little slacker.

'Charles!' She opened the door wide. 'You can't believe how relieved I am to see you . . . We thought we might be dealing with some stranger . . . *Do* come in.'

Of all the possible receptions he might have anticipated this was the most bizarre. Caroline was close to offering her cheek to be kissed. Yet his last visit had ended in a manslaughter and a murder charge, both affecting the family.

He was taken into the drawing room which seemed poised over the cove, its essential tattiness drowned in a great flood of light from the sea.

Virginia arrived; her welcome was more restrained but she did not disguise her relief. 'Now we shall get some sense!'

A trousered Virginia, a little leaner, a little bonier and a voice that had acquired a masculine resonance.

Caroline said, 'Paul has gone out walking, poor lad. On his own,

of course. There's nothing anybody can do or say to help him. This, on top of all that's gone before. I only hope to God that he doesn't do anything foolish—' She broke off and turned sharply to Wycliffe, struck by a new and frightening possibility. '*You* don't suspect him of . . . of what happened to Fran, do you?'

Wycliffe hesitated, then decided that there are times when it is right to stop being a policeman and try being human. 'No, I don't. I think I know Paul well enough to understand that he is incapable of such a coldly premeditated crime.'

Caroline let out a deep sigh and turned to her sister. 'There! I told you we would be safe if only it could be Charles who came.'

Wycliffe decided it was time to assume control. 'I want to ask you about Francine. I understand that she chose to come here when she was released on parole and that she lived here until quite recently.'

It was Virginia who responded. 'Yes, it was an extraordinary situation but we felt that we must do what we could. Father, Aunt Stella and Ernest, our brother, had all passed away during those three years, so we had only ourselves to consider. Paul, of course, wanted it above all else. Although still a teenager he had visited her regularly while she was in the Young Offenders, and it was only through his persistence that we eventually succeeded in getting her on the craft course in wood-carving.'

'So what happened when she came here?'

Virginia sighed. 'It's a long story. Paul was already one of Archer's precious Guild of Nine as a wood-carver, and eventually Fran joined him, first as an assistant, and later, when there was a vacancy in the Guild, as a member herself. They made a good team apparently and until recently it seemed that things were beginning to go their way.'

Virginia was sitting in one of the easy chairs, legs crossed. She lit a cigarette and watched the smoke spiral upwards.

'So what changed?'

It was Caroline's turn. 'It happened from one day to the next. Out of the blue, it seemed, Francine decided to move out of here and she went to live in the flat over their workshop.'

'What was Paul's reaction?'

Virginia again. 'You will remember that at sixteen Paul was infatuated with Fran, though I admit she gave him little encouragement. That situation never really changed, even when the poor lad discovered that his adored girlfriend was his half-sister. He visited her whenever he could while she was in custody and when she came out they seemed to take up where they left off; but living here and working together. It seemed that they had accepted their ambivalent relationship.'

Wycliffe realised that he might be treading on thin ice, and he chose his words with care. 'Do you think that Francine moved to the flat in order to have greater freedom in her relationship with Paul?'

Caroline said, 'You mean so that they could go to bed together without upsetting me. That's what Vee thinks.'

Virginia hesitated. 'I'm not sure that I do.'

Caroline snapped, 'You said it was sex.'

Virginia reached out to tap ash from her cigarette into a monstrous Canton jar. 'I say a lot of things but I don't believe this move had anything to do with Paul. I think he was puzzled by it.'

Caroline said, 'You see! Although I'm his mother he talks to her.'

And Virginia came back. 'That's because you never listen!'

Wycliffe felt he could get no further. What good would it do to mention the money? Paul would tell them at some stage. Sufficient unto the day . . . He left, promising to keep in touch.

Lucy, deciding that discretion might be the better part, had parked some way up the track and he joined her. It was Lucy's first sight of Mynhager.

'It's fantastic! It's like a backdrop for the Rhine Maidens.'

They swapped stories and Lucy said, 'Do we tackle Collis before going back?'

'No. He and the rest can wait until we're organised. We'll get back to Penzance and see what we've got in the way of an Incident Room.'

They set out for Penzance. Sunday evening, and they had the moorland road to themselves. Even when they reached the town many of the streets were deserted.

They were booked in at an hotel on the Promenade. The same hotel in which Wycliffe had stayed years before, during investigations into the murder of a Penzance bookseller. They joined Kersey for the evening meal.

'What did you make of Paul Bateman?'

Kersey stroked his bristly chin. 'Good question, and the answer is that I wouldn't expect him to kill a garden slug. But he was obsessed by that girl and, I guess, profoundly frustrated.' Kersey paused before adding, 'He certainly had opportunity, but motive? . . . It's hard to say exactly what the word means in this context.'

Kersey launching into semantics was a surprising phenomenon, but Wycliffe saw his point.

'On balance?'

'I don't think he'd top my list if I had one. Anyway, he made his statement and I sent him back home in a patrol car.'

'Back home?'

'To his mother at Mynhager. That's where he said he wanted to go.'

Later, Wycliffe stood at his bedroom window looking out over the bay, with the Lizard light sweeping the sky to the south-east, and the magic Mount, Island of Ictis, a twinkling silhouette in the foreground. He felt that he wanted to praise somebody for something but he wasn't quite sure who, or for what.

He telephoned Helen instead.

End of an eventful day, Whit Sunday.

That night Wycliffe dreamed that he was alone in Marsden's studio. Greatly daring, he removed the drape from the portrait of Francine. It was as he remembered it. Except for the face . . . The face was that of the girl on the bed, corrupted by the ravages of death.

He awoke, distressed and fearful, like a child after a bad dream.

He had a restless night and by seven in the morning he was showered and dressed, waiting for the day to begin.

Whit Monday

Breakfast with Kersey and Lucy. News of the murder had spread and they were aware of attention from the sprinkling of tourists in the dining room. Kersey had the *Morning News* and he pointed to a brief front-page report, but the media had not yet grasped the colourful possibilities of the case.

As they walked to the police station a moist breeze was blowing off the sea. Whit Monday looked like being a day of sunshine and stealthy showers. For Wycliffe as a young boy Whit Monday had meant a picnic if the weather was fine, and the fair in the evening. But home by nine because father had milking in the morning.

The Incident Room was housed in one of those ubiquitous huts which clutter the breathing space behind most public buildings. As a plus, the place already had the regular nick smell, so everybody would feel at home. Already the organisation and equipment were well under way. By ten o'clock the team was assembled for Kersey's briefing. Remnants of the old guard included DCs Dixon and Potter – known because of Dixon's lean length and Potter's girth as Pole and Pot. Then there was the studious DC Curnow, a unique specimen – almost two metres of Penzance Cornishman. Curnow was reputed to spend his spare time reading and re-reading the *Encyclopaedia Britannica* from A to Z.

Added to these were the comparative newcomers, both of them women: the one and only DS Lucy Lane, now well on in her thirties, and DC Iris Thorne, the vivacious, no-nonsense black girl, who sometimes said, with notable effect, what others dared only to think.

Wycliffe, growing sentimental in his old age, looked them over with something very like affection.

The headquarters team was supplemented for the briefing by local CID and uniformed personnel who were, or were likely to become, involved.

Kersey explained the agreed programme which centred around systematic formal interviews with all those working or having

regular business at the Guild site. It was arranged to have a caravan on the site that would be a temporary base for the team; the order and timing of such interviews to be arranged in consultation with DS Lane.

As Wycliffe put it to Kersey: 'We want first bite.'

Key witnesses would be required to make their statements for the record.

Questions were asked and answered. Wycliffe closed the proceedings with the obligatory blessing and the party broke up.

With Kersey and Lucy Lane, Wycliffe adjourned to the little room which had been set aside for him.

DS Fox arrived with his report.

Fox was a phenomenon; nobody really knew him. There was a nebulous wife. Children? It would probably be in his dossier but who reads dossiers? In any case they were flawed in that they trimmed gossip down to fact.

Fox's reports were models of their kind, and their preparation must have involved hours of his own time, yet the mere mention of his name was good for a smirk.

Now he laid his offerings on Wycliffe's table as though upon an altar. 'My report, sir; and the relevant documentation.' A neat bundle of typescript and a folder.

Wycliffe's defences went up. 'I'll need to go through all this but can you put us in the picture generally?'

Fox looked resigned; he was used to it. 'There are several items in my report, sir.'

'I'm sure there are, but— '

Fox stroked his long chin. 'I suppose there is only one really significant point: three months ago Francine Lemarque received a substantial legacy from an aunt.'

'We know there was a legacy, do you have any details – the amount, for example?'

'All the correspondence is there, sir.' Fox pointed to his file. 'The amount was something over eighty-five thousand pounds. It was left to her by an aunt.'

Kersey said, 'I wish I had a rich aunt.'

Wycliffe wondered about this aunt. Another figure emerging from the past? He recalled a brisk, kindly woman, clearly affluent, Francine's aunt on her mother's side but from a totally different milieu. Ten years ago she had turned up to comfort and care for Francine at crisis time – only to be rejected. Francine had no use for a shoulder to cry on.

'Was this aunt called Devlin?'

'I think that was the name, sir.'

Wycliffe, still reflective, said, 'So she's dead.'

'It would seem so, sir.'

Wycliffe sometimes suspected that these Jeevish responses were Fox's way of taking the mickey. And who could blame him for that? Wycliffe had long since decided that Fox was an enigma and, as that was one of his favourite words, it made him think more kindly of the man.

When Fox had gone, Kersey said, 'I wonder who gets the money?'

'Good question. But as a motive?' Wycliffe shook his head. 'There's much more to this case than money but we had better get Shaw down to look into that side of it.'

DS Shaw, born under the sign of the silicon chip, had somehow taken a wrong turning and found himself a policeman. Now he was the squad's front man in dealing with money and the disciples of money.

'At the same time he can go into the economics of the Guild and the fringe activities, whatever they are.'

Wycliffe was trying to get some sort of order into his own thoughts and at the same time to establish firm lines of inquiry. Along with much else he needed to check the records of possible suspects, likely and unlikely.

He skimmed through Fox's report and sifted through the remaining contents of the folder. Like most surviving remnants of a life they made a sad package: her pass book, four or five Christmas cards (one from Paul and another from the now deceased aunt), a little wad of business letters, some newspaper cuttings and, finally, two dog-eared engagement books, one for the

63

current, and the other for the previous year. Wycliffe flicked through the pages of the current book and noticed that certain entries were inconspicuously starred. He checked, and found that the same was true of some of the later entries in the previous book. He passed them to Kersey. 'Get Iris to take a look at the starred entries and see what she makes of them.'

He glanced through the letters: six of them, clipped together, were from a firm of Bristol solicitors concerned with her legacy. He noticed that the first was addressed to her at Mynhager but the others were directed c/o The Guild of Nine. The dates made it clear that she had changed the address well before moving into the flat.

So the Bishops were to be kept in the dark about her legacy.

He turned to the newspaper cuttings. Francine hadn't seemed to him the sort to cut bits out of newspapers and he was interested. All the cuttings were from the local paper and concerned the Guild of Nine, chatty little pieces, evidently inspired by Lina.

One recent item referred to a possible extension of the Guild's activities into ornamental ironwork. Another was one of a series: 'Our Reporter Visits. This week, the Guild of Nine.'

Wycliffe had seen enough to be going on with. 'We'd better get moving, Lucy.'

They drove to Mulfra and on the way Wycliffe brooded, finally coming up with: 'I can't see this as a man's crime, Lucy.'

'You think that blocking up a flue outlet with a towel is more a woman's trick. Is that it?'

'It doesn't strike you that way?'

Lucy was driving, and she continued to look straight ahead. 'Devious and underhand; not like a good, honest, straightforward strangling or battering that we've come to expect from a man.'

Wycliffe grinned. 'All right, we won't halve the suspect list just yet.'

But Lucy had more to say. 'All the same, although I don't see it in a gender context, I think it might tell us something about the sort of person we are looking for.'

When they arrived the site displayed no unusual activity. In fact,

none at all. They found two white-coated females from Forensic packing up in Francine's flat. Their report was unlikely to add much to what was already known, but hope springs eternal.

The senior of the two, Florence ('Please don't call me Flo'), was plump and didactic. 'Evidence from fingerprints suggests that the girl had three more or less regular male visitors and that one of them came much more frequently than the others, but there is nothing to indicate that he ever spent the night in the flat. There is a fairly fresh but smeared set of his prints on the bedroom doorpost. The indications are that he stood in the doorway for some time, supporting himself.'

Paul Bateman; and the other two would almost certainly have been Collis and the as yet unseen Blond Bob. Routine checks would settle these identities.

'Anything else?'

'There are two used sherry glasses which have remained by the sink for some time, unwashed. Both carry the prints of the dead girl but one has been used by another female. The implication being that there was a woman visitor at least a day before the crime.'

'Anything on the towel that blocked the vent?'

'An ordinary medium quality bath towel; no distinguishing marks but in the unlikely event that it had been used *and* that the user had left identifiable traces, I'm sending it for laboratory examination.'

Basic file fodder.

As at the start of any investigation Wycliffe began his search for the first hint of a pattern, but so far there was nothing. He was handicapped – or thought he was – by his inability to retain facts, to arrange them in an orderly fashion, and from them to arrive at logical conclusions. His mind didn't work that way. Any thread of logical thought soon became tangled in a web of recollected scenes, incidents, remarks and impressions.

He must hold on to the facts: Francine Lemarque had been murdered in a coldly calculating fashion. Some months earlier she had inherited a very substantial sum of money and, shortly after

that, she had moved into the flat over the wood-carver's shop where she worked with her half-brother Paul Bateman.

Her treatment of Paul and her relations with Collis and Bob Lander had caused comment and, perhaps, jealousy. But that was a slender scaffolding on which to start building a case.

'We need to get more people talking, Lucy. More gossip.'

They were standing on the little balcony and Wycliffe was looking towards the neighbouring premises. 'The bigger building to the right is the pottery – the Scawn empire, if I remember rightly. What about the little place to our left?'

Lucy consulted her plan. 'Arthur Gew, typographer and engraver.'

'Right! You talk to Arthur. I'm going to take a stroll around to see the sights; then I might try my luck with Scawn and his side-kick, Lander.'

'We shall get some fresh points of view, if nothing else, and we can do with them.'

Arthur Gew. For some reason the name brought to Lucy's mind the image of a fussy, precise and reclusive little man, wielding his stylus or whatever, and wearing watchmaker's spectacles.

She was not far wrong. He was little, and he wore spectacles. He occupied a tiny room cluttered with apparatus and equipment of every description.

He was working with a stylus on a copper plate but he broke off and started talking at once. 'Whatever they've told you, I'm the Guild's dogsbody. Anything nobody else wants to do ends up here: wood- and copper-engraving, lettering, illumination, even the odd spot of enamelling – you name it.

'At the moment I'm designing personalised Christmas cards for a London barrister.'

He studied her, grey eyes peering over half-glasses. 'And you're a detective. You don't look like one but Madam told me on the phone that you were, so you must be. Madam is never wrong.'

Lucy got a word in. 'DS Lane. I'm making some general inquiries in connection with the death of Francine Lemarque.'

'Yes.' Reflective. 'Poor little bitch.'

'Is that how you saw her?'

'As a little bitch? More or less. She went around putting people's backs up as though it was her mission in life. She used to come here, poking and quizzing into everything, asking questions. And Madam let her get away with it. I don't know why – unless there was money involved. I've heard rumours.'

Lucy tried to direct the flow. 'You live over your workshop?'

'Yes. And I live alone. I don't get visitors and I'm neither homo nor hetero. I think that they must have neutered me at birth, and I'm grateful.'

Another look over those spectacles. 'It saves you from a lot of aggro.'.

Lucy, cautious, held on. 'Francine had a visitor on Friday evening – a woman, apparently. You didn't happen to see who it was?'

'But I did. It was Madam. I saw her going up the steps to the flat. Very unusual. Madam doesn't go in for social calls. I said to myself, "It must be money!" And she was there for more than an hour so it was probably quite a lot of money.'

'You don't happen to remember when she left? I mean, was it dark? Have you any idea of the time?'

'If it was dark I wouldn't have seen her, would I? No, it was dusk – getting dark.'

It was obvious that Gew knew more than he was saying but he had picked up his stylus and seemed about to resume work. He was not the sort to respond to pressure and Lucy asked with a certain desperation, 'I don't suppose you know anything of the kind of tensions or fears or jealousies that might have led to the girl's death?'

Gew looked at her with a half-smile. 'We have plenty of all those in our "little community" as Daddy Archer likes to call it, but as far as I know none of us has yet reached the point where we might resort to murder. In fact, I've probably overstated the case against the girl simply because she happened to irritate me.'

Lucy risked: 'Exactly what is Mr Archer's role in the Guild?'

67

A quick frown. 'Hard to say. Daddy doesn't have much impact, but he's all right as long as Madam makes sure he gets his oat-bran for breakfast every morning. Keeps him regular, you know.'

Lucy grinned. 'You have a wicked streak, Mr Gew.'

'Well, my dear, you either laugh or you cry in this life. By the way, have you met Evadne?'

'Mrs Penrose?'

'The same. Evadne isn't one of the Guild. On the face of it she's just a spot of domestic help for the Archers, but don't under-estimate her; even Madam has to tread carefully where that little woman is concerned.'

Lucy was about to put another question but Gew stood up. 'No, that's it. I've said my piece and you must make what you can of it.'

An awkward cuss, but Lucy felt that she had no reason to complain. What Gew had said confirmed Lina's account of her visit to the dead girl, at least as to time and duration.

She left, but it was drizzling rain and she had stopped in the shelter of the doorway to consider her next move when Gew called after her, 'If you're thinking of the pottery for your next call you might tell Bob Lander to get a silencer for his blasted motorbike. Woke me up at six this morning.'

Consulting one of Lina's site plans, Wycliffe made himself familiar with the layout. On the west side of the stream there was Arthur Gew with his typography and engraving, Derek Scawn with his pottery, and Paul and Francine in the wood-carvers' shop. On the east side where Alice Field had her miniature crafts, there was the Archer house, and, on the rising ground behind, Emile Collis's studio and lodgings.

Wycliffe was intrigued by a substantial single-storied building, isolated and very close to the stream on the west side. On Lina's plan it was labelled 'The Guild-hall'. He noted the meticulous hyphenation and decided to take a look.

In contrast with the other buildings on the site, all of which owed something to their mining antecedents, it was clear that this little edifice had been purpose-built. Wycliffe walked around it,

counting the sides, and after doing it twice, decided that there were, in fact, nine: a nonagon. Each side had a window of apparently stained glass so that it was not possible to see the inside. But the door was not locked and he went in.

The interior was dimly lit, theatrical, but in its way impressive. The stained-glass windows each displayed one of the signs of the Zodiac. Did they correspond with the nine members of the Guild? If so, any change of membership would be expensive. But closer examination revealed that they were not stained glass but made up of coloured papers, exquisitely cut and fitted together. Money might be a problem; time was not.

The ceiling was tent-shaped, a blue vault studded with stars, and the centre of the floor was occupied by a nonagonal table with nine chairs, each chair inscribed with the name of a Guild member and with his or her birth sign.

Like the 'reconstructions' of 'King Arthur's Hall' it was touched with both romance and absurdity.

Anyway Archer had been prepared and permitted to spend money on his fantasy and Wycliffe thought, with a certain sympathy, of the poor man struggling to reconcile all this with Lina's entrepreneurial ambitions. Squaring the circle might have been easier. And he wondered if it might be important to gauge the depth of Archer's commitment. Did it amount to an obsession?'

A trifling sound, and Wycliffe became aware that he was not alone. Evadne Penrose emerged from behind a screen on the other side of the room. Duster and whisk in hand she looked for all the world like a church-mouse intent on her self-imposed tasks. But there was nothing mouse-like about her manner. 'What do you want in here? There's nothing here for you!'

She came around the table to stand looking up at him.

Wycliffe's manner was conversational and placatory. He cut across her aggression. 'Do you go along with all this?'

Taken by surprise, she hesitated. 'It's Archer's way.'

'But as an astrologer yourself do you support him in his attempts to stand by the principles on which he founded the Guild?'

Evadne did not answer at once, then she said, 'It's not for me to

say. I am not even a member of the Guild. But Archer is a man with a mission. He wants to see his Guild as a community in the service of the crafts but also in harmony with the Spheres. He knows well enough that as a commercial enterprise it must pay its way to survive but, after all, the monastic orders managed that sort of thing for long enough and some of them still do.'

Wycliffe reflected that ten years ago he had written this woman off as a rather kinky village gossip in a pinafore.

He wanted to keep her talking but realised that it would be easy to put her off. He risked an apparently casual comment: 'Archer strikes me as a dedicated man.'

'As I've said, he's a man with a mission. He sees himself as having been born a rather special person, with unique obligations. There's his name, and the fact that he was born under Sagittarius, the Archer, in the *ninth* house of the zodiac. Then there are the numerological implications in his name.'

'And they are?'

Evadne smiled. She had softened towards him. 'You should read it up, Mr Wycliffe. Archer's full name, believe it or not, is Francis Bacon Archer. His father wrote a book about Bacon. But the point is that in numerological terms the letters of his name add up to seventy-two, and seven plus two is nine. You see? Once again, the magically powerful number.' She broke off. 'And there is a lot more to it; most of it beyond me.'

She went on, 'At the moment Archer is having difficulty with his ideas on natal astrology. It has occurred to him that the planetary configurations which influence a child's future are those that apply at the actual time of birth, but science tells us that the genetic pattern is determined at the moment of conception. This worries him, and he is working desperately to reconcile the two.'

Wycliffe was intrigued. 'As an astrologer yourself, do Mr Archer's doubts trouble you?'

Evadne was totally dismissive. 'Not one bit! It's something on which we disagree. Archer is trying to apply logic to one of the magical arts, where the only rules that matter are the ones that work. They are their own justification.'

She brushed back a few grizzly hairs from her forehead. 'If there is anything good to be said of Aleister Crowley it is that he warned us against attributing objective reality to any such rules.'

Wycliffe felt that he was learning something of what made these people tick and he was loath to let go. 'You, like Archer, are, I believe, a Sagittarian. What is Lina's sign?'

A shrewd look. 'Lina is an Arian, Mr Wycliffe. What else? Impatient, born to lead. Certainly not to follow. Aries is the sign of the Ram.' The little brown eyes twinkled. 'Perhaps the battering ram.' She broke off. 'When were you born?'

'August the fifteenth.'

She nodded, 'A Leo . . . Not a bad sign for a policeman, but Leos have to guard against self-righteousness.' She squinted up at him. 'And on the physical side, watch out for your heart as you get older.'

She turned away. 'Well, I don't know about you, but I've got work to do.'

Evadne Penrose. A woman to be reckoned with.

Lucy was waiting for him in the shelter of the doorway. 'Collis next?'

'I suppose so, but I feel I've had enough already. However, onward and upward. We'll do him together.'

Collis had his studio and living quarters on the rising ground behind the Archers' house. It was a long, single-storied building with a number of windows, but it was impossible to see inside because the front of the building was raised on stilts to accommodate the slope.

They climbed the steps to the front door which stood open. Wycliffe knocked on the glass panel but there was no response. 'Let's go in.'

On the other side of a makeshift screen they found themselves in a large, square studio with cupboards and racks around the walls, the usual painter's gear and easels for work in progress. One of these was covered with a drape.

There was a door at each end and Wycliffe called out, but there was no response.

71

Lucy said, 'Look at these . . .'

Pinned to a large notice-board near the draped easel there were sketches, some in pencil, others in charcoal, all of the same girl and ranging from head only to the whole body in different postures.

Wycliffe said, 'Francine.' And he knew enough about drawing to recognise the economy of line and sureness of touch which spells talent.

'Are you looking for me?' A soft voice.

They had heard no sound but the door at one end of the room was now open and a man stood there. He was thin, very pale, with dark hair in tight curls which gave him a foreign look. Levantine? That was the word that came to Wycliffe's mind but he wasn't quite sure what it meant.

He made the routine introductions, holding out his warrant card as though it were a talisman. 'You are Mr Emile Collis?'

'Yes. I was resting and I must have fallen asleep. I know that you are here about Francine.'

'Is there somewhere we can talk?'

He looked vaguely around the studio. 'You'd better come in here.'

They followed him into an all-purpose room, shabbily furnished with an armchair and three or four other chairs, a table, a desk and a sort of dresser with an eclectic display of crockery and glass on its shelves.

Collis got them seated. 'You must forgive me; I am very distressed about Francine.'

'Have you any idea at all why someone might have done this to her?'

'No idea. It is horrible!'

'Did you know her well? Were you close to her?'

Collis looked up sharply but when he spoke his manner was hesitant. He seemed to be groping for the words that would best express his meaning. 'I don't know . . . I doubt if anybody was close to Francine. I was fascinated by her and, at the same time, wary. I had never before met anyone like her.'

'Can you enlarge on that?'

He looked at Wycliffe, frowning. 'It's very difficult. Francine was totally self-absorbed.' He hesitated. 'That sounds like a criticism and in a way I suppose it is. She was aggravating, but one didn't altogether resent her behaviour. Francine made her own rules and one accepted and respected them – even admired her for her courage and consistency, I suppose.' He broke off. 'Does that sound absurd?'

Wycliffe was impressed. 'No. I think you have described her as she was.'

'You knew her?'

'Many years ago.'

'Of course! You are the policeman who . . . She told me all about that. I assumed it was that which made her what she was.'

'From what you tell me, I don't think she'd changed.'

There was silence in the little room and it was Lucy Lane who broke it. 'You were painting her portrait?'

A self-deprecating smile. 'Oh, I've always wanted to be a portrait painter but one has to be a special sort of person; one has to establish a rapport with the sitter and that was beyond me. However, Francine was irresistible and I had to try.'

Wycliffe found this man interesting and the interview was turning into an informal chat. Time to get back to the nitty-gritty. He said, 'You will be asked to make a formal statement for the record, Mr Collis, but in the meantime there are one or two questions. Did you become emotionally involved with Francine?'

Collis hesitated. 'I suppose so. She fascinated me, I liked being with her— '

'Were you attracted sexually?'

'Sexually?' . . . A pause, then, 'No, sex didn't enter into our relationship and I can imagine Francine's reaction if I had approached her in that way.'

'It seems likely that the blocking of the flue outlet responsible for Francine's death was carried out after dark on Friday night. Were you out and about at any time during darkness that night?'

73

'Friday night? . . . I spent most of the evening framing.'

'Framing?'

'Yes. You may think it odd, but I do all the framing for the pictures we sell. I have a little workshop at the other end of this building. To do any picture justice it must be appropriately framed, if it is going to be framed at all. Anyway, I enjoy the work and I'm supposed to be good at it.'

'Did you go out at all on Friday night?'

Collis considered. 'As I recall, I packed up in the workshop at around ten and went for a walk over the moor. I— '

'Did you go anywhere near the wood-carvers' building?'

'No. I went out the back way from here, straight on to the moor. There is a footpath. I often take a walk before going to bed if the weather is anything like reasonable. I don't sleep well and I find it helps. I can't say exactly when I got back but I went to bed and slept until morning.'

'Do you know of any situation in which Francine was involved that might conceivably have led to her death?'

There was a moment for consideration before the answer came. 'No. It's true that Francine did not go about making friends – not in the Guild anyway, but I cannot see how any of these . . . these trifling antagonisms could have led to this.'

Wycliffe said, 'Just one more question and a very personal one. I gather from your colleagues that you have seemed to be a very worried man in recent weeks. Do your worries have any connection with Francine or with any events involving her?'

For the first time Collis's manner changed and he became brusque. 'My worries, as you call them, have nothing whatever to do with Francine. I have taken medical advice and I am told that being worried does not necessarily mean that one has specific cause for worry. I gather that it can be a psychological disorder which may be thought of as mental indigestion.' Collis sounded oddly spiteful.

And, for the time being, that had to be that.

On their way out Wycliffe stopped by the draped canvas. 'Is this your portrait?'

'Yes, but I would rather not show it to you at the moment.'

Outside Wycliffe said, 'Well?'

Lucy shook her head. 'I'm not falling for that one, sir, not at this stage.'

Chapter Five

Whit Monday continued

Lucy said, 'Shall we try the potter?'

Wycliffe looked at his watch. 'No. The Tributers'. It's lunch-time.'

As they drove to the Tributers' Kersey came through from the Incident Room on the car radio. 'The media are waking up, sir. Just three or four of them so far, including regional TV, but I'm afraid the murder of a girl in an art colony on a Cornish moor will go to their heads and it won't be long before they tumble to the "Quiet Virgin" link. Uniform are sending a couple of chaps to keep an eye on visitors as well as comings and goings in general.'

There were several cars and a camper-van parked near the Tributers' and among the group around the bar Wycliffe recognised two west-country journalists. Most of the tables were already occupied but Phyllis led them to one at the far end. 'There! I thought you might be in so I put a "reserved" on that one. You'll be nice an' quiet here.'

When they were settled, Lucy said, 'How do you do it? There must be something I've missed.'

A cheese salad for Lucy; the dish of the day for Wycliffe – roast chicken with cauliflower and chips. 'You've never lived, Lucy, until you've tasted Phyllis's chips.'

And almost in the same breath: 'There's Marsden and he's got the boy with him. I wonder what he's up to.'

Marsden had a table in a far corner by the bar and Paul Bateman was with him. Marsden raised a hand in salute.

Lucy said, 'From what you've told me he could be good for Paul.'

'You may be right at that.'

A few minutes later, after they had been served, Wycliffe said, 'This place is getting uncomfortably crowded. See who's just come in?'

The newcomer was a little woman, thin and angular, and she was almost totally enveloped in a coat made from the skin of some creature that seemed to have met its end in the middle of a moult.

Lucy, in a voice touched with awe, said, 'Ella Bunt! Just when I thought and hoped she'd got lost or something . . . And she's wearing that coat that smells of goat.'

Ella Bunt had been a notable if unlikely freelance crime reporter. With no apparent qualities or qualifications that fitted her for the job Ella had made a name for herself. As far as the police were concerned she had developed an uncanny knack of popping up with tradable bits of information which she would offer in return for privileged access. And she had a soft spot for Wycliffe. But in recent years she had faded out.

'She's seen us and she's coming over.'

On her way Ella collected a stray chair, brought it to their table, and, with a deep sigh, sat down. 'I thought I might find you here. What are you eating? . . . I'll have what you're having, Charlie.'

'Do you want something, Ella – other than food?'

'You need something other than food, Charlie. That's for sure.'

'And you've got it?'

'You tell me.'

Ella's meal arrived and she removed her coat to achieve greater freedom of action.

Wycliffe looked at the coat with distaste. 'That used to be part of your winter wardrobe, Ella.'

'Yes, but as I get older I feel the cold more. And it's a good coat. It cost real money once. Anyway, getting down to business, did your friend Marsden ever tell you about the Stylov Gallery?'

'I know that it was one of Lemarque's projects where they took

commissions for paintings in the style of notable or famous painters.'

Ella drew her coat about her. 'Exactly. "Your friends will never know the difference." That was their line; and some of those paintings were sold on as the genuine article. They did a good job – canvas, stretchers, colours – all in period as you might say.'

'It was never proved that they were faking with intent to deceive.'

Ella was contemptuous. 'What the hell does that matter? You know it and I know it.'

'Are we coming to the point?'

Ella was rueful. 'I don't have to do this for you, Charlie. Anyway, the point is that there were two hack painters involved, and your Marsden was one of them.'

'I know that.'

'But you probably don't know that the other was Collis, though he wasn't Emile Collis then, he was Edward Collins, which could have been his real name for all I know. You notice that he kept the initials.'

Wycliffe was impressed. 'What you've told me could be very useful, Ella.'

'I'm glad you admit it. And, what's more, you'll find if you get CRO on the job that Edward Collins was sent down for two years in ninety-one and that the charge was forgery. He seems to have got off lightly.

Wycliffe reflected that the past was catching up with a lot of people, including himself.

'Well, there it is, Charlie. I reckon that I've overpaid for this lunch and that you owe me.'

She turned to Lucy. 'I was in on it last time – as far as he would let me. He palmed me off on a widow-woman who was nutty about astrology, but she was more helpful than he imagined in other ways. I shall have to look her up if she's still around.'

And then to Wycliffe. 'You probably know that I'm semi-retired. Now I pick the odd case that attracts me and I'm rehashing some old stories with a book in mind.' She grinned. 'I'm mobile and fancy-free. The camper-van outside is mine and I share it with

Dickie Doyle who used to be my camera man. Dickie does the driving. Anyway, when I saw that you were back, picking away at an old sore, I couldn't resist offering a helping hand.'

And to Lucy Lane: 'What is it about him that makes women want to spoil him?'

Time passed in eating and reminiscence. Wycliffe said little and at last it was over; the party broke up.

Outside Lucy said, 'She gets to look more and more like an old witch. Can you really take her seriously?'

Wycliffe, sensitive about Ella, was curt. 'Editors do.'

'So where do we go from here?'

'I want to check up with Marsden but not while he's got Paul in tow. I think another visit to the Archers. With luck we might get Lina on her own, and now that we are better briefed . . . '

They were received in the Archers' sitting room – lounge? Anyway, good solid Dutch furniture, plenty of wood to polish; not very comfortable, but no smear or speck of dust anywhere. Lina had brought with her more than her baggage when she crossed the water.

There was a flower painting, elaborately framed, on the wall above the fireplace; probably worth a small fortune if it was what it seemed to be.

Lina said, 'You're looking at my painting. No, it's not the real thing, it's a copy of one of Huysum's which I did while I was still at the Rijks.'

She smiled. 'I'm rather proud of it.'

Lina seemed anxious to draw attention to her skill as a copyist and Wycliffe was duly complimentary.

Lina had rejected trousers in favour of a dress which she would regard as *de rigueur* in the circumstances: mauve with grey trimmings; decently sombre.

When they were seated she opened at once. 'I was past thirty when I met Archer; bored with the tedium of my work at the museum, and looking for a fresh start— '

But Wycliffe decided against allowing Lina to choose her

ground. 'Let's begin with the events of the past few days, and work back if we need to. You told me that you visited Francine in her flat last Friday evening. Will you tell me a little more about that and its possible implications?'

Diverted from her prepared script Lina was put off, but her recovery was swift. 'Emile told me that you had been asking about that visit. My reason for talking to Francine was simple. We needed to discuss her present and future role in the Guild.'

'Because she was considering a substantial investment.'

'Yes.'

'And, naturally, you wanted these discussions to be confidential.'

'Of course.'

Wycliffe asked, with an air of innocence, 'Your husband was not involved in this discussion?'

Lina shifted in her chair with a show of impatience. 'As I was about to explain earlier, Archer has very strong views about maintaining the Guild in its present form.' An indulgent smile. 'He is a romantic, Mr Wycliffe; a dear man, but not cut out for business. He wants to see the Guild as a small community of workers, mutually dependent, and wholly devoted to their respective crafts. Of course it has never been like that and never could be. Even Eric Gill, his role model, had a keen eye for business and rarely allowed his religion or, for that matter, his sex life to interfere. To survive we have to make a reasonable profit and ensure that our members are able to earn a decent living.'

Lina paused, considering her words. 'Another equally important factor for Archer is, of course, his preoccupation with astrology. I saw you coming out of the Nonagon.' A gesture. She seemed to be saying, You must realise what I'm up against! And she went on, 'Archer believes that there is great significance in his name and birth sign and that leads, along with other things, to his insistence that there must be nine of us.'

She spread her hands. 'You may think that this is nonsense but Archer, along with a great many others, takes it seriously, and I respect his beliefs. However, with or without Francine's investment it has been clear for some time that we must expand to survive and,

inevitably, much of the present organisation by which Archer sets such store will have to go.'

Lina sat back in her chair as though to say, So there we are! Cards on the table.

Lucy Lane said, 'So any difficulties you had were with your husband rather than with Francine?'

An emphatic nod. 'Exactly! I needed time to discuss the business with Archer; above all to give him the chance to think again, and help him to see where our future must lie.'

Wycliffe, surfeited with the caring, affectionate, but frustrated wife, decided to give the proceedings more of an edge. 'Can you tell us how your purchases of pictures at auction in Amsterdam fits into the Guild's activities?'

It was clear that the question was not totally unexpected, but she managed a show of resentment. 'My purchases are an entirely private matter and have nothing to do with the Guild nor, I would have thought, with your inquiry.'

Wycliffe was equally blunt. 'I don't know what is relevant to my inquiry and what is not, but I intend to find out.'

Lina flushed. 'All right, I have nothing to hide. If it concerns you, I buy pictures in Amsterdam, backing my judgement, and, after cleaning and reframing where necessary, I sell them on. I get, as you English say, a kick out of it, and on balance I make a sufficient profit to justify my self-indulgence.'

'Did Francine raise this matter?'

'Yes, and she understood.' After a brief pause Lina went on, 'As far as Francine and I were concerned I have to say that we had a good deal in common. We both liked to have clear objectives and we were prepared to take risks to attain them. We were ready to place bets on the future.' She smiled, as though pleased with the simile. 'I enjoy pitting myself against the dealers and, like most gamblers, I hope one day to make what you might call "a killing".'

Wycliffe was thinking that in dealing with this woman it could become a question of who tripped up first.

The room looked out over the site and down the valley, with a glimpse of the sea. Drifting cloud shadows and patches of sunshine

made ever-changing patterns on the face of the moor, and there were rain streaks on the window panes.

Wycliffe shifted his ground. 'If we assume that Francine's death was unrelated to the activities of the Guild then presumably it was a consequence of her personal relationships.'

Lina relaxed visibly. 'Yes, Mr Wycliffe, I think that is where you must look for an explanation of this terrible tragedy.'

'In our earlier conversation you mentioned her association with Paul Bateman, with Emile Collis and with the young man known as Blond Bob who works and lives with Scawn at the Pottery.'

Lina pulled her dress a little further down over her knees. 'Bob is something of a mystery but he is Scawn's problem and I interfere as little as possible.' A brief pause before she continued. 'I think that I've said all that I can about Francine and men. In her relations with them, as in everything else, what gave her satisfaction was the feeling of being in control; the sense of power.'

Lina paused before adding, 'Of course, it's not unlikely that in pursuing that line she got herself into some highly charged situations.' Another pause, then, 'But I know no more than I have told you.'

Lina was beginning to feel that she had won the round and her manner was confident.

But Wycliffe had not finished. 'You are a painter. Do you have a studio separate from the one used by Mr Collis?'

A quick smile. 'Yes, I have my own little studio upstairs. Do you wish to see it?' She was playing a game; her manner was almost flirtatious.

'Please.'

'Then you must come upstairs.'

Everywhere there was gleaming white paintwork setting off pile carpet in traditional colours, meticulously hoovered.

Lina's studio was in a former back bedroom. It was bare, spotlessly clean and innocent of clutter. An unframed painting rested on an angled board placed in a good light. There was a painter's trolley beside it.

Lina said, 'This is one of my recent purchases in Amsterdam. It

has a scratch and I am doing a little minor restoration.' She added, 'That was my job in the museum.'

Her manner was teasing. 'This painting was a good buy, actually. A Paris street scene by the French Cortés – not the Spanish painter.' She turned to Wycliffe with a confiding smile. 'I hope to make a little on this one.'

She summed up: 'Well, Mr Wycliffe, we are honest practitioners of our craft, whatever you may suspect.'

Wycliffe was satisfied to leave Lina with her confidence intact. He said his thanks.

They were on their way along the passage to the stairs when she pushed open a door that was already ajar. 'While you are here, you might like a word with Archer. This is his room – a little different from mine, as you can see.'

Archer was seated at a table by the window, his back to the door. He turned in his chair, looking at them over his spectacles, none too pleased at the interruption.

'Mr Wycliffe would like a word, dear.'

All the available wall space was covered with what appeared to be star charts. Books spilled over from shelves on to heaps on the floor. A painter's easel and trolley stood apparently neglected in one corner, and the table at which Archer worked was littered with papers and books open for reference.

There was a single bed against one wall.

Lina said, 'Archer has all but given up painting in order to pursue his astrological researches and, as you know, he has recently recruited Evadne Penrose to help him. It seems that she is also very knowledgeable about such things.'

Archer composed himself. Initially resenting the interruption, he was not prepared to miss a chance to spread his gospel. And Wycliffe was well aware that the situation was of Lina's deliberate contrivance. Mere mischief? Or with some serious intent?

Archer was under way. 'I believe that our theory of natal astrology has to be recast in the light of scientific knowledge that was not available to our ancestors. I refer, of course, to the science of genetics.'

83

Archer shifted his chair to face his audience. 'The study of genetics, beginning with Mendel, and enormously developed since, has made it clear that our characteristics are, in terms of the actual physical process, determined not at the time of birth but at the moment of conception. In my view it must therefore be at that moment that the planetary influences make themselves felt.'

There was a pause awaiting some comment from Wycliffe and he did his best to sound intelligent. 'And that, I suppose, throws the whole system about nine months out of gear?'

An emphatic nod and a quick smile. 'As our prime minister said in another context, we have to think the unthinkable. Either all our interpretations are totally wrong or we are associating those interpretations with the wrong configurations of the planets. For example, the characteristics which we now associate with the configuration in Sagittarius – November/December – may in fact be determined by the situation in Aries – March/April.'

Archer removed his spectacles and stroked his silky beard. 'It is a revolutionary idea, Mr Wycliffe, and for me, a very disturbing one.'

Wycliffe was silent but Lina was quick off the mark. 'And in my view a good time to make those changes in the Guild which are desirable, even if they are inconsistent with astrological principles which you are discarding anyway.'

But Archer was emphatic. 'Oh, no! Oh, no. One doesn't throw away an old coat until one is quite sure that the new one fits. I am a long way from that situation at the moment.' And he turned his back on them as a peremptory sign of dismissal.

Back in the corridor Lina's manner was almost conspiratorial. 'You see? Never mind; we shall get there in the end.'

Downstairs they were shown off the premises with a display of apparent good will from both sides.

Lucy asked, 'Why were we treated to all that?'

Wycliffe said, 'I hoped that you were going to tell me. The point she was making was pretty obvious but I wish I knew why she troubled to make it.'

'You saw the bed in his room.'

'One could hardly miss it. Anyway, we've left Lina in the right

mood. The last thing I want is to have her getting scared without us knowing exactly what she's scared of. We want her to feel pleased with herself and at the moment she doesn't need encouragement.'

'It sounds Machiavellian.'

'You think so? I only hope that we can keep up with her.'

'You didn't mention Collis's record.'

'No, we need something up our sleeve.'

Wycliffe looked at his watch. It was four o'clock and still Whit Monday.

A little more than thirty hours ago he had been lounging in the Watch House garden. Helen was weeding, Macavity was asleep at his feet. It was hard to believe. His mobile had put an end to all that.

A girl had been murdered.

Now he knew the girl was Francine Lemarque. As in a dream he was meeting familiar faces in a fresh context and it looked as though threads from the past had been interwoven with others into a new and ugly pattern.

He turned to Lucy Lane. 'I need to get home this evening, Lucy.'

'You're thinking of your interview in the morning?'

'Yes.'

There was a moment or two of silence, then Lucy said, 'We all hope that you will be there to see us through, sir.'

'See you through? I don't understand.'

Lucy was looking straight in front of her. 'You might be tempted to pack it in – and who could blame you? But we just hope that you won't.'

He was surprised, taken off balance, and all he could find to say was, 'Thank you.'

Lucy changed the subject. 'How do we go tomorrow?'

'We are neglecting the potter and his assistant, Lander.'

'You want me to make a start?'

Wycliffe hesitated. 'Concentrate on Lander. Send for him and get him talking. I would rather we tackled Scawn together.'

Lucy got the message.

Wycliffe was looking across the stream towards the wood-carver's workshop. 'I wonder if Paul is there.'

'Shall we find out?'

'I'd like to tackle him alone, Lucy.'

'You don't think that you may be letting sentiment run away with you in this case?'

About to take offence, he changed his mind. 'Of course I am, and so would you in similar circumstances.'

Lucy grinned. 'You may be right at that.'

'When I've talked to Paul I shall look in on Marsden. Then homeward.'

Lucy said, 'Good luck!'

The door of the wood-carver's workshop was open and inside Paul was using a tiny gouge on a plaque with a floral design. He turned to face Wycliffe, dropped the gouge, and stood with his back to the bench, waiting for what was to come. He looked haggard and ill.

'I want to talk to you, Paul. Do you think we could sit down?'

Paul pointed to a couple of trestles. 'We don't have chairs.'

'I'm not talking as a policeman, and we are alone. I want to find whoever killed Francine and so do you. If you tell me what is in your mind – your private thoughts about what has happened – I will promise that nothing you say will recoil on you in any way.'

There was a silence and when Paul finally spoke, words came slowly. 'It took me a very long time to realise that Francine would never enter into a stable relationship with anybody. I only really understood it after she moved into the flat upstairs . . . Until then I had always hoped.'

Another silence, but Wycliffe was content to wait.

'I was . . . I was disappointed – hurt, I suppose. I knew that my attachment was too strong to face any break. If all I could have was her company at work, and perhaps her companionship sometimes outside of work, I would settle for that. We'd been through so much together that for me the idea of separation . . . ' He left the sentence unfinished.

Such total commitment must be very nearly unique and Wycliffe

could not help wondering what the future held for Paul without the girl.

'Were you jealous of her association with other men?'

He considered before answering. 'I don't think I was. They had less of her than I had.' He shifted his position on the trestle. 'Being put away changed Fran and, God knows, that's not surprising. She came out determined to get her own back on life but I don't think you can do that; you can only get your own back on people.'

'You knew that she had inherited money and that she was proposing to invest it in the Guild?'

'I heard the talk but that didn't affect me one way or the other.'

'Can you suggest any reason why anyone would have wanted to murder Francine? Can you think of anyone who hated or feared her enough to plan and carry out such a cold-blooded crime?'

Paul shook his head. 'It's beyond me . . . In the night I have difficulty in persuading myself that it could have happened. I can almost believe that it was a bad dream.'

Wycliffe said, 'I saw you with Marsden. I think he might be helpful to you.'

'He is. He's been very understanding. He showed me his painting of Francine and he's promised to give it to me. It's wonderful! I mean it's Francine *before* . . . ' There were tears in his voice and in his eyes. 'To think that I didn't even know of its existence . . . And Marsden talks about Fran as though he understood her in a way I think nobody else did.' He added, after a pause, 'Not even me.'

Just time, before he left, to tackle Marsden. Wycliffe drove himself.

The sky was overcast and a thin drizzle kept the screen-wipers busy. Gloom! But it was very mild. Good weather for growing Cornishmen and cabbages, but Wycliffe did not quite fit into either category.

The light was on in Marsden's living room but there was no music. Wycliffe banged on the door and it was opened by Marsden. 'You! I've got a visitor.'

'Good! Now you've got two.'

Evadne Penrose was installed in one of the Windsor chairs by the fireplace with Percy stretched out at her feet. For once Evadne was caught off balance.

'I came to bring Hugh up to date. He so hides himself away in this place that he never hears anything unless someone takes the trouble to tell him.'

Wycliffe felt he owed Evadne something but policemen rarely pay their debts, and he gave her no encouragement. She went on, 'Hugh and I have been neighbours more or less for twelve years.'

Put off by the continuing absence of any response, she stood up. 'Well, I've done my duty so I shall leave you to talk.'

She wore a navy-blue gabardine mac, which looked as though she might have had it since her schooldays.

Marsden, unusually silent, saw her off. When he came back, and had closed the door, he said, 'You can never tell with Evadne. There's more to her than you'd think.'

'What did she want?'

'She told you.'

'Interesting!'

'You think so? I might ask what business it is of yours, anyway; but I won't. Evadne gathers what she can where she can.'

Wycliffe took the chair Evadne had vacated and refused to be diverted from her visit. 'Perhaps Evadne knew that your acquaintance with Collis goes further back, and that you know a good deal more about him than you've admitted to me. For example, that he worked with you in the Stylov Gallery racket, not as Emile Collis, but as Edward Collins, and that he's done time for forgery since then.'

Marsden was recovering his poise. 'So you've tumbled to it, or somebody's tipped you off. But get this straight, I'm not your snout waiting to grass up my acquaintances, past or present.'

'But you're as anxious as I am to find the killer of Francine.'

Marsden turned to Wycliffe with something of his old style. 'I'm as dry as a boot-jack so what about a glass of our Phyllis's elixir?'

When they were settled, Marsden went on, 'Look at it my way

for once. The whole art trade, as far as painting is concerned, is an elaborate scam. Somebody turns up with a painting of bloody sunflowers. "Is it an unknown Van Gogh?" he asks with bated breath and twitching fingers. Well, if there's a chance in hell, it will eventually get to be brooded over by the art gnomes in London, in Paris or New York. And, in due time, after taking into consideration many things not in the least relevant to the picture itself, they will make their Olympian pronouncement.'

Marsden paused to take a great gulp from his glass. 'And as a result, this bit of canvas with paint on it will be worth either ten million or five hundred to its owner. And even the five hundred will need a bit of luck. And, the poor bugger who painted it – or didn't – shot himself in despair more than a century ago.'

'So? Are we going to get to the point?'

This time Marsden only sipped his beer. 'We're already there. The whole bloody business is a stupid but legal racket with a lovely fat profit for some. Well, if there's still anything in it for my old mate, Collins or Collis, or whatever he's calling himself at the moment, I'm not going to start nit-picking over his morals.'

'You didn't hesitate to point me in the direction of Lina and her Amsterdam trips. It was obvious that you suspected some jiggery-pokery there that was almost certain to involve Collis.'

'And this is the thanks I get. No, you are investigating the murder of a girl for whom I had a lot of time and, as you pointed out earlier, I want the bastard who did it caught, locked up and the key lost. Whoever he or she turns out to be.'

'How did Collis get into the Archer set-up?'

'It was through me, actually. Lina offered me the job but I'm not joining any bloody production line so I passed her on to my former mate. He'd just been let out after doing fifteen of his twenty-four months inside, and he was down on his luck. Lina took to him – he appeals to a certain type of woman – but there was more to it than that.'

'Did she know of his conviction?'

Marsden grinned. 'What do you think? Lina didn't go in for any pig in a poke. That was half the attraction.'

'Are you saying that he might be copying her Amsterdam purchases and that she flogs them as originals?'

Marsden pouted. 'I don't know. I suppose it's possible. But not all of them, that's for sure. She'd never get away with it. In any case, they're not really in a class that makes forgery worthwhile. It would have to be the odd one now and again, carefully selected and even more carefully placed. I gather that she rarely buys anything without good evidence of provenance. I suppose she could be really naughty and flog the fake with the provenance and let the original speak for itself. Even so there can't be a fortune in it but it might pay for her trips back home and leave a bit over. Though, knowing our Lina, she might even be doing it for kicks.'

Wycliffe sighed. 'And Francine is dead.'

'Yes, and that gets me where it hurts, but I can't believe that her death has anything to do with any picture fiddle they may be working. It's a jigsaw and there must be more than one way of putting it together, but you're supposed to be good at that.'

'Another thing. Derek Scawn – anything on him?'

Marsden frowned. 'A potter. They're a rum lot, neither fish, flesh nor fowl. Anyway Scawn is well out of my class – he's got brains. Or so they tell me.'

'What do you know about this chap they call Blond Bob – Robert Lander?'

'I know nothing about him. He was brought in by Lina, ostensibly to keep Scawn happy, but Lina isn't the sort to do anything unless there's something in it for her.' Marsden yawned. 'It's nearly tea time and what with one thing and another I haven't had my afternoon nap.'

'Poor you.'

Marsden saw him off. 'Don't let it get you down.'

Back at the site DCs Curnow and Thorne were in the caravan working through their formal interviews. Lucy was nowhere to be seen.

Wycliffe set off for home. By the time he reached the Hayle bypass he had left the mist and drizzle behind and when he arrived at the Watch House in the early evening, the sun was shining, the

air was still and the waters of the estuary were like the proverbial mill pond.

He found such evenings mildly depressing; they reminded him of Bishop Heber's hymn, with 'all the saints casting down their golden crowns around the glassy sea'. As a child, the hymn had put him off quiet summer evenings. And heaven too.

Helen had made a prawn salad and, as part of his continuing musical education they listened to Sibelius's Seventh. Pleasantly gloomy, and in tune with his mood. Anyway, no sonic shocks.

They went to bed early and read. Before they settled down Helen asked, 'How do you feel about tomorrow?'

'I've decided to soldier on for a while. See how things go.'

'Good. I don't think you are quite ready for your clock, or whatever, just yet.'

'But if she thinks she's going to run me— '

'She'll be making a big mistake. I know, I've tried it. Now, kiss me good-night and go to sleep.'

And Wycliffe went to sleep, wondering at the number of odd-shaped hours which somehow slot together to make a day.

Chapter Six

Tuesday morning

In the morning, uneasy in his mind, and irritated because he was uneasy, Wycliffe's mood was not improved by the breakfast-time news on the radio: 'Investigations are continuing in the case of the young woman murdered on Saturday night at a craft colony near St Ives in Cornwall. The police have acknowledged that the victim was Francine Lemarque who, ten years ago, was herself convicted of the murder of Gerald Bateman, a rising political figure of the time, and her natural father— '

Wycliffe said, 'That's all I needed.'

'It was sure to come out.'

'You think that helps?'

He queued his way into the city inhaling his ration of exhaust fumes. For most of those stuck in the traffic it was back to work after a holiday weekend. Not for him. He arrived at police headquarters resolved to be difficult, and at nine-fifteen he presented himself outside the padded door. Queenie, the grey-haired and revered guardian of the sanctum, said, 'Go on in. She's waiting for you.'

'Oh, Charles! Do come in and sit down. I've been looking forward to this.' Smiling. She looked trim and youthful in her uniform.

A brief review of his file, then, 'I assume you're not planning to walk out on us? If you are, I hope I can change your mind, so listen to me first.

'You must know better than most how well Bertram Oldroyd ran

this force and I understand that he did it largely by letting his heads of departments run their own shows as long as they stuck to the accepted rules of policing and got results. I've no intention of trying to change that.' A quick smile. 'I want to make it clear that if you sometimes choose to do the job of a DI or a DS, or, for that matter, of a beat copper, you won't hear any criticism from me as long as you continue to get the results the Force has come to expect from you, and that your administrative responsibilities are not neglected.'

Jane Elizabeth Sawle in Bertram Oldroyd's chair. It took some getting used to but she was putting him in the mood to try.

'I intend to make changes but they will be mostly concerned with administration. I want to reduce paperwork and so get more of our people away from their desks and out on the ground. I can see you saying to yourself, "She'll learn!" and you may be right, but I've got one or two ideas and I'm going to try. Much of our trouble comes from lawyers in the CPS and the Courts making jobs for themselves. Well, I'm a lawyer and that must be good for something.'

She laughed. 'All right so far? Now, I'm obviously interested in budgets – I have to be – and here again I think it may be possible to divert funds away from the offices and into practical policing with more men on the ground.'

Wycliffe had been wrong-footed but he was not going to be smothered in honeyed words. He had come prepared to say his piece and he said it.

The ensuing exchange, and it soon became a vigorous one, lasted for more than an hour and ended with, 'By the way, I hate being addressed as Ma'am, Charles. I have two names and of the two I prefer Jane, so when there are no junior ranks present I suggest we can dispense with Ma'am and use our first names.'

Wycliffe found himself back in Queenie's office feeling as though he had got there by parachute. All too good to be true? Perhaps. But time would soon tell.

Queenie, who had never hitherto been known to express any opinion about anything, remarked, 'She takes you that way, but we'll get used to it.'

He went through to his own office. Diane, his personal assistant, was there, sorting through the mail.

It was an odd feeling; he seemed to have been away for a long time.

'Well?' Diane was in her forties; she had been with him for more than twenty years and in private they no longer stood on ceremony.

'I think we shall survive.'

'You'll stay?'

'I'll give it a go.'

'Good! Hadn't you better ring Helen? . . . I'll leave you to it.'

Helen said, 'So I'm not going to have you here mooning around all day in carpet slippers. Seriously, love, I only want what you want, but I don't think you're ready for the handshake just yet.'

Helen. Bless her!

It was still only half-past eleven when Wycliffe was driving over the road bridge which, with the railway, the ferries and the airways, keeps Cornwall in touch with and at the mercy of the English. The sun had broken through the morning cloud and it looked like being a pleasant day. Oddly, his thoughts revolved around two clever and very different women, Lina Archer and Jane Sawle.

He sometimes wondered how different the Western world would have been if women had come into their own a hundred years earlier.

Better?

A good question, which he sometimes answered one way and sometimes the other. Eve, with the serpent in the garden, should have been a lesson to all mankind but it took a lot of learning, and Islam preferred to overlook it altogether. Or perhaps the Muslims overreacted.

He decided to put in an appearance at the Incident Room before going on to the Guild site.

Kersey was there at his table, working through reports from HQ which had been faxed through. None of them had anything to do with the case in hand but somebody had to deal with routine and, with a sense of guilt, Wycliffe recalled his licence from the new

chief to stay out of line: 'If you sometimes choose to do the job of a DI or a DS, or a beat copper . . . '

All very well for him, but Kersey seemed to harbour no grievance.

Wycliffe did his best to reassure him about the new management.

Kersey said, 'So she's not going to be on our backs. That's something if she sticks to it. You'll stay on?'

'I shall stay long enough to see how it works out.'

'Well, that's what we've been waiting to hear. I don't have to say that the team will be pleased.'

Coming from Kersey that was a great deal.

'Any news of Lander?'

'He's back. I heard only just before you came in. Lucy is handling it.'

Delegation. Wycliffe had quite a good vocabulary but this was one word he had never really learned.

Kersey went on, 'Franks' report on the autopsy arrived. Nothing new that I can see. The statements are coming in. Nothing startling so far.' He yawned, patting his gaping mouth inadequately. 'And incidentally the inquest on the girl has been opened and adjourned. Anyway, it's lunchtime, so let's forget it for half an hour.'

Wycliffe was temporarily won over and they ate canteen sandwiches washed down with coffee from the machine.

'I think I'd better get out there.'

Kersey's grin said it all.

Wycliffe drove to Mulfra. As always, he felt that lift of the spirit as the car topped the rise outside Eagle's Nest. He could see the little village with its church tower below him, dwarfed by that vast spread of moor, and cliffs and sea. The sun still shone, but not with that Mediterranean monotony and intensity. There were clouds, white and puffy, that knew their places in the changing pattern of the sky as though they had been choreographed.

Perhaps, when we do retire . . . But on second thoughts, it's a long way from a Marks and Spencer's.

He arrived at the Guild site to find Lucy Lane in the police caravan about to interview Lander, and decided to sit in.

'Mr Robert Miles Lander, sir.' And to the young man. 'This is Detective Superintendent Wycliffe. At this stage we are interviewing everybody who had any connection with the dead girl, gathering as much information about her as possible. There is no implication of guilt or suspicion. You understand?'

'Of course.'

Lander was probably in his early thirties, tall and muscular, but his face was round and his features had an unfinished look, lumpy like a clay mask awaiting its final moulding. With his straight blond hair and pudding-basin cut, he looked like a vastly overgrown child.

Lucy said, 'Mr Lander has been away. He left yesterday morning and returned today.'

Lander was apologetic. 'I should have let you know but I was worried. I had a message from my father to say that my mother was unwell. She gets periodic attacks of migraine and father gets worked up. She's all right now.'

It was clear to Wycliffe that Lucy was uneasy, and he was puzzled. He decided to leave the questioning to her.

'How well did you know Francine?'

A frown. 'Hard to say. As you know, I live with Derek Scawn and Francine worked and lived a couple of doors away. She looked in occasionally and we seemed to get on. Derek liked her. In the same way I would drop in at wood-carving when they weren't too busy. It was all very casual.'

'Have you been to her flat?'

'Three or four times.'

'Was your relationship a close one?'

'You are asking me if it included sex. It did not.' Lander hesitated before adding, 'I'm not interested in women in that way.'

'Did you see her on the day she died?'

'No, I did not.'

Wycliffe asked, 'Did she confide in you at all?'

'She told me that she had come into money, and that she was negotiating with Lina about investing in the Guild.'

'What was your opinion about that?'

'I didn't have one. It was none of my business.'

'Did she talk to you about her past?'

'Yes, quite early on. I thought she was making it up just to be interesting.' He looked at Wycliffe. 'Some girls are like that. Then of course I heard it from others.'

Unusually, Lucy cut across Wycliffe's line of questioning. 'How long have you lived with Mr Scawn?'

'Nearly three years.'

'Are you related?'

'We are cousins twice removed.'

'So you have known him all your life?'

'No.' Hesitation. 'It was only by chance that I discovered our relationship.'

'Was that before or after you came to live with him?'

'It was after.'

Wycliffe was puzzled by Lucy's line of questioning but it was clear that Lander was becoming unsettled so he held his peace. Then, to his surprise, Lucy wound up the interview.

'Well, that will be all for the moment, Mr Lander. In common with the others who knew the dead girl at all well you may be required to make a formal statement later.'

Lander too seemed bewildered. 'I can go?'

'Of course. Thank you for your time.'

When he was gone Wycliffe said, 'What was all that about? I realise that I blundered in when I shouldn't have done.'

'You could say that. It was awkward but you couldn't have known. The point is that David Wills, the local DS, spotted Lander and told me just before the interview that he'd come across him before. It goes back several years to when Dave was in uniform and stationed in Exeter. Lander is a case of once seen never forgotten, and Dave remembers him being brought up on a drugs charge which was thrown out for lack of evidence. Dave wasn't directly involved but he's going to follow it up.'

'Interesting.'

'I thought so, and it seemed just as well not to put too much pressure on Lander in the meantime.'

'I shall eat humble pie.'

'Not too much. I don't want you getting indigestion.'

Half-past three, and Wycliffe said, 'So where do we go from here?'

Lucy suggested, 'Collis?'

'I'm not ready for him yet. Let's see what Scawn has to say for himself.'

The pottery building was on a larger scale than any of the others. The workshop was fitted with folding doors with a wicket. And parked nearby was a well-groomed Volvo, two or three years old.

Inside there was a bake-house warmth. The light was dim and a red eye glowed on one of the kilns. As their vision accommodated they could see work-benches, and at least two potters' wheels. There was a background smell of damp clay and on shelves lining the walls there were pots of different shapes and sizes in various stages of embryonic development.

A group of finished pots, presumably ready for packing, stood on a side table. Wycliffe was impressed by the brilliance of the colours and by the moulded figures of mythical beasts which twined round and clung to the elegant curves of some of them. For Wycliffe, uninspired by Helen's taste for the severities in colour and form of the Leach school, these pots were a revelation.

'May I help you?' A cultured voice from the far end, and a figure emerged from the gloom. 'Derek Scawn. You must be from the police.'

Introductions over, Scawn went on, 'I gather you've been talking to Robert. We were about to start unloading one of the kilns but he's just gone into Penzance to catch up on our shopping. We'd better go upstairs to my living quarters.'

Scawn was long, lean, dark and fiftyish, with a strong bone structure. Wycliffe found his steady gaze disturbing; he seemed to be looking through one, as though at some more distant object of greater interest.

But his manner was friendly, even chatty. 'I expect you're here to talk about Francine.'

He led the way to the back of the workshop and up a flight of stairs. At the top they were in a large room with a window on to the moor. White walls, Japanese prints, bookcases, a polished stripped-oak floor and Chinese rugs. At one end a vintage word processor shared a table with a few books and a bundle of typescript. No pots, Scawn or Leach, to be seen.

A silver-point Siamese padded about in restless disdain, while another achieved a complex yet elegant posture attending to its more intimate toilet.

When they were seated Wycliffe said, 'So Lander was called away unexpectedly.'

'Oh, yes, a telephone call yesterday from his father. Some family crisis. They live in Devon – Honiton, I think it is. I probably have the address somewhere. He visits them regularly, whenever he can get away.'

'I gather he has a motorcycle.'

'Yes – *very* useful in these lanes and on the moorland roads. As I said just now, he's off doing our shopping at the moment.'

Wycliffe was putting the onus on Scawn to do the talking, and the potter went on, 'Robert has kept me up to date with your investigation. The young woman came here several times and I believe Robert visited her at the wood-carving shop.'

Wycliffe, casual, asked, 'Do you see much of the other Guild members here?'

'Not a lot. Collis looks in at the pottery occasionally, and sometimes up here. He and Robert seem to have interests in common.' A ghost of a smile. 'Archer himself is a fairly regular visitor. As you probably know by now he has made a study of natal astrology and he comes here to share his thoughts.'

Wycliffe, anxious to keep the man talking, said, 'At the moment he seems to have got himself into a logical tangle concerning conception and birth in relation to astrological prediction.'

Scawn stooped to lift one of the cats on to his knees, and stroked it into purring contentment. 'Archer's tangle arises from his

insistence on confusing two totally different systems of thought: the concept of cause and effect, which has been the keystone of Western science, and the idea of meaningful coincidence which underlies classical Chinese philosophy. Of course it is the latter which provides what logical framework there is for the study of astrology. Certain events "go together", and that is that. No point in further discussion— '

Scawn broke off. 'But is it really Archer that you have come to talk about?'

Wycliffe's response was brusque. 'I've come to talk about anyone and anything that may seem relevant to my investigation. I have to discover the motive for Francine's murder, and to do that I need to know as much as possible about the people with whom she was in regular contact.'

Scawn was not intimidated. Still with a hint of amusement in his voice he said, 'And I suppose one possibility is that poor Archer could have done it to secure the future of his Guild against a predator from within.' A thin smile. 'Interesting! I must admit that the thought occurred to me but I can't really see him going that far even in defence of his Guild.'

Wycliffe let that pass and Scawn went on, 'We all make what we can of the flux in which we find ourselves. We search for patterns in its swirls and eddies, and when we think we've found one we try to pin it down, to give it permanence. We theorise and rationalise about it, and say, "This is how things are." '

A broad gesture. 'Then, according to our bent, we call what we have contrived philosophy, science, religion, art or whatever.'

Scawn paused and looked directly at Wycliffe. 'In those circumstances, who am I to pass judgement on Archer's ideas or anyone else's?'

Wycliffe decided to go along with the whimsy. 'You've told us that Francine visited here and that you talked to her. What was your impression? If you like, what would you say was her selection from the eddies and whirlpools of the flux?'

Scawn grinned. 'A good question! And I need to think . . . Yes, well . . . I would say that Francine had chosen the most baffling

and frustrating of them all, the illusion of individuality, of seeing in the flux her own image.' A pleased nod. 'Yes, and what is more she seems to have believed that she could isolate herself from the flow, and even attack it.'

Wycliffe was intrigued, and decided to play along. He waited until Scawn resumed: 'Freud believed that most of us are scared of our own individuality. We take refuge in the Family, the Team, the Party, the Church or the Mob. But Francine delighted in her self-hood and deliberately set out to exploit it . . . A risky business.'

Wycliffe was silent and Lucy, unsure whether this was her cue but anxious to find firmer ground, decided to risk it. 'Coming back to Robert Lander, what exactly is his position here?'

Scawn, momentarily wrong-footed, recovered. 'Officially he is my apprentice and he is a promising one, with the makings of a good potter.'

'Do you know anything of his background?'

'Very little. No more than he has told me in casual conversation.'

Wycliffe took up the thread. 'We have to make detailed inquiries concerning everyone who was in any way involved with the dead girl.'

'Naturally; and you may well find that Robert does not have an unblemished record. He is much given to blending fiction with fact and he does it so successfully that he is often unsure which is which.'

'And that doesn't trouble you?'

'Not in the least. Let me say at once that Robert has no streak of viciousness in his make-up. If you *know* him, you make allowances for his foibles, and he is harmless. At the same time he is a valuable companion: he is willing to work, he interests himself in those things that interest me and he is an excellent housekeeper. Without him this place would sink into squalor.'

'I understand that he is a relative of yours?'

An indulgent smile. 'That is one of his fantasies. He took the trouble to find out all he could about my background then came up with fictitious relatives of his own and fitted them together. It's just one of Robert's little games. Quite harmless.'

'And you let him get away with it?'

'Why not?' Another smile. 'God, or whatever, lets me think I've won sometimes.'

'How long have you known him?'

Scawn frowned. 'A couple of years, something like that. Lina realised that I needed help in the pottery and she sent him along for a trial period. He had had no experience but he was quick to learn.'

'What does he live on? Does he have anything apart from his wages?' Lucy again, feeling on firmer ground.

A quick look from Scawn. 'No private means, as far as I know. Robert works with me and, if you like, for me, so I make sure that he is provided for and though he does not know it, that will continue should anything, as we so coyly put it, "happen to me".'

Wycliffe tried one more throw. 'Do you have any ideas concerning Francine's murder?'

Scawn considered. 'Not really. I believe that she intended to work her way into the administration of our little community.' Scawn smiled as he said this. 'To work her way in and eventually, perhaps, take over from Lina.'

He added after a pause, 'You must realise, I'm sure, that friend Archer only operates under licence from his dear wife.'

Wycliffe had one more point. 'You know of Lina's visits to Amsterdam?'

'Of course. There's no real secret about them: she's Dutch and she goes back home.'

'And the pictures she buys and sells on?'

Scawn frowned. 'Lina is careful with her money and she probably does it to cover the expenses of her trip.'

For the moment it seemed that all had been said that needed to be at this stage, and Wycliffe stood up. 'Perhaps you will allow us to take a look at Lander's room.'

Scawn looked surprised. 'His room?' . . . Then, 'In the circumstances I suppose that is reasonable.'

The room was small but it looked out over the moor and despite the mist there was an illusion of space. A bedsitter, but with no resemblance to the traditional bachelor pad. The little room was

plain, obsessively neat and tidy, with an institutional flavour. Wycliffe went to the bookshelves. A diverse collection of paperback novels kept company with books on history, science and philosophy, with language tutors in French and German, and an ageing set of the *Encyclopaedia Britannica*.

Scawn said, 'I believe that Robert thinks knowledge is power and so he does his best to get it.'

As they walked away from the pottery the mist was lifting and the moor slowly emerged in contour and colour. A few minutes later they could see the sea.

Wycliffe said, 'What did you make of Scawn?'

'Would you settle for a magnetic personality?'

Wycliffe grinned. 'It'll do for the present but I doubt if we've finished with him yet.'

'I'm glad to hear it.'

'Why, in particular?'

'I'd hate to see a Detective Super, still in fair condition, being carried away by the flux.'

Wycliffe could think of no apt reply to that, so he said nothing.

They crossed the stream. A post van was parked outside the Archer house, and the postman was delivering mail; a reminder that in the larger world life went on.

Wycliffe said, 'Our next port of call?'

Lucy said, 'What about Collis?'

'Yes, I think so. At least we can hear what he has to say about Lina's trips to Amsterdam.'

They made their way around the Archer house. Collis was in his studio, wearing a grey paint-stained overall which almost reached the floor, working on a beach scene. He was unwelcoming.

'I realise that our interruption may be troublesome but we need to talk to you.' Wycliffe was brusque.

Without a word, Collis wrapped a strip of polythene around the bristles of his brush and dropped it into a jar.

'We'd better sit down, I suppose.'

He led the way into his living room, and when they had found

seats he waited like a man about to be sentenced. He was in a bad way; the change in such a short time was remarkable. His movements were unsteady, sometimes exaggerated, and a tic affected one side of his mouth.

Drugs? Wycliffe wondered.

The first question took him by surprise. 'Do you know that Lina spent an hour with Francine in her flat on Friday evening?'

'No, but I can imagine there were matters they needed to discuss.'

Lucy asked, 'Money matters?'

A quick look. 'Probably.' He hesitated, then made up his mind. 'You must know that Francine had come into money and that there was a proposal that she should invest it in the Guild as capital for an expansion of the business. It was supposed to be very hush-hush but there's no point in that now. However, an investment of that kind would have required changes in our constitution so there was a lot to discuss.'

He spoke in a low voice; he was lucid, but it was obvious that he was under great strain.

Wycliffe spoke more gently. 'I'm sorry to press you on matters which may seem to have nothing to do with Francine's death, but you must understand that we have to look at every possibility.'

'I suppose so.'

'I gather that Francine was going around the workshops asking questions, and prying into details of how the present system affected different people. Did this upset some members of the Guild?'

'Yes, you could say that. Francine wasn't always as diplomatic as she might have been. But I can't see how that could be in any way connected with what has happened.'

'Unless she stumbled on something of real importance that she was not intended to know.'

Collis burst out, 'You are being melodramatic. To suggest that there was some secret that cost Francine her life is nothing less than absurd!'

Wycliffe was patient. 'But Francine was murdered and there

must have been a motive. Does it seem to you more likely that her death was a result of tangled personal relationships?'

For a moment Collis looked at Wycliffe in silence, then his features contorted as in a child about to burst into tears. He almost shouted, 'I don't know! I really don't know! What is the use of asking me these questions? You must know by now that Francine was a difficult young woman with a deeply distressing past. I suppose you could say that she wanted relationships without commitment. A lot of people do, but they are not murdered because of it.'

Collis slumped back in his chair, apparently exhausted by his effort.

Wycliffe said, 'What you say is obviously true but it gets us no further. However, while we are here, as part of the routine visits we are making, I would like to see your framing workshop.'

A surprised look; perhaps of relief, 'All right. But I don't know what good it will do.' He gathered himself together and stood up, 'Anyhow, if that is what you want. This way . . . '

They followed him back through the studio and into a room at the far end, a small but seemingly well-equipped workshop. On a central bench there was an elaborate mitring machine. Another bench was laid out with clamps for assembling and gluing, while a third had a device which appeared to be used for the cutting of cardboard mounts. Mouldings of all sorts and sizes were stacked in racks along one wall; and there were cupboards.

'Well, this is it.'

With apparently casual but total irrelevance, Wycliffe asked, 'When did Lina last go to Amsterdam?'

Marsden had deliberately sown the seeds of suspicion about Lina's visits and the pictures she brought back. Whether there was any connection with Francine's death was another matter, but he couldn't afford to neglect the possibility.

Collis was doing a spot of compulsive tidying in the manner of a fussy housewife, and he looked up as though startled by the question. 'Surely you should ask her that.'

'Why? Is it a matter of some secrecy?'

'No . . . No, not at all. It's just that I thought . . . I mean, Lina is Dutch and she visits her relatives in Amsterdam from time to time, as you might expect. Anyway, if it concerns you, she returned from her last visit a week ago last Saturday.'

Lucy Lane asked, 'Had she bought any pictures?'

Hesitation, then, 'Yes. She sometimes buys pictures at auction there. On the whole prices are significantly lower, and when the pound is strong— '

'She sells them on here?'

'Yes, but that is really her business.'

'You mean that it's unconnected with the Guild?'

'That is what I mean. It is a purely private matter.'

Lucy asked, 'Does she bring the pictures back with her?'

'No, they follow as air-freight and they arrive several days later.'

'Are there many as a rule?'

'It varies. Last time there were six, but I really cannot see how this can have any bearing— '

Wycliffe, fencing in the dark, interrupted, 'Do these pictures arrive framed?'

'No – well, yes.' A pause before he added, 'But often unsuitably. As I think I've told you before, we attach a lot of importance to the way a picture is framed.' Collis said this with a finality that was intended to close the subject.

Wycliffe, feeling his way, followed the established principle that those questions which make the witness uncomfortable are most likely to prove worthwhile.

'Do you reframe the ones which need to be?'

'Yes.'

'Would it be possible for us to see any of the pictures which arrived recently?'

Hesitation, then, 'I suppose so but I can't imagine why you would want to.'

'Let's say curiosity; even policemen have their share of that.'

Collis went to a cupboard and lifted out several pictures of differing sizes separated by sheets of bubblewrap, and arranged them in a row against one of the benches.

Collis said, 'All the pictures are removed from their frames on arrival for cleaning. This is a fairly average purchase, nothing spectacular, but readily saleable.' He pointed them out: '*A Café Scene* by Quinsac; a Tom Lloyd, *Rose Garden*; a Robert Henri, *Portrait of a Young Girl*— '

Wycliffe interrupted. 'There are only five; I thought you said six.'

Collis sighed. 'You are playing with me. You know perfectly well that Lina has the sixth picture in her studio for a minor retouch. After all, that was her job, and it is perfectly legitimate.'

'Does Mrs Archer do any original work in her studio?'

'I've no idea. You should ask her.'

Wycliffe decided that without some sort of theory to work on there was little point in pushing Collis further. And he felt pity for the man.

'Very well, Mr Collis. Thank you for your help.'

Outside, Lucy said, 'Does that take us any further?'

'At least we know more about what goes on. Marsden obviously thinks that there's something fishy about Lina's picture-buying and I certainly got that impression talking to Collis. I know nothing about the picture market but I would have thought that making and flogging copies of the sort of thing we've seen would have to be done for love rather than for much in the way of money.'

He broke off. 'Shaw might help us there. Collis is obviously scared but I had the impression that it wasn't so much what we talked about as where the talk might lead. Am I being fanciful?'

'It's one of the privileges of rank, sir. He's like a cat on hot bricks about the whole set-up. He's pathetic. You didn't mention his police record.'

'What would be the point at this stage?'

There is an idea dreamed up by a French mathematician called the 'Cluster Theory', which suggests among other things that even apparently unrelated events occur in clusters.

Odd! But it seems to work in criminal investigation. Either nothing happens, or everything does. Either you are snowed under with fresh information or the case you've built up seems to be falling apart. For days at a time you can be running around in

circles trying to cope, or you find yourself thinking that for all the good you are doing you might as well go home.

Perhaps they were in for a spell of the latter.

Statements were being taken from everybody on the site, while a last-resort clip-board team was at work in the village, harvesting gossip. And there was plenty of that. With a hand-picked collection of oddities on your doorstep and a murder, in particular the murder of someone already the subject of local myth and legend, gossip is irresistible.

Wycliffe sat in the van and tried to think constructively; something he found very difficult to do, and which was usually unprofitable.

Francine was dead. She had been murdered in a particularly cold-blooded fashion. These were facts.

There seemed to be several possible lines of inquiry depending on the motive for the killing. Francine had been killed by a frustrated lover. She had been killed because she was a threat to the craft guild of Archer's dream. She had been killed because she knew too much about some major scam involving Lina and others. There was a fourth possibility which had to be considered, that her death was directly linked to her part in the events of ten years ago. The last seemed unlikely though not impossible.

Wycliffe tried to be systematic and consider each in turn but it failed to get him far. The frustrated-lover angle he discarded. Paul was the only real candidate and Paul would not step on the proverbial cockroach let alone harm the girl he had loved, and whose vagaries he had endured for so many years.

To protect the integrity of the Guild?

That pointed only to Archer . . . A fanatic? No doubt. But a murderous fanatic? Just possible, but without some added incentive, some irresistible drive . . .

The picture scam – if it was one? It could be the best bet. Lina's pictures. But it had seemed to him more than once that she was deliberately drawing his attention towards rather than away from her precious pictures.

A link with the past?

He could think of nothing credible unless it concerned Francine's inheritance.

He had his evening meal at the Tributers' with Lucy Lane and afterwards he said, 'You'd better be getting back to the hotel. Get one of the lads to pick you up.'

'What are you doing, if I'm allowed to ask?'

'I've got my bag in the car so I shall stay the night here if Phyllis will have me.'

Phyllis said, 'A room? I've three empty tonight. 'Tis still early in the season for our sort of visitors. Anyway, I'll see your bed is nice an' aired.'

Before bedtime Wycliffe walked down the track towards Mynhager and then followed the footpath out to the point. It was dark, and he could see the flashing beams of Godrevy and Pendeen Watch. The sea was quiet, a vaguely luminous expanse under the stars. And the stars set Wycliffe thinking of other worlds, of boundless space, and endless time. Such thoughts had troubled him as a child, and still did, Einstein and his successors notwithstanding. He hoped that there was a god, at least somebody who might reasonably be expected to know what it was all about. He would feel better if he could believe that.

He walked back to the Tributers'. In the bar Phyllis was cashing up.

She had given him the same room in which he had spent that Christmas night ten years ago, and from a phone in the passage he spoke to Helen and told her so.

'Look after yourself.'

'And you.'

Fifteen minutes of Virginia Woolf's diary put him to sleep.

Chapter Seven

Wednesday

Day four of the inquiry. Wycliffe woke to a sloping ceiling and bare beams, a small square window low down and a grey light. For an instant he was back in the little bedroom of his childhood. A confused night: he seemed to have been dreaming most of the time but he could recall only one dream. Once more he was sitting opposite Archer, across that office desk, and Archer was looking at him, his expression unusually shrewd. 'If only Francine had been a Piscean.'

At breakfast there were two other guests, a middle-aged married couple 'doing' Cornwall in the off season. They had porridge, toast and marmalade; he was given no option but a Phyllis breakfast. Much more of this and he would have to let his belt out a notch.

He drove to the site shortly before nine o'clock. There was patchy sunshine, but once more clouds were closing in from the sea and rain was not far off. In the police van he found Iris Thorne alone, reading through her notes. She had carved out a place for herself in the team as individual and respected as Lucy Lane's. Another very attractive young woman, but as far as Wycliffe knew there was no man in her life. Like Lucy, she lived with her parents and seemed content. There were others like them in the Force and Wycliffe sometimes wondered if these women were inhibited by the job.

'Has DS Wills got anything on Lander?'

'I don't think so, sir. He's been in touch with Exeter CID and they are trying to find somebody who remembers the case.'

Among the papers on the table Wycliffe noticed Francine's two engagement books. 'Any luck with the starred entries?'

Iris frowned. 'I'm not sure how far I've got, sir. Without making too much of an issue of it, I've been using these interviews to find out about the starred dates. One thing seems definite: wherever I've been able to check there is a star against the date on which Lina returned from Amsterdam.'

Iris paused, choosing her words. 'In every case these starred dates are followed by another, six or seven days later and, as far as I've been able to check, these correspond with the arrival of the pictures themselves.'

Wycliffe was pleased. 'So we know that for several months Francine thought it worthwhile to keep a check on Lina's activities. It could lead to something.'

But Iris had not finished. 'There's a complication. For the more recent visits there is yet another starred date, and in each case it's the first Friday following the delivery of the pictures.'

'Any suggestion?'

Iris pouted. 'I haven't a clue. Of course we can't be sure that it has anything to do with the pictures.'

Wycliffe was impressed, and tried to contribute his bit. 'Assuming that it has, I've been told that Lina returned from her last trip to Amsterdam on Saturday May the eighth.'

'Yes, sir. And the pictures were delivered on Friday the fourteenth.'

'So the next starred date should be the following Friday, that's to say the twenty-first – the day after tomorrow.'

Two people pleased with themselves.

'We must keep our eyes and ears open, Iris. Good work!'

The pictures again. Marsden had been disinclined to offer any firm opinion about the pictures except to question them as a major source of income. But Francine must have thought otherwise or the starred entries in her little engagement books would seem to be meaningless.

Lucy Lane arrived and was almost immediately followed by Archer, a distressed Archer. 'I'm sorry to burst in like this but I'm worried. It's my wife . . . I can't understand it!'

He slumped into the chair Wycliffe placed for him. 'She's missing. Her bed hasn't been slept in and I can't find her anywhere . . . ' The large, soft hands were clasped tightly together and the masterful Eric Gill image had altogether disappeared.

'When did you last see her?'

Archer considered. 'Yesterday evening. We had our meal, and by the time we had cleared away it must have been about half-past eight before we went to our rooms to work.' A brief hesitation, then, 'As we have very different sleep patterns we do not share a bedroom, and so we did not meet again last night.'

He stopped speaking and Wycliffe prompted, 'So when did you miss her?'

Archer was having difficulty. 'I must explain that it is often late in the morning before we happen to get together. We have no organised breakfast. This morning I fetched Evadne at eight, as I do every day.' He glanced at his watch. 'It must have been nearly an hour ago, just after nine, that I wanted a word with Lina about something and went in search of her. Evadne said that she hadn't seen her so I went up to her room. As I say, the bed was made up.' A faint smile. 'Lina is Dutch, and airing beds that have been slept in is an article of faith.'

'So what have you done since then?'

Archer shifted on his chair, his hand went to his beard. 'Of course I was concerned. I phoned round but nobody had seen her. There was no reply from Emile's studio so I went along to see for myself. The blinds were drawn and the door was locked. I knocked and called out, but there was no reply. I went back for the spare key but it was missing.'

He looked at Wycliffe and his expression was almost pleading. 'I really can't imagine what can have happened.'

Wycliffe, matter of fact, said, 'Obviously, we must take a look in the studio.'

A few minutes later Wycliffe, Archer and Lucy Lane trooped across to the Archer house, around it and up the slope to Collis's studio. Wycliffe was aware that their procession was probably being watched from every building within range.

Up the steps, and faced with the locked door, Wycliffe performed one of the few tricks he had learned from the best part of a lifetime in association with crime. From his pocket he produced a bit of bent wire and inserted it into the keyhole. A moment or two of delicate fiddling and to his relief and surprise it worked. He opened the door.

The dimly lit studio looked much as he had seen it before: the beach scenes, the veiled portrait of Francine, the painter's litter . . . He led the way towards Collis's living quarters, then stopped. A woman was lying on the floor at his feet, just inside the communicating door.

'Let's have some light!'

He knelt beside the woman. It was Lina Archer. She was lying on her back, her wide-open eyes staring upwards. Her blonde hair was caught back from her face emphasising the strong features. Wycliffe felt for a pulse. There was none, and he realised that rigor was well advanced.

Lina Archer was dead.

The body was fully dressed: a grey woollen jumper, trousers and house shoes. The face was very pale. It was a moment or two before he noticed the cord encircling her neck just below the larynx. It was all but hidden by the high neck of her jumper. Despite the absence of the usual post-mortem symptoms it seemed that Lina had been strangled.

'I am deeply sorry. Your wife is dead.'

Archer let out a muffled cry and turned away.

Wycliffe spoke quietly to Lucy. 'See him back to the house. I'll deal with things here for the moment. Send somebody to hold the fort.'

Without a word Archer allowed himself to be escorted away and Wycliffe was left alone.

From the top of the steps he called Kersey on his mobile. A brief updating, then, 'The whole works, Doug. Get Forbes out here as soon as possible. I'll talk to Franks.'

Franks was his usual self. 'I shall have to get a season ticket. What is it this time? Another monoxide?'

'A woman strangled. At least that's what it seems to me but you may have a different idea.'

Back in the studio he stood looking down at the body and, for the first time, noticed on the floor not far from the head but almost hidden by the open door a sizeable pestle, the sort of thing Collis might have used if he ground his own colours. It could have a story to tell.

Wycliffe entered the living room and went through into the bedroom. Blinds were drawn everywhere and the bed was made up. Otherwise nothing unusual.

Returning, he edged once more past the body and went through the studio to the frame workshop. Nothing much had changed here either, certainly nothing of any relevance to what had happened in the living room.

In more than thirty years as a policeman he could only remember one other occasion when he had been first on the scene of a murder. He would have to give evidence in Court of the discovery: 'At twenty-five minutes past ten on the morning of Wednesday the nineteenth of May last . . . '

An odd situation in which to be rehearsing Court jargon, and a reminder that he was still vulnerable to shock. High time to take himself in hand.

A uniformed constable arrived to stand guard and Wycliffe was released.

It had started to rain, a fine drizzle. Wycliffe walked back to the caravan, both puzzled and troubled.

Two murders: Francine Lemarque and Lina Archer. Presumably by the same hand. Two killers in such a situation defied credulity. In the case of Francine it was possible to envisage a motive, but with this second killing what common motive could there have been?

And Collis was missing.

The troops began to arrive: DI Prisk with DC Curnow in tow and four uniformed men. The Collis premises were taped off. Fox was let loose with Dr Forbes, the police surgeon; neither of them was

permitted to disturb anything until Franks had had his say. Forbes would confirm death. Fox would photograph the body *in situ* and everything else.

They were all followed by a pair from Forensic, the plump Florence – 'Don't call me Flo!' – and her assistant. Floodlights were rigged but the blinds remained drawn.

Lucy Lane joined Wycliffe.

Wycliffe asked, 'What's he like?'

'Very shaken but fit to be questioned, I'd say.'

Wycliffe turned to Prisk. 'Let me know when Franks arrives. I shall be in the Archer house. Obviously we'll need statements from everybody concerned, with special attention to those who live on the site.'

Lucy Lane said, 'Archer is in the office with the Penrose woman.'

It was strange to see the man in his office looking, at first sight, as Wycliffe had seen him at the start of the inquiry. Then Lina had joined him; now Evadne Penrose was already at his side.

Archer seemed disorientated and very tired.

Wycliffe was sympathetic. 'I realise that you are in great distress and I would not intrude at this time if it could be avoided but there are questions which must be answered if we are to get the investigation under way.'

Archer nodded. 'I understand.'

'Is it at all likely that your wife might have gone to Collis's studio last night, after you had parted to go to your rooms?'

Archer considered. 'It's certainly possible. Lina has never been one for putting things off. If an idea occurred to her which seemed important and involved Emile, she might well have gone along to discuss it with him.'

'You can make no suggestion as to what the subject might have been this time?'

Archer looked vague. 'I'm afraid not.'

'You realise that Collis is missing?'

A lengthy pause, then, 'Of course I realise he isn't here but I can't believe that he had any part in this terrible thing.'

'I am not suggesting that he had but he must be found.'

Archer stroked his beard. 'The odd thing is that Lina seems to have taken our spare key with her. As I think you know, we have keys to all the site properties but the one to Emile's place is missing.'

'When did you last see Collis?'

Archer frowned. 'I don't remember seeing him at all yesterday but that is not unusual. Indeed, when things are quiet Emile will sometimes go off for a whole day or even overnight. And he's often away at weekends. Of course, he never goes without telling us, but he could have mentioned yesterday's absence to Lina.'

'Do you know where he spends his time when he's away?'

Archer looked blank. 'No, I've no idea.'

'You know of no friends or relatives?'

'No. Emile is a very private man. He doesn't talk about himself and he's not the sort to whom one puts personal questions.'

'Has he taken his car?'

'He always does, and it isn't parked behind the house where he usually keeps it.'

Archer rested his hands on the desk top as though for support and closed his eyes. 'I'm sorry— '

Evadne had not spoken so far but she intervened. 'Can't you see that he's had enough?'

'I won't keep you much longer. What sort of car does Collis drive?'

'A little blue Peugeot 205 diesel.'

'Do you know its registration?'

Archer stirred himself. 'It's an up-country number – K-reg; he bought it second-hand . . . ABO something. I can't get nearer than that.'

Wycliffe stood up. 'I'll leave you for now but we shall talk again and I will keep you informed of any developments.'

Outside, Lucy said, 'Odd!'

'In what way?'

'I don't know. It seemed unreal.'

Wycliffe said, 'It looks bad for Collis. I couldn't make up my mind about him. He's unimpressive but intelligent, a good

draughtsman and an adequate painter, able to make a living from his work. But he was scared. Marsden says he was easily led, and he'd had one brush with the law over forged paintings. But murder? Anyway, the sooner we get on his tracks the better, and Lander may be able to help.'

Lucy said, 'I don't trust Lander and it strikes me that there may be more between those two than a gay relationship.'

Wycliffe agreed. 'Well, you've got enough to do a vehicle check and circulate the details. At the same time you must set our people on questioning everybody who spent last night on the site. You don't need me to spell it out.'

He hesitated. 'But before we get down to routine interrogation it might be an idea for us to have a word with one or two of them. I'm sure they know more than they've come up with so far. More perhaps than they think they know, and formal questioning may not be the best way to get at it.'

Lucy Lane said, 'On the same point, I had the impression that Archer was holding something back. I'm not saying that he was lying, just that we didn't get the whole story.'

They were interrupted by a great roar and a slithering of protesting tyres, as Franks' Porsche breasted the grassy slope behind the Archer house and came to a halt outside the Collis building.

Franks got out, followed by Viv, who registered obvious disapproval. He came towards them, rotund and, as ever, pleased with himself.

Wycliffe said, 'Did you have to bring that machine up here?'

Franks looked at Lucy. 'That's the welcome I get! They told me back there that this is where the action is, and I'm not paid to walk.'

In Collis's studio lights blazed and there was a subdued bustle of activity. Dr Forbes presented himself and the two medics went to brood over the body of the victim.

The team from Forensic and Fox, with his assistant, were busy in the living quarters. Fox recorded on film the pathologist's

examination of the body while Viv made notes. The Forensic delegation concentrated on a meticulous study of the immediate environment of the crime.

Wycliffe, superfluous, confined himself to the studio and the framing room. It was strange. Within a few feet of the body of a murdered woman, nothing had changed. He brooded on the implications of Archer's account of what must have happened the night before. At some time after going up to her room Lina had apparently left the house, taking with her the spare key of Collis's studio. Had she assumed that Collis would not be there? Or that he would not let her in?

Somebody must have been there, and who else but Collis?

Wycliffe had been wandering aimlessly and came to stand by Collis's portrait of Francine, still hidden behind a cloth. He had been curious about that picture and he removed the cloth. Disappointment. Francine was seated in an armchair, reading. Conventional to the point of boredom. And her face had been painted out. Evidently Collis had experienced difficulty with the face and Wycliffe was not surprised.

At another level he was trying to come to terms with the idea that Collis had murdered Lina Archer by strangulation. It seemed incredible. If only on physical grounds. Lina was a well-built, muscular woman and Collis was close to qualifying as a wimp.

'Dr Franks would like a word, sir.'

Wycliffe followed the constable back to Collis's living room where Lina's body still lay on the floor, though its position had been changed.

'Getting shy of bodies in your old age, Charles? See what our Florence has for us.'

The plump young woman from Forensic was holding a plastic exhibit bag by one corner. It held the pestle he had last seen on the floor near the body. It was about nine inches long with a club-like form.

Franks said, 'There are bloodstains on that thing and a couple of hairs. There is also a nasty wound at the base of the victim's skull.

She was clobbered, Charles, before being strangled. Our killer did a belt and braces job.'

As a weapon, the pestle put a different complexion on Collis's possible guilt.

Franks went on, 'Well, I've done all I can here. They tell me the mortuary boys are on their way so she can be shifted on your say-so. In my opinion, at present, she died of strangulation by means of a nylon cord tightened around her neck below the larynx. But she was already unconscious when that was done.'

'Time of death?'

Franks glanced at his watch. 'It's now half-past one. No lunch again. Anyway, my guess is that she died between ten and midnight.'

Wycliffe walked with Franks to his car. A minute or two later the Porsche slithered down the slope and disappeared around the Archer house, miraculously without mishap.

With Franks gone the studio premises could be handed over to Fox and the people from Forensic. Prisk, with a DC and one of the Forensic team, would accompany the body and attend the post-mortem.

So on physical grounds at least, Collis was back in the running.

Wycliffe was thinking of the Guild of Nine. Two of its members, including the *de facto* chief, had been murdered and another was missing. Archer himself was, presumably, struggling to come to terms with a situation that was both deeply personal and a threat to his whole way of life. He was left with Scawn, the potter, Arthur Gew, Alice Field and a devastated Paul Bateman.

With the whole organisation seeming to fall apart, what were these people thinking, and what did they know?

Time he made contact with his new chief. 'Keep in touch' was the watchword. He telephoned from the police van.

'Your case gets curiouser and curiouser, Charles!' Was it possible that Madam was another disciple of Lewis Carroll? 'You need to keep in with the press in all this. Otherwise we shall have headlines of the "Mass Murderer in Art Colony" genre, and we can do without that.'

It made sense, and Wycliffe spoke to Kersey. 'A press briefing in the morning at your end, Doug. Fix it for eleven.'

Through the window he could see a police refreshment van being manoeuvred into position near the entrance to the site. Murder or no murder, you can't have starving coppers on your hands.

But he still settled for beer and sandwiches at the Tributers'.

Chapter Eight

Wednesday continued

Phyllis's sandwiches with home-cured ham were something to be remembered and should have been followed by a period of rest and meditation but this was unavailable.

Back at the site he found Lucy in the van with Scawn. 'Mr Scawn has news for us.'

Scawn's manner was contrite. 'I'm afraid that Robert has left us. He must have gone at some time during the night.'

'And you've only just got round to telling us?'

Scawn looked uncomfortable. 'I know it looks odd but it's not all that unusual for us not to meet up until the afternoon. This morning I got up late, had a scratch breakfast, then worked in my room on a couple of new designs that I have in mind. I assumed that Robert was in the pottery, sorting out the stuff unloaded from the kiln yesterday.'

Scawn paused and drew a deep breath before continuing. 'At some time after two I went down to take a look. Robert wasn't there, and nothing had been done. To cut my story short I discovered that his motorcycle was missing and, when I went to his room, it was obvious that he had gone off with the more portable of his belongings.'

'But you hadn't heard him drive off?'

'No, but it's quite possible for him to freewheel down to the road if he chooses. He does that when it suits him.'

'So you've no idea at all when he left.'

Scawn was regretful. 'I'm afraid not. And I have to say that I am astonished and disappointed by his behaviour.'

Wycliffe was official. 'Thank you, Mr Scawn. That will be all for the present, but you will be asked to make a formal statement for the record.'

Scawn stood up, looked vaguely about him, and left.

Lucy said, 'Turmoil in the flux. Anyway, we'd better circulate Lander and his bike.'

'Has anything more come through on him?'

'Nothing specific. Dave Wills has been in touch with Exeter and they're trying to locate Lander's family, although the whole story that he fed to Scawn could be on a par with his alleged relationship.'

'I suppose it's possible that he and Collis have gone off together.'

Lucy said, 'The thought occurred to me. We shall soon have nobody left.'

'No news of Collis? Or of his car?'

'Nothing so far, sir.'

'We're getting nowhere fast, Lucy.'

'You don't feel that we might be on the last lap?'

Wycliffe was mildly derisive. 'Collis murdered Francine by blocking the flue of her bath heater, now he's strangled Lina and cleared out, running scared. Is that what you think?'

Lucy was equal to that. 'I suppose you intended that as irony, but what you're saying sounds credible to me.' She hesitated, then, 'You saw the blocking of that flue as a woman's trick, and though I didn't agree I understood what you were getting at. Times are changing but I believe that most women intent on murder will, understandably, still avoid the direct physical violence that comes more easily to a man.'

Wycliffe finished for her. 'And Collis, though an accredited male, is sexually ambivalent. You may have a point, Lucy, but it doesn't appeal to me. In any case, can you see Collis strangling Lina? Even allowing for the pestle, I would find it more credible the other way round.'

Lucy pondered. 'I'm not so sure. Collis is slight of build but I

don't see him as a weakling. And she could have driven him too far over the picture business; he's been depressed and worried for some time, and now that we know his background and his record— '

Wycliffe said, 'This picture business seems to be the chorus of every verse. Anyway, changing the subject, have you heard anything from Fox?'

'No, he's still at the studio and so is the Forensic team.'

'Then let's hear what they have to say for themselves.'

The lights were still on in the Collis building. They found Fox with his assistant at work in the living quarters. The Forensic team was packing up, and the white-coated Florence reported: 'I've finished here. The deceased's clothing and certain specimens will be taken for laboratory examination.' Florence's earnest blue eyes seemed to question whether Wycliffe's understanding was up to this statement of technical procedures. 'Anyway, you will have my report on Friday morning.'

'I shall look forward to it.'

Wycliffe turned to Fox. 'Anything?'

Fox was subdued. 'Nothing of obvious significance, sir. I'm puzzled.'

Fox admitting to being puzzled; a first, as far as Wycliffe could remember.

Fox enlarged. 'I'm struck by the absence of anything really personal. I mean, there were no letters, no bills, no bank statements and no documents of any sort – no passport, birth certificate or driving licence . . . And no photographs.'

'Do you get the impression that these things have been recently removed? Or that he didn't in the ordinary way keep them here?'

In his time Fox had delved into the lives of a great many people as seen through their cupboards, closets and drawers. So he spoke with authority.

'My guess is that he saw himself as lodging, rather than living here, sir. I suspect he had a base somewhere else.'

Wycliffe was impressed. If Collis had a hideaway it would explain his mysterious absences, perhaps including the present one. 'So what did you actually find?'

'Here in the flat, apart from his everyday needs, there's very little. There are quite a few books on the history of art, several paperback novels, a few magazines and a newspaper or two. Not much else, other than the tools of his trade.'

Wycliffe was beginning to feel more kindly disposed towards Fox. And Fox was not through.

'Prints taken from Collis's living quarters suggest that he had a regular male visitor and that they were on intimate terms. The prints occur in the sitting room, kitchen, bathroom and bedroom. Some are quite recent.'

Wycliffe said, 'Almost certainly Lander. I'd like you to check on Lander's room and see if there's a match. And anything else you can find there, especially anything that might give a clue to his background.'

At four o'clock, back in the caravan, news of a development came through from the Incident Room. A patrol car covering neighbouring cliff and moorland roads and tracks as part of the 'no stone unturned' routine had found Collis's car, abandoned.

Lucy took down details, including the map reference. 'Do you want to go there?'

She spread a map on the table. 'Here it is.' Her pencil indicated a point on the road which crossed the moor, linking the coast road in the north with Penzance in the south. The whole distance was no more than six miles as time-conscious crows are said to fly. A little longer, taking into account the vagaries of the terrain.

Lucy went on, 'It's just beyond New Mill, less than three miles from the outskirts of Penzance.'

Wycliffe knew that road well enough – they used it for their trips to and from Penzance. In a drive lasting less than fifteen minutes the rugged cliffs and barren moors of the north were exchanged for a low-lying coast, a magnificent bay and the rich soil of the south.

Lucy said, 'According to the report the car was found early this morning, parked just off the road in a field gateway.'

Wycliffe was puzzled. 'What was he up to? He must have driven there, ditched his car and just cleared off. But where?'

'Do you want me to lay on a team for collection and assessment?'

'We'll see for ourselves first.'

They drove up on to the moor and along the unfenced track across land rich in pickings for the archaeologist but offering little or nothing to the modern farmer. Wycliffe wondered why the Iron Age people apparently chose to work this unrewarding terrain. Probably they were more concerned with pasture than cultivation. There followed a pattern of tiny fields and then the road dipped down into a valley with trees, leading into the odd little village of New Mill which, to Wycliffe, looked as though it ought to be an appendage of some stately home, but wasn't.

Just beyond the village they came upon a patrol car sheltering a uniformed PC, presumably guarding the blue Peugeot 205 parked ahead of him. The little car was several yards from the nearest field entrance.

The PC shifted himself and joined them. 'Constable Jago, sir. The farmer moved it first thing this morning when he wanted to get his tractor into the field. I haven't touched it.'

Wycliffe recognised the breed. They make a cult of doing nothing about anything in case there's any blame about.

Jago went on, 'Apparently the car was unlocked, with the key in the ignition and the farmer tried to drive it, but though it started, it died on him. The tank was empty, so he just pushed it out of his way to where it is now.'

'When did he first see the car?'

'This morning. It must have been left there at some time during the night. He assumed that it belonged to some guy, well over the limit, who would come back and collect it after he'd sobered up.'

Wycliffe muttered, 'It makes no sense but where was he going?'

Lucy offered, 'Penzance station to catch a train?'

'If he was making a getaway, why draw attention to himself by catching a train when he had a car? . . . No, don't tell me! It's possible that Lander picked him up on his pillion and they went off together.'

Lucy was becoming impatient. 'In which case they could be

anywhere by now. But isn't it about time we attended to the routine?'

'What? Yes, of course. Arrange for the Vehicle Examiners to take a look, then remove it to their garage and hand over to Forensic.' After a pause, he added, 'Though what we can expect them to tell us, I can't imagine.'

He had in his mind an absurd picture of Collis, lumbered with a couple of suitcases, tramping through the darkness and the rain. 'The Runaway' – a black and white illustration from a Victorian novel.

'Presumably Collis has been listed as missing?'

'Of course.'

'Then get a couple of chaps on a house-to-house in the village and along the road from the coast. This isn't the M25 and those little diesel Peugeots make themselves heard.'

'But if somebody did see the car drive past in the middle of the night, what good would that do us?'

'None, but we might turn up something.' Wycliffe looked at the dismal dripping hedgerow and the narrow ribbon of tarmac snaking away into the mist and said, 'Anyway there's nothing more here for us. Let's get back to the caravan. At least we can have a coffee.'

In the car Lucy was silent and Wycliffe said, 'Lost your tongue?'

'No, I'm just wondering if it's safe to use it.'

Wycliffe said, 'On the face of it Collis is a fugitive, wanted for questioning in connection with two murders. That's the scenario to which we have to respond.'

'But you've got reservations?'

'Haven't you? Anyway he's got to be found. Somebody must know where he spent those times when he was away from the site. After all, Fox is an experienced man and by no means the fool he pretends to be. He thinks Collis had another place – a hideaway if you like, and everything points to that.'

They arrived back on the site. 'Let's break the news to Archer, I want to see how he reacts.'

The office was empty but the ubiquitous Evadne arrived. 'He's been lying down but he's up now. I'll tell him you're here.'

There was no need. Archer joined them, looking flushed and on edge. 'You've got news of Emile?'

Wycliffe told him.

Archer shook his head. 'I can't understand it! I mean, why would he do this to Lina? They were close . . . It's beyond me . . . ' A ghost of a smile. 'And he'd run out of diesel. That's Emile! It's not the first time . . . Near New Mill, you say . . . But where was he going? And where is he now?'

'We've no idea but we have to find him. You can make no suggestion?'

Archer frowned. 'I wish I could.'

'Does he have a mobile phone?'

'Yes, he does and I think he kept it in his car.'

'So, when he ran out of diesel he could have phoned someone to come and pick him up.'

'I suppose so, but I've no idea who.'

And that was that.

Outside, Lucy asked, 'A grieving husband?'

Wycliffe did not answer and they took refuge in the caravan, empty at the moment, but now available to the whole team and cared for by nobody. File copies of statements sent over from the Incident Room littered the table along with plastic coffee cups, and cigarette ash, and squeezed-up balls of discarded paper.

Wycliffe let his temper show. 'This place is a shambles, Lucy! Tell somebody to clean it up, and all of them to keep it that way.'

Lucy tidied superficially while Wycliffe got coffee out of the machine, and they sat down. The mist had closed in and their outlook was circumscribed. The silence was absolute, punctuated only by the plaintive bleat of the foghorn at Godrevy. Presumably the work of the Guild was going on in those invisible little buildings close by, but in the caravan there was a sense of total isolation and so it seemed that whatever was done or said it could have no real significance.

Wycliffe cleared his throat and tried to clear his mind. 'The truth is, Lucy, that we are skirting around the crucial question of motive. Why was Francine murdered? Why Lina?'

'Good questions,' from Lucy, drily.

'If we take Francine first, the most plausible answer so far seems to be that Francine knew, or guessed, that there was something fishy going on in the Guild.'

Wycliffe picked up his plastic coffee mug, discovered it was empty, replaced it on the table and tried again. 'Now, from Iris Thorne's work on the starred diary entries it looks as though there was some fraud concerning Lina and her imported pictures. There are indications that Collis was involved, probably in copying or faking of some sort – work for which he has experience and talent.'

Lucy nodded. 'So the girl tried to use her knowledge against the pair of them and paid the penalty. I suppose it hangs together as a motive for her murder.'

Wycliffe shifted uncomfortably on his bench. 'Until it falls apart. There's a snag. Marsden is sure that with what is known of the value and status of Lina's pictures it could be no more than a small-scale fiddle. In fact, he wonders why she bothered unless she did it for kicks. If Marsden is right, and he should know, it doesn't look like the kind of scam that might lead to murder. And Lina – why would Collis kill her?'

'All right. So where do we go from here?' Lucy with mild irritation. 'Can there be anything in the sex angle? Variations on the theme of a frustrated lover?'

'But who are the possible candidates? We've already dismissed Collis from that role and we don't see Paul Bateman as a killer. Of course there's Blond Bob about whom we know little enough. We can't afford to ignore any possibility, but on present showing I don't think we shall get far down that road. And even if we have a feasible motive for Francine's murder it doesn't apply to Lina.'

Lucy was silent and Wycliffe went on, 'There is another possibility that occurs to me, though in some ways it sounds even less credible than the others: Francine's money. But as I've said before there's much more to this than money, Francine's or anybody else's.'

'You're thinking of Archer?'

128

'Who else? The idea occurred to Scawn but only, I think, as a sick joke.'

'And Lina? It doesn't explain what happened to her.'

'Are we dealing with two killers?'

'It's just not credible.'

That evening Lucy returned to Penzance while Wycliffe decided on another night at the Tributers'. News of the second murder did not make early evening radio or TV news so he was allowed to have his meal in peace.

Mackerel fillets in an egg, butter and herb sauce. Cornish to her toenails, Phyllis was not above filching from Elizabeth David. But who is?

Afterwards he walked to Gurnard's Head. High cloud obscured the sky and reached to just above the horizon. But as he watched, an angry sun emerged below the cloud and sank slowly into Homer's wine-dark sea.

There was no living thing in sight, and not a single human artefact, but Wycliffe did not feel alone; just part of the theatre.

He walked back to The Tributers' and had a drink at the bar, feeling that he was returning from an excursion into a different world.

Early to bed.

But before that he made his phone call to Helen.

Helen said, 'I had a call from Ruth this evening. She's moving to a new job with an advertising agency in Baker Street. She's on top of the world.'

'I'm glad, but I wish she would marry and settle down.'

Helen laughed. 'That's always been my line until now. Anyway, sleep well.'

'And you.'

Chapter Nine

Thursday

Wycliffe had one of those dreamless sleeps which are denied to us by psychiatrists who, apparently, sacrifice long nights to the study of eye movements in their sleeping subjects. However, the illusion was enough for him to awake refreshed. A shower. Phyllis had modernised the essentials, leaving the fabric of the building and the decor to rusticity. Wycliffe's breakfast was all but spoiled by the eight o'clock news.

'We are receiving reports of a second murder at the Cornish craft centre, where the body of a young woman was found on Sunday morning. The police have so far released no details of this second death but they are treating it as murder. The victim is believed to be a woman in her late forties, a leading figure in the affairs of the craft centre. The police have already been investigating possible links with a tragedy in the same area ten years ago when three people, including Gerald Bateman, a well-known political figure of the time, died by violence . . . '

Wycliffe left his toast and marmalade untouched.

From his car he spoke to Kersey. 'All set for blast-off at eleven? I think we are in for a rough passage . . . Yes, I shall be there on time.'

Once more the team would be questioning everybody on the site concerning what they might have seen or heard, but also and in greater detail about relationships, tensions and suspicions, real or imagined.

Wycliffe felt protective about Paul and decided to tackle him himself.

He drove to the site. The mist had cleared and it was a fine morning. He walked across to the wood-carving shop but the door was locked.

Arthur Gew saw him. 'The boy hasn't been in since Monday. Poor lad. He's really knocked up. All because of a woman. And now we've lost our leader. What next, I ask?' But Gew showed no signs of distress.

Wycliffe joined Lucy Lane in the caravan.

'No sign of the missing Bob, sir. He's no record – not as Lander, anyway. Of course, it's quite possible that he's nothing to do with our business but if his past is at all dicey he could have cleared out on the principle that you don't hang about where there's trouble.

'Scawn seems upset about the whole affair but either because he can't be or won't be, he's not much help. He did, under a bit of pressure, come up with a snapshot of him with Lander at the entrance to the pottery. It's not very good but I've sent it to the lab to see what they can do with it.'

Kersey was right. Delegation works.

'Anything else?'

'Just that Exeter CID are going through the voters' lists for the whole area in search of Landers. Nothing yet. So his whole story seems to have been phoney.'

Lucy turned the pages of her notes. 'And that's about it, sir.'

Wycliffe was pleased but refrained from saying so. There was a tacit assumption of competence between them so that compliments were apt to sound patronising.

'I want a word with young Paul. He's not on the site so I'm going to Mynhager.'

The harsh rugged lines of Mynhager stood out like an etching against the brilliant background of sea and sky. The courtyard was dank and gloomy; the bell shattered a silence that was total.

'Oh, Charles!'

It would take more than murder to change Caroline's ritual responses. But the 'do come in' which followed was less assured and he guessed that his arrival was inopportune.

'You know us well enough by now, Charles . . . We can't treat you like a stranger.'

He was taken into the kitchen where the table held the remains of breakfast.

Virginia had her newspaper spread amid the debris, working on the crossword, cigarette in hand, a saucer for an ashtray. 'For God's sake, Carrie, haven't we got a drawing room?' She glanced across the table at the stained cloth, at the random assemblage of china and at her own contribution. 'Well, there's not much point now.'

Caroline said, 'Has something happened?'

'You haven't heard?'

He told them.

'You're saying she was murdered?'

'Yes.'

Caroline paused in the middle of clearing the table. 'I always said there was something wrong with that place. I didn't like Paul going there. And now— '

'Is Paul about? I would like a word – I shan't upset him.'

'He's up in his room. He's had scarcely any breakfast. He's not eating enough to feed a cat. You know his room, it's across from the one that used to be Father's.'

Up three flights of stairs, the last narrow and twisted. A tiny landing with a window like an arrow slit. He was in the tower. He remembered 'Father's' room but resisted the temptation to look inside to see if it had changed. Almost certainly it had not been disturbed since the old man's death. The sisters were not innovators.

He knocked on the other door and got a 'come in!'

The room was the size of a large cupboard but flooded with light from a window that looked out to sea and down the coast in a vast panorama.

Wycliffe said, 'I suppose you get used to it.'

'Yes.' Paul had been sitting at a draughtsman's table working on a design, presumably for a carving. There was room for that and a bed, but little else.

Paul was very pale but seemingly composed.

'I want to talk to you about Lina.'

'I heard about it this morning.' He glanced at a little radio perched, with several books, on a shelf by the bed.

'You realise this puts what happened to Francine in a different light.'

'I see that.'

'I must tell you two things that were not mentioned in the radio report. Both Emile and Robert Lander are missing. They were neither of them seen after some time on Tuesday. Collis's car has been found abandoned and out of fuel just beyond New Mill. We have nothing on Lander or his motorcycle.'

Paul said, 'I don't understand it.'

'No, but you may be able to help us with background. I want to know, and you want to know, who is responsible for what has happened.'

A moment for reflection, then, 'Yes. Of course! I'll do anything I can.'

'You must have talked to Francine about things that went on in the Guild about which there was gossip. In her little engagement book she starred certain days which seem to correspond with Lina's visits to Amsterdam – the day she left, the day she returned, the day the pictures arrived . . . Did she ever mention any of this to you?'

He looked puzzled. 'Never. She knew that I worried about her . . . ' He hesitated. 'That I thought she would only stir up trouble by enquiring into things which didn't really concern us.'

'Did she ever say anything in particular about Lander or Collis?'

More hesitation. 'Bob Lander was something of a mystery to everybody. It was generally accepted that Lina only tolerated him because of Derek Scawn.'

'So?'

'Well, Fran said that was only a sham, that she was sure Bob and Lina were involved in something and she was determined to find out what.'

'And Emile?'

Paul considered. 'Fran seemed to think he was doing work for Lina that was nothing to do with the Guild.'

'What sort of work?'

'I don't know.'

'Could it have been copying pictures?'

He frowned. 'Possibly. At one time Fran mentioned something about framing but it didn't seem to make sense to me. I mean, we all knew that Emile did the framing but he told Fran something about framing in the Oude Kerk in Amsterdam. I know no more than that.'

Wycliffe had to be content.

Half an hour later he was facing a dozen press persons and a couple of TV cameras in the Incident Room at Penzance.

'Do you connect the murder of Francine Lemarque with her part in the death of her father, Gerald Bateman, the politician, ten years ago?' Ponderous question, but it got in most of the potentially spicy elements.

'I have no reason to suspect that there is any causal connection.'

'Is it likely that her death was linked to the substantial legacy she received shortly before she died?'

'That is one line of investigation but so far we have no evidence to support the idea.'

'Presumably you are treating her death and that of Lina Archer as connected?'

'It would be remarkable if they were not.'

'Will you comment on rumours concerning fraudulent activity within this Guild of Nine?'

'I have no evidence to support any such rumours at the moment.'

Then, from a wag, 'Have you considered consulting the stars?'

'We do not have an astrologer on our team at present.'

'Is it the case that two important witnesses are missing?'

'We are anxious to get in touch with Robert Lander, an assistant in the pottery department, and with Emile Collis, the Guild's painter. Mr Collis's car, a blue Peugeot 205, was found abandoned on the Penzance side of the village of New Mill, on Wednesday.'

And so on . . . And so on . . . Wycliffe was too old-fashioned to

welcome press inquisitions, or even to look as though he did. His policy for the most part was to stonewall, but long association had bred a mutual tolerance which usually allowed him to get away with it.

At any rate, it was over at last.

When he was about to return to the site DS Shaw arrived to report on his investigations into Francine's inheritance, the financial background of the Guild, and anything else where there was a smell of money.

Wycliffe had long recognised the value of Shaw's links with those – for him – closed worlds of money and information technology, so Shaw had been encouraged to operate on a long leash.

'The girl's inheritance first. As soon as she heard about the money she went to a lawyer – Hicks and Bone in St Ives. Bone, the surviving partner, is a wily old bird and he was fascinated by the girl. Francine had firm ideas about what she intended to do, and all she asked of him was advice about how to do it.'

Shaw put on his glasses and consulted his notes. 'Her legacy amounted to something over eighty-five thousand pounds, of which she intended to invest fifty in the Guild if she could come to terms with the Archers.'

Shaw broke off. 'Bone tried to talk her into getting financial advice but she got up to walk out, so he held his peace. Then, at the same session, she insisted on him drafting her will.'

Shaw looked at Wycliffe. 'You're going to like this, sir. The whole of her estate is bequeathed to Paul Bateman, with the exception of five thousand pounds which goes to Hugh Marsden, if he survives her.'

'And that will stands?'

'Completed and witnessed according to Bone.'

Shaw continued. 'Anyway, now we come to the Guild's finances. They are a private company and they seem to conform with their articles. Archer keeps his gallery accounts, and Lina her picture accounts, quite separate. The Guild makes a decent profit, Archer's venture pays its way and Lina's picture dealing is in credit, though it hardly seems worth the trouble.

'Anyway, Archer made no difficulty about giving me access and he was helpful in persuading the bank to co-operate without a lot of legal flannel.'

'So, no evidence of any major scam?'

'Not that I can find. If there is any funny business going on – and there may be – it's well covered up.'

Wycliffe sat in his little office off the Incident Room. Marsden, a beneficiary under Francine's will. Talk about twists of fate! And Paul Bateman, a well-off young man.

Should it affect his approach to the case? He dismissed the idea.

As to the rest of Shaw's report, any suggestion of a major scam remained a matter for speculation.

The routine work was going ahead: statements were being fed into the computer; reports were coming in; officers were still out on the ground. But Wycliffe realised that without some new development they were unlikely to get very far.

He leafed through preliminary faxes from the Vehicle Examiner and from Forensic. Next to nothing nicely wrapped up in jargon. The report on Collis's car was a masterpiece. It showed conclusively that anyone *could* have driven the car but that there was no evidence that anyone other than Collis did.

Franks' report on the Lina Archer autopsy had arrived. It stretched the six sentences over the telephone to three pages of close type. Fine for the lawyers, but for Wycliffe, one sentence was enough: 'Lina Archer was rendered unconscious by a blow to the occiput before being strangled.'

Wycliffe skimmed it all. Just in case.

Then lunch with Kersey, and afterwards back to the site. It seemed that he could have conducted his case just as well from a chair in his office and earned Brownie points, but away from the action (not that there was much) he felt lost.

He joined Lucy in the police caravan and, together, they went in search of Scawn. They found him in the pottery, apparently at a loose end and surprisingly apprehensive.

'You want to talk to me? But there's nothing I can tell you that you don't know already.'

They followed him upstairs and when they were settled, Wycliffe said, 'Since we last talked the situation has changed radically.'

'You mean that Lina has been murdered. I am shocked, I simply do not know what to think and— '

Wycliffe cut him short. 'Lina has been murdered and Lander and Collis have both disappeared. As far as Lander is concerned, although well aware of his capacity for fantasy, you apparently accepted without question the account he gave you of his immediate family and of his visits to them.'

A rueful smile, 'I have to admit that I was taken in. His stories concerning his parents, and their problems, were so circumstantial that they seemed in a quite different category from, for example, his tale about our alleged relationship.' A pause, 'Of course, it was not I who employed him in the first place, but Lina, so I had no access to any correspondence there may have been.'

One of the Siamese cats jumped on to Scawn's knees, flexing its claws before settling down. It must have been painful, but Scawn gave no sign.

Wycliffe's manner was official. 'I am going to ask you a question, Mr Scawn, to which I want a clear, unequivocal answer. Have you at any time suspected that Lander was involved in some illicit activity here – perhaps something which involved Collis and Lina?'

The brown eyes showed concern. 'Unequivocal, you say. It is difficult to be at all specific. As I've told you, I've always found Robert a pleasant person to have about the place, helpful, intelligent, quick to learn and anxious to be agreeable.'

'But?'

Scawn frowned. 'Robert likes to be mysterious – to pretend that he is privy to all sorts of secrets about which his lips are sealed.' A faint smile. 'I don't take him too seriously. It seems to be a somewhat childish aspect of his character and I find it amusing.'

'Can you give examples of the kind of thing?'

Scawn considered. 'He makes remarks like, "You don't know the half of what goes on in this place," or, "Lina is a very clever woman. If Archer only realised . . ."'

'Has he ever mentioned Lina's trips to Amsterdam and the pictures she bought there?'

Very gently, Scawn lifted the cat from his lap on to the floor before replying, 'Yes, he has. Lina's visits and her pictures were becoming a subject of gossip on the site anyway, stirred up, I believe, by Francine.'

'Has Lander ever implied that there was something dubious about Lina's transactions?'

A moment for reflection, then, 'Oh, I think so – yes. But as with all Robert's remarks of that kind, his manner conveys more than his words. I am really out of my depth in all this, Mr Wycliffe.'

Wycliffe seemed to accept this and Lucy Lane took his silence to be her cue. 'Can you tell us anything about the relationship between Lander and Collis?'

It required a moment or two for Scawn to adjust. 'It's clear that Robert has a problem with women, but he went out of his way to be agreeable to Francine. On the other hand Collis and he are certainly close.'

Lucy lost patience. 'Do you think they are having a gay relationship?'

Scawn gave up. 'I think that is very likely but that sort of thing doesn't bother me.'

Lucy said, 'All part of the flux.'

Scawn, on the point of a too-hasty rejoinder, changed his mind. 'I suppose so.'

Wycliffe felt that they had got as far as they were likely to and stood up. 'Well, thank you Mr Scawn. No doubt we shall be back.'

It was one of those dead afternoons with no worthwhile 'input' but at least he was learning to think in terms of the new vocabulary.

That evening he had a leisurely meal with Kersey and Lucy Lane in the hotel dining room. Afterwards he felt in need of one of his walks but, too tired, he settled for a meandering stroll along the promenade.

The mist had cleared and over the sea the stars were coming out. It was almost dark.

The Mount, the Lizard light, the gleaming, rippling sea – they were all putting on their show but he was unappreciative.

Two murders, two witnesses missing, and no obvious way ahead . . .

Recently, as he sometimes did, he had dipped into Ronald Clark's *Freud*. 'Dipped' was the word; he found larger helpings of Freud indigestible and he had some sympathy with the lady who said, 'If that man is right, then we are none of us very nice.'

It was word association which had caught his attention in this latest dip. Once upon a time it had been tried as a tactic in police work and off and on for the past two or three days he had been trying it out on himself. He did so now: sea – ships – sailors – Nelson – Trafalgar Square – The National Gallery – pictures . . .

He had startled himself. Did it really work? Or had his subconscious led him to the subject of his latest preoccupation? But that could be the point anyway . . .

He tried again: pictures – Collis – frame shop – frames – Paul Bateman – Francine – Mynhager . . .

Frames – Paul Bateman? He must have gone astray. Odd! What had Paul to do with pictures? – or with frames? It hadn't worked. Never mind; it was only a silly private game he'd been playing.

But as he walked back to the hotel he was made uncomfortable by the feeling that he had missed something.

He was late with his phone call to Helen. 'I've been wool-gathering.'

'I suppose it's as good an excuse as any other. Sleep tight.'

It was two-fifteen by his little bedside clock when he woke. It often happened that after his first sleep he would lie awake for half an hour, running over in his mind the events of the day. Memories would come back to him in pictures, like shots on a television screen; and in phrases which he seemed to hear in the voice that had spoken them. His problem, or so he believed, was an inability to fit all this into a pattern – to be *logical*.

He could see Paul's room at Mynhager, that little cell, open to the great plain of the sea.

He was trying to get the young man to talk, to unwind a little. Paul was regretting Francine's attempts to probe into Lina's supposedly dubious activities which, she believed, involved Emile.

Perhaps she had proof that he was copying pictures to be sold as originals? Wycliffe still wondered. Though, so far, in following that line he had come up against the snag that there could be no real money in it, certainly not the price of murder.

And Paul, pensive and slow, had said that at one time Francine had mentioned something about framing – whether Collis framed them, or whether it was done in the Oude Kerk in Amsterdam.

Pictures – Collis – frame shop – frames – Paul Bateman . . . It had worked, after all. But did it mean anything? 'I shall have to think about it.'

He turned over. 'But not now.'

Chapter Ten

Friday

Breakfast at the hotel, the short walk to the Incident Room, a mini briefing, another phone conversation with his deputy at headquarters and, by shortly before ten, he was driving out of Penzance on his way to the Guild site.

A clear day with a great expanse of intensely blue sky, but there was a bank of mist on the horizon. Outlook unsettled. But who wants settled weather? Those who do should avoid Cornwall where each day is an adventure, and weather forecasters pretend not to notice.

The sixth day of the inquiry. Some murder inquiries stretch over months, even years; for some the file is never closed. But these are usually 'open' cases with an undefined range of possible suspects, and no clear indication of rational motive. Here Wycliffe was dealing with murder in a small, almost a closed, community; the range of suspects and of motive were both limited, and the locality was defined.

Arriving at the Guild site he deliberately avoided being seen from the police van and, feeling guilty, he wandered around without an idea in his head. He consoled himself with the words of his DI, when he was still a DS: 'You think too much, Charlie. Keep your ears and your eyes open. Remember the three Ls: Look, Listen and Learn.'

He was vaguely depressed. Often cases reached a stalemate with nothing happening to open up fresh lines of investigation. In this instance too much was happening too quickly: a second murder

and the disappearance of two, perhaps crucial, witnesses. He muttered to himself unprofitably, 'Collis and Lander *must* be found!' A house-to-house was under way over a wide area; staff at Penzance Station had been interviewed, and taxi and hire-car drivers questioned, all without result.

His wanderings had taken him to the west side of the stream, past the Guild-hall, and near to the group of buildings that housed the pottery, the wood-carvers' shop and Arthur Gew's whatever. Gew's place was nearest and the door was open so he went in.

He found himself in a smallish room with a bench and walls lined with shelves, pigeon holes and drawers, all bearing labels. Every inch of space seemed to be utilised.

'What do you want? I'm in here.'

Wycliffe went through. Another small room with a bench, a tiny kiln, a row of glass jars containing brightly coloured powders, a minute vice . . .

'Oh! So Muhammad has come to the mountain.'

'Detective Superintendent Wycliffe.'

'I know who you are, but I wondered if I rated a visit. This is my enamelling shop. Your girl probably told you that I'm the jack-of-all-trades in this establishment. She may not have added that I'm master of all of 'em.'

The little man was perched on a stool by the bench, heels caught on the crossbar. 'I'm tidying up. Can't find the will to do much else.' He added after a pause, 'This place is finished.'

'You think so?'

Gew looked at Wycliffe with his tiny brown eyes, serious as a child's. 'I know so, mister. Without our Lina to drum up business and keep Archer in line we shall find ourselves running around in nightshirts with our birth signs stencilled on our bottoms – and damn-all to do. Those of us who stay, that is.'

'Will you be one of them?'

'Oh, yes. Whatever my birth sign, I was born to be on any sinking ship that happens to be around.'

'So you were an admirer of Lina?'

Gew considered. 'That would be pushing it. I admired her drive.

She was our meal chit. But as a woman . . . I'm old-fashioned where women are concerned. But don't ask me what that means. Anyway, if you've come to talk you'd better bring up a stool.'

Wycliffe did, and decided to try his luck at striking a productive chord. 'Francine and Lina have been murdered; Collis and Lander are missing. Any comments?'

An appreciative look. 'So it's gloves off! That suits me. You mentioned Collis. Collis was supposed to be Lina's lap-dog – hers to command. So he was, but he didn't like the role one little bit, and recently he's been trying to get out from under. She had some hold over him and she was using him, but for what purpose I have never discovered. Picture faking comes to mind but I've a feeling there was more to it than that.'

'You seem surprisingly well informed.'

Gew turned on his stool. 'Isn't that what you want?'

'I'm simply wondering how you manage it.'

Gew smiled. 'I live here alone, I've no friends or relations and no real interest outside my work, so I devote myself to knowing other people's business and it suits me. It's less physically demanding than golf or bowls, and a hell of a lot less boring than fishing.'

'Do you have any view on Lander's relationship with Lina?'

Gew picked up a tiny pair of tweezers from his tray of little tools and began to play with it. 'Oh, Bob Lander simply did what he was told by Madam.' A mischievous smile. 'But I thought the great detective might have been more interested in the relationship between Madam and Lander's boss.'

Wycliffe waited.

Gew was enjoying himself. 'I said nothing of this while Madam was still with us, but now . . . Well, things have changed. You may not know that she was a more or less regular visitor at the pottery. Of course, those visits could have been on matters of business but, if so, they took place at odd times. Usually, it seems, in what we call the small hours.'

'You mean that she visited Scawn at night? Were these visits frequent?'

A dismissive gesture. 'I've never kept regular watch, Mr

Wycliffe! . . . It's simply that I don't sleep well and I sometimes find myself looking out of the window when I should be in bed. All I can say is that several times during the past year I've seen Madam on her way to or from the pottery during the night or in the early morning.'

'I suppose you have no idea whether Archer was aware of this?'

Gew was ironic. 'Now I come to think of it, I've never asked him.'

Wycliffe, feeling that he had not shone in this interview, but satisfied that there was no more to come, got off his stool. 'Well, thank you, Mr Gew. You've been most helpful.'

Gew did not see his visitor off. He said, 'I've made myself an expert in other people's business, Mr Wycliffe. I may well do a Ph.D. in it when one of our sociologically minded universities gets round to the idea.'

Outside, that bank of mist had moved in, moist and all-pervading. Oblivious, Wycliffe trudged across the site. Lina and Scawn. The mind boggled, but sex can be a great facilitator. It's living together that brings out the problems.

However, the question remained: did Archer know?

Wycliffe passed the Archer house and continued up the slope to Collis's studio. He was making for the framing shop. At the back of his mind he was still brooding on the word association game which had recalled Paul Bateman's reference to Francine's mention of framing at some place in the Oude Kerk.

Arriving at the top of the steps, he broke the police seal and went in.

On the face of it nothing had changed since his first visit five days before. The two embryonic beach scenes were still on their easels and the drape over the third easel still, presumably, concealed Collis's attempt to capture Francine on canvas. Now Francine was dead, Lina was dead. And Collis . . . ?

Wycliffe made for the framing shop.

There were several cupboards and he opened each one. He found the unframed pictures which Collis had shown him, the fruits of Lina's last visit to Amsterdam. Nothing to add to his suspicions

there. In other cupboards there were ready-made frames sorted according to size and design – just what one might expect in a frame shop.

But it was in one of these cupboards that he discovered an oddity – a type of frame quite different from any of the others. There were six of them, identical with each other, and he removed one to examine it in detail. The frame was very light, made of a pale grey plastic material. In section and proportion the moulding was little different from some of the wooden frames. Wycliffe was about to put it back when he noticed that there was a small ridge in the plastic, midway along each side of the frame. He examined the ridges more closely and realised that the frame seemed to consist of four right-angled 'tubes' which slid one into the other. With a little effort he was able to slide them apart so that the frame increased in size until it fell apart. In fact these frames were adjustable, to fit a range of picture sizes.

Ingenious.

But it dawned on him that there could be a great deal more to his discovery than that. At long last he thought that he knew what Lina's picture scam was all about.

Collis had shown him Lina's most recent purchases only after they had been removed from their frames.

On his mobile he spoke to the police van and was lucky enough to find someone there. It was DC Potter.

'I'm at the studio – Collis's place, and I want you over here now.'

A fresh angle. And he told himself that it was one which should have occurred to him when the economics of the picture dealing were first questioned. Everybody knows about Amsterdam where banned drugs are available like sweets. They are not, of course, but that is the image. Now he had to decide what to do. There would have to be a forensic examination of the frames. Probably nothing would come of it but it had to be done. The Drugs Squad must be immediately involved. That sounded impressive, but the squad comprised only DS Boyd and three DSs. Of course they worked closely, and sometimes amicably, with Customs and Excise.

He recalled the starred entries which Iris Thorne had found in

Francine's diaries. He had been satisfied that they concerned Lina's picture transactions, but was it also possible that Francine had some notion of what she was really up to?

Potter arrived and was briefed. The fifteen-stone Potter in place of a police seal. 'Nobody to be admitted except on my say-so. I'll see that you're relieved as soon as possible.'

Wycliffe had reassembled the sections of the frame and he took it with him as he walked down the slope to Archer's office.

He needed to be careful. It was still possible – just – that the frames were no more than what they seemed to be, an ingenious device for accommodating pictures of different sizes.

The office was empty but it was not long before Archer arrived in answer to the bell. The Eric Gill image had faded and now the man looked almost frail, at least weighed down. He stood behind his desk, waiting for Wycliffe to speak.

Wycliffe laid the assembled frame on the desk top. Archer merely glanced at it, and all he said was, 'So you've got there.' He sounded relieved.

'You knew?'

Archer nodded. 'I've known since Tuesday afternoon. Three days. And it feels like for ever.'

Wycliffe said, 'We must be quite clear about this, Mr Archer. Are you saying that since Tuesday afternoon you have known that your wife was regularly importing illegal drugs concealed in the special frames of the pictures she bought in Amsterdam?'

'Yes, that is what I am saying.'

'How did you find out?'

Archer clasped his hands on the desk top. 'She told me.' The words were informed with an intense bitterness and he repeated them. 'She told me.'

Outside there was the mist and in the little office the light was dim. Wycliffe experienced a sense of unreality, of detachment, as though he was a spectator rather than a participant in the drama.

Archer went on, 'I think you must have realised, Mr Wycliffe, that Lina and I were not compatible. We had different views on almost everything and, in particular, on how the Guild should be

run . . . The long and short of it is, of course, that I should never have married an Arian.'

A lengthy pause, then, 'It was early in April that I began to be really worried; worried about the way things seemed to be going. I was concerned about Collis in particular. Emile was becoming increasingly disturbed and his mysterious absences were more frequent.'

Archer shifted vigorously in his chair. 'For some time I had been aware that there was some sort of special relationship between him and Lina which I could not understand. Collis and Lander were known to be involved in a homosexual affair and for that reason, if for no other, it seemed unlikely that Lina . . . '

Wycliffe said nothing and eventually Archer resumed. 'In the end I tackled Emile and although he told me nothing, it was obvious that he was frightened of Lina, that she had some sort of hold over him. Of course, this only increased my worries and it became clear that my wife and Collis, and possibly Lander, were involved in some activity of which I knew nothing.'

Archer sat back in his chair looking directly at Wycliffe. 'To test the ground I suggested that we should get rid of Lander. After all, he was not even a member of the Guild, and she had often spoken of him with a certain contempt.

'But Lina would not hear of it, and when I pressed her she became angry.'

Archer removed his spectacles and began to polish them with a large handkerchief. 'On Tuesday afternoon we had, for the first time in our lives together, a real row. In the course of it she told me, quite deliberately, and in detail, what was going on. She seemed to take pleasure in shocking me. And in the end she said, "Now you can do what you like about it." '

There was another lengthy silence before he added, as though to himself, 'Of course, she knew me well enough to know that I would do nothing.'

'But you must have known that this put a quite different complexion on the murder of Francine Lemarque.'

Archer played nervously with his spectacles before putting them

147

back on, then he said, 'Lina was my wife. Everything depended . . . Everything! But you must understand that I did not believe for one moment, and I cannot believe now, that Lina was in any way responsible for the girl's death.'

Wycliffe said, 'When, on Wednesday morning, you reported that your wife was missing, you made no mention of the row on Tuesday afternoon. You spoke of an evening meal together and of separating to go to your rooms to work at around half-past eight as though your relationship was quite normal.'

Archer looked down at his hands. 'What I described to you was the usual pattern of our days. On Tuesday there was no evening meal. I have to admit that after the row I did not see Lina alive again.'

'Was Evadne Penrose aware of the quarrel?'

'No. It happened that she had some medical appointment and she left after lunch. In fact that was why I decided to bring things to a head just then.'

Wycliffe changed the subject. 'Do you know the nature of the drugs that were smuggled in the frames?'

'Oh yes. Lina made a point of keeping nothing back. It was heroin.'

Archer looked up, his manner resigned and bleak. 'What will happen to me now? I suppose that I am guilty of concealing a crime.'

Wycliffe had no wish to pursue that line. He had already decided that the interview had gone far enough; that further questioning would have to be formal, and a matter of record.

He said, 'You will be taken to Penzance Police Station where you will be interviewed formally and given an opportunity to make a statement which will be recorded.'

'Shall I be under arrest?'

'No. And you are, of course, free to seek legal advice and to be represented if you think that is necessary.'

Then, to make sure that the perspective was right, he added, 'You must understand that my main concern is still with the murders of Francine Lemarque and your wife.'

*

148

Back in the van, where he was alone, he telephoned Kersey and brought him up to date, then he called DS Boyd at headquarters.

'I want you down here, Tim . . . Say, with one of your team to start with. You might update your briefing on the present scene in the Plymouth, Exeter and Torbay areas beforehand . . . It's heroin, as I understand it. At the moment I've no information about quantity or quality but it comes from Amsterdam in hollow picture frames carried as air freight . . . Yes, this seems to have been going on for at least a couple of years . . . Once you've got the picture we must have early liaison with Customs. We've got a double murder inquiry on our hands and I can't afford to have our chaps swanning off to Amsterdam . . . I may not be around tomorrow until later in the day but Mr Kersey and Lucy Lane will be fully briefed.'

With Boyd in the picture Wycliffe tried to sort out his own ideas and get some kind of perspective. He recalled Iris Thorne's work on the starred entries in Francine's diaries and turned up the file in search of her report. Somebody, probably Lucy, had transformed the heap of papers which had littered the table into a file, and in it he found the report.

The first of Francine's stars in each case corresponded with Lina's return from Amsterdam. The second referred to the arrival of the pictures she had bought at auction. The significance of the third star against each first Friday following a delivery of the pictures had remained in question.

Could it be that the drugs, having been removed from the picture frames, were dispatched on these days?

It was an attractive idea and it occurred to him to wonder if these Fridays corresponded with Lander's alleged visits to his parents. Was Lander, with his motorbike, the courier?

He reminded himself that the transfer of payments up the line in these transactions was often a complicated and hazardous business: another problem for Boyd.

Lucy Lane arrived in time to play her usual role – to listen, then to put his thoughts into her own words with any comments she deemed appropriate.

She listened and then said her piece: 'So it's heroin rather than

pictures. That makes sense. Tell me if I've got this straight. In Amsterdam Lina had her pictures reframed in hollow plastic, stuffed with packaged heroin. Presumably this would be the pure drug. At this end it would have to be removed from the frames, mixed with a high proportion of adulterants, and repackaged for the market. At the moment you are inclined to think that Collis was responsible for all this and that Lander was the errand boy who had the necessary contacts among the distributors.'

Lucy broke off. 'Is that how you see it?'

Wycliffe grinned. 'I do now.' A brief pause, then, 'If Collis really was responsible for unpacking the frames and adding the adulterants, presumably he did the work in his studio. Which means that there must be another forensic examination of his frame workshop possibly in conjunction with Customs, but that will be up to Boyd.'

Wycliffe tried to get comfortable on his bench and decided that it was not possible. He said to Lucy, 'So far you haven't mentioned the two murders.'

'No, I haven't. Well, on the face of it Collis seems to be our number-one suspect. Francine let him see that she knew too much and she was dealt with, presumably by him; then Lina put him under such pressure that he cracked. It doesn't take much imagination to reconstruct the probable sequence of events during the studio encounter on Tuesday night.'

Wycliffe said nothing and Lucy asked, 'You go along with that?'

'I can't see much in the way of an alternative. But I don't like it.'

A moment or two later he said, 'Did you get any lunch?'

'No.'

'Neither did I. Shall we see what Phyllis can do for us? The interview with Archer is at four and I want you to be there.'

'You won't be?'

'No, and I'm leaving Mr Kersey and you to deal with Boyd. I want to get home this evening. And look in at the office in the morning for a word with Mr Scales. Things are getting a bit hectic back there.'

Detective Chief Inspector John Scales was a long-term friend and colleague. A wizard at administration, it was he who made it possible for Wycliffe to spend so much time away from the office.

Lucy said, 'You know that tomorrow is Saturday?'

'That's the point; it will be quiet. As things stand, apart from those involved in the drug business, I'm inclined to call a halt for the weekend. It will give as many of the team as possible a break and, incidentally, help to rescue our budget. What's left of it. I'll have a word with Mr Kersey.'

But Man only proposes.

Four o'clock in an interview room at the police station: the tiny window of parboiled glass let in a minimum of light from the misty gloom outside. This competed with rather than supplemented the yellow glow from a low-wattage bulb.

'Present: Mr Francis Bacon Archer, Detective Chief Inspector Kersey and Detective Sergeant Lane. This interview is timed at sixteen-hundred hours and it is being recorded.' Lucy recited the obligatory preface.

Archer had groomed himself for the occasion: his beard had been trimmed, his long, greying hair was set in its silky waves. In appearance at least something of the Eric Gill image was restored. To sustain it he wore a black jerkin and dark grey trousers.

Kersey, as usual, looked the epitome of a traditional hard-faced cop, and Archer was clearly uneasy. The genus was probably unfamiliar.

Kersey pushed away the papers in front of him. 'I gather that you were concerned about Collis before Francine Lemarque was murdered.'

'Yes, I was puzzled by his manner – he was so edgy and tense and he seemed to get worse as time went on.'

'Did you connect this is any way with the girl?'

Archer stroked his beard. 'To some extent. I knew that Francine was stirring up a certain amount of resentment by her questions. As I saw it, she was no more than a source of mild irritation and I had

no idea why what she was doing should upset Collis or anybody else at all seriously.'

'And then Francine was murdered.'

Archer raised his large pale hands. 'That was terrible! And totally inexplicable. I mean, I couldn't imagine what she could possibly have found out that threatened anyone; let alone something that could drive them to murder.'

Kersey leaned forward in his chair, arms on the table, his face close to Archer's. Off-putting, but Archer held his ground. Kersey said, 'That was on Sunday. And on Tuesday afternoon you quarrelled with your wife and in the course of that quarrel she told you exactly what was going on. Did that change your mind?'

Archer took his time, then in a low voice he said, 'I couldn't help seeing that there must be some connection.'

'Did she directly implicate Collis?'

'Yes, of course she did. She— '

'And Lander?'

Archer hesitated and Kersey gave him time. 'It was because of my tentative suggestion that we should get rid of Lander that we quarrelled. Lina didn't say how he was involved but it was obvious that he was.' Archer broke off. 'And he's gone, hasn't he? Just as Collis has gone.'

Archer, plaintive, added, 'I told all this to Mr Wycliffe.'

'And now you're telling it to the tape. Anyway, you said nothing and did nothing about what you had learned from your wife.'

There were little beads of perspiration on Archer's nose. 'What could I do or say – just like that? . . . At least I needed time to think and a chance to talk calmly with my wife. I decided to wait until the morning when Lina also would have had a chance to think more calmly.'

'But it turned out to be too late to talk to her.'

'Yes.'

'And Collis had gone.'

'Yes.'

'Do you have any idea where Collis might have gone? Where he spent the time he was away from the Guild site?'

'*No* idea at all. I wish to God I had.'

Kersey sat back in his chair. 'For the record, I want you to give an account in as much detail as you can remember of what exactly you did, saw and heard from the time at which you and your wife separated after the quarrel until you reported her missing the following morning.' Kersey broke off. 'Are you willing to do that?'

'I'll do my best.'

'Good! DS Lane will look after you.' Kersey turned to Lucy Lane. 'I'll send a PC to stand in.'

Kersey had had enough.

At just after five o'clock Wycliffe set out for home. He left the mist behind at Hayle and arrived at the Watch House in early evening sunshine. The estuary at full flood looked sleek and shining and smug. Helen was in the garden, dead-heading azaleas.

They got through those few moments of unease which are inevitable when two people who are close come together again after a spell of separation.

'I wasn't expecting you.'

'I know.'

'There's nothing in the house.'

'A crust of bread and thou . . . '

Helen giggled; an unusual phenomenon. 'You are a fool, Charlie Wycliffe! But I quite like you in small doses.'

Chapter Eleven

Saturday

At shortly before nine Wycliffe drove into the city, to police headquarters. There, the weekend had taken over. The desk officer was reading the sports pages of his *Mirror*, the lifts were being serviced, and the cleaners were loose on the stairs. (In sub-stations it would have been very different, with officers preparing for the weekend's wild men.)

But Wycliffe joined John Scales in the latter's office, and for the next two hours they discussed cases on hand, CID politics and their probable future under the new management.

Back in his own office he found Diane.

'Can't keep away?'

Diane had been with him long enough to graduate from eye-catching youth into a distinguished early middle-age. Never a man in sight.

She said, 'I thought you might turn up but there's plenty for me to do here. Anyway, mother's got her friends in and it will be one of those mornings. I'm better out of it.' She went on, 'As you're here, I'd like you to go through the assessments file with me. The chief will be asking for it when she gets settled in.'

'Have you seen much of her?'

'Very little. I'll get the file.'

They worked through the rest of the morning and had a canteen lunch, rather pleased with themselves.

It was half-past two when Wycliffe crossed the bridge once more into Cornwall and proceeded comfortably down the A30 to pick up

the mist again at Hayle. Either it had been there since he left or this was a return visit. If anything it was denser than before.

He drove directly and with his usual caution to the Guild site and found Lucy Lane in the van drinking plastic-cup coffee while filing the latest house-to-house reports.

It occurred to him that his relationships with Diane and with Lucy had much in common. And perhaps Helen should be included. Three women who contrived to manage him without appearing to? He didn't care for the sound of that. So perhaps it was as well not to look at such matters too closely.

'Well?'

Lucy pushed her papers away. 'Tim Boyd is in the studio with his DC and a chap from Customs who specialises in narcotics. I put Tim in the picture and left them to it. Otherwise, nothing to report.'

Wycliffe helped himself to coffee from the machine, while outside the mist still blotted out that other world.

'I'll go and have a word.'

He was greeted by DS Boyd, lean, bony and dark. A man whose every movement had a quick, bird-like precision. Boyd was a phenomenon. His work in the Drugs Squad had developed into a campaign pursued with almost religious fervour. Boyd's eighteen-year-old daughter had died as a result of a single experiment with Ecstasy and following the tragedy Wycliffe had wondered whether he should continue in the job. But his intense hatred of importers, dealers and pushers had not so far affected his judgement, nor his responsibilities under the law.

Boyd was working with Doris Smale, one of his three DCs, and a grey-headed professorial-looking man from Customs whom Wycliffe did not know.

Boyd introduced him. 'David Blackwell – Detective Superintendent Wycliffe. David specialises in this field.'

A grave acknowledgement and David returned to an investigation of one of the cupboards, using a minute vacuum cleaner.

Boyd went on, 'No positive evidence yet, but it will come. It must be here and David will find it. No matter how thoroughly

Collis cleaned up he will have left traces of the adulterants if not of the actual drug.'

Boyd paused. 'Anyway, I can give you some idea of the quantities involved and they are significant.'

He picked up one of the adjustable plastic frames. 'I've looked at the last consignment of pictures and their average perimeter measurements work out at something over seventy inches. The hollow section of these frames has an area of almost exactly three-quarters of a square inch, so that the average picture offers a storage space of a little more than fifty cubic inches, say three hundred cubic centimetres if we go metric.'

Wycliffe could do without the arithmetic. 'What does that mean in terms of weight of heroin?'

Boyd frowned. 'Say a possible twenty-five ounces, or the best part of seven hundred grammes. In fact, I doubt if they would put in anything like that amount. It would probably be packed in polythene tubes to reduce the risk of possible leakage and betrayal, and not all the frames would be loaded. Even so it would not be difficult to make a good payload.'

'We are talking about pure heroin?'

'Oh yes. It wouldn't make much sense otherwise.'

'And you think the adulteration would have been carried out here. Knowing the current market, have you any idea of the probable extent of the adulteration?'

Boyd shrugged. 'Twenty times would be a minimum. There's very little smack on the market above the five per cent level . . . And it can easily go anywhere down to one per cent or even lower. The stuff we're finding at the moment in our area is in the three to four per cent range.'

'And the common adulterants?'

'Still the same. Almost anything goes. "Bulking out" as they call it is sometimes done with sugar or baking powder – even brick dust isn't unknown.'

'I'll leave you to it.'

Wycliffe had had his lesson which was in the nature of a revision course.

He walked back through the mist to the van, where Lucy had news for him.

'Mr Kersey's been on the line from the Incident Room. He's been approached by one of the local uniformed men who came off leave on the afternoon shift. A PC Laity. Laity saw the listing of Collis's car and though it's been recovered he had the sense to report that he might have come across it earlier. He has a friend who farms out in the sticks near Bodrifty, and he's pretty sure that he's seen Collis's car at intervals, over several months, parked outside a cottage not far away.

'At any rate he's sure it's a K-reg blue Peugeot 205 and he thinks that the index letters might include an A and a B.'

Wycliffe said, 'Worth taking a look at the place.' He called Kersey. 'Can you fix it for PC Laity to meet us at New Mill? . . . Say, in twenty minutes.'

'No problem. I'll have a word with his sergeant.'

Wycliffe turned to Lucy Lane. 'We'd better get moving.' He added, 'You can finish your coffee first.'

She gave him a look more eloquent than words and took her time. Looks are excluded from the disciplinary code.

Lucy drove with the screen-wipers working overtime. At New Mill, PC Laity materialised out of the fog.

'I got one of the patrol cars to drop me off, sir.'

Laity was fiftyish and grey, a shrewd man of a reflective turn of mind who thought before he spoke. Which was why his career would probably end more or less as it began.

In the car he pointed out the location on a map.

'Fine, but you'd better drive.'

Laity took over from Lucy Lane. 'We turn off within a few yards up into the moor.'

Lucy said, 'It was just beyond here that Collis's car was found abandoned.'

Laity said, 'Yes.'

Lucy tried again. 'So you know this part of the moor pretty well?'

'I'm learning. Billy Ward, who has a smallholding up there, is a

friend of mine and he's interested in the archaeology of the area. So we get around a bit. Bodrifty is on his doorstep.'

'Isn't that the Iron Age site where they found all that pottery?' Lucy, keeping her end up.

'They call it Iron Age and the excavated huts belong to that period but the pottery points to the site having been in continuous occupation at least from the Late Bronze, and probably up to the first century A D.'

There seemed to be no response to that so Lucy held her peace.

At a little distance beyond New Mill they turned off into the moor. A twisting uphill course through the mist, with no visible landmarks; then, abruptly, the mist would thin, with glimpses of the colours and contours of the moor, only to close in again almost at once.

Laity said, 'We are on the western slopes of Mulfra Hill. If you look at the map you'll see that we are surrounded by standing stones, Bronze Age field patterns, so-called "tumuli" and "settlements", and Mulfra Quoit is just up there on the hill.'

A moment or two later he added, almost apologetically, 'If you spend much time here it all comes alive.'

An odd policeman, and Wycliffe, who had said little, warmed towards him. Suddenly their preoccupation with the murder of two women had found its place in a pattern of four thousand years of human striving and endurance.

'There's Billy's place.'

A bleak little house of stone and slate with a few outbuildings backed on to a pattern of tiny Bronze Age fields. Only a pre-war tractor in an open shed even hinted at the present day.

Lucy Lane (BA: Eng. Lit.) said, 'Stella Gibbons must have been here.'

Wycliffe asked, 'Does your Billy make a living?'

Laity's answer to such a question marked the true Cornishman – a snub? 'He's still there.'

Then, remembering his manners and his company, 'Well, sir, that's where I've seen the blue Peugeot 205.'

Laity pointed to another house, built after the same fashion as

Billy's, but somewhat larger, with three windows upstairs instead of two and probably with more headroom inside. It was a hundred yards or so away, up a narrow stony track which ran between drystone walls.

They left the car at the bottom of the track and got out. Laity said, 'I'll fetch Billy if that's all right, sir.'

Billy was fiftyish, short, thick-set and dark, a possible and worthy successor to those Iron Age people who built and lived in the huts next door. He was attended by a suspicious black and white Collie.

Introductions over and the situation explained, Billy said, 'We never did more than pass the time of day and that not very often. He just came and went at all sorts of times and I can't say I took a lot of notice. I heard his name through the agent. He's called Collins, but that's about all I know.'

'Can you tell us anything about him? . . . Age? Looks?'

Billy frowned, 'Fortyish, slim, dark . . . A bit foreign-looking I thought.'

'Sounds like our man.'

Wycliffe led the way up to the other house. The place looked cared for. Even the cobbled path had been weeded. The front door and the window frames were painted blue and there were patterned curtains drawn over the single window on the ground floor.

Lucy put her hand on the door and it opened a little. She knocked but there was no response.

Wycliffe, recalling his childhood, said, 'Perhaps they don't lock up round here.'

Whenever his job took him into the private world of a stranger Wycliffe knew that same sense of anticipation and mild excitement which he experienced when opening the pages of a biography or journal for the first time. He was about to discover how somebody else had coped, or failed to cope, with this odd business of being alive.

They entered a room that ran the length of the cottage but it was a moment or two before their eyes accommodated to the dim light. The floor was made of slate slabs, worn and polished by generations of feet. There were rugs. The ceiling beams had been

159

stained, and an oil lamp on an adjustable chain hung from one of them. The walls were colour-washed in sunshine yellow.

Apart from a couple of bookcases, a desk and a wall cupboard, the furniture consisted of a sturdy round table, kitchen chairs and a couple of comfortable-looking armchairs set by the open fireplace. The fireplace held a mass of burned paper which had spilled over into the fender and there was a slight but pervasive smell of decay. But in all other respects the room was a model of order and cleanliness.

To Wycliffe it spoke of a reclusive, fastidious man who had created for himself a refuge. And it fitted his image of Collis like a glove. If this was his hideaway, it came as no surprise.

But the walls were bare; not a picture in sight. And, oddly, that seemed to fit too.

Wycliffe often wondered how he would cope if he were ever left totally alone. Sometimes he imagined himself descending passively into squalor; at others he could see himself in a place of refuge like this, polished and sterile.

Behind the living room there was a lean-to kitchen, primitive but clean. No sink, no tap, no water laid on, but there was a bucket and dipper on the floor. Any cooking must have been done on an antique oil stove with a fretted top, or on the open fire in the living room.

'Look here!' Lucy sounded urgent. Wycliffe came out of the kitchen and joined her at the bottom of the stairs which were screened off from the room by a door which Lucy had opened. The smell of decay was now overpowering.

A man's body hung in the stairwell, suspended on a cord secured to a roof beam.

It was Collis. The slender build of the man, the dark hair in tight curls – even in the poor light there was no room for doubt. But the clothes were unfamiliar: a gaily patterned shirt, and tightly fitting plum-coloured trousers with matching socks. The body gyrated slowly in the gentle air currents, with the feet well clear of the middle stair. Wycliffe climbed the stairs, easing past the legs. 'He's been here quite a while . . . Nothing we can do . . . Poor devil!'

Never at ease with death in any circumstances, Wycliffe forced himself to look at the face he had last seen in life. Pale then, now it was livid; the eyes were open and they bulged slightly; the lips were parted, showing the teeth. A noose of nylon cord encircled the neck just below the chin but above the larynx. The cord was secured to a cross-beam in the unceiled roof.

This inanimate thing, dangling at the end of a rope, had, not very long since, been a man.

Poor Collis.

As the body rotated gently he saw that the hair at the base of the skull was bloodstained. A blow? Then he realised that if Collis had launched himself from the top step into the stairwell, the knot in the noose could have been wrenched up against the base of the skull in precisely that position.

He called down to Lucy, 'I'm going to take a look around upstairs.'

He glanced at his watch: it was half-past seven.

Upstairs there was not much to see: three rooms, one little more than a cupboard with a window. Only one of the rooms was furnished: a double bed, a marble-topped wash-stand with ewer and basin, and a wardrobe. The bed was made up and covered by a white counterpane, in keeping with the rest.

Over the bed, the only picture he had so far seen in the house, was a framed drawing, a superb pencil sketch of Francine, head and shoulders, in profile; and it was initialled EC.

Wycliffe joined Lucy downstairs. On his mobile he spoke to Kersey. 'We need the full crew, Doug. Looks like suicide but we need to be certain. You get hold of the police surgeon. I'll tackle Franks.'

To Lucy he said, 'Collis went off during Tuesday night, and it's now Saturday evening. Almost four days. We need to know how long he's been dead. Let's hope that Franks will be gracious enough to tell us.'

Wycliffe used his mobile again to speak to Franks. The pathologist was in a mood. 'Where is this place? It sounds like the back of bloody beyond.'

'It is. So if you can't read a map then drive to the Guild site and I'll arrange for somebody to pilot you the rest of the way.'

Outside, they joined PC Laity who was chatting with Billy Ward.

Wycliffe said, 'I'm afraid we have bad news for you, Mr Ward. Your neighbour has been dead for a matter of days.'

Billy looked shocked. 'I had no idea he was still there.'

'Did you see or hear anyone there on Tuesday night?'

'Tuesday night . . . ' Furrowed brow. 'Yes, it was Tuesday night. He woke me up in the small hours. I remember flashing my torch at the clock and it was just turned half-past one. He was driving off and I wondered where anybody could be going at that time of night.'

'You are sure that he was leaving, not arriving?'

'Of course I'm sure. I listened to the sound dying away in the distance.'

'You've no idea when he arrived at the cottage?'

'No. Except that he was there when I went to bed. I don't take much notice of comings and goings unless they happen to disturb me.'

Wycliffe said, 'I'm sorry to be persistent but this could be important. Do you feel reasonably sure that the car you heard leaving was the one belonging to your neighbour?'

'Unless it was one like it. Those little diesels make a row like a small truck.'

'Thank you, Mr Ward. You've been very helpful. Do you live here alone?'

'Ever since mother died.'

The troops were gathering. Posts and tapes were set up to create an exclusion zone. Wycliffe asked himself for whom? But it was routine. Fox, who always managed to appear rather than arrive, presented himself like a genie out of a bottle. His van and his assistant would be somewhere around.

'Any special instructions, sir?'

Forbes, the police surgeon, arrived and made his inspection. 'Obviously it's a job for Franks but to me it looks like a clear case of

suicide. I'd guess that he's been there up to four days . . . Look, I'm supposed to be at the hospital. I shall get scalped. If you will apologise to Franks . . . '

Wycliffe talked to Fox: 'To start with we want the usual shots of the body with special attention to the noose and to the injury to the base of the skull. I leave the rest to you.'

Wycliffe felt unusually benevolent towards Fox. 'You thought it probable that Collis had a hideaway and here it is; so after the body has gone it's all yours. Obviously much that we might have wanted to see has been burned, but do what you can. See what you can make of it.'

Fox nodded wisely. 'I quite understand, sir.'

Forensic came next, in the person of 'Flo'. She came with her assistant and they were followed by the mortuary van. And finally, Franks, piloted by a PC, who looked pale, as well he might. Franks drove like Jehu of old, but Jehu had to make do with a chariot and a horse or two.

The area had probably not seen so many people gathered together in one place since the Bodrifty 'dig' and perhaps before that, when the 'old' people were still pasturing their sheep and their tiny oxen on the moor.

'Well, Charles? Let's get on with it!'

It was nine o'clock; the mist was clearing with the coming of dusk, and as it did so their little island expanded into the landscape of the moor. It was still chilly.

Franks climbed the stairs and spent some time examining the head and neck of the dead man while Wycliffe watched from below.

Franks said, 'You think he hanged himself?'

'That's how it looked to me.'

'How did he get the injury to the back of his neck?'

Wycliffe realised that he was being tempted on to thin ice and was cautious. 'I thought at first that it might have been the result of a blow but it occurred to me afterwards that if he had launched himself from the top of the stairs, the knot in the noose might have caused it.'

Franks muttered to himself, then, 'So he jumped – or *launched* himself, as you put it, from the top stair. Is that your version?'

'You tell me yours.' Wycliffe had had enough.

Franks came back down the stairs and into the living room. 'In the days when murderers were judicially hanged, how did they in fact die?'

'I'm listening.'

'Well, they weren't strangled by the noose: the sudden six-foot drop dislocated the cervical vertebrae and ruptured the spinal cord.'

Franks waited for the question which did not come, then went on, 'Your man was strangled by the noose. In my opinion there was no jump.'

'Are you saying— '

'I'm saying that he *could* have swung – not jumped – off the top of the stairs. In which case he *could* have been strangled *and* suffered injury to the base of his skull. I need to look into the nature and extent of that injury before I can give an opinion, and I can only do that when I've got him on the table.'

'You think the hanging could have been faked?' Wycliffe was shaken.

'I'll tell you what I think when I've established the facts.' Franks being Franksish.

'Anything to say about how long he's been dead?'

Franks pouted. 'It's a guess, but I'd say at least three days, probably longer.'

Half an hour later the body had been removed and was on its way to the mortuary. Franks had gone, but he would be unable to start on the autopsy until the body had been formally identified. In his present mood he might well delay a start until morning.

Wycliffe said, 'Now, Lucy. With no next-of-kin that we know of we shall have to find somebody from the Guild to do the ID. Archer is the obvious choice, but in all the circumstances he may not feel that he can do it. Anyway, there's nothing more for us here so let's leave it to the experts.'

It was agreed that Fox would attend to the recording of any evidence that might suffer from further delay, then pack it in until morning.

Wycliffe and Lucy Lane were driven back to the Guild site by Laity and, as they were about to get out of the car, Wycliffe turned to Laity. 'Are you willing to act as coroner's officer *pro tem?*'

Somebody had to shepherd and console the bereaved relatives or their stand-ins, and brief the coroner.

'I've done it a couple of times before, sir.'

'Good! We can regularise it in the morning. Now you'd better come with us to break the news to Archer.'

It was dark; the stars were out in a clear sky and lights twinkled around the site. There was only one light in the Archer house and it came from a window on the first floor.

'That's his room. I hope he hasn't gone to bed.'

Lucy rang the door bell and, after a lapse of time, a light came on in the hall and the door was opened.

It was not Archer but Evadne Penrose, in her dressing-gown. Her manner was subdued, almost apologetic. 'He's up in his room but whether he's gone to bed or not, I don't know. He's in a state, and I thought somebody ought to be in the house with him at night, so I stayed.' She broke off. 'Do I have to get him down?'

'I'm afraid so.'

'In that case you'd better come in.'

They waited in the little hall and eventually Archer arrived, fully dressed. He stood looking at them, silent and apprehensive.

'Is there somewhere we can talk?'

Without a word Archer led the way, not into the drawing room, but into the office. There, he seated himself behind his desk and let them find chairs for themselves.

'I suppose you have news of Emile.' His eyes were red-rimmed with tiredness and his hair and beard were unkempt. Archer was near the end of his tether.

Wycliffe told him the news.

'So Emile is dead.' He spoke very slowly. 'I was afraid that was what you had come to tell me.' His large pale hands, resting on the

165

desk top, seemed to grope for something which they failed to find. 'It was suicide, of course.'

Wycliffe said nothing and Archer went on, 'I find it impossible to think of Emile killing anybody . . . But he was a Piscean, you know, Mr Wycliffe. Highly strung, nervous – easily led to a certain point . . . He had ability as a draughtsman – many Pisceans have artistic skills – but little *stamina*.' Archer shook his head. 'When I look back I realise that he must have felt hopelessly trapped . . . '

Wycliffe said, 'We do not know that he killed anyone. The autopsy will tell us exactly how he himself died, and our investigation will carry on from there. But before any of that can happen we have to have a formal identification of the body. And in the absence of relatives it needs to be done by someone who knew him well.'

Archer looked up. 'Are you suggesting that I might do it?'

'I shall fully understand if you decide that you cannot.'

Archer shook his head. 'On the contrary, whatever has happened, I feel that I must help you in your investigation in any way that I can.'

Wycliffe thanked him. 'In that case Constable Laity will acquaint you with the procedure and take you to the mortuary.'

On their way back to the hotel Lucy put the question of the moment: 'Well, what do we make of it? Collis was a fugitive, a murderer twice over. Frustrated in his efforts to get away, he decided to put an end to it. Is that our line?'

Wycliffe took his time. 'We can't have a line until Franks makes up his mind about the neck injury, and gives us his opinion as to whether or not Collis took his own life. All we've got to go on so far is the fact that Collis is dead, and Archer's revised version of what happened on Tuesday afternoon – and afterwards.

'According to him, he and his wife had a showdown on Tuesday afternoon and that was the last time he saw her alive. They did not have their usual evening meal together and they do not in any case share a bedroom. It was only when he had not seen her by ten o'clock on Wednesday morning, and her bed had not been slept in,

that he went to consult Collis and found the studio locked and apparently deserted.

'At that point he came to us. And it was later that day when Collis's car was found abandoned on the Penzance side of New Mill.'

Wycliffe paused and took a deep breath. 'Along with all this we have Billy Ward's account of the little Peugeot leaving in the small hours. He doesn't know when Collis or anybody else arrived at the cottage. And there we have it.'

Wycliffe sighed. 'I suppose all this can be fitted together, but not by me – not tonight, anyway.'

They arrived back at the hotel.

Too late to ring Helen.

The night staff gave them sandwiches and, of all things, cocoa. 'It will help you sleep. No caffeine.'

But the recipe did not work for Wycliffe. And the Woolf Diary 1931–35 failed him too. At one o'clock he was still wrestling with permutations of the facts of the case as he could recall them. And always at the back of his mind was the memory of that pathetic body swaying gently in the air currents of the stairwell at the end of a nylon cord.

Collis and Lander both left the Guild site at some time on Tuesday night.

Together?

A good question.

And Lina Archer's body was found on the floor of Collis's studio next morning.

Billy Ward had his sleep interrupted by a car leaving in the small hours of Wednesday morning, and later Collis's abandoned car, out of fuel, was found at New Mill, at a point a little beyond the turning which led to his cottage.

Was Collis alone?

If it turned out that he had been murdered then obviously there must have been someone with him in the cottage. Had the car been abandoned by his killer?

And what about Lander in all this? Lander and his motorcycle

were missing. Billy Ward had not mentioned a motorcycle. Had Lander been a regular visitor at the cottage?

It seemed more than likely. But, more to the point, was he there on Tuesday night? It was possible that Fox and Forensic might have something to say about that.

Wycliffe's thoughts processed in circles.

From time to time he had browsed in popular works on quantum theory and he could get himself into a similar sleep-destroying mode over the ambivalent life/death of Schrödinger's cat.

Chapter Twelve

Sunday

But sleep came at last, and the very next thing he knew was that the sun was shining into his room, and somewhere a church bell tolled. He didn't need the church bell to tell him that it was Sunday. Wycliffe was convinced that if he awoke after being unconscious for a week he would know if it was Sunday. There was something in the air, something in the rhythm of life – something, anyway. But Helen maintained that it was nonsense.

He looked at his bedside clock. Three minutes to seven.

On Sunday morning a week ago, admittedly a good deal later than this, he had been sitting in his garden at the Watch House, concentrating hard on thinking about nothing. Now that was seven days, and three deaths by violence, away.

The eight o'clock news carried a report of the finding of Collis's body: 'Following the two recent murders at the craft colony, known as the Guild of Nine, at St Ives in Cornwall, the police, last night, acting on information received, visited a remote cottage on the moor and discovered the body of Emile Collis, the Guild's painter. An investigation is under way to establish the circumstances in which Mr Collis met his death.

'A police spokesman refused to comment when asked if this discovery was likely to bring closer a solution to the mystery surrounding these crimes.'

Wycliffe had been successful so far in holding back news of the drug trafficking, for fear of putting suspects on their guard and driving them underground.

Downstairs the 'Sundays' were displayed in the hotel vestibule and 'The Guild Murders' had made the front page of one of the tabloids with a photograph in full colour of the interior of Archer's nonogon under a caption 'Boardroom for Death?' Somebody must have turned a blind eye.

Wycliffe had breakfast with Kersey and Lucy Lane. In view of the latest development Kersey had cancelled his day at home with the family. He would remain in charge of the Incident Room while Wycliffe and Lucy Lane worked from the van on the site. Scene of Crime would resume at Collis's cottage but routine inquiries had been suspended to save money on overtime.

At shortly before nine, in the Incident Room, Wycliffe had a call from Franks. The pathologist was in ebullient mood. 'I was right, Charles!'

Wycliffe refrained from pointing out that as he hadn't given an opinion one way or the other he could hardly be wrong.

'So?'

'The injury to the base of the skull was certainly aggravated by the knot in the noose. Whether the knot *caused* the injury is another matter. There *could* have been a blow to that area but it's now impossible to say that there was. In my opinion *if* there was such a blow it did not break the skin but it could have been sufficient to cause insensibility.'

'In fact, you don't know whether Collis hung himself or was hanged.'

'I'm afraid that is so. If I'd been called in even twenty-four hours earlier I could have been more definite.'

Wycliffe dispensed sympathy. 'We must try to give you better notice in future. Unfortunately we don't know that we've got a corpse until we find it.

'Anyway, in your view, we could be dealing with suicide or murder.'

'Yes. Collis could have put the cord around his own neck and swung out over the stairs. As I said before, there could be no question of a jump. That would have resulted in dislocation of the cervical vertebrae of which there is no trace.'

Franks had not finished. '*If* it was murder, it could have been a repeat of what happened to the woman. She was bludgeoned, then strangled, but in her case there was no attempt to make it look like a suicide.'

'Anything else?'

'Since you ask me – yes. Our man could have been involved in a bit of a struggle. There was a certain amount of light scratching to the face. It is conceivable that an attacker tried to stop him crying out, but it could have been nothing of the sort. It might have happened earlier – when and if he killed the woman.'

'Is that it?'

'No, there is something else that may be worth mentioning. There were a few spots of blood on the front of Collis's shirt. It is unlikely but I suppose they could have come from the wound at the base of his skull, or even from the scratches to his face. On the other hand, it's just possible they belonged to somebody else. Anyway, Forensic have his clothing and I've asked them to take a look, so I expect you will be hearing from them.

'That is it, unless you want to know that he has all his teeth with only two fillings, that he had a slightly enlarged spleen— '

'I can do without that.'

'Good! I'll let you have my report. But, Charles, do try not to be so bloody awkward. Life is too short.'

Wycliffe replaced the telephone with commendable restraint and spoke mildly. 'Franks can be extremely irritating without even trying.'

He passed on the news to Lucy. 'We seem to get in deeper and deeper . . . We must bring in Lander.'

'You think— '

'I've given up thinking.'

It was an odd feature of this case that at each stage he had found some reason (or excuse) to talk to Marsden. It was not that he had any suspicion of the man and he was certainly not, or so he told himself, seeking advice, but half an hour spent in the old reprobate's company seemed to broaden his perspective.

He said to Lucy, 'Join me at the Guild site in an hour, and then we'll see what Fox is up to.'

Sunday morning. The road to Mulfra was almost deserted, the sun shone, the bell of Mulfra church tolled, and it was possible to believe in almost anything.

He turned down the lane past the Tributers' and parked near Marsden's cottage where the track was wide enough. Marsden's door was open and music blasted out across the valley. Classed as 'spiky music' in Wycliffe's technical vocabulary, it had long since been dismissed by him as 'modern stuff' by composers with unpronounceable Russian names.

He stepped over Percy, asleep in the sunshine, and went in.

'What do you want? I'm busy.' Marsden's voice came from the studio . . . 'Oh, it's you.'

Marsden was at work on a blocked-in painting of the cove, with Mynhager in the foreground.

'A commission. Woman who used to live round here wants a pretty picture to hang on her wall to remind her of times past. A photo would do her just as well but this will keep Percy in cat food for a bit.'

He suspended operations, attended to his brushes and palette, then joined Wycliffe in the living room. 'Have you found Collis?'

'You haven't listened to your radio. We found him last night.' Wycliffe described the circumstances and Marsden seemed genuinely distressed. 'Poor EC! I'm really sorry. We had a couple of good years together and what makes it worse is that it was I who got him mixed up with Lina.' He broke off. 'I suppose he put an end to it himself?'

'We don't know. Franks says it's too long since death for him to give a firm opinion. It's possible that he was rendered insensible by a blow to the base of the skull and then strung up in a fake suicide, but Franks won't commit himself.'

Marsden was shocked. 'But what *is* this? You can't tell me that there've been three killings over some fiddle with a few bloody paintings that were hardly worth bringing in anyway. It doesn't make sense.'

'The pictures were a cover for drugs.'

Marsden looked blank. 'But how? I still don't see— '

'They arrived framed.'

'So?'

'The frames were hollow and it seems that they were stuffed with pure heroin.'

Marsden was incredulous. 'I can't believe . . . The clever bitch! . . . I knew that she was greedy with no holds barred: that's one reason why I kept clear of her bloody Guild. But this!'

And a moment later: 'So where did EC come in?'

'As far as we can tell, he dealt with the unpacking, bulking-up and repacking, plus the reframing of the pictures; all carried out in his studio, presumably by him, possibly with Lander's assistance.'

Wycliffe had never seen Marsden so agitated. 'Poor bugger! EC could never say "No" and stick to it. She could twist him round her little finger.'

He was silent for a while, then, 'But even so these killings don't fit . . . I mean, even if she's cut in on the big boys they wouldn't risk drawing attention to themselves with this kind of mayhem. It doesn't add up.'

Wycliffe had got what he wanted: his own ideas put into words by somebody who also knew something of life on the other side. He said, 'What I've told you is confidential for the moment.'

Marsden grinned. 'My lips are sealed.'

'They'd better be.'

He drove back to the Guild site and joined Lucy in the van. As usual Marsden had helped him to orientate his thinking and he needed to talk.

'We are dealing with three deaths by violence, Lucy: Francine, Lina and Collis; three murders, or two murders and a suicide, because it's still possible that Collis killed the other two and then took his own life.'

Lucy said, 'Forensic could help us there if they are able to identify the source of the bloodstains on Collis's shirt.'

'Yes. And all we can do about that is to keep our fingers crossed. But there's another point. It's not only a question of "who?" but

also, of "why?" It seems to me that the motives behind the killings of Francine and Lina were almost certainly different. Presumably Lina died, at the hands of Collis or another, as a direct result of her involvement in the picture scam. But what about Francine? There is really nothing to suggest that she knew anything of significance about what was going on. She was inquisitive, but Francine was inquisitive about anything that might affect her involvement with the Guild.'

Lucy agreed. 'In any case, she would have been more likely to have involved herself than go for exposure.' Lucy had a less favourable view of Francine than Wycliffe. 'But are you saying that we may be dealing with two killers?'

Wycliffe hesitated, 'No, that would be incredible. Anyway, we shan't get any further by talking. Let's see what Fox is up to at the cottage.'

Lucy drove to New Mill then up on to the moor and through deserted lanes to Collis's refuge.

In sunshine the bleak little cottages looked out of place. Billy Ward was pegging out his washing and the Scene of Crime van was parked outside Collis's cottage.

Lucy said, 'All right if I have a word with Billy? I've a feeling that we might not have got all he has to tell us.'

'Good idea. See what you can do. And sound him out on motorbikes. I'll deal with Fox.'

Fox greeted him at the door.

The room looked just as Wycliffe had last seen it except that the grate had been cleared of burned paper and Fox's current assistant, a young DC, was seated at the table sorting through a heap of charred paper fragments with forceps and probe. Promising fragments were placed between sheets of polythene for later examination by a specialist.

Over the years Fox had had a succession of assistants, all out of the same mould: male, youngish, largely mute and incredibly long-suffering.

Wycliffe gave him the news from Franks and Fox received it without any great surprise. 'So he could have been murdered. I've a

gut feeling that he didn't do all this himself with suicide in mind. I mean, why bother?

'Anyway, somebody burned all this and the bulk of it isn't going to tell us much. Hicks is sorting out the fragments, and so far they confirm what I said. Collis kept all his personal stuff here and not at his studio; not only documents, but letters, and the sort of things people keep in drawers which they never open. He seems to have kept a diary or journal at some time in a hard-covered exercise book, but it was ripped to pieces before being thrown on the fire with the rest.'

Wycliffe said, 'Anything you've got on his visitors here is going to be useful.'

Fox stroked his bony chin, his most conspicuous feature next to the length of his legs. 'He certainly had one regular visitor and that was Lander. Lander's prints are all over the place, just as they were in the studio flat.'

'Any recent?'

Fox hesitated. 'I gather from what you said that Collis probably died on Tuesday night. All I can say is that, from the prints I've found, it's *possible* that Lander was around as recently as that.'

'Other visitors?'

'There were others: two other males, unidentified so far. They were not frequent visitors and their prints are confined to this room.'

Fox summed up: 'I've no doubt at all that this is where the man really *lived*, but somebody has systematically set about destroying everything that might have told us anything about him and his background.'

'And he could have done that himself in preparation for clearing out but it is possible that he was murdered first.'

'As you say, sir.' Fox added, uncharacteristically, 'I feel sorry for the poor devil.'

Wycliffe said, 'Don't forget that he must have played a role in the drug racket.'

Fox made a dismissive gesture. 'Women! They can make a man do anything. I reckon the Bible story got it just about right but the fig leaves were too late and too few.'

Wycliffe said, 'But it's pretty obvious that Collis was gay.'

'In my opinion, as often as not, that can be an escape route. Anyway, sir, you want to know what I've found, and it amounts to very little so far. We may have something when Hicks has finished playing with his bits of burned paper but I doubt it.'

Wycliffe was intrigued by this unique insight into Foxian philosophy. The records showed that Fox was married but nobody seemed to know anything of his life away from the job.

'When do you expect to finish here?'

'I should be through by this evening.'

'Morning, miss. What can I do for you?' Billy picked up his empty clothes basket. 'Nice day for drying. You don't get too many o' them up here. That's why you find me washing on a Sunday.'

'I'm DS Lane.'

'I know you're police. I saw you here last night. Funny job for a woman I always think. But there; times change. You'd best come in.'

Billy led the way into his kitchen which was also his living room: stone floor, mats and, wonder of wonders, a Cornish cooking range. Must be one of the last in use, Lucy thought. Basic furniture plus well-filled bookshelves. On the mantelshelf above the range there was a row of pots, some of them with bits missing.

'They came from the dig. They let me keep 'em as souvenirs. And I've got quite a little collection of sherds and other oddments which I keep in drawers.'

Billy's collie came to inspect her, then settled on the mat in front of the range, forepaws thrust out, tail tucked away.

Lucy said, 'I suppose you get quite a few visitors through your interest in archaeology, and having Bodrifty on your doorstep.'

'Too many sometimes. Come July an' August they can be a nuisance.'

'Do you ever see anybody from the Guild?'

A smile. 'I thought we might be getting there, miss. I've had the potter up here a couple of times – Scawn, that's his name. Very knowledgeable chap. It does a man good to see him handle a pot.

He even smells it. You can see that he's back with whoever made it. In tune like.'

'Anyone else?'

'Archer himself came here once. Not about pots. He wanted to talk about the old people's interest in astrology.'

'And were they interested?'

'Perhaps, but in a more practical way than the stuff he believes in. His ideas came from out East much later; along with a lot of other funny notions.'

Lucy decided to get down to basics. 'It's possible that your neighbour didn't hang himself, Mr Ward. He could have been murdered.'

Billy was shocked. 'Oh dear! That is nasty! . . . Murdered . . . Poor man!'

The old wall clock with a yellowing face ticked away the better part of a minute before he went on, 'Now I see what you're after, but I'm afraid that what I can tell you won't get you far.'

'Did either of your visitors from the Guild show any interest in your neighbour?'

Billy pursed his lips. 'Not that I recall . . . If they did, I don't remember, but I wouldn't have thought much about it anyway.'

'Did your neighbour have a visitor who came on a motorbike?'

Billy nodded. 'Oh, he's a regular, and he's sometimes there overnight.'

'Can you say when you last saw him?'

A smile. 'I don't think I *saw* much of him at all, and when I did he had his helmet on, but I heard him all too often. That bike of his is enough to wake the dead. He hasn't been around for a few days.'

'Can you recall the last time you heard him?'

'I know it was evening . . . ' He considered. 'That's right. I was having a bit of a clean-up in the barn an' that's a Tuesday job. So it must've bin Tuesday. He didn't stay long that time. I remember I was still working in the barn when he left.'

Lucy prompted. 'You told us that it was Tuesday when you heard Collis's little Peugeot being driven off in the middle of the night.'

Billy looked concerned. 'So I did. But I never connected the two. You wouldn't, would you? You're asking me about things that didn't seem to matter at the time, and then you don't take much notice.'

Lucy was appreciative. 'I quite understand. You've been very helpful.'

She left to rejoin Wycliffe in Collis's cottage.

Wycliffe said, 'So Lander was here on Tuesday but, according to Billy, he didn't stay long. All the same, we need to find him.'

Back at the site there was a curious feeling of suspended animation. It was a Sunday, but they had been told that Sundays made little difference to the routine. If there still was a routine.

As they left the car and walked towards the police van they were joined by Archer, looking almost dishevelled. His hair was unbrushed and his beard untrimmed; his glasses had slipped, apparently unnoticed, halfway down his nose. 'You've had a report on Emile's death?'

Wycliffe said, 'It's inconclusive. The pathologist says that he can't decide whether or not Collis died by his own hand.'

They had stopped in a little group by the van. It seemed that Archer had more to say but had difficulty in finding the words. 'You've been to the cottage?'

'We've just come from there. Our people are still in possession.'

Archer shook his head. 'I didn't even know that he had a cottage.'

They had lunch at the Tributers' where Phyllis, with two assistants – girls from the village – still had her work cut out. A fine warm Sunday brought out the trippers. Wycliffe and Lucy turned down the roast chicken that was most in demand and went for a salad.

They were less than halfway through their meal when Wycliffe's bleeper bleeped and he went outside to take the call.

DC Potter, on duty at the Incident Room. 'Sorry to disturb you, sir, but I've just received a message from PC Foster at the Guild site. He says that a chap has turned up there, on a motorbike,

claiming to be Robert Lander. He wants to talk to you and he won't talk to anyone else. Foster says there was something odd about the man and he even had doubts about his identity – thought he might be some nutter. But the potter, Scawn, happened to see him and he had no doubt, though he seemed anything but pleased to see him again.'

Wycliffe said, 'Make sure they hold on to him and tell them I'll be along.'

Back in the Tributers' he passed the news to Lucy. He was disturbed. 'We have the whole police force supposed to be looking out for this man and he turns up of his own accord, on our doorstep, on his bike. Is he trying to take the mickey or something? At any rate we'd better get over there.'

Lucy said, 'Aren't you going to finish your lunch?' And then, 'Remember Drake? . . . And Lander isn't exactly the Armada.'

Wycliffe grinned. 'One of these days, Lucy . . . ' But he went on with his meal.

They found Lander in the police caravan on the Guild site, drinking coffee, apparently self-possessed and relaxed. By contrast, his watchdog, PC Foster, seemed tense and had placed himself between Lander and the door.

'You have met us both before: Detective Superintendent Wycliffe and Detective Sergeant Lane.' Wycliffe was not quite sure of the line to take, so he opened with a question which would set the man talking. 'Why have you come back?'

Lander looked surprised. 'Because I heard this morning on the radio that Emile was dead.'

'And that meant something to you?'

'It meant a very great deal to me. Emile and I were very close friends . . . More than that.'

'Lovers?'

'Yes.'

Lander was as Wycliffe remembered him: the tall, muscular blond with the pudding-basin haircut.

'Where were you this morning?'

'In Torquay. I've been there since I left here, staying with a friend. How exactly did Emile die?'

'I'll answer your questions when you have answered some of mine. You knew that you were wanted for questioning in connection with these crimes?'

'No. I did not! I had no idea.'

'But you managed to get here without being picked up by our people.'

Lander patted his hair. 'Well, with this lot under a helmet I don't suppose there's much to see and my bike is much like other people's. Anyway, I wasn't picked up.'

Wycliffe looked at him steadily without speaking, then, 'Are you a congenital liar, Mr Lander?'

A faint smile. 'That's laying it on a bit. I make up stories.'

'About your relationship with Derek Scawn, about the parents you found it convenient to visit from time to time— '

Lander looked positively sheepish. 'I've done that sort of thing since I was a child, Mr Wycliffe. When things were not as I would have liked them to be I've pretended that they were different. But as far as I know I've never harmed anyone in my life.'

'So how does it come about that you are now wanted for questioning in connection with possibly three murders, and offences under the Dangerous Drugs Acts?'

Lander was looking at Wycliffe with total incomprehension. 'But I – I don't understand. I've done nothing – nothing! Then after a brief pause, 'You said *three* murders . . . '

'It's possible that your friend Emile Collis was murdered.'

Lander looked stunned.

'When you heard that he was dead you thought that he must have taken his own life – is that it?'

'Of course!'

Wycliffe still could not make up his mind whether Lander's concern was genuine or all part of the act. '*If* what you now say is true I think the time has come for you, in your own interest, to be totally honest about what you know and the part you have had in what has happened.'

'I'll do my best.'

Lander, like Wycliffe and Lucy Lane opposite him, was wedged on a narrow seat by the fixed table, but he contrived somehow to strike an attitude, conveying total openness and transparency.

'You knew that, under cover of importing pictures, Lina was engaged in smuggling illegal drugs, and that Emile was involved?'

'Yes, I knew.'

'How did you find out?'

Lander ran long fingers through his blond hair. 'Pillow talk. Emile was becoming increasingly edgy and depressed, and in the end I got him to talk. He was the sort to find himself in a mess without realising how he'd got there, and he desperately wanted out. I suggested that we should go off together but he wouldn't hear of it. He had some crackpot idea of making Lina see the error of her ways . . . I'm afraid I lost patience.'

'In all this Collis referred to Lina as though she were still alive?'

'Of course.'

'Were you in any way involved with the drug trafficking?'

'No, I was not.'

'Are you saying that you did not act as Lina's courier, taking her drugs to market?'

For the first time Lander reacted with vigour. 'I most certainly am saying exactly that!'

'Did Emile discuss with you any of the details of Lina's dealings?'

'In so far as he knew them. He knew nothing of the monetary transactions, although he admitted that Lina paid him well.'

'If you didn't act as courier do you know how the drugs reached the distributors?'

Lander smiled. 'It was by courtesy of the Royal Mail. They were sent in smallish packages by book post.' He shook his head. 'Lina was a clever witch. She'll haunt whoever killed her, that's for sure.'

Wycliffe glanced at Lucy Lane who had sat through all this in silence, but ready and waiting.

Now her turn had come. 'Returning to the facts. Where did you spend those times when you were away from the site, supposedly playing the part of a dutiful son?'

Being questioned by a woman, it was strange to see the change in Lander's attitude. There was no hostility, but an increased wariness and he answered only after a significant pause. 'I was at Emile's cottage on the moor. We spent a lot of time there. Really, we shared the place and the cost.'

'So the mother who suffered from recurring attacks of migraine was just one more of your fantasies?'

'I'm afraid so.'

Wycliffe intervened. 'Were you at the cottage at all on Tuesday?'

A momentary hesitation, then, 'Yes I was.'

'At what time?'

'It must have been early evening. I didn't stay long.'

'Why did you go there?'

'I was bailing out, at least until things quietened down a bit. I wanted to pass the word, and recommend him to do likewise, but he wouldn't listen.'

'He was alone?'

'Oh yes. We didn't have visitors at the cottage.'

'What was he like? Was he worried? Depressed?'

'He was like a man waiting for the house to fall in on top of him but he wouldn't do anything about it.'

'He wasn't turning out his papers? Burning stuff – or preparing to?'

'I've told you: he wasn't doing anything.'

'When you heard that Emile was dead you assumed that he'd committed suicide and, in the circumstances, you were not all that surprised. Is that correct?'

'Yes, that is true.'

'Where did you spend Tuesday night?'

'I was in Torquay. As I said, I thought the whole situation was getting too difficult and I'd decided to move out.'

Wycliffe said, 'What you have told us needs to be checked. You will be detained for questioning for forty-eight hours. You will be taken to Penzance Police Station where you will be questioned by Detective Sergeants Lane and Boyd. DS Boyd is from our Drugs Squad.'

'That suits me. I'm in the clear.'

When Lander had been taken away Lucy said, 'Why did he come back?'

Wycliffe was thoughtful. 'Good question. He strikes me as an oddity – a really clever fool, and there are not many of them about. One could say that once he knew Collis was out of the way there was no longer anybody here in a position to make a formal accusation against him. He could turn up and tell his own tale, and that's what he's doing.'

Wycliffe contacted DS Boyd and put him in the picture. 'Lander is a consummate liar, Tim, but it's hard to know how far he's involved. DS Lane will bring you up to date. Any news from your end?'

Boyd said, 'We are working closely with Customs. We want news of what Lina did with her money. According to Customs, the likelihood is that she kept it over there. Of course their *weekeinde* is not much different from ours and we have to wait until they wake up bleary-eyed on Monday morning before we really get anywhere.'

Boyd went on, 'As far as Lander is concerned a lot depends on how much he gives this evening. Unless we have enough to charge him I suggest that we get authority to hold him for another forty-eight hours, by which time we should know where he fits in. I need photographs to circulate in the Torquay area. There's one on file which will do for the moment. It's largely a question of who sees them.'

'So where do we go from here?'

Wycliffe's conversation with Boyd was followed by a call from Forensic. In business on a Sunday!

'Regarding the clothing of Emile Collis, Dr Franks left word that you were interested in bloodstains on the front of the dead man's shirt. There were three spots of blood and they were approximately of the same age as the blood from the wound in his neck, but of a different group. Collis's blood was group A while the spots were from group AB.

'We can, of course, go further with this if you have any source for comparison.'

Wycliffe put down the telephone and passed on the news, 'So what we need, Lucy, is a source for comparison.'

'Would sir like to enlarge?'

'With pleasure. Franks suspected that the blood on Collis's shirt was not his. And he was right. Added to the scratches on his face the spots suggest that there was a struggle in which Collis's antagonist suffered what was probably a very minor injury.'

Lucy interrupted, 'You are saying then that Collis was murdered.'

'I've thought so all along and what Lander said didn't change my mind. For me there are just two questions, who? and when?'

Lucy said, 'According to Lander, backed up by Billy, he arrived and left in the early evening. And again, on Billy's word, we have Collis's car being driven off in the small hours. We know that it was dumped just outside New Mill at sometime during the night of Tuesday/Wednesday.'

Wycliffe agreed. 'And we considered the possibility that Collis had decided on a getaway, that he ran out of fuel, abandoned the car and returned to the cottage to make away with himself. To me, that is fantasy. The scratches on his face and the blood on his shirt-front alone are an answer to any such idea.'

'So?'

'I need to think.'

'Then I'll leave you to get on with it.'

It was evening, and Wycliffe was still in the police van. The sun had been shining all day with the sky a canopy of blue, but now clouds were creeping in from the west and the sun was already hidden.

The whole site was quiet. Presumably the residents were still around: Archer; Scawn the potter; Gew, the man of all work . . . Whatever happened in the future this, for the moment, was still their home. Presumably in the morning Alice Field would continue the furnishing of her little houses for the American market, and it was even possible that Paul would be at work in his carving shop.

All carried along for a little while by sheer momentum. But how long could it last?

Wycliffe was striving to relate the murder of Lina Archer in Collis's studio on Tuesday night to the discovery of Collis's body in his cottage on the following Saturday afternoon.

According to Franks Lina had died between ten and twelve on Tuesday night, while Collis had been dead for at least three, and possibly four days when he was found on the Saturday. In fact, all the evidence pointed to the likelihood that he too had died on the night of Tuesday/Wednesday.

The obvious interpretation, and the one relied upon by the killer, was that Collis had murdered Lina Archer then, after a desperate but futile attempt at escape, he had taken his own life.

But the latest evidence, that Collis had himself been a victim, was convincing, and the implication must be that the killer had gone straight from Collis's studio, where Lina Archer lay dead, to Collis's cottage.

And, in Wycliffe's view, the probability was that he had walked there.

He could not afford to risk driving a car off the site in the middle of the night nor, indeed, being seen on the road.

Lucy Lane returned to the van to find Wycliffe studying a 1/25000 map of the area. 'How far is it from here to Collis's cottage, Lucy?'

'Five and a half to six miles.' Lucy was tidying away the accumulated litter of the day.

'That's by road. If these paths are walkable it could be no more than two and a half.'

Lucy glanced at her watch. 'It's half-six already and I've got this interview with Lander in the Penzance nick.'

Wycliffe continued to study his map. 'You take the car. I'll get one of the patrols to pick me up when I'm ready. You'd better let them know at the hotel that we shall neither of us be in to dinner.'

'May one ask what you intend to do?'

'I'm planning a little walk.'

Lucy seemed about to say something but changed her mind and left.

The night guard was marking time, patrolling the site, waiting to settle in the van, but he would have to wait for another hour.

From the van Wycliffe could look across the site to the Archer house. The sky had clouded over entirely by now and already there was a light in a lower window.

It was eight o'clock when Wycliffe set out on his walk, his mobile in his pocket. He made a circuit, and arrived at the top of the slope above Collis's studio.

He was trying to imagine the state of mind of the man, the killer, when he left the studio that night with the body of Lina Archer lying lifeless on the floor. Only a little earlier the woman had been active, *involved*, and confident in her expectation of the days and years ahead.

He had he taken away her future. And the experience must have been many times more real, more immediate, than it had been with the girl, where his action had been remote from the event of her death.

Had he meant to kill for a second time? Almost certainly not. But anger and hatred and fear, and something more than all three, a kind of lust, had taken possession of him.

And what he must do next was determined by what he had already done.

He had no option.

The footpath Wycliffe had seen on the map snaked away through the heather and gorse, and in a very few minutes he had reached a road which, according to his map, must be Trewey Hill.

He had to pick up the footpath on the other side, and lost time because he was looking for a gap in the hedge instead of a primitive stile.

Once over the hedge the path was open to the moor so that if there had been anyone to see he would have been conspicuous, but the killer had had the protection of darkness.

Wycliffe trudged the moorland path, mainly uphill, for a mile or more, and came to the New Mill road.

Another crossing, another stile, and from the top of that stile Wycliffe could see Billy Ward's cottage against the skyline.

A dip, then a steep rise, a final stile, and he came out close to Billy's cottage, with the short lane to Collis's in front of him. The walk had taken him a little over forty minutes.

On that Tuesday the night had been clear and moonless, but Collis's car, parked in the lane, would have been dimly visible under the stars.

Now, although it was not yet dark, the light was poor. There was a light in Billy's cottage behind the drawn blind, and his collie gave a single sleepy bark, but that was all.

Wycliffe walked up the lane to Collis's door. He had a key and a torch, and he let himself in.

His torch-beam swept the dimly lit room. Fox had left it spick and span as though ready for Collis's return.

Wycliffe told himself that it was foolish to feel uneasy.

Of course Collis would have been there to greet his killer. Had he been troubled by the fact that his hideaway was known? Had he greeted his visitor with surprise? Or in fear? Was there immediate aggression? Or did they talk?

Wycliffe was sure that the attack, the blow to the base of Collis's skull, had taken place upstairs. Collis's body, unconscious or semi-conscious, had not been dragged or hauled, or even carried, up those narrow stairs without leaving traces for Fox to find.

The pretext by which the killer had got his victim upstairs would probably never be known.

But Wycliffe climbed the stairs. Unless he lit the paraffin lamps he had only his torch; and daylight was fading. Nothing seemed to have changed. Collis's framed pencil sketch of Francine still hung above the bed in the bedroom.

He felt sure that the blow when it came could not have been immediately and totally effective. It must have been at this point that the brief struggle occurred in which Collis's face had been scratched, and the blood spots from his attacker had stained his shirt-front.

But the killer had prevailed, and it was essential to create the impression of suicide. Collis was to hang himself, and the stairs provided the ideal setting.

Another period of action during which necessity was overtaken by obsessive involvement that was almost frenetic.

And then the burning, for which there could have been little if any purpose . . .

How long would it have taken the killer inside? Certainly not less than an hour and possibly two.

Then, if all this was more then a product of Wycliffe's imagination, the car had to be moved. The longer there was no obvious association between the cottage and the missing man, the more difficult it would be to determine the actual cause of death. Through it all the killer had kept in mind his own security.

And it had worked. Franks had been unable to pronounce between suicide and murder.

The keys of the car must have been taken from the body and the car driven away.

But the engine had died just to the south of New Mill. What would the killer have done if it hadn't?

In any case, presumably, he had had to walk home.

Wycliffe used his mobile to contact the Penzance nick and he gave them his position. Then, for twenty minutes, perched on a low wall, he was left to arrange his ideas into a credible pattern.

Of one thing he was now convinced: he knew who was responsible for the deaths of Francine Lemarque, Lina Archer and Emile Collis. There was no alternative. The blood tests would be significant evidence in support of a charge for the murder of Collis, but three spots of blood on a dead man's shirt would not go far in bringing charges for the other killings.

Well, tomorrow would be another day.

It was quite dark now. Billy had gone to bed, and light flared in the sky above St Ives on the one hand, and Penzance on the other.

No place for the old people.

Back at the hotel he joined Kersey and Lucy for a drink and a snack in the bar.

He seemed to have come from a different world and he tried almost frantically to adjust. 'Lander?'

Lucy said, 'We didn't get far. Tim Boyd persuaded him to give us some names – two of them people he claims to have been staying with in Torquay. One is a suspected dealer they've had an eye on for some time. Lander can be held for a further forty-eight hours and I've a strong feeling that is how he wants it. He's a slippery customer and he knows exactly how much to give.'

Wycliffe made no direct comment; he said simply, 'I want you to arrange a formal interview with Archer in the morning.'

Later, from his bedroom, he spoke to Helen.

Helen said, 'You sound odd. Is something wrong?'

'No, everything is fine.'

But he was a long time getting to sleep. His evening walk had, in a curious and most disturbing way, seemed to put him 'inside' the mind of the killer and he had glimpsed something of the man himself.

Or thought he had.

Chapter Thirteen

Monday

Another fine day. Wycliffe had slept little and he attended the morning's mini-briefing with almost nothing to say. The papers had reported the finding of Collis's body with photographs of the cottage, and several broad hints that this was the end of the trail as far as the Guild of Nine murders were concerned. Two of the papers mentioned a possible link with drug smuggling.

At the briefing most of the talking was left to Boyd. 'Dickie Mellor, from Customs, flew out last evening. The shop in the Oude Kerk has been under discreet observation since we passed word, and there will probably be a raid later today. Dutch financial guys are to start looking into the money set-up. Lander still maintains his innocence but we've authority to detain him for another forty-eight hours. He doesn't seem anxious to go anyway and I think the truth is that he feels safer with us.'

Wycliffe listened, and felt like a spectator.

In his office afterwards Lucy Lane reported that the Archer interview had been arranged for eleven o'clock.

'What was his attitude?'

'Reserved. I told him that he was entitled to be accompanied by a solicitor and he said there was no need.'

On the telephone Wycliffe made arrangements for an official from Forensic, in company with the police surgeon, to be available at the police station the following day to take a blood specimen from a suspect. The suspect's attendance would, in the first instance, be voluntary, but refusal might be met later with a Court Order.

Wycliffe wondered how much of his experiences of the previous night he would pass on to Lucy Lane. He had established nothing new; he had merely convinced himself, and he felt vaguely uncomfortable about the whole episode. He ended by giving her an edited version, and she seemed impressed. He summed up. 'Well, we shall see. In the Archer interview we will concentrate on the Collis case and see where it gets us.'

At eleven o'clock they were assembled in one of the interview rooms: Wycliffe, Lucy Lane and, of course, Archer.

Archer seemed to have lost weight, and his pink cheeks which had pouched slightly above his beard looked shrunken and pale. His hair had lost its sheen and much of its curl. He looked almost haggard.

Lucy Lane, in charge of recording, made the required introductions and handed over to Wycliffe.

Wycliffe said, 'Did you know that Collis was in possession of a cottage near Bodrifty where he spent much of the time that he was away from the Guild site?'

'No, I did not, not until the recent tragedy.'

'It seems that he was away quite often; sometimes overnight, and, occasionally, for whole weekends. Did it never occur to you to wonder where he spent his time? Surely it was the kind of thing you might have talked over with your wife?'

Archer hesitated. 'I suppose I might have been mildly curious but no more. I cannot recall discussing it with my wife. Members of our Guild work together, but they have their lives apart from the Guild.'

'You are acquainted with a man called Ward – Billy Ward, who occupies the cottage near Collis's. I understand that you visited him on one occasion to hear what he had to say about the Bronze and Iron Age people and their attitude to astrology.'

Archer looked surprised. 'That was some time ago, and he was unhelpful.'

'You did not at that time get any hint that Collis was in possession of the cottage close by?'

'I did not.'

'How did you get to Ward's place? Did you walk?'

Archer showed mild irritation. 'I went in my car. I don't understand— '

'I wondered if you were acquainted with the shortcut across the moor, virtually from your house to Billy Ward's – or to Collis's. I walked it last evening.'

Wycliffe allowed a brief interval and then changed his approach. 'I think I should tell you that yesterday I had a report from the pathologist on the autopsy he conducted on Collis's body. He could not decide whether Collis took his own life, or was murdered. As far as he is concerned the only indication of a possible struggle is that there were slight scratches on the dead man's face which *could* have been caused when and if he was responsible for the attack on your wife.'

Archer's arms rested on the table which separated him from Wycliffe, his hands clasped tightly together. 'So the cause of Collis's death is likely to remain in doubt?'

'In so far as the evidence from the pathologist is concerned – yes.'

There was a lengthy pause, then Archer, tentative, said, 'I would never have believed that Collis was capable of murder . . . '

Speaking slowly and quietly Wycliffe said, 'I know of no way of deciding who is and who is not capable of murder. I came into this case to investigate the death of Francine Lemarque. To the killer, who had never committed murder before, it must have seemed incredibly simple . . . In the final analysis it came down to a towel in the wrong place.'

Archer never took his eyes from Wycliffe's face but he murmured to himself, 'A towel in the wrong place.'

Wycliffe continued, 'Yes, put there with intent to murder, but there was a significant element of chance. What the killer did might, for several reasons, have failed to achieve its object. However, a little later the girl died, but by that time her killer may well have felt distanced from his crime.

'But the point is that a barrier had gone: murder had become possible. From that time on it would always be there, an ultimate solution.'

'So?' Archer spoke as though the word had been forced from his lips.

Wycliffe went on, 'It was my job to investigate her death. Now my investigation has broadened to cover the deaths of your wife and of Collis, as well as the systematic importation of illegal drugs.'

He shifted on his chair, which was uncomfortable. Archer did not move a muscle.

'Three people have died; two of whom were certainly murdered, while the third, Collis, *could* have taken his own life after bringing about the deaths of Francine and your wife. A bungled escape followed by suicide.'

When it seemed that the silence might continue indefinitely Archer said, in an oddly strained voice, 'You do not accept that explanation?'

Wycliffe was emphatic. 'No, I do not. Yesterday I heard from Forensic that bloodstains on the front of Collis's shirt were not of his blood, although they are of the same age as the other stains on his clothing.

'It is obviously possible that these stains came from an attacker, slightly injured in the struggle which rendered Collis unconscious.'

Archer said nothing and Wycliffe went on, 'It will be a simple matter to obtain specimens from those close to Collis for comparison.'

Archer seemed to consider what he would say, but said nothing.

'You have nothing to tell me, Mr Archer?'

'No.'

'Very well. Now that you are acquainted with all the facts you may need time to consider your position. This interview is over: it has been recorded and you will be asked to sign one of the tapes before leaving. A police car will take you home.'

When Archer had left Lucy said, 'What was the point? Within the next two or three days we could have positive evidence from Forensic of his presence at the cottage, and of his involvement with Collis.'

'A dubious foundation for a charge of triple murder, Lucy. Unless we can get him to talk we've still a long haul in front of us.'

A canteen lunch and by half-past one they were on their way to the Guild site; a drive that was becoming routine. As they passed the entrance sign he saw Alice Field, apparently at work as usual. Scawn would presumably be in his pottery, and Gew next door. The main door of the wood-carvers' shop was open, so presumably Paul was there. People wondering how to sort out their lives.

In the van, the duty PC said, 'Scawn has been here, sir. He's anxious to talk to you and he left his mobile number for me to call him when you are available.'

Wycliffe agreed and a few minutes later Scawn arrived.

'Sit down, Mr Scawn.'

With some difficulty Scawn folded himself into the van seat on one side of the table, facing Wycliffe and Lucy Lane on the other. Scawn was anxious and he began to speak at once.

'I'm afraid that I've held back certain information which, although it can hardly be relevant to anything that has happened, you may feel you should have had sooner.'

Wycliffe waited.

Scawn ran a hand through his dark hair. 'It concerns Mrs Archer – Lina.' There was a pause, then, 'We had a relationship.' His dark brown eyes searched the faces of his listeners for some reaction but found none.

Wycliffe said, 'You are speaking of a sexual relationship?'

'Yes.'

'Was Lander aware of this?'

Hesitation. 'It was never mentioned between us but in all the circumstances . . . Lina came to the flat, and although we were both very discreet it is probable that Lander was aware of what was happening.'

'And now that Lander is under some pressure you think that he may attempt to gain favour by passing on what he knows.'

Scawn said nothing.

'Does Archer know of your liaison with his wife?'

'Lina was quite sure that he did not. They did not share a bedroom. But in recent weeks I think he's been avoiding me,

and when we have met he's been distant. Now, since Lina's death . . . '

Wycliffe took time to think. 'In your contacts with Lina Archer did she ever confide or discuss anything at all that might shed light on what happened to Francine?'

'No, she did not.'

'Did she ever say anything that even hinted at her involvement in the importation or handling of illegal drugs?'

'She certainly did not. All that came as a great shock to me.'

Wycliffe considered before speaking, then, 'I am going to ask you to put what you have told us into a formal statement which will only be used if at some time it appears to have direct relevance to our inquiry. DS Lane will be in touch.'

Scawn got up and stood for a moment, relieved but uncertain. 'I have no idea how free we are to leave the site. On Mondays I usually spend the evening with friends in Truro, returning at around midnight. Last Monday I put them off but I wondered about tonight.' A faint smile. 'I don't want to be posted as missing . . . '

Wycliffe said, 'There is no need to disappoint your friends, Mr Scawn.'

Another moment of hesitation, and Scawn left.

Lucy Lane said, 'Well, well! One way and another the flux seems to be getting pretty murky.'

Archer was alone in the house. Against opposition he had insisted on taking Evadne home earlier. Now it was dark, but he had not switched on any lights. He looked at the illuminated dial of his wristwatch. It was fifteen minutes to eleven. Plenty of time.

He let himself out, and closed the house door behind him, making sure that the lock had snapped shut. The night was clear and chilly, with a nor-easterly breeze, but he wore only a thin mackintosh. He had thought very carefully about this and decided that an overcoat might be a problem.

He left the site and walked down the track to the road. There he turned to the right, towards Zennor. A more or less straight stretch

of road ran for perhaps two hundred yards to a sharp corner. On the seaward side there was a low drystone wall, on the other side the moor was bordered by a bank of ragged elder shrubs.

Archer knew precisely where he wanted to be. He trudged along the road to within a hundred yards or so of the corner, to a gap in the bushes where he could stand off the road.

He looked at his watch. It was almost five minutes past eleven. Plenty of time.

It was not really dark, because of the stars.

The stars. He could pick out the familiar constellations of the May sky . . . Better not to think along those lines.

He was surprised by his own calm. I am not even impatient . . . I am *composed*. He said the word aloud: 'Composed.'

The sea gleamed in the starlight and the coast line was a complex silhouette against the sea.

Archer wondered, *What shall I see afterwards?*

Will there be an afterwards?

Does it matter?

Wycliffe will have something to think about. He is a man of conscience, and he will be troubled. 'A towel in the wrong place' – those were his words. Now he will have, 'A man in the wrong place.'

He looked up and saw a glare of light above Eagle's Nest, then the headlights of a car cut great shafts into the night.

I must be sure.

The car swept down the hill and as it took the turn at the bottom Archer caught a glimpse of the Volvo's white chassis.

No doubt.

The corner, and the car accelerated. Fifty yards . . . Twenty . . . What would it be like?

An instant of excruciating pain . . .

And then?

It was three o'clock in the morning when Kersey, in a dressing-gown, woke Wycliffe from a disturbed sleep. 'I've just had a call from the duty officer at the nick, and I thought you should be told. There's been an accident on the coast road not far from the Guild

site. It seems that a car, driven by Scawn, collided with a pedestrian who turns out to be our friend Archer. Archer is dead, and Scawn has been taken to hospital suffering from minor injuries and shock. It all sounds bloody odd to me.'

Wycliffe was already dressing. 'And to me. When did this happen?'

'They don't know exactly. It seems that Scawn, incoherent, arrived at one of the cottages scattered along the road and they phoned. Our lot and the ambulance arrived, but it took a while to dawn on some Einstein that the driver of the car was mixed up in our business and they went on from there.'

'What did you tell them?'

'To hold everything at the scene till we can take a look.'

'They will get the Vehicle people out there but you'd better get hold of Fox. I don't want any doubts about this.'

It was already broad daylight when they reached the coast road at the bottom of Trewey Hill where a PC was diverting what traffic there was.

A hundred yards along, the road was totally blocked by Scawn's Volvo slewed across it. The car's front bumper was half-buried in the rubble of a drystone wall: the radiator was damaged and dribbled water.

The police surgeon had visited the scene and, on the assumption that he was dealing with a road accident, he had allowed the body to be removed to the mortuary. The Vehicle examiners were there, and one was busy with a camera. Alan Turner, a uniformed inspector who had trained with Kersey, was in charge.

'I've never seen anything like it. The man was lying face-down, and the near-side front wheel actually went over his body. He was literally crushed to death. I can only think that he was drunk and fell asleep on the road.'

Turner gestured at the road ahead. 'This is one of the straighter stretches and the driver had probably just put his foot down.'

Wycliffe said nothing. Kersey called him to the near-side of the vehicle. There was no wall on this side, just a shrubby bank against the moor, and the ground between this and the car was littered and

contaminated with the evidence of what had happened to Archer. The man's spectacle case was there, pathetically intact, a ballpoint pen . . . And the whole area was spattered with his blood and other, nameless, tissues.

It was then that Wycliffe noticed a gap in the thicket of elder bushes which bordered the road at this point. The gap was wide enough for a man to stand in, and there were signs that the grassy, peaty ground had been recently trampled.

He said to Kersey, 'I want this on record, Doug.' Then, to Turner, 'Where have they taken Scawn?'

'To Penzance hospital.'

Again to Kersey: 'I'm leaving you here, Doug. I'll keep in touch.'

Penzance was just coming to life for the new day; even the hospital had not yet got into its stride and a visitor was not welcomed.

'Yes, we do have a patient brought in after a car accident . . . You're from the police? . . . Very well, I'll check with Sister.'

Sister mobilised a young man in a white coat who looked fagged out. 'Dr Ruse. The police, about Mr Scawn.'

'We had him checked over. Minor superficial injuries but nothing dangerous. The surgeon is satisfied that he's not at risk . . . Yes, you can see him, but not too long. Remember he's in shock . . . '

Scawn's black hair and pale face on a white pillow. He opened his eyes, blinked, and sat up.

A word or two of sympathy.

'Yes, but I still can't believe what happened . . . He must have been standing by the roadside . . . I had a glimpse of his figure and of his face . . . He just threw himself in front of the car face-down . . . It was deliberate . . . This was no accident . . . I think I swerved in a useless attempt to avoid him but at the same moment there was a most awful crunch . . . I shall never forget it. Never!'

By nine o'clock Wycliffe was in the Incident Room, where he was joined by Lucy Lane. 'So you've been up most of the night?'

'Half of it.'

'I've heard the story. It's incredible!'

The morning mail was on Wycliffe's desk and he was going through it. He opened an envelope with a scrawled address. Inside there was a single sheet of paper which he spread on the desk for Lucy to read:

'Now you can have all the specimens you want but you can't prosecute a dead man. You will remember me as "The man who was always in the wrong place".'

Lucy was thoughtful. '*Is* that how you will remember him?'

Wycliffe took his time. 'No, it is not. In my opinion Archer was a man so obsessed by his own ideas that he would allow nothing to stand in their way. Not even another life.'

'You are thinking of the killing of Francine.'

'Yes. Because she had the means to threaten his precious Guild he decided to remove her, and he set about it with a chilling detachment that to me is the essence of wickedness.'

'But that was not how you put it to him.'

'No, because we needed to draw him out. We had, and we have, no material evidence to involve him in her death.'

'And the other two – his wife and Collis?'

'The difference was in motivation. When Archer discovered how he had been systematically deceived on all fronts he was tortured by a blend of hatred and fear and blinded to the risks he would run if he attempted revenge.'

They were interrupted by a great gust of wind which brought rain lashing against the window. 'There! They said we were in for a rough day. I only hope our people have finished on the road.'

The battering subsided and Wycliffe went on, 'I believe that Lina's murder was deliberate and that it was carried out with the intention of implicating Collis . . . It was a mad business, with risks at every stage.'

'But it almost worked.'

'It could still have worked. Apart from the blood on Collis's shirt which, incidentally, has yet to be identified as Archer's, we have

little material evidence against him in any of the three deaths. It would have been a very long haul to build up a sustainable case, and with a good defence team he might have got away with all three killings . . . '

'So you gave him time and opportunity to talk himself into trouble. I wondered why you delayed his blood test. It could have been done yesterday.'

Wycliffe said nothing but continued going through his mail while Lucy turned over the pages of the report file.

It was Lucy who spoke first. 'Did it occur to you that he might take the problem out of our hands?'

It was some time before Wycliffe answered, and then he spoke slowly. 'I did not for one moment imagine that he would involve someone else.' There was a pause before he added, 'And that's all I'm going to say, Lucy.'

A Sunday afternoon six months later

With no murder trial pending, and the investigation into heroin smuggling having lost its first dramatic impact, the Guild and its members had been forgotten by the press.

Wycliffe was turning the pages of the local weekly while Helen read a novel. Outside it was raining. Wycliffe spotted a minor headline: 'Guild of Nine Revival?'

'Listen to this.' He read the report aloud:

Our correspondent has learned that the lease of the property on the moor near St Ives, occupied by the Guild of Nine, has been acquired by Paul Bateman, the distinguished wood carver, with the intention of creating a new craft centre.

Paul Bateman, a member of the Guild, will be joined by three of his former colleagues and by Hugh Marsden, a near neighbour, and long-established figure in the field of landscape painting.

Helen said, 'Well?'

'What can one say except to wish 'em luck? Marsden has

probably done Paul a lot of good . . . But there will never be another Francine.'

Helen returned to her book. 'Odd, your attitude to that girl, considering that in her short life she caused so many people so much grief.'